ATMOSPHERE
The Shape of Things to Come
Architecture, Interior Design, Design and Art

ATMOSPHERE
The Shape of Things to Come
Architecture, Interior Design, Design and Art

Atmosphere

ATMOSPHERE
The Shape of Things to Come
Architecture, Interior Design, Design and Art

Compiled by Hanneke Kamphuis and Hedwig van Onna

Frame Publishers
Amsterdam

Birkhäuser
Basel · Boston · Berlin

Atmosphere

Content

04 Introduction

09 Almost Alive

41 Fields of Colour

73 Drawing the Line

105 In the Mix

137 Form Follows Fold

169 Handicraft 2.0

201 Down to Earth

233 Addresses Architects, Designers and Artists

239 Colophon

Atmosphere

8

Introduction

Surrounding the earth is a blanket of air: the atmosphere. It occupies a vast area, only part of which is visible from our vantage point here below. Thanks to continuous research and sensitive instruments, we are learning more and more about how the atmosphere functions and about the gases that make up its various layers.

The atmosphere is a useful and meaningful metaphor for the artistic climate that fills our lives and responds to our sensors. Here, too, one can distinguish various layers that can be analysed and reduced to the basic components of any creative effort: form, colour and material. In this book we explore seven atmospheric layers that not only exist simultaneously but — owing to their fleeting nature — can easily merge to form new combinations, over and over again.

The highest atmospheric layer, 'Almost Alive', is also the one expressing the most earthbound ideas. It's a supernal stratum with an organic, capricious and unpredictable character. Underlying the mood generated by the work in this chapter are references to Mother Nature, a source of inspiration for centuries. Currently, the focus is on microcosmic entities. New technologies and intelligent materials are enabling the design of objects and buildings that really do seem 'Almost Alive'. Unprecedented possibilities are straining to be born from a combination of research and science — particularly new insight into biological processes — in a dialogue with design.

Colourful, never-ending mirages float in the following atmospheric layer, 'Fields of Colour'. Colour applied in monolithic, monochrome planes has proved to have a powerful impact on the human mind. Alienating, as in City Lounge, an installation by Pippilotti Rist and Carlos Martinez that immerses entire streets, cars and public furniture in red. Dynamic and chameleon-skin changeable, as in Galleria Hall West, a department store in Seoul designed by UN Studio. Strong and signalizing, as in Herzog & de Meuron's Allianz Arena. When we think of colour, we think of innovative lighting technology and, in particular, light-emitting diodes (LEDs), for tinted light stirs the senses and produces emotionally charged design and architecture.

The line — the purity and spontaneity of the first sketch — is an indispensable tool in the design process and the protagonist of the following layer, 'Drawing the Line'. These three words refer to half-formed ideas as they hatch from deep contemplation and to beginning brainwaves as they materialize on paper. Diaphanous, transparent structures that guarantee a sense of spatiality. Taking a straightforward approach to linearity in design is Swedish quartet Front: four women who draw furniture in the air. Their airborne pen strokes are recorded, converted into 3D digital files and, with the use of rapid prototyping, made into real pieces of furniture.

'In the Mix' implies not only the position of the next atmospheric layer, but also the highly kaleidoscopic process in which waste generated by overconsumption trumps the surfeit of 'designed' products to come back as brand-new, often bizarre and apparently impulsively fabricated objects, installations and even buildings. The aesthetic value of rubbish and used goods joins moral awareness and recent developments in the field of materials to yield new hybrids in product design and architecture. The design language may be asymmetric, unexpected or deliberately out of balance — or, on the contrary, homogenous, thanks to the use of uniform colours or textures. Other designs blend past and present, for example, or perhaps a variety of functions.

The same sort of playful impudence emerges in 'Form Follows Fold', a layer of Atmosphere in which designers experiment with flat sheets of material — different materials, different sizes — in an attempt to produce three-dimensional objects. They bend, fold, pleat, notch, crinkle and crush as long as it takes to create a structure that's airy, light and no longer flat. This type of work and the designs it generates are especially interesting because they combine spontaneous, almost childlike steps with an underlying knowledge of mathematics. The flat-pack objects featured in this chapter necessitate little loss of material during manufacture and require minimal storage space: two reasons to champion this economical method of design.

Although present in more than one of the seven atmospheric layers, the search for a more emotional or authentic form of design is interpreted in different ways. In 'Handicraft 2.0'

we find a crossover involving cottage industry, a perhaps more feminine aspect of design, and technology and architecture, long felt to be the more masculine aspects. Traditional techniques, especially those used in textile design, play a major role in handicrafts, but today these techniques are in close communication with cutting-edge developments in technology. An example is Japanese designer Tokujin Yoshioka's Pane chair, which is baked in the oven as though it were a loaf of bread: polyester fibres and all! Like the 2.0 version of a computer program, handwork is being rescaled and textile techniques are being reinvented through the use of new materials and methods. Here, in the most decorative and narrative layer of Atmosphere, the relation between ornament and construction is investigated.

'Down to Earth' – a layer featuring the bold and the primitive – describes the work of designers and architects who are tired of perfect forms fashioned in a computer-controlled world. They're setting their sights on a more intuitive, subconscious approach. The work expresses the same preference for tactility that we saw in the handcrafted designs of the previous layer, but these projects rely on rough, unfinished – and sometimes even battered – forms and textures. Designs that might have come from ancient civilizations that no longer exist. Once again, however, despite the rugged appearance of their work, these designers are not reluctant to use sophisticated technology.

Like the earth's atmosphere, this book consists of a number of layers that sometimes appear to be clearly distinguishable from one another and, at other times, seem to intermingle and overlap. Here's hoping the oxygen in Atmosphere will be pumped into future projects and fuel The Shape of Things to Come.

Hanneke Kamphuis and Hedwig van Onna

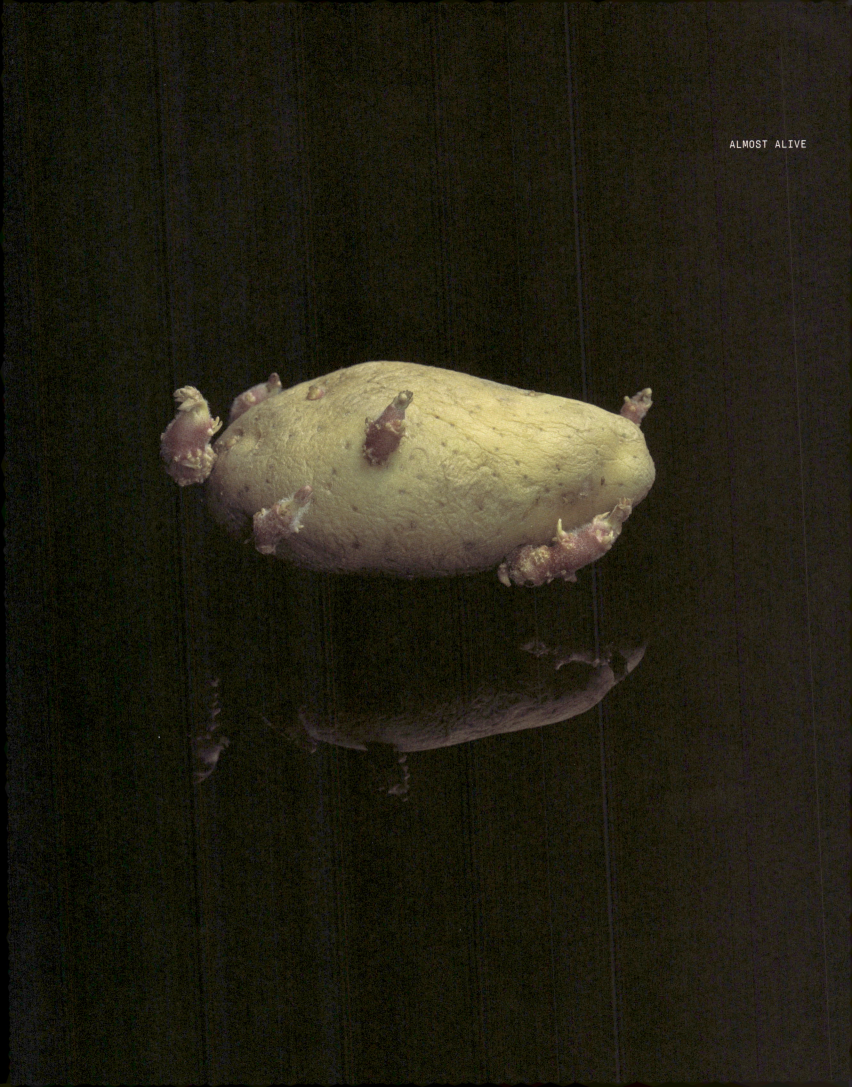

previous page:
POTATO
Photography by Blommers/Schumm

Atmosphere

Almost Alive

Natura artis magistra. Nature is the mistress of art. We've become increasingly better at investigating every tiny facet of nature, delving into the deepest seas, thrashing through the densest jungles, peering into the tiniest particles of matter. Experts in the field of biomimetics explore biological processes and structures that can contribute to the latest technologies and cutting-edge products. Biometrics has come into its own only during the past ten years, yet the applications seem boundless. Examples are sharkskin bathing suits that shave seconds off record times, super-strong fabrics based on the structure of cobwebs, and sea sponges whose skeletons are aiding architects to make more efficient skyscrapers. Nendo, the outfit that created the Hanabi lamp, is using the natural properties of metals in an attempt to imitate nature. Warmed by the heat of the light source, Hanabi's petals, which are made from an alloy, gradually open; when the lamp is turned off and the petals cool, they close again, little by little.

In recent years, many designers have expressed ideas on nature in romantic and often decorative ways. This approach — which interprets nature in the form of two-dimensional, stylized motifs — is quite unlike that taken by a growing number of designers who base their work directly on biological examples. In most cases, their designs accentuate the awesome aspects of nature. Serving as sources of inspiration are not the picturesque fawns and flowers of the recent past, but virulent germs, regimentally organized colonies of insects, enormous jellyfish, mountain ridges and natural disasters.

Design of this sort has a sinister side as well, which touches on the secret anxieties so typical of human nature — fears emerging from the idea that we are nothing more than nature's plaything. A good example is Tjep's Shock Proof, a project in which the designer applied a special coating to popular vases made by other designers so that the objects can be smashed, without breaking, thus creating something entirely new. Another 'parasitic' design is Lionel Theodore Dean's Holy Ghost, which started as Philippe Starck's classic Louis Ghost chair and ended as a seat partially encapsulated within a coralline structure. Dean is a fan of rapid prototyping techniques, which allow him to translate a digitally constructed image into a tangible structure. In the same way that an inkjet printer fills sheets of paper with line after line of words, a 3D printing machine builds the structure, one layer at a time, with the use of a laser-melting process and plastic powder. The designer, now more of a 'creator' than ever, watches as the fruit of his mind develops and matures before his very eyes. Although the process offers him a nearly unlimited amount of freedom, the whimsical shapes and complicated structures found in nature seem particularly suited to this technique. As in nature, each of the various models based on a single design displays unique characteristics. The purchaser of Dean's Tuber9 lamp takes home an evolving, mutating 'animation'; attaches it to any surface desired; and claims ownership of a one-off. We try to control nature, we view nature with amazement and dismay, we fear nature to the depths of our being, and we sometimes feel cut off from nature. But we are forced to recognize, time and again, that nature nurtures.

HIDDEN.MGX
2006
DAN YEFFET

Atmosphere

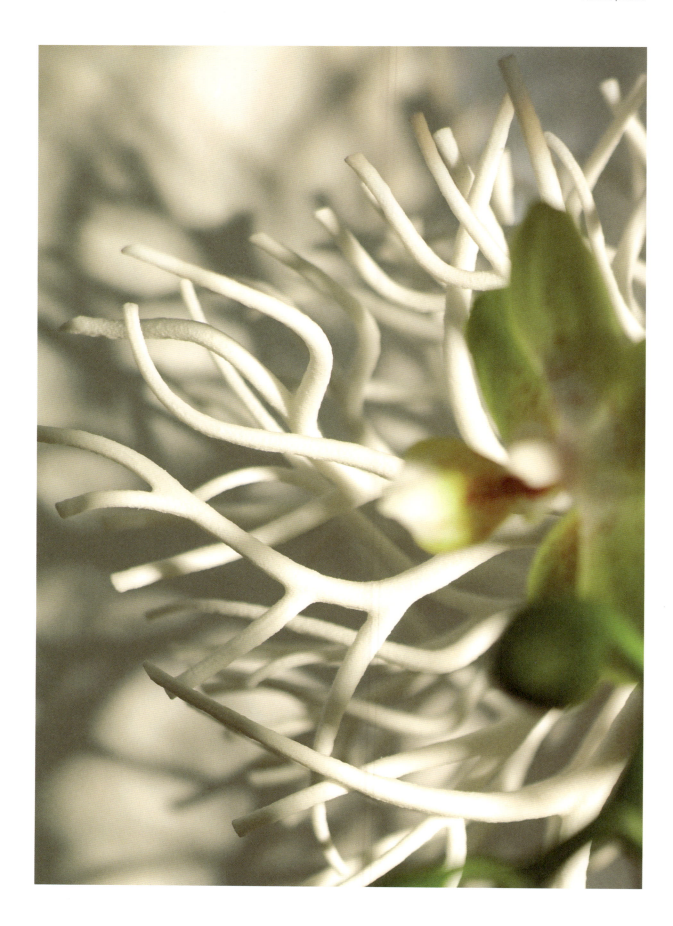

Almost Alive

HIDDEN.MGX
2006
DAN YEFFET

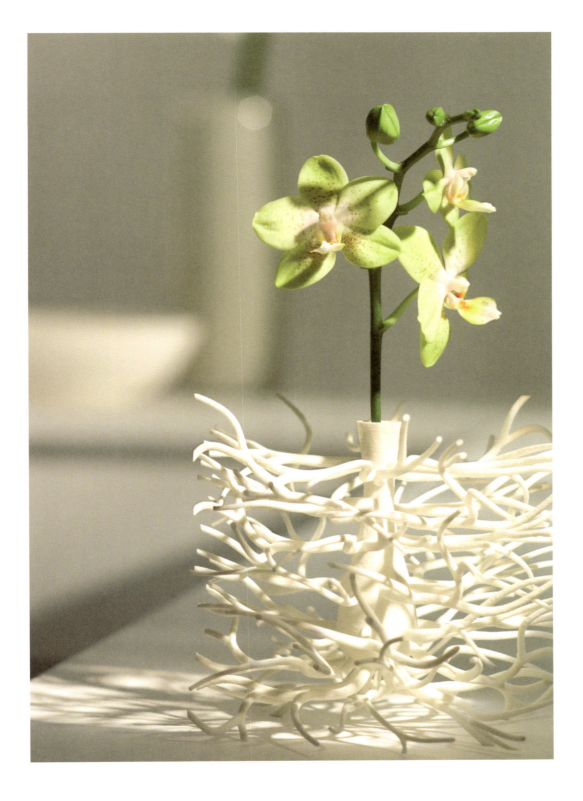

A close look almost reveals an actual vessel that is hidden deep within an orderly disorder of venous structures extending in a web of probing tentacles. In fact, you could be forgiven for thinking that this is a model of a human artery that feeds the living organism inside it.

ELASTIKA
Temporary Installation at the Moore
Building; Miami, Florida, USA
2005
ZAHA HADID ARCHITECTS
Photography by Tancredi

Atmosphere

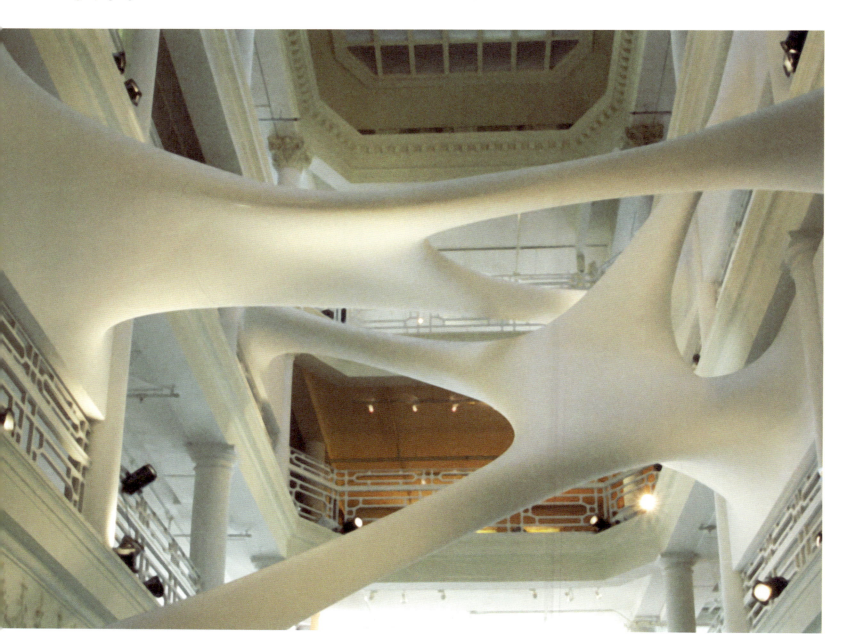

What is it that makes this installation so overwhelming and so majestic? The forms found in Hadid's work differ so much from those of its host, the Moore Building in Miami, that one thinks immediately of an alien being occupying the space or, at the very least, of an abandoned building overgrown with vegetation. At the same time, Elastika's sleek, soft-white steel parts seem oddly familiar. Comparisons can be made with bone structures, with microscopic discoveries or even, as Hadid has mentioned herself, with long strands of chewing gum. Combine images of smallish objects like bones and chewing gum with the mammoth scale of this installation, and the result is the not-unpleasant sensation of insignificance and vulnerability. Thank you, Zaha Hadid, for this cosmic experience. Sublime.

Almost Alive

HYPNOTIC ROOM
MAM, Paris, France
2005
R&SIE(N) ARCHITECTS
Photography by R&Sie(n) Architects

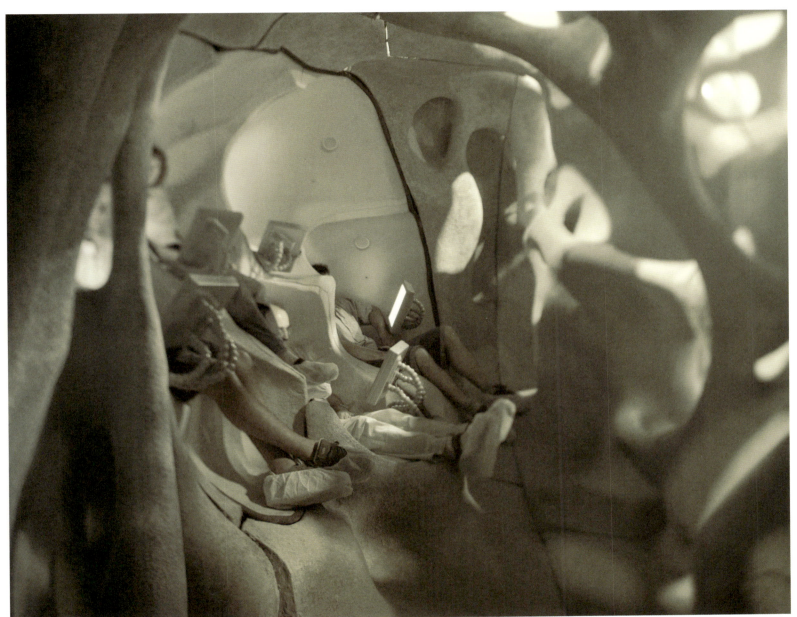

R&Sie(n) Architects' interest in organic structures has led to forms with an apparent relationship to a protomodernist, nature-inspired design movement dating back to about 1900.

ASPHALT SPOT
Tokamashi, Japan
2003
R&SIE(N) ARCHITECTS
Photography by R&Sie(n) Architects

Atmosphere

16

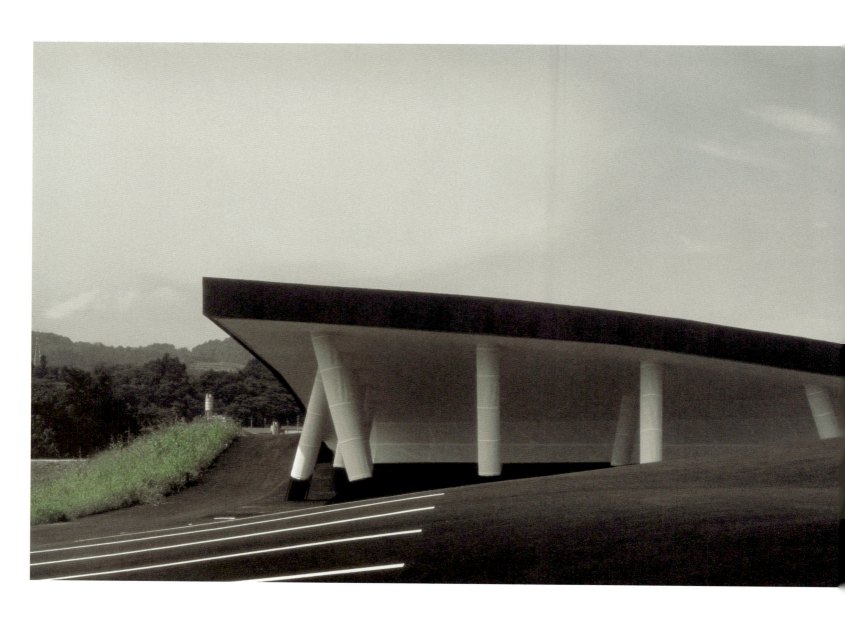

Almost Alive

17

The rolling black surface of this car park, which unites indoor and outdoor spaces, is partly supported atop white columns all askew. Designed by a team of French architects, Asphalt Spot has a rather ominous atmosphere. It grips you by the throat. What natural disaster has ripped open the earth in this place? A quake of the magnitude that many in Japan have experienced in real life? The architects explain: 'Visitors are tempted to drive or walk up the slope as a way to handle their own disequilibrium.' To actually ride that quake?

METROPOL PARASOL,
Redevelopment of Plaza de la
Encarnacion, Seville, Spain
2004-2007
J. Mayer H.

Atmosphere

The tops of large mushroom-like structures fuse to form an enormous parasol that covers an archaeological excavation project – the site of Roman ruins – and a farmers' market. A number of bars and restaurants are located in and under the parasol, and a promenade atop the structure provides a view of the surroundings. The 'mushrooms' are formed by a grid made from a lightweight wood with a self-cleaning, polyurethane coating that needs to be repainted only once every 20 to 25 years. During the day, the parasol casts a cooling shadow. At night, it offers shelter, and the underside becomes an artificial sky whose surface can be used for spectacles such as light shows.

Almost Alive

19

TUBER9
2004
LIONEL THEODORE DEAN/
FUTUREFACTORIES
Photography by John Britain

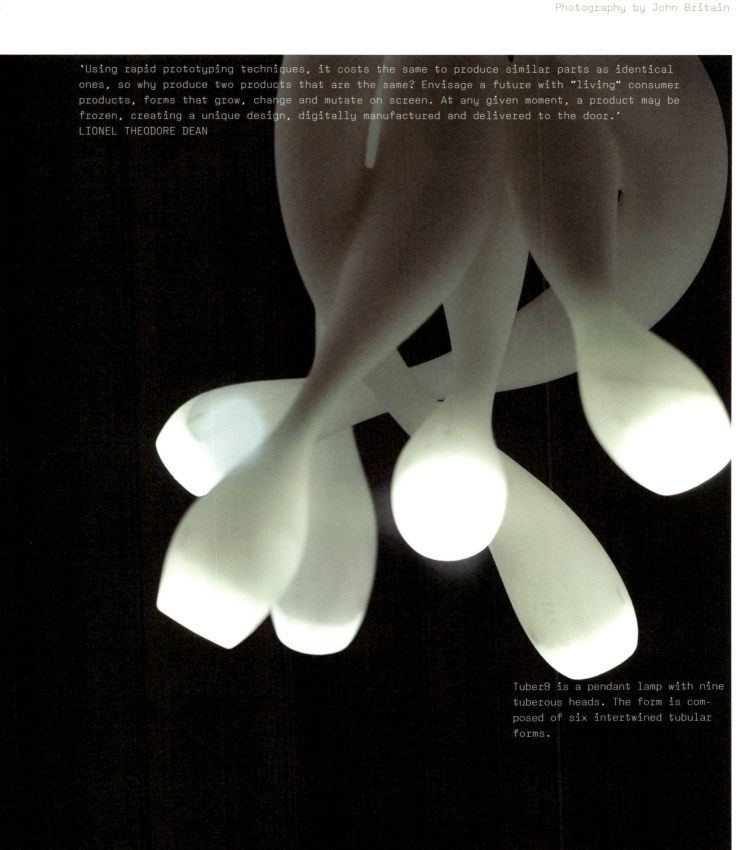

'Using rapid prototyping techniques, it costs the same to produce similar parts as identical ones, so why produce two products that are the same? Envisage a future with "living" consumer products, forms that grow, change and mutate on screen. At any given moment, a product may be frozen, creating a unique design, digitally manufactured and delivered to the door.'
LIONEL THEODORE DEAN

Tuber9 is a pendant lamp with nine tuberous heads. The form is composed of six intertwined tubular forms.

DUSTY RELIEF/B-MU DESIGN FOR
A CONTEMPORARY ART MUSEUM
Bangkok, Thailand
2002
R&SIE[N] ARCHITECTS

Atmosphere

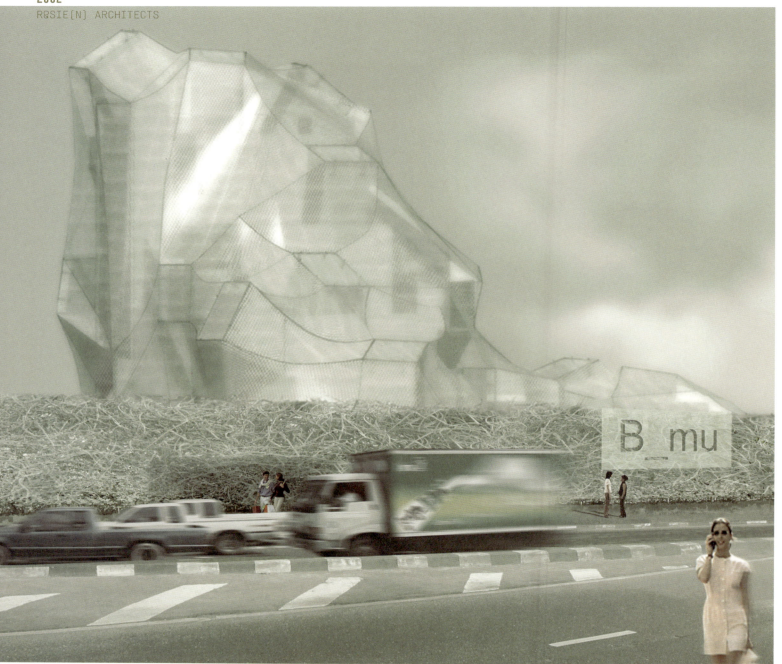

R&Sie(n) is developing an installation for the as-yet-unrealized Bangkok Art Museum. The work, designed to feed off the city's pollution, will use electrically charged wires that pull all floating debris from the air and use that waste material to grow icky, skanky fur.

Almost Alive

HAT FROM BIONIC COLLECTION
2006
PETER BERTSCH AND ELVIS POMPILIO
Photography by Ronald Stoops

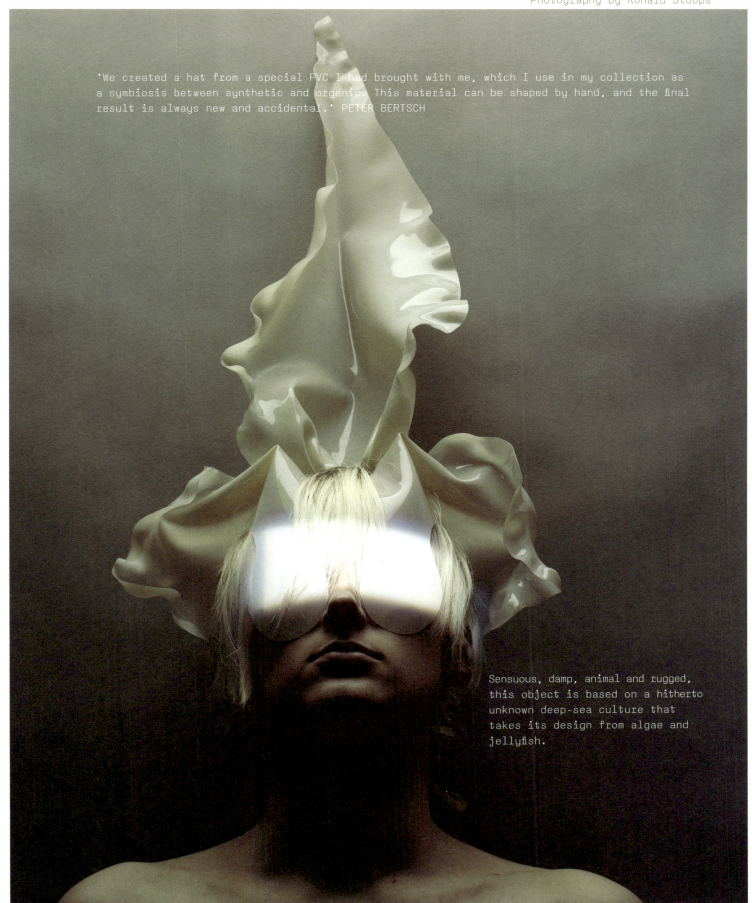

'We created a hat from a special PVC I had brought with me, which I use in my collection as a symbiosis between synthetic and organic. This material can be shaped by hand, and the final result is always new and accidental.' PETER BERTSCH

Sensuous, damp, animal and rugged, this object is based on a hitherto unknown deep-sea culture that takes its design from algae and jellyfish.

UNTITLED (PLASTIC CUPS)
Courtesy of PaceWildenstein,
New York, New York, USA
2006
TARA DONOVAN
Photography by Kerry Ryan McFate

Atmosphere

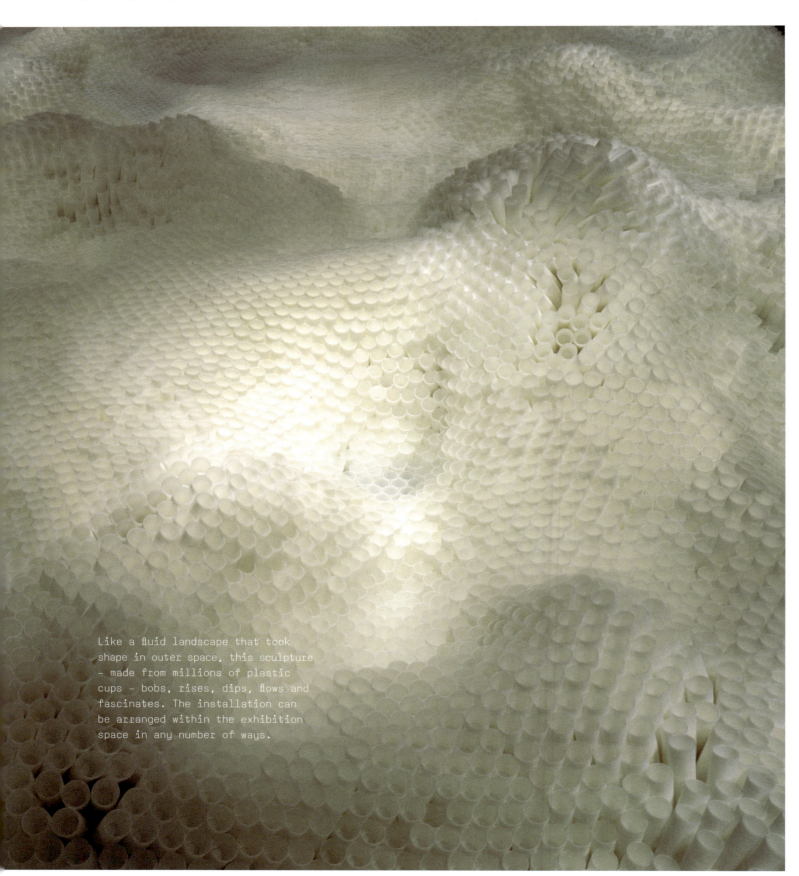

Like a fluid landscape that took shape in outer space, this sculpture – made from millions of plastic cups – bobs, rises, dips, flows and fascinates. The installation can be arranged within the exhibition space in any number of ways.

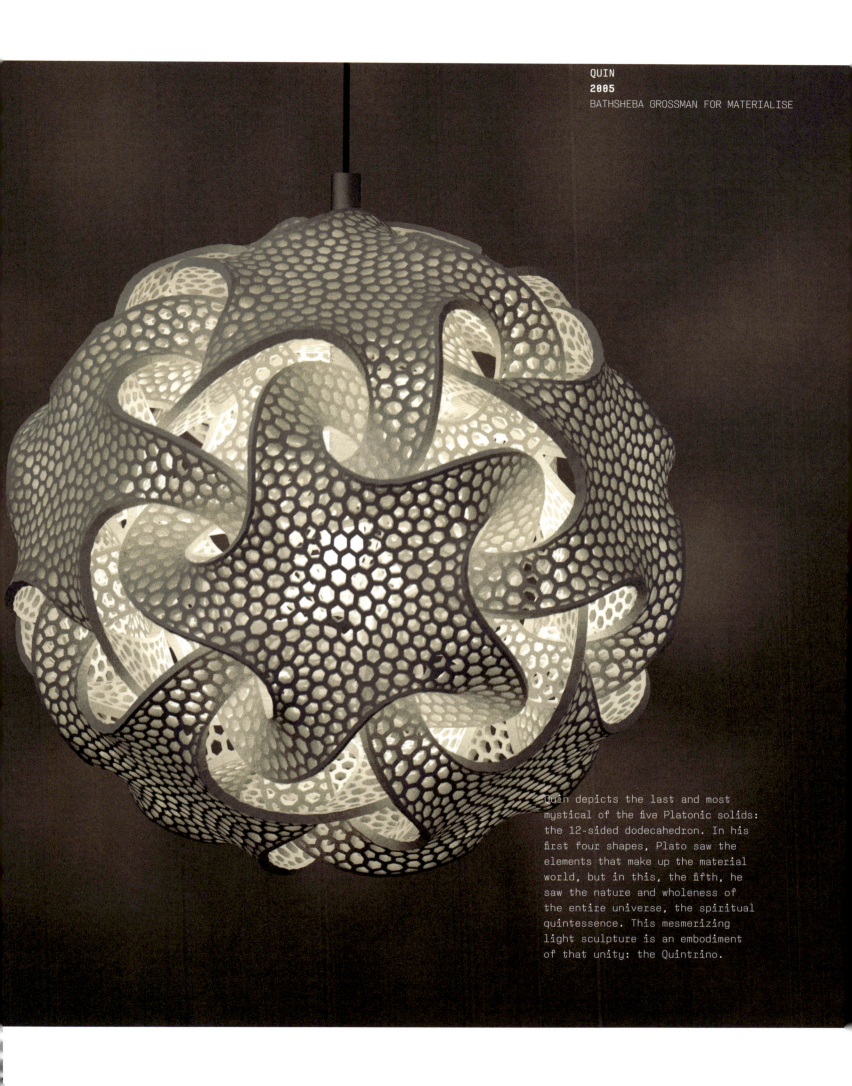

QUIN
2005
BATHSHEBA GROSSMAN FOR MATERIALISE

Quin depicts the last and most mystical of the five Platonic solids: the 12-sided dodecahedron. In his first four shapes, Plato saw the elements that make up the material world, but in this, the fifth, he saw the nature and wholeness of the entire universe, the spiritual quintessence. This mesmerizing light sculpture is an embodiment of that unity: the Quintrino.

ISHICORO
2002
NAOTO FUKASAWA FOR AUKDDI
Photography by Hidetoyo Sasaki

Atmosphere

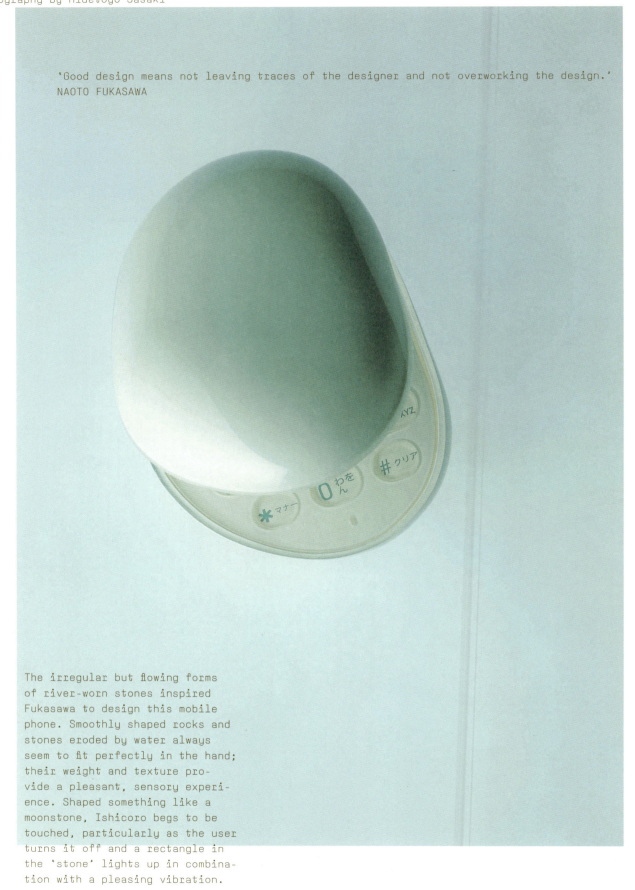

'Good design means not leaving traces of the designer and not overworking the design.'
NAOTO FUKASAWA

The irregular but flowing forms of river-worn stones inspired Fukasawa to design this mobile phone. Smoothly shaped rocks and stones eroded by water always seem to fit perfectly in the hand; their weight and texture provide a pleasant, sensory experience. Shaped something like a moonstone, Ishicoro begs to be touched, particularly as the user turns it off and a rectangle in the 'stone' lights up in combination with a pleasing vibration.

Almost Alive

DOWNTIME AIRPORT HOTEL
2006
ROB GOULDER

25

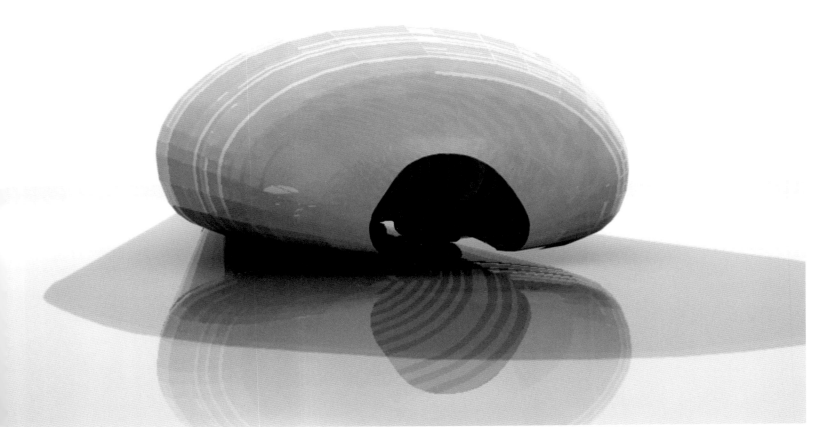

Downtime is a caterpillar-like modular hotel system that travels around airport complexes, providing a safe space for relaxation or sleep during long layovers.

TEXTILE + LIGHT
2006
ANNIKE LAIGO
Photography by Romer Laidsaar

Atmosphere

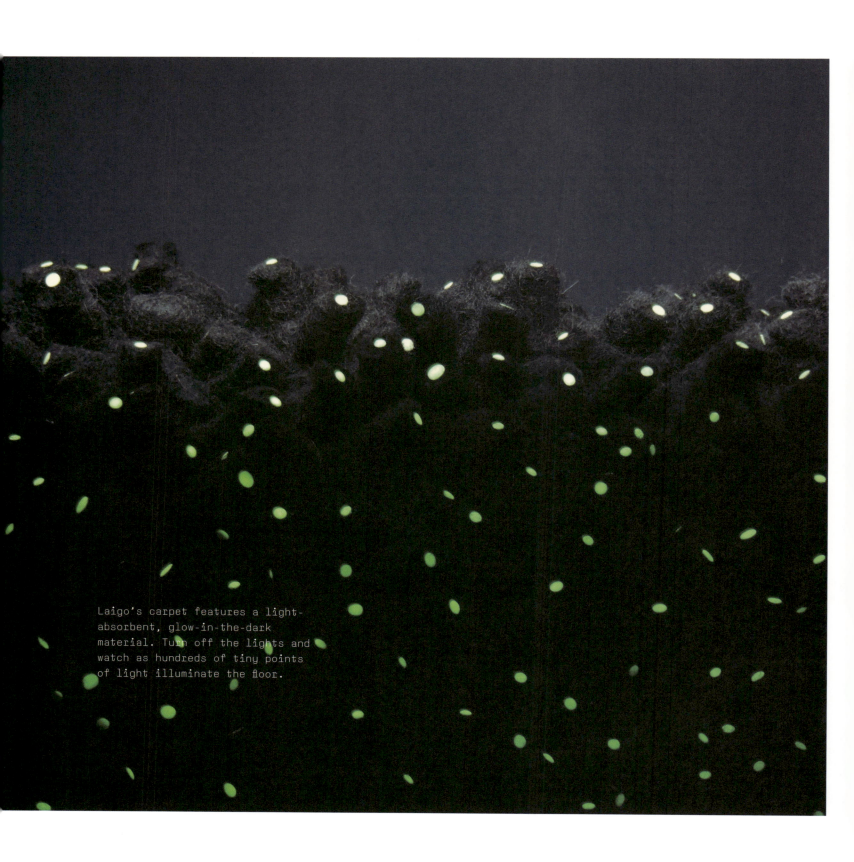

Laigo's carpet features a light-absorbent, glow-in-the-dark material. Turn off the lights and watch as hundreds of tiny points of light illuminate the floor.

Almost Alive

TRAILER
Courtesy of Galerie Diana Stigter, Amsterdam, Netherlands
2005
SASKIA OLDE WOLBERS
Photography by Saskia Olde Wolbers

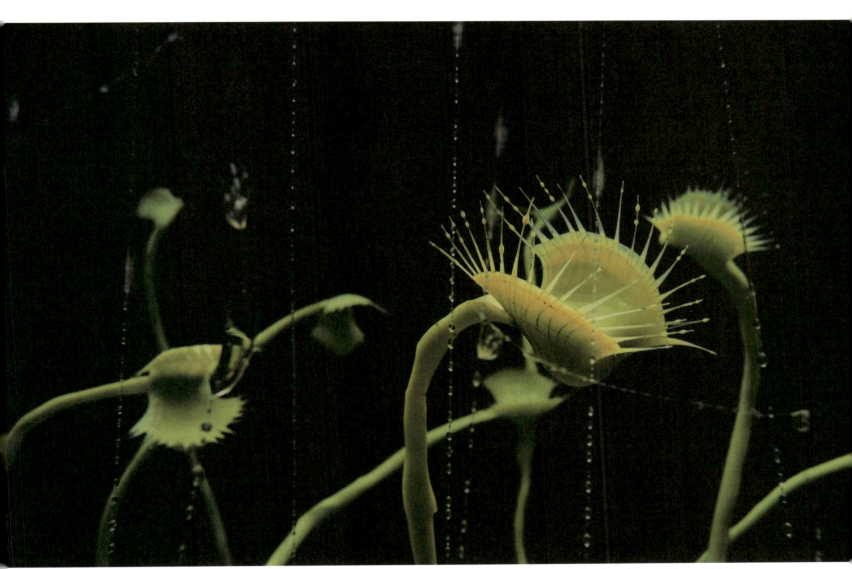

Saskia Olde Wolbers created Trailer, a cinematic work that tells the story of Alfgar Dalio, who watches a film trailer and discovers that he is adopted. His real mother, Elmore Vella, a little-known film actress of the 1930s, survived the crash of a plane that went down in a South American jungle, where she became addicted to a hallucinogenic plant, which was eventually named after her.

The 'virtual reality' shown in Trailer comes to life as the camera slowly glides along sticky, dripping, bilious-green jungle vegetation. This is not the result of a 3D computer program, however, as everything the visitor sees has been meticulously handcrafted and shot with tiny cameras under water. The lethargic pace, the narrator's sonorous voice and the alienating scenery are enough to put even the most wide-awake viewer into a hypnotic trance.

SHOCK PROOF BLOSSOM
2006
DESIGNED BY WIEKI SOMERS,
SHOCK PROOFED BY TJEP.
Photography by Tjep.

Atmosphere

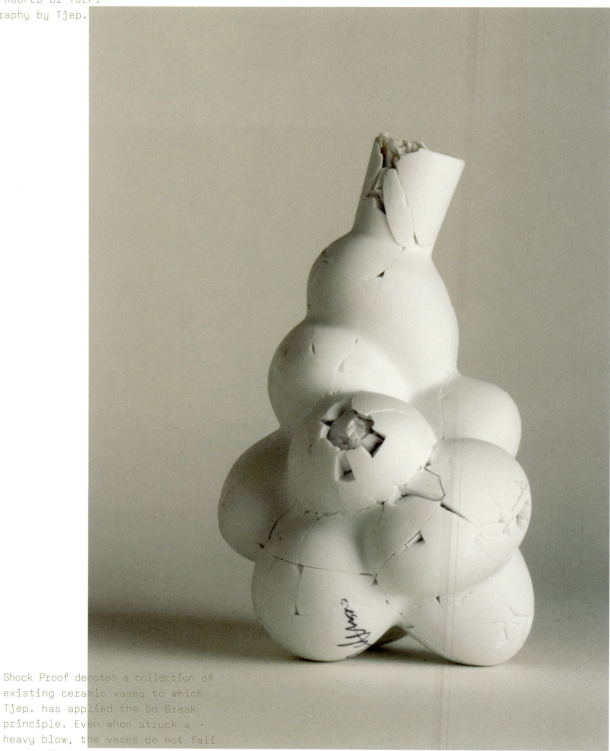

Shock Proof denotes a collection of existing ceramic vases to which Tjep. has applied the Do Break principle. Even when struck a heavy blow, the vases do not fall apart. They remain watertight because of a special rubber coating that lines the inside of each vase. Cracks form a new, decorative pattern that testifies to the dramatic events that may take place during the lives of such vases, from lovers' quarrels to earthquakes.

Almost Alive

BLOOMROOM
Milan, Italy
2006
NENDO
Photography by Nacasa & partners

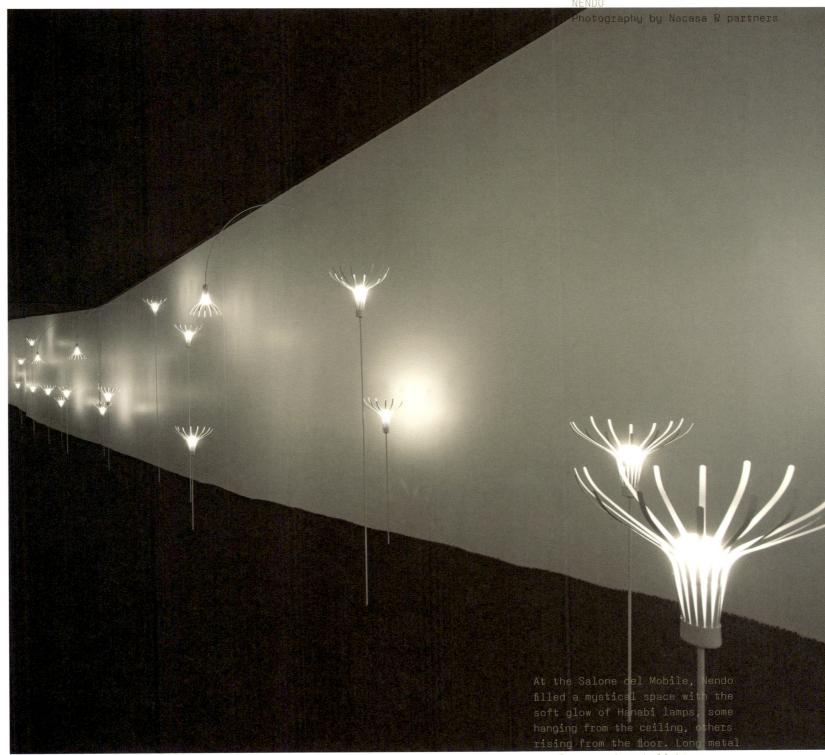

At the Salone del Mobile, Nendo filled a mystical space with the soft glow of Hanabi lamps, some hanging from the ceiling, others rising from the floor. Long metal petals around each light source gradually opened in response to the heat of the bulb. When the petals had opened fully, the light went off and the petals slowly enfolded the bulb once more. The literal translation of *hanabi*, the Japanese word for 'fireworks', is flower + fire.

KUNSTHAUS GRAZ
Graz, Austria
2003
PETER COOK AND COLIN FOURNIER
Photography by Paul Ott

Atmosphere

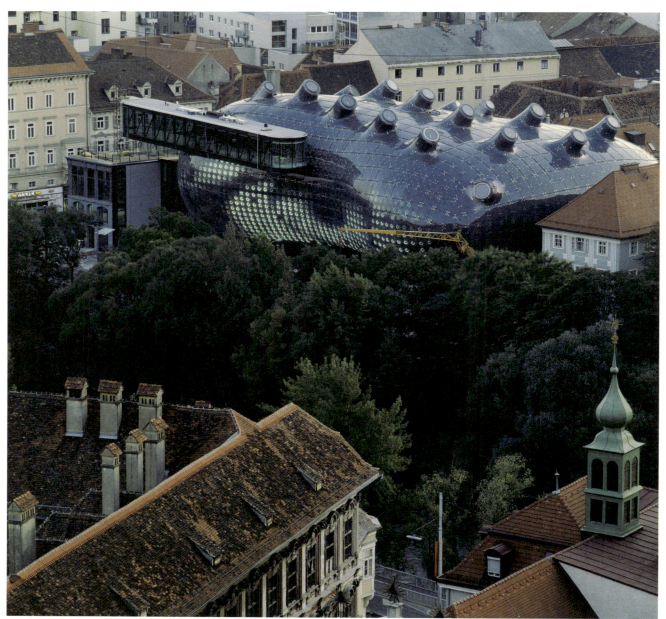

In 1961 Peter Cook co-founded an experimental group of architects that called itself Archigram. Among their visionary projects was The Walking City, a community of gigantic reptilian structures that were to move across the earth on towering legs. A 1968 proposal dealt with the transport, in 'Instant City airships', of metropolitan entertainment and educational facilities to 'sleeping towns'. The idea was to transform such towns into dynamic, creative places.

Only now have we become receptive to the ideas of these pop-art architects: a combination of the two aforementioned concepts appears to be stranded in Graz. In terms of scale, form and colour, this building – nicknamed 'The Friendly Alien' – is an unearthly phenomenon.

Almost Alive

BIX FAÇADE KUNSTHAUS GRAZ
Graz, Austria
2003
REALITIES:UNITED
Photography by Paul Ott

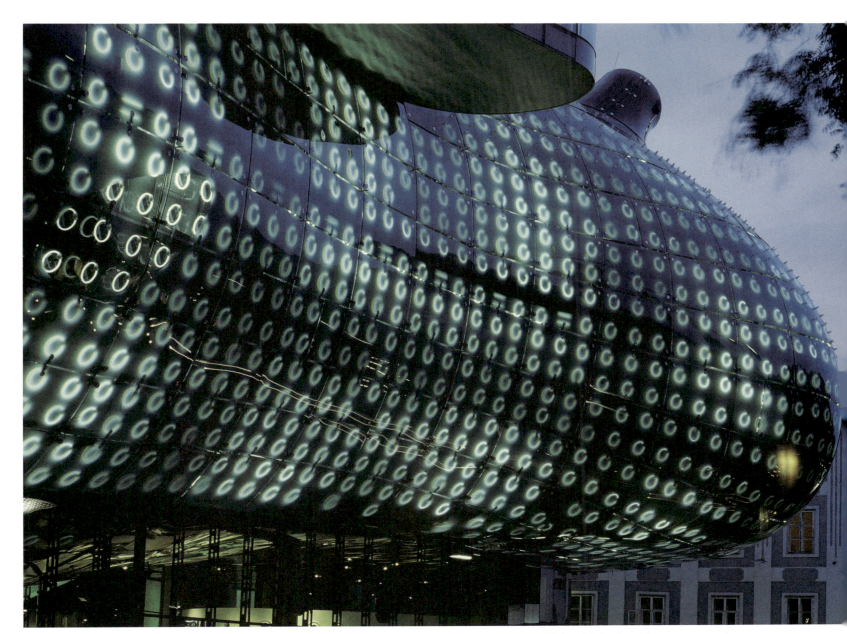

BIX, which functions as a membrane between Kunsthaus Graz and public space, is the Austrian museum's way of identifying and presenting itself. A matrix of 930 fluorescent lamps has been integrated into the eastern, acrylic-glass façade of the biomorphic building. Thanks to the possibility of adjusting the intensity of each lamp individually, an infinite number of films and animations can be created, transforming the skin of the Kunsthaus into a giant low-resolution computer display.

BLUE TREE
Cornerstone Festival of Gardens,
Sonoma Valley, California, USA
2004
CLAUDE CORMIER ARCHITECTES
PAYSAGISTES
Photography by Richard Barnes

Atmosphere

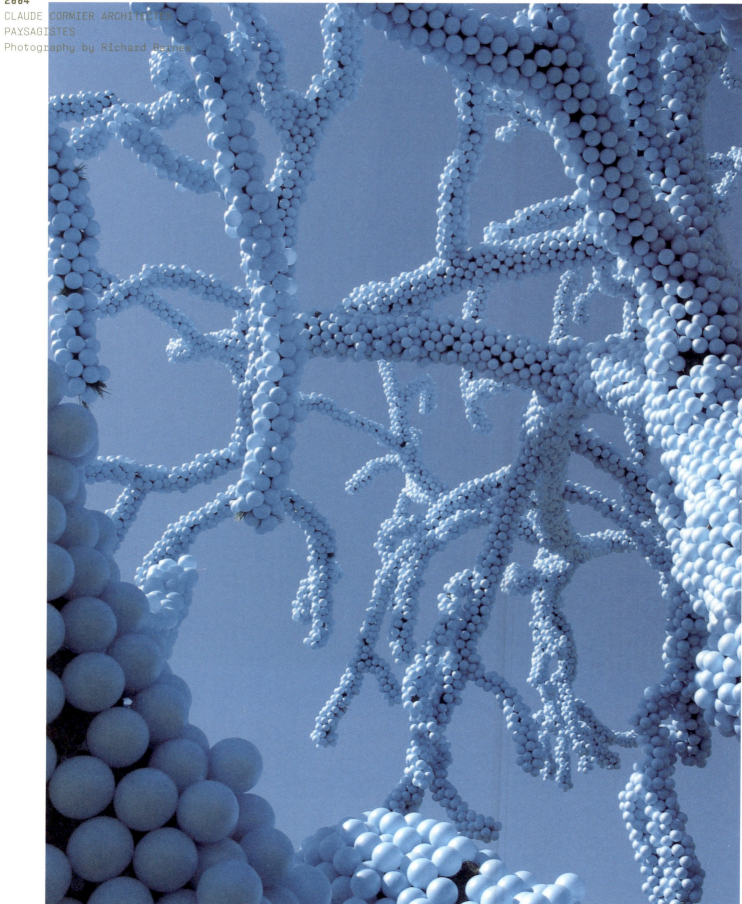

Almost Alive

33

BLUE TREE
Cornerstone Festival of Gardens,
Sonoma Valley, California, USA
2004
CLAUDE CORMIER ARCHITECTES
PAYSAGISTES
Photography by CCAPI

In 2004 new life was given to a diseased tree slated for removal by decking its branches with 75,000 sky-blue Christmas ornaments. The landscape equivalent of a Photoshop eraser saturated this natural tree with the artificial, in a bid for total camouflage. But the opposite result occurred. Blue Tree stood out against the ever-changing sky, becoming a barometer for subtle fluctuations of natural light.

BONE CHAIR
2006
JORIS LAARMAN
Photography by Bas Helbers

Atmosphere

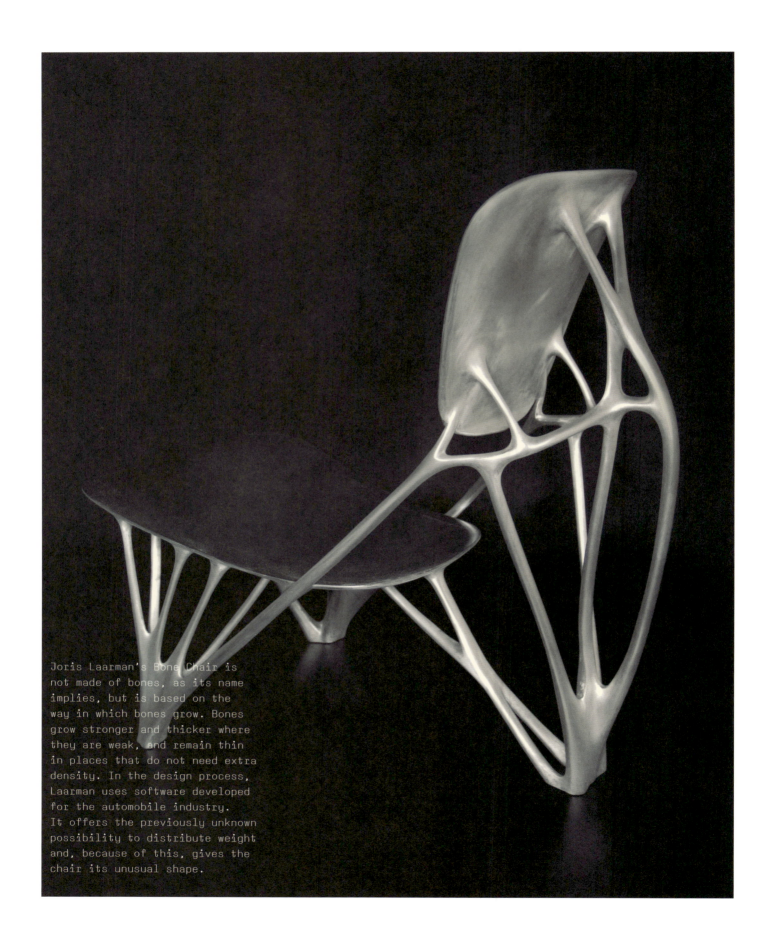

Joris Laarman's Bone Chair is not made of bones, as its name implies, but is based on the way in which bones grow. Bones grow stronger and thicker where they are weak, and remain thin in places that do not need extra density. In the design process, Laarman uses software developed for the automobile industry. It offers the previously unknown possibility to distribute weight and, because of this, gives the chair its unusual shape.

Almost Alive

35

STYRENE
2003
PAUL COCKSEDGE
Photography by Jean-Francois Carly

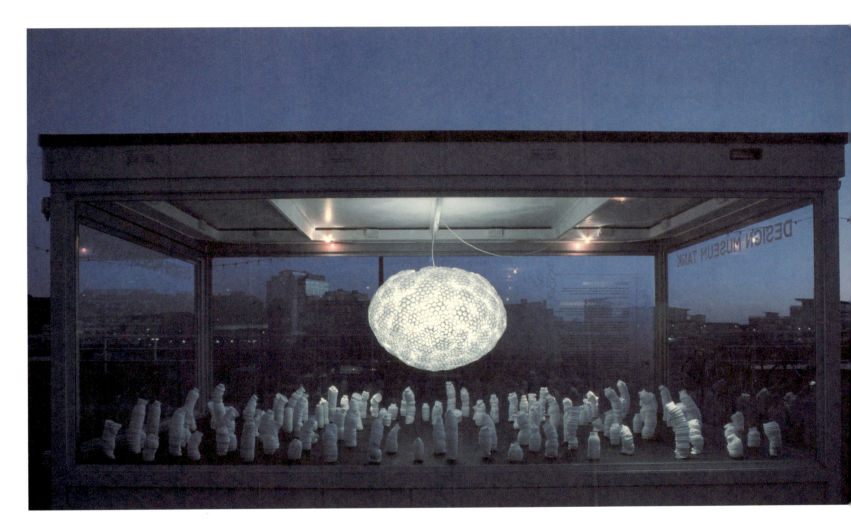

Styrene was inspired by the concept of growth as a process. When heat is applied to polystyrene, the form changes and, with it, the properties of the material. Here the result is a highly symbolic image: a radiant globe whose cracked surface allows light to pass through.

SERPENTINE GALLERY PAVILION
2006
Kensington GARDENS, London, England
REM KOOLHAAS, CECIL BALMOND
WITH ARUP LIGHTING
Photography by Iwan Baan

Atmosphere

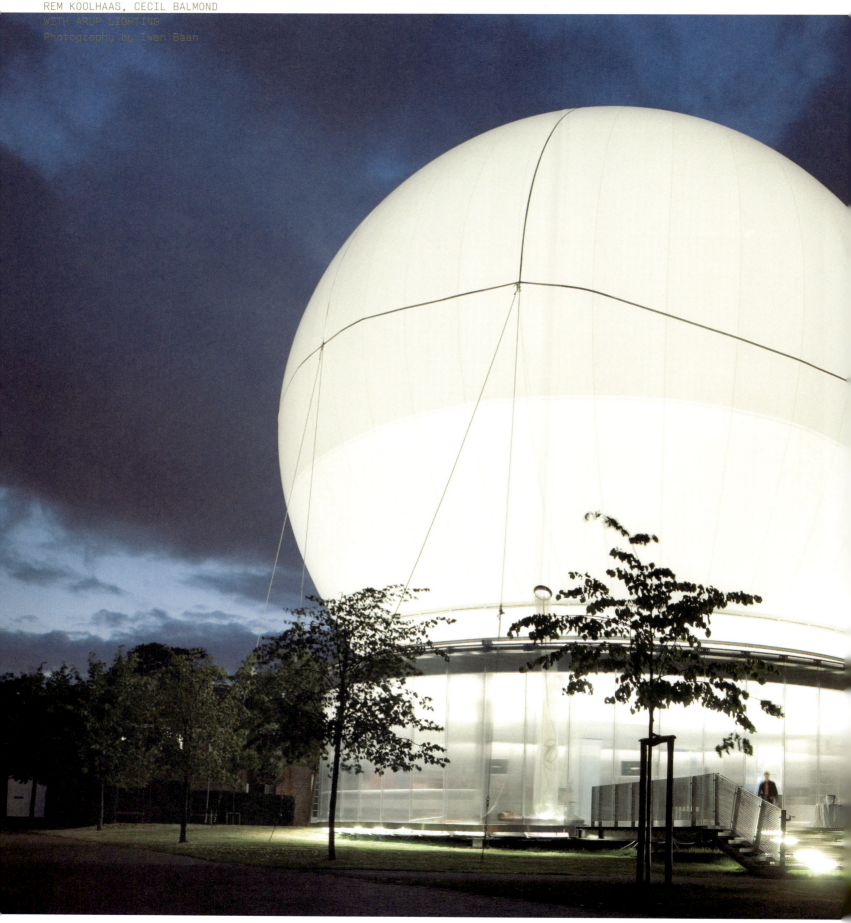

Almost Alive

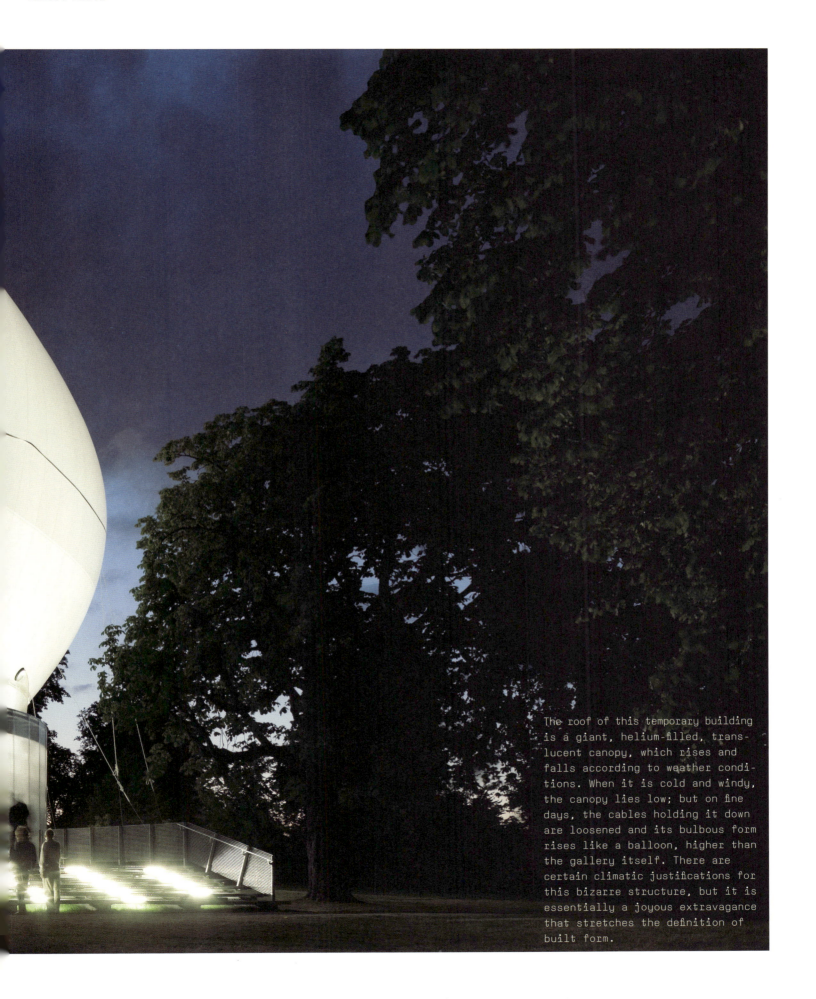

The roof of this temporary building is a giant, helium-filled, translucent canopy, which rises and falls according to weather conditions. When it is cold and windy, the canopy lies low; but on fine days, the cables holding it down are loosened and its bulbous form rises like a balloon, higher than the gallery itself. There are certain climatic justifications for this bizarre structure, but it is essentially a joyous extravagance that stretches the definition of built form.

previous page:
MATERIAL
Photography by Blommers/Schumm

Sample of Xtreme Acrylics by
PyraSied.

Materials provided by Materia

Atmosphere

FIELDS OF COLOUR

previous page:
POTATO
Photography by Blommers/Schumm

Atmosphere

Fields of Colour

The effect of colour on the psyche is open to debate. In the late 1970s, the interiors of certain American prisons were painted bubble-gum pink in an attempt to influence the inmates' behaviour. 'Even if a person tries to be angry or aggressive in the presence of pink, he can't. The heart muscles can't race fast enough. It's a tranquilizing colour that saps your energy. Even the colour-blind are tranquilized by pink rooms,' was the claim made by Dr Alexander Schauss of the American Institute for Biosocial Research. The positive effect had no more than a short-term impact on a number of prisoners, however, who began to scratch the paint from the walls after a mere three hours of pink placidity.

Despite the failure of this American experiment, in recent years we have seen the application of colours, mainly in public spaces, which do appear to alter the human mind and emotions. The use of monochrome, monolithic planes – such as those in Katrin Korfmann's Pink Wall and Herzog & de Meuron's Allianz Arena – are reminiscent of American art created in the mid-twentieth century known as 'colourfield painting'. Applying large angular planes of colour to their canvases, colourfield artists strived to exert a direct sensory influence on the observer's emotional state. Comparable to the way in which you feel your bones vibrating at a hard-rock concert, looking at these paintings is like seeing the chromatic volume turned up so loud that viewing them produces a physical sensation. The experience can also be linked to certain descriptions of the sublime or to the human perception of vast areas of nature such as deserts, oceans and starry skies, the sight of which often generates extraordinary sensations. Aware of the enormity before us, we are momentarily overwhelmed. Unbounded space turns us into vulnerable, frightened, insignificant creatures. Not wanting to be afraid and defenceless, we resist the initial experience of never-ending space. Nonetheless, those who keep their eyes open and face the immensity with courage will be lovingly absorbed into its measureless mass and made a part of the greater whole.

Large, abstract areas of colour have the same qualities as large, natural areas of the outdoors. When the viewer stands close to the field of colour and allows both eyes to be filled with a single hue, the result can be either a floating feeling or a sinking sensation; either way, one is immersed in infinite space. Fields of colour found within a city, for example, perform the same psychological function as the rabbit hole that drew Alice into Wonderland. They are escape routes from an everyday routine glutted with greengrocers and plumbers and grey urban environs. In enclosed passages such as stairwells and corridors, the use of huge fields of colour replicates the aforementioned experience of immersion, further intensified by the added dimension of motion. Edi Rama, who has been the mayor of Tirana since 2000, applied colour-shock therapy to Albania's capital city. The former artist gave his neglected, once-corrupt city a radical face-lift. An army of painters wrapped the grey veil of Communist buildings in a patchwork of bright colours: think yellow, green, violet. Rama was out to create a positive psychological impact on the population and to underline the possibility of change. A closer and more critical look reveals buildings that resemble the so-called dazzle-painted ships of the First World War. By painting ships with large, well-placed patches of colour, the Allies attempted to make a visual mishmash of their warships, thus greatly lessening the chances of successful torpedo attacks by German U-boats. Ultimately, however, enemy submarines managed to sink many an Allied ship. Here's hoping that the newly painted Tirana will have a more beneficial and long-lasting effect.

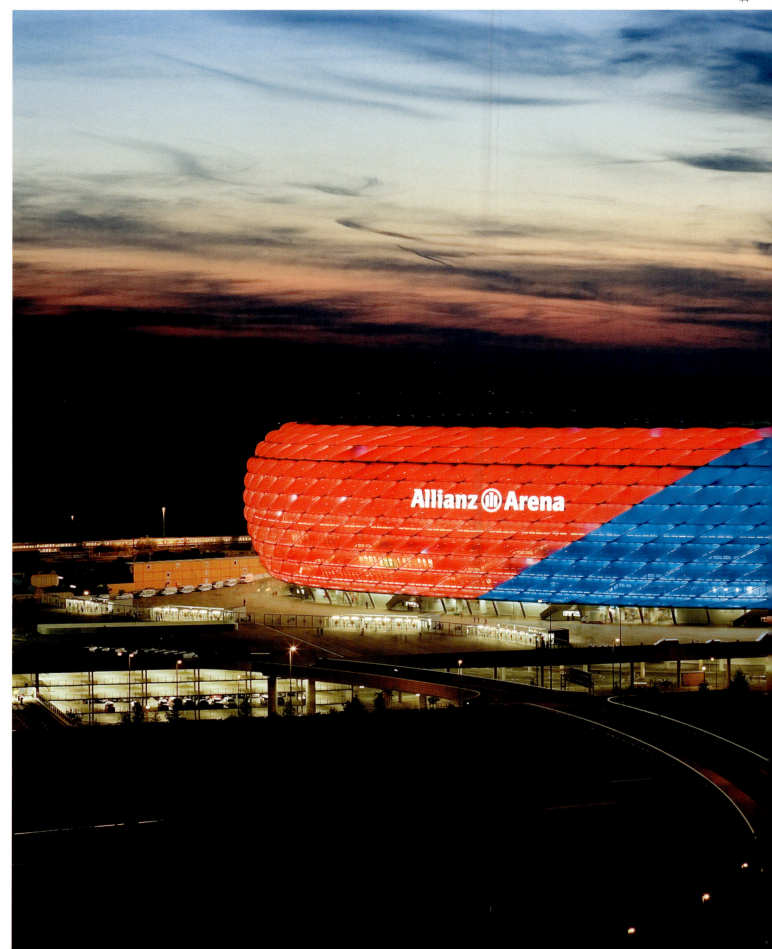

Fields of Colour

ALLIANZ ARENA
Munich-Fröttmaning, Germany
2005
HERZOG & DE MEURON
Photography by Duccio Malagamba

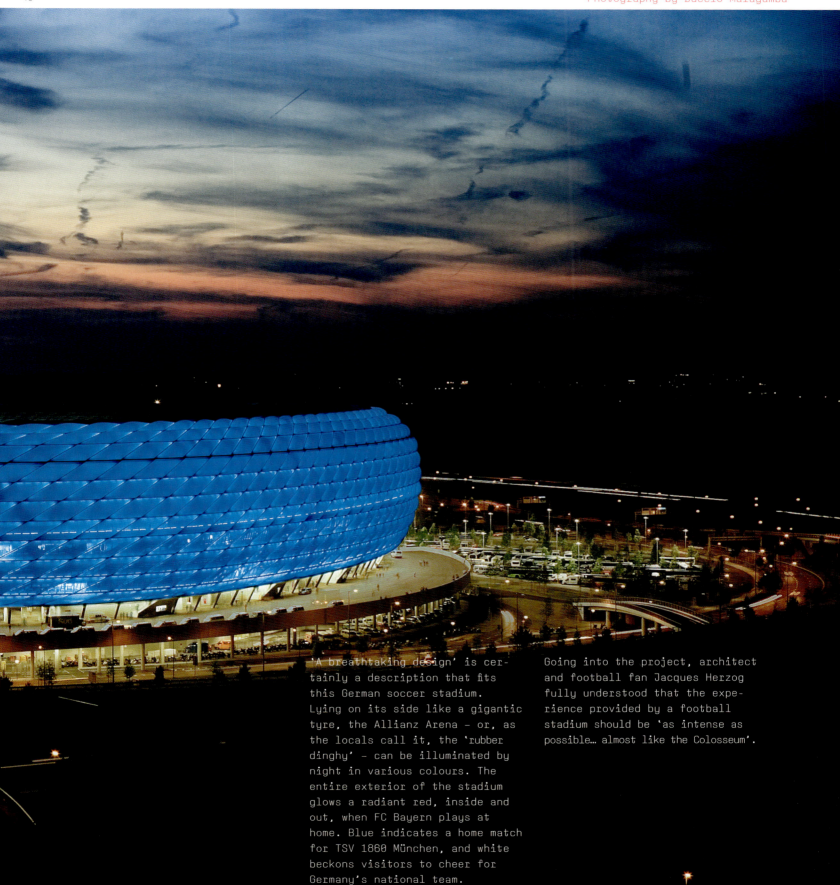

'A breathtaking design' is certainly a description that fits this German soccer stadium. Lying on its side like a gigantic tyre, the Allianz Arena – or, as the locals call it, the 'rubber dinghy' – can be illuminated by night in various colours. The entire exterior of the stadium glows a radiant red, inside and out, when FC Bayern plays at home. Blue indicates a home match for TSV 1860 München, and white beckons visitors to cheer for Germany's national team.

Going into the project, architect and football fan Jacques Herzog fully understood that the experience provided by a football stadium should be 'as intense as possible… almost like the Colosseum'.

ALLIANZ ARENA
Munich-Fröttmaning, Germany
2005
HERZOG & DE MEURON
Photography by Duccio Malagamba

Atmosphere

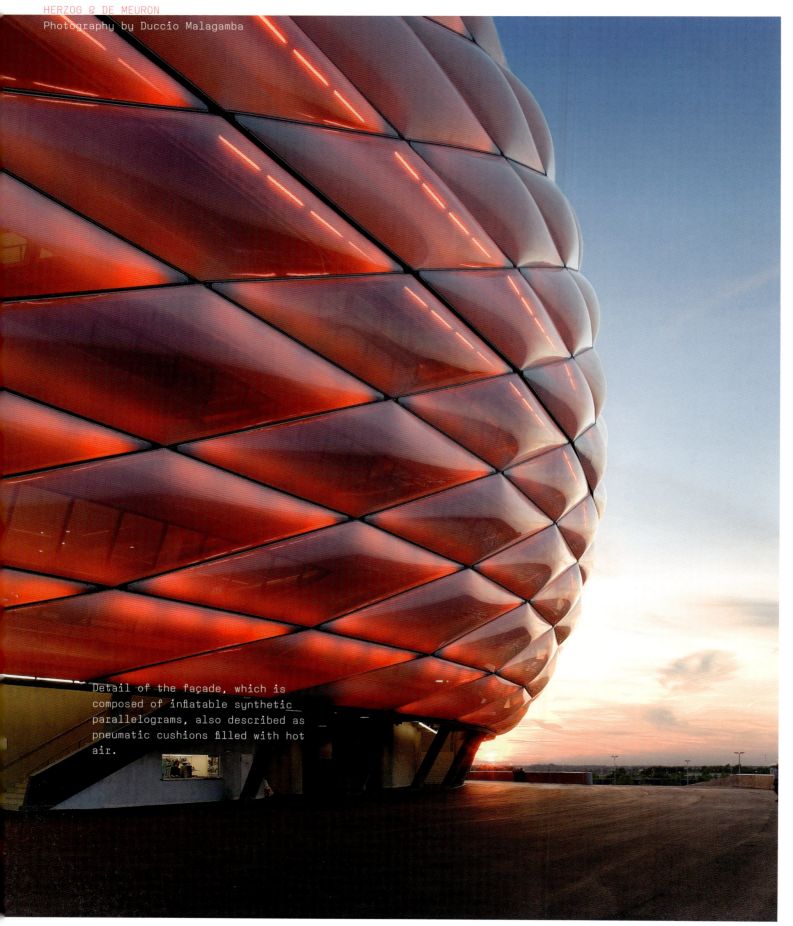

Detail of the façade, which is composed of inflatable synthetic parallelograms, also described as pneumatic cushions filled with hot air.

Fields of Colour

MÖVENPICK HOTEL
Amsterdam, Netherlands
2006
CLAUS EN KAAN ARCHITECTEN
Photography by Luuk Kramer

Using various materials, Claus en Kaan created a play of lines featuring blue and grey bands that seem to wrap Amsterdam's Mövenpick Hotel like a package. Fenestration subtly interrupts the linear design.

LIGHT INSTALLATION
De Verdieping,
Veldhoven, Netherlands
2005
HERMAN KUIJER
Photography by Norbert van Onna

Atmosphere

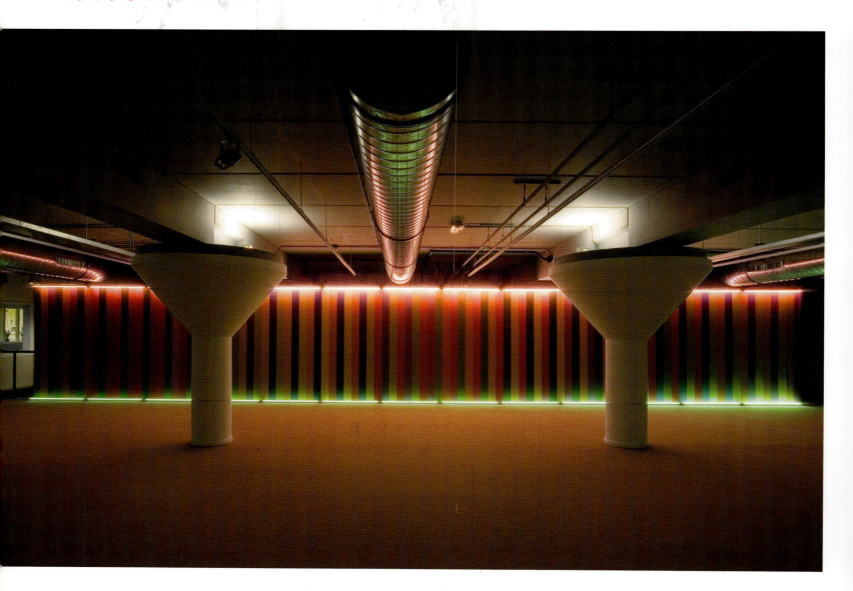

The challenge for light artist Kuijer lies in creating an image that conveys a highly complex reality. He moves constantly within a field of tension that includes both order and chaos. Each of Kuijer's chromatic systems features a unique series of colour combinations based on subtle differentiations. Pictured is the coloured wall of light he designed for an exhibition in the Netherlands. Radiating from dimmable T bulbs, computer-controlled beams of varying intensities travel in opposite directions across the wall, creating a fascinating random flow of colour.

Fields of Colour

THE TILES
2006
RONAN & ERWAN BOUROULLEC
FOR KVADRAT
Photography by Paul Tahon

The Bouroullec brothers' textile walls consist of separate interlocking tiles. The warm, sensuous tiles are used in Kvadrat's Stockholm showroom to highlight the various textures and materials of products by this well-known manufacturer. The extreme ease with which these tiles notch into place facilitates a quick change of spatial configuration. The impressive palette of colours runs the gamut from deep brown to pale blue. And, equally important, the foam-and-fabric tiles are an excellent means of soundproofing an interior. The Tiles system also provides a new way to build walls with modular units, in the tradition of earlier Bouroullec designs, such as Algues and Twigs. Modules can be put together to make an infinite variety of shapes, both organic and geometric.

POTSDAM DOCKLANDS
Potsdam, Germany
2002-2007
J.MAYER H.

Atmosphere

Potsdam Docklands is a new urban prototype that makes use of historical references to build up a contemporary urban area. Development increases as it moves from the south end of the project towards the congress centre, where it again begins to decrease in size. All façades are articulated horizontally. By opting for reddish-brown materials - glass, Corten steel and copper - J. Mayer H. has updated the colour scheme of existing brick buildings in this area. The overall appearance of the project is dominated by these earthy colours, yet the architects have achieved a sense of lightness with panoramic bands of fenestration.

Fields of Colour

SEATTLE CENTRAL LIBRARY
Seattle, Washington, USA
2004
REM KOOLHAAS, OMA
Photography by Iwan Baan

Seattle Central Library is divided into eight horizontal layers that vary in size, density and opacity to correspond to eight unique functions. Rem Koolhaas made a grand gesture in the form of colour, which he also used for coding the separate zones of the library. Yellow escalators are easy to find, as is the main staircase, a part of the circulation route that is submerged in a deep, warm shade of red.

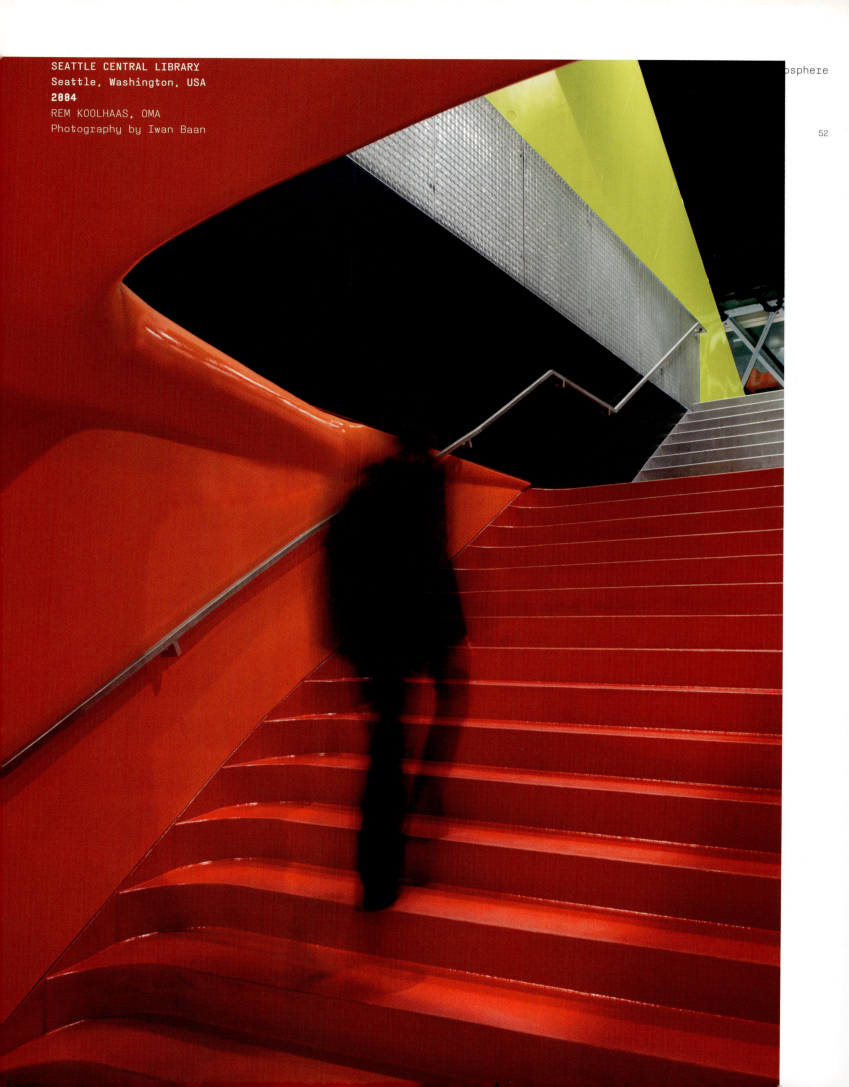

SEATTLE CENTRAL LIBRARY
Seattle, Washington, USA
2004
REM KOOLHAAS, OMA
Photography by Iwan Baan

Fields of Colour

CUPBOARD OF PLASTIC CRATES
MARK VAN DE GRONDEN FOR LENSVELT

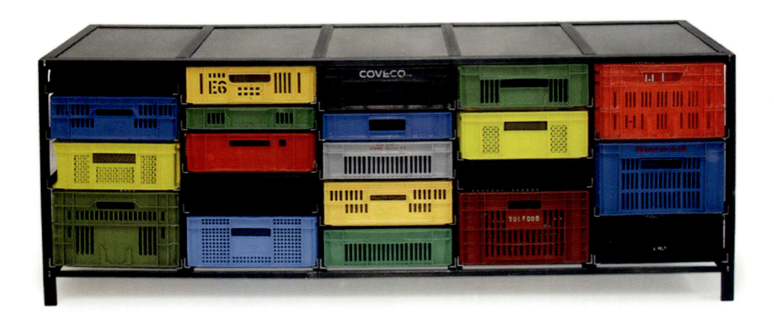

Mark van de Gronden's design consists of a galvanized-steel frame containing crates made of coloured plastic.

INFOBAR: ICHIMATSA AND NISHIKIGOI
2003
NAOTO FUKASAWA FOR AUKDDI

Atmosphere

54

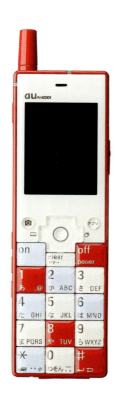

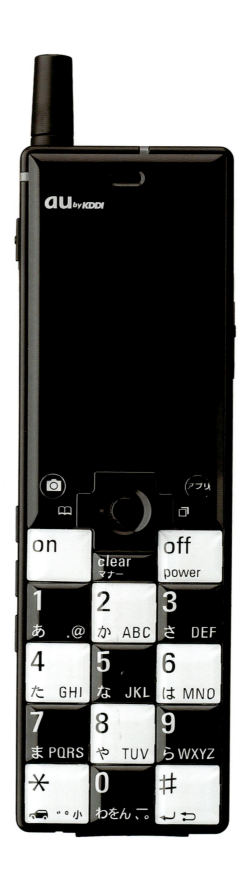

Inspired by a stack of Lego bricks, Naoto Fukasawa went on to create mobile phones that look like toys with tile-like keys. Partnering the cheeky red Nishikigoi (*nishikigoi* is Japanese for 'koi') is Ichimatsu, with its black-and-white chequerboard pattern.

Fields of Colour

CITY LOUNGE
St Gallen, Switzerland
2005
PIPILOTTI RIST AND CARLOS MARTINEZ
Photography by Hannes Thalmann

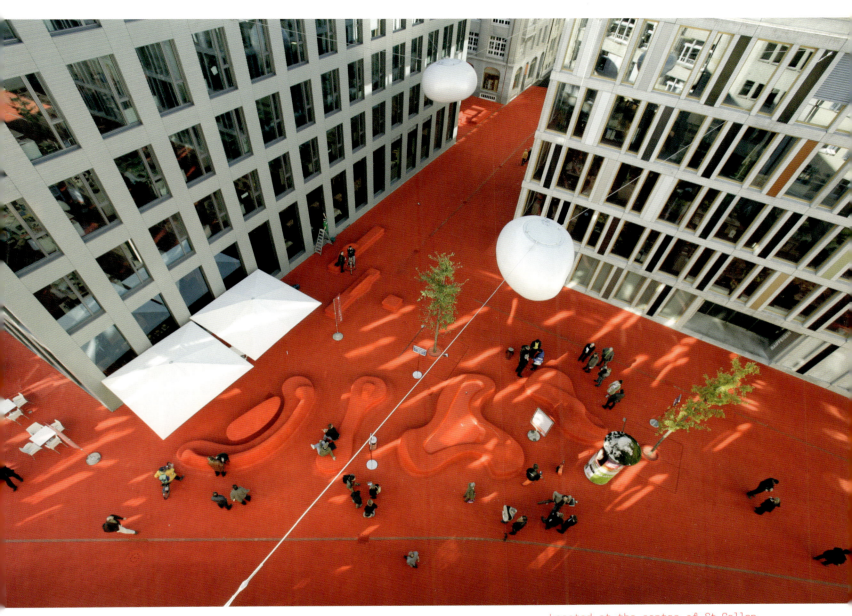

Located at the centre of St Gallen is City Lounge, a permanent installation realized within the framework of building activities funded by the Union of Swiss Raiffeisen Banks. Red-rubber flooring makes its way between buildings, covering the street, public furniture and everything else in its path. The installation is illuminated by large oval lamps that bathe the space in a warm light. City Lounge invites passers-by to linger, but it also offers meeting space in zones with names like Relaxation Lounge and Business Lounge.

SIMMONS HALL
Cambridge, Massachusetts, USA
2002
STEVEN HOLL ARCHITECTS
Photography by Andy Ryan

Atmosphere

A building that has been compared to a giant Rubik's Cube, as well as to a computer punch card from the 1950s, is Simmons Hall, an undergraduate residence that serves the student body of MIT (Massachusetts Institute of Technology). The design is based on the concept of 'porosity'. Colours on the façade are keyed to structural stress levels.

Fields of Colour

LABAN
London, England
2003
HERZOG & DE MEURON
Photography by Ludwig Abache

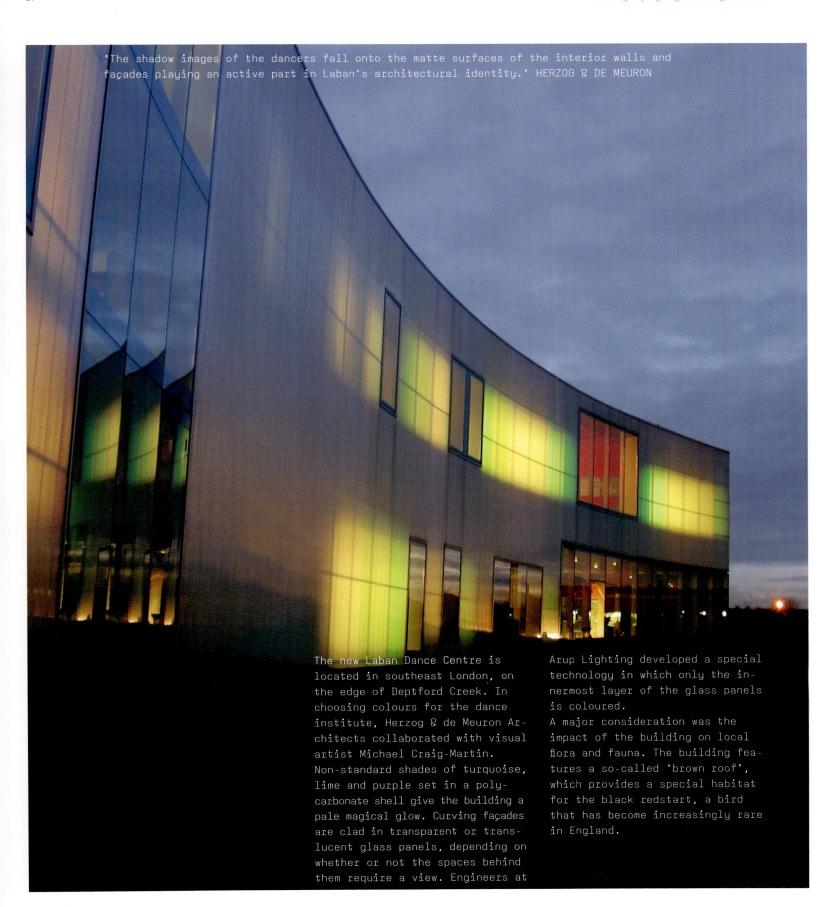

'The shadow images of the dancers fall onto the matte surfaces of the interior walls and façades playing an active part in Laban's architectural identity.' HERZOG & DE MEURON

The new Laban Dance Centre is located in southeast London, on the edge of Deptford Creek. In choosing colours for the dance institute, Herzog & de Meuron Architects collaborated with visual artist Michael Craig-Martin. Non-standard shades of turquoise, lime and purple set in a polycarbonate shell give the building a pale magical glow. Curving façades are clad in transparent or translucent glass panels, depending on whether or not the spaces behind them require a view. Engineers at Arup Lighting developed a special technology in which only the innermost layer of the glass panels is coloured.

A major consideration was the impact of the building on local flora and fauna. The building features a so-called 'brown roof', which provides a special habitat for the black redstart, a bird that has become increasingly rare in England.

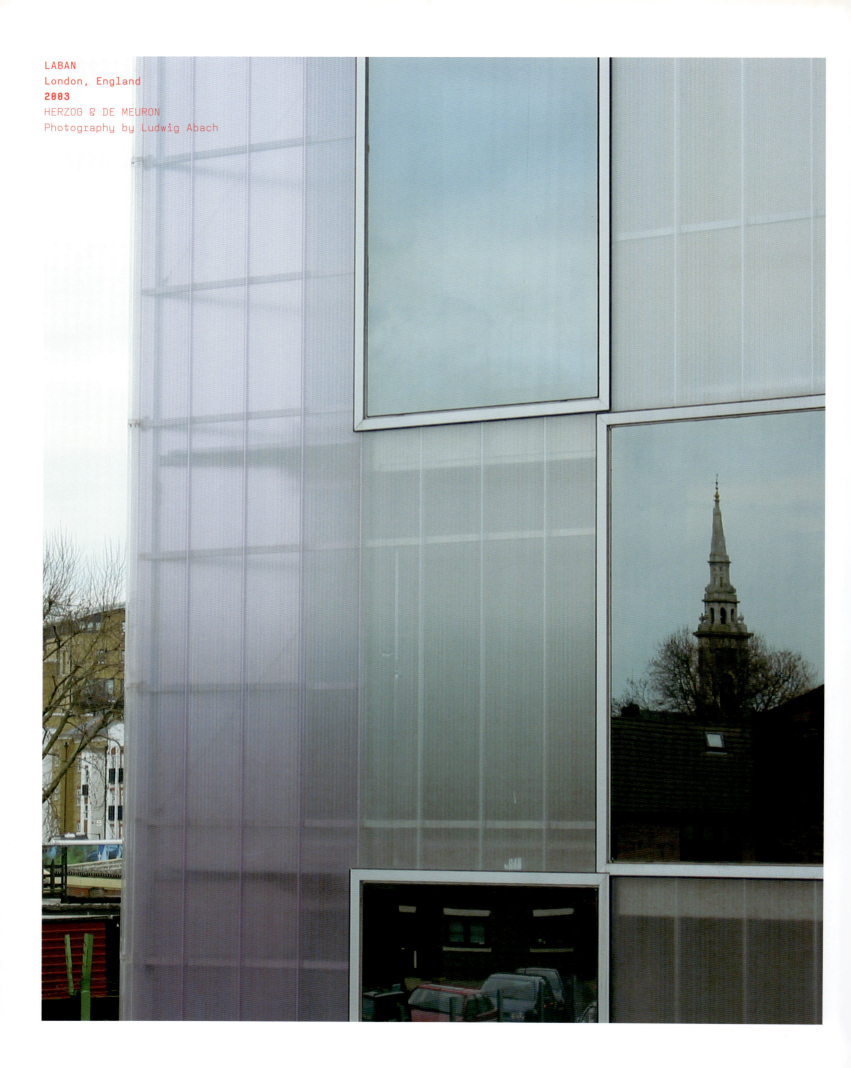

LABAN
London, England
2003
HERZOG & DE MEURON
Photography by Ludwig Abach

Fields of Colour

CUPBOARD WITH COLOURED DOORS
2001
MAARTEN VAN SEVEREN
Photography by Clearhout

This anodized-aluminium cupboard with sliding doors is available in a total of seven colour combinations.

PINK WALL
Turin, Italy
2002
KATRIN KORFMANN
Photography by
Katrin Korfmann

Atmosphere

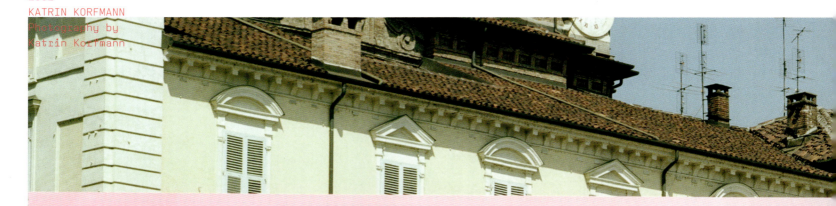

The leitmotif in the work of Berlin artist Katrin Korfmann is the observation and registration of human behaviour determined by unwritten codes. Her Pink Wall appeared at the Piazza Castello in Turin, Italy. The brightly hued installation made a striking contrast to neighbouring neoclassicist buildings. Surprisingly, however, few observers realized they were looking at a work of art. Only a few even noticed the installation. Others posed in front of it as if it were a wall that might have been anywhere in the world. Pink Wall turned passers-by into actors who merged with the art. After building her installations, Korfmann films or photographs the way in which people make use of the spaces she has created.

Fields of Colour

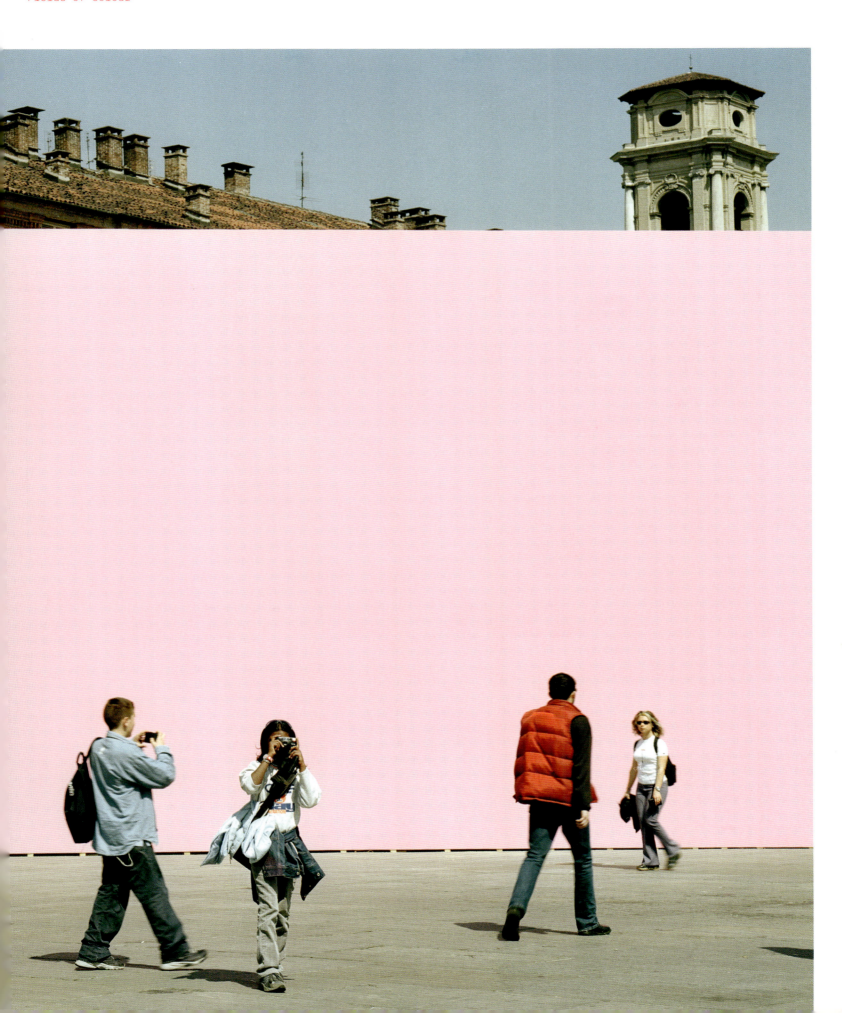

(NEW) TIRANA
Tirana, Albania
2003
Photography by Walter Bettens

Atmosphere

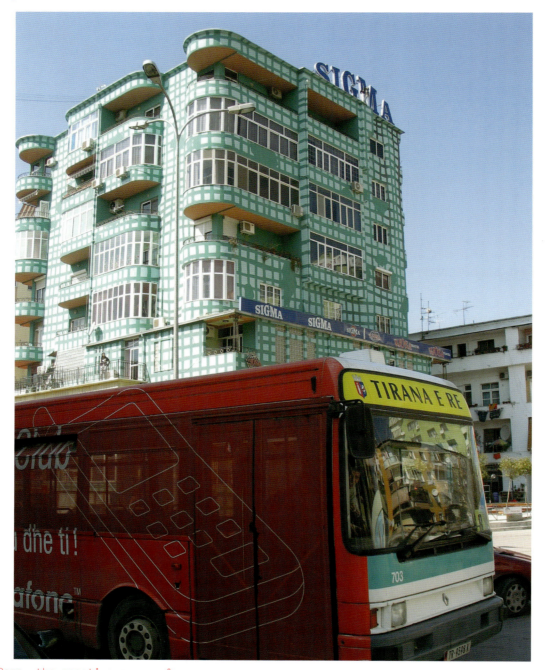

Edi Rama, the creative mayor of Tirana, commissioned a number of artists to dress up some of the city's buildings with collages of colour. The face-lift turned a collection of old, grey buildings into aesthetically pleasing structures that enrich Albania's capital with bold contrasts and patterns. The dialogue that occurs between buildings left untouched and those flaunting makeovers has led to a remarkably fascinating cityscape.

Fields of Colour

GANGSHA
Shenzhen, China
2005
URBANUS ARCHITECTURE & DESIGN
Photography by Urbanus
Architecture & Design

Responding to the turbulent developments that have been turning China's cities into modern metropolises, Urbanus Architecture & Design is researching new ways to lend urban areas a sense of coherence. According to the architects at Urbanus, an optimal integration of architecture and public space can prevent the city from becoming a motley collection of high-rise buildings. As nurturers of China's cultural traditions, they want the ever-increasing process of urbanization to retain a human dimension. In designing a housing block for the village of Gangsha in Shenzhen, Urbanus used various methods — among which demolition, infill and rooftop urbanization — to relieve urban density and lessen the fragmentation of public space. Future plans include better-defined commercial streets, service roads and public courtyards.

GALLERIA DEPARTMENT STORE
Seoul, South Korea
2002-2004
UN STUDIO
Photography by Christian Richters

Atmosphere

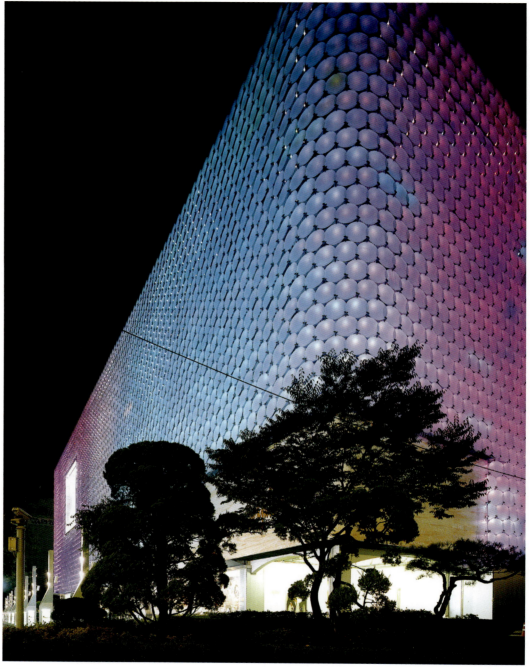

UN Studio renovated the Galleria Department Store, located in the Apgujung-dong fashion district of Seoul, and transformed it into a lively, colourful shopping destination. The architects covered the existing concrete façade with 4330 frosted-glass discs, each equipped with an LED. The exterior lighting system – designed by UN Studio in collaboration with Arup Lighting – provides the store with a continuous, light-reactive, computer-programmable façade that works like a giant video screen. It has a mother-of-pearl appearance by day, and at night the sensitive discs react not only to atmospheric conditions, but also to what's happening inside the building. The visual phenomenon alone is a mood-altering experience.

Fields of Colour

GALLERIA DEPARTMENT STORE
Seoul, South Korea
2002-2004
UN STUDIO

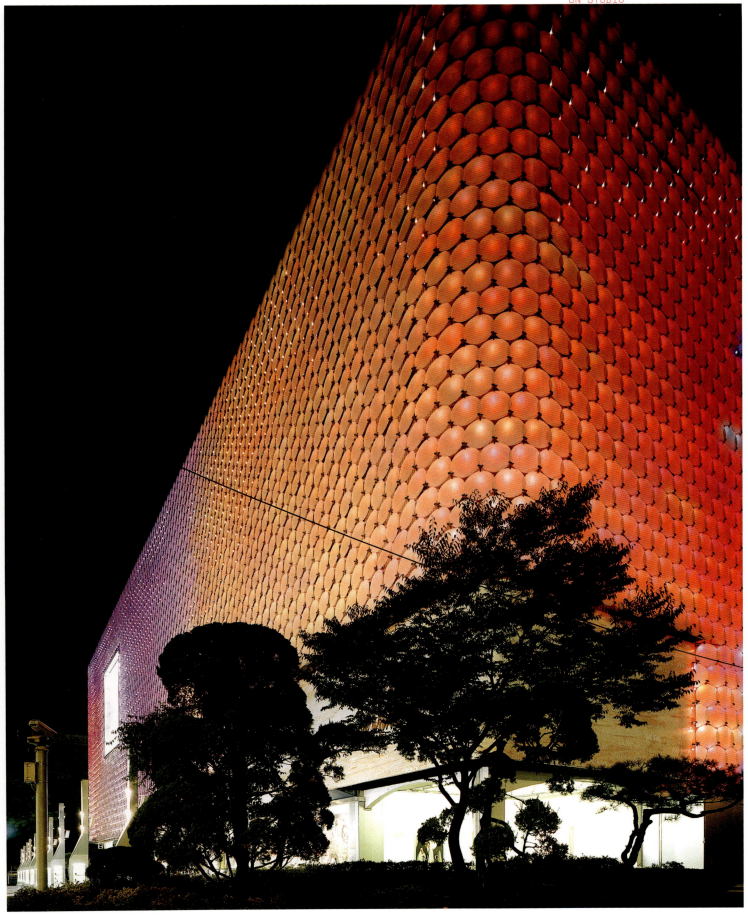

LIGHT OBJECT
De Verdieping,
Veldhoven, Netherlands
2005
HERMAN KUIJER
Photography by Norbert van Onna

Atmosphere

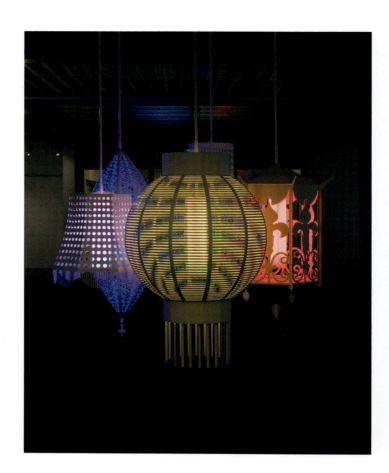

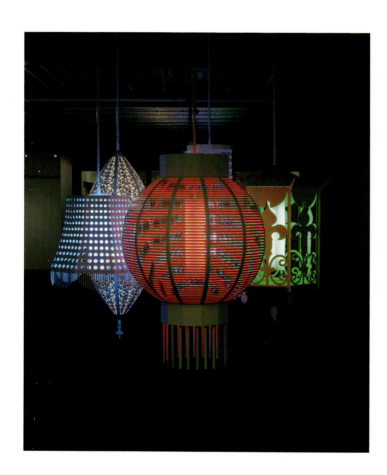

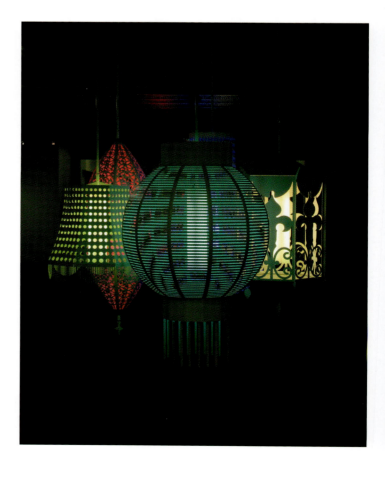

Inspired by various aspects of culture, Herman Kuijer created an installation of snow-white, laser-cut, metal objects that hang closely together and are illuminated from within by colour-variable light sources. The inner surface of an object may reflect red light, for example, while its outer skin reflects the green glow of the object next to it. The result is an optical game of ongoing communication among objects.

Fields of Colour

JEAN PAUL GAULTIER READY TO WEAR
SPRING/SUMMER 2007
Photography by Peter Stigter

Atmosphere

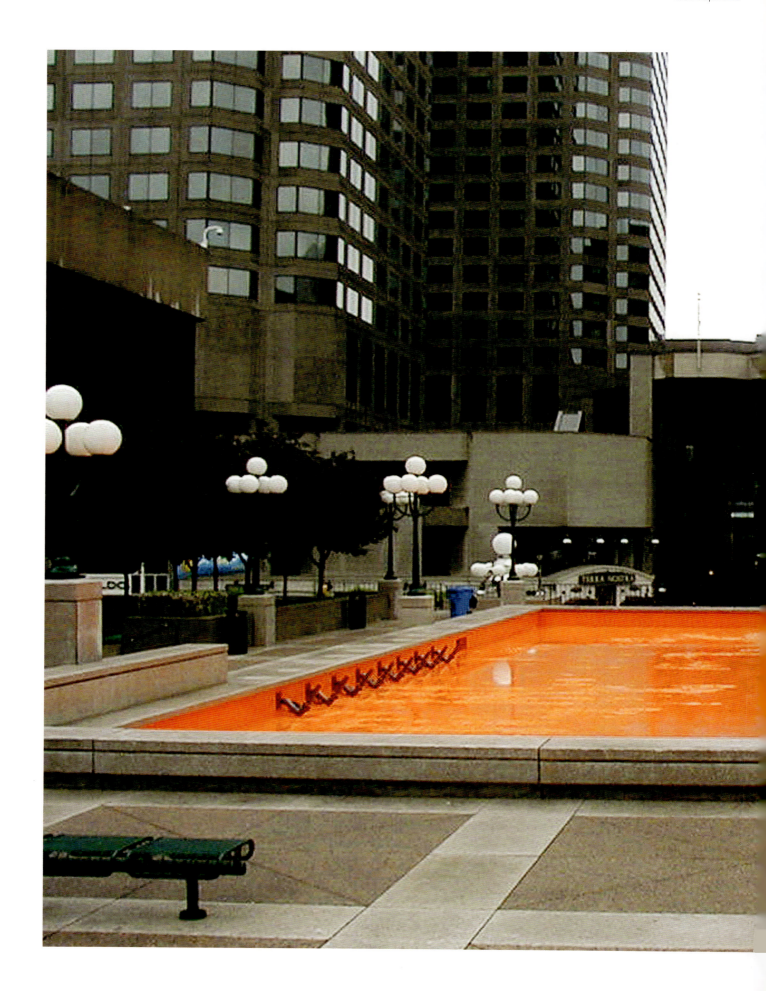

Fields of Colour

ORANGE BASIN, PLACE DES ARTS
Montreal, Canada
2003
CLAUDE CORMIER ARCHITECTS PAYSAGISTES

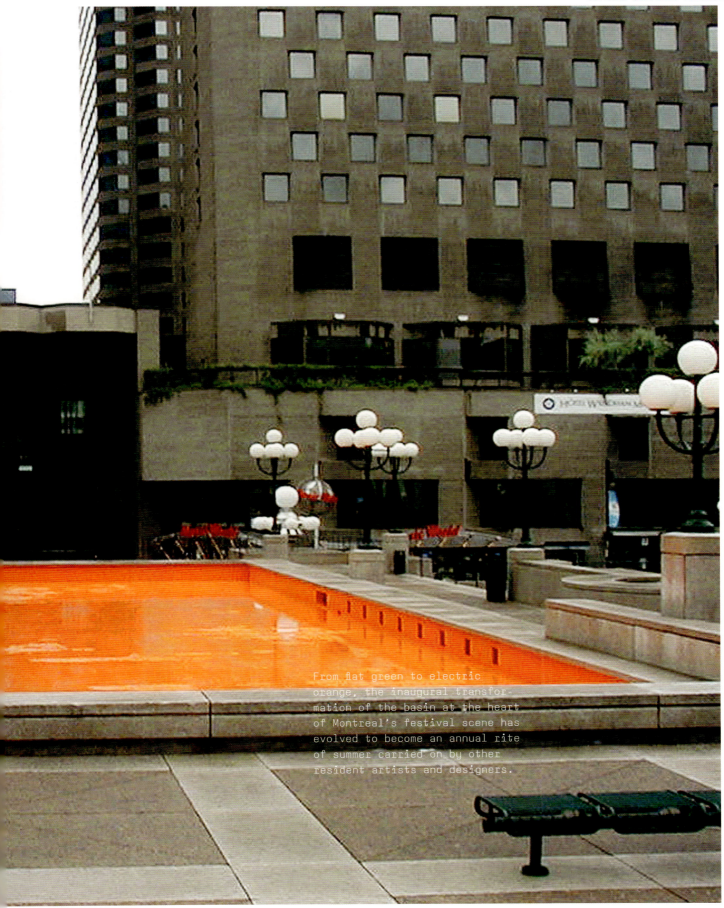

From flat green to electric orange, the inaugural transformation of the basin at the heart of Montreal's festival scene has evolved to become an annual rite of summer carried on by other resident artists and designers.

previous page:
MATERIAL
Photography by Blommers/Schumm

CompoSied and Xtreme Acrylics in
various colours by PyraSied.

Materials provided by Materia

DRAWING THE LINE

previous page:
POTATO
photography by Blommers/Schumm

Atmosphere

Drawing the Line

Flat, sharp-edged silhouettes have dominated the design world, and particularly graphic design, for quite a while. It's time to follow another line. The line of an impulsively scribbled, perhaps blazingly brilliant brainwave. A tension-filled line that carves deeper and deeper into wood. An erratic pencil line hastily scrawled in an attempt to cross out an unwelcome statement or an incorrect answer. Wispy lines made by the strands of a dense network of cobwebs in a room unvisited for years. Lines drawn in the air by a child wildly waving a sparkler on New Year's Eve. A line that moves beyond the flat surface of wall or ceiling to define an entire space.

The atmosphere created by such lines can vary greatly. Sometimes the line is clear, lucid and taut. More often, though, it's a sketchy, scratchy line with blurred, velvety contours. Vague, disorderly lines of a repetitive sort communicate a sense of instability that emerges from their uncertain, undefined ramblings.

The form given to Miss Blackbirdy's Sunday dresses makes them look as though they are held together by only a few barely remaining threads. Bertjan Pot's Carbon Cloud seems to express a denial of space, as if someone has tried to cross out the place occupied by the bed. Monika Grzymala's Transition provides a feeling of increasing acceleration or of finding oneself suddenly swept into a wind tunnel. Watch out, or you'll be slurped, swallowed or suctioned away.

These are all designs that touch the emotions in the same way that a drawing or painting can move the viewer to tears or laughter — here, however, the work is three-dimensional.

TRANSITION
2006
MONIKA GRZYMALA
Photography by Monika Grzymala

Atmosphere

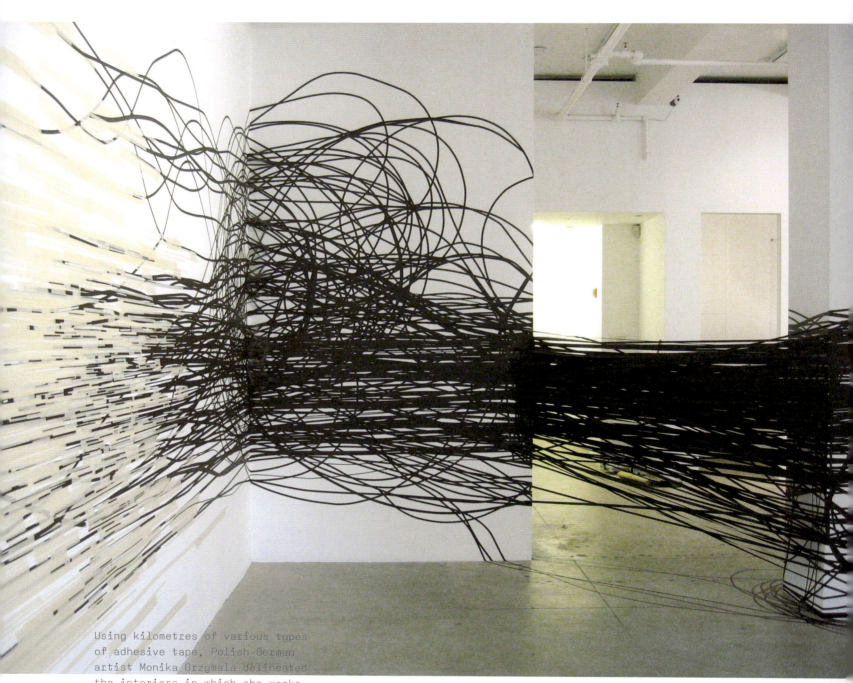

Using kilometres of various types of adhesive tape, Polish-German artist Monika Grzymala delineated the interiors in which she works. Tape runs from wall to wall, crisscrosses rooms, meanders up columns. The rhythm and dynamic of this spatial entwinement of lines alters the initial perception of each interior and generates new, transparent, spatial structures. This *Raumzeichnung* was made for Freeing the Line, an exhibition held at the Marian Goodman Gallery in New York City.

Drawing the Line

A JOURNEY TO MISS BLACKBIRDY'S WORLD
2006
MEREL BOERS
Photography by Ivo Hofste

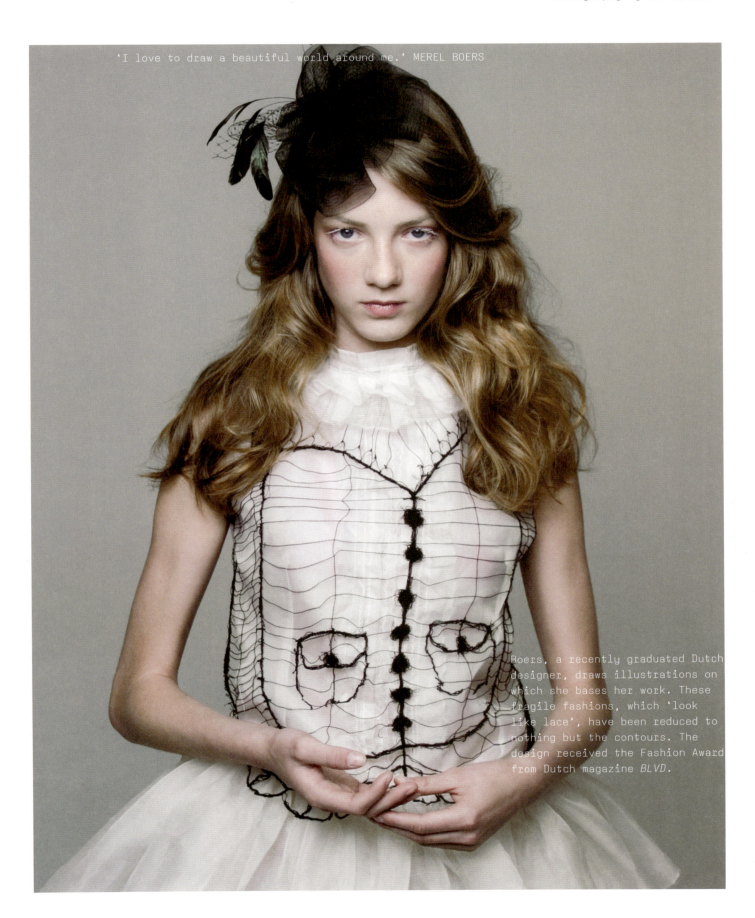

'I love to draw a beautiful world around me.' MEREL BOERS

Boers, a recently graduated Dutch designer, draws illustrations on which she bases her work. These fragile fashions, which 'look like lace', have been reduced to nothing but the contours. The design received the Fashion Award from Dutch magazine *BLVD*.

TRANSFER TWO # VII
2006
NOËLLE CUPPENS

Atmosphere

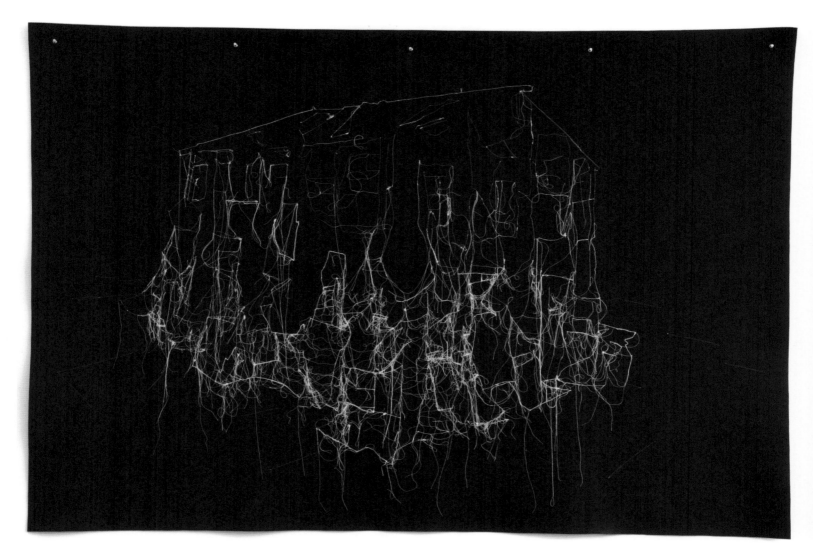

Creating a picture that resembles a pencil sketch, sewing cottons form lines 'drawn' on felt. The zigzag stitches of the sewing machine produce a shaded effect, and loose threads give these interior scenes an added dimension. Cuppens works mainly with fabric in her installations, which are sometimes two- and sometimes three-dimensional.

Drawing the Line

CARBON CLOUD
2006
BERTJAN POT
Photography by Bertjan Pot

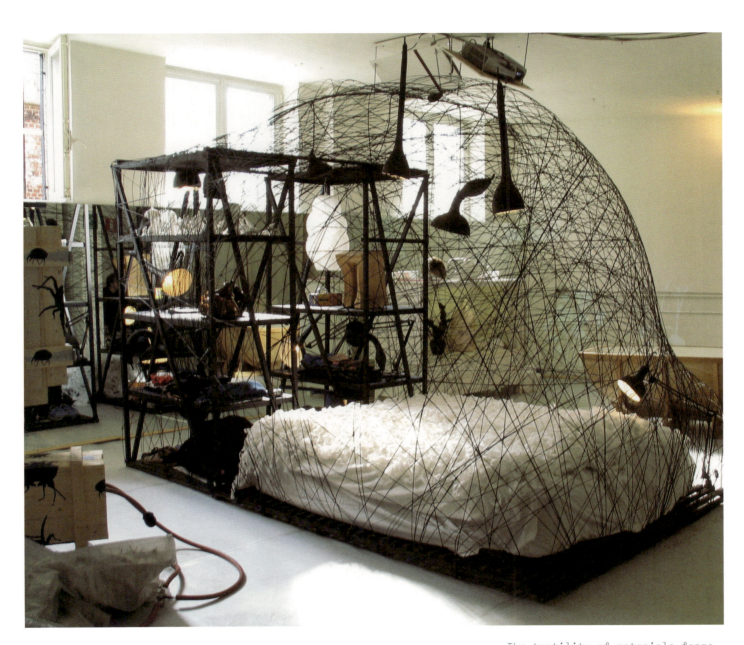

The tactility of materials forms the basis of Pot's designs — highly innovative products that might be described as 'structural and non-structural skins'. In Pot's Carbon Cloud, two shelving units and a bed are covered by a dome-like canopy that is reminiscent of a giant spider web or a huge, arching dreamcatcher. Observers standing outside the carbon cage might envision a bubble whose surface, with its crisscrossed lines, separates the worlds of waking and sleeping.

SKETCH FURNITURE
2006
FRONT DESIGN

Atmosphere

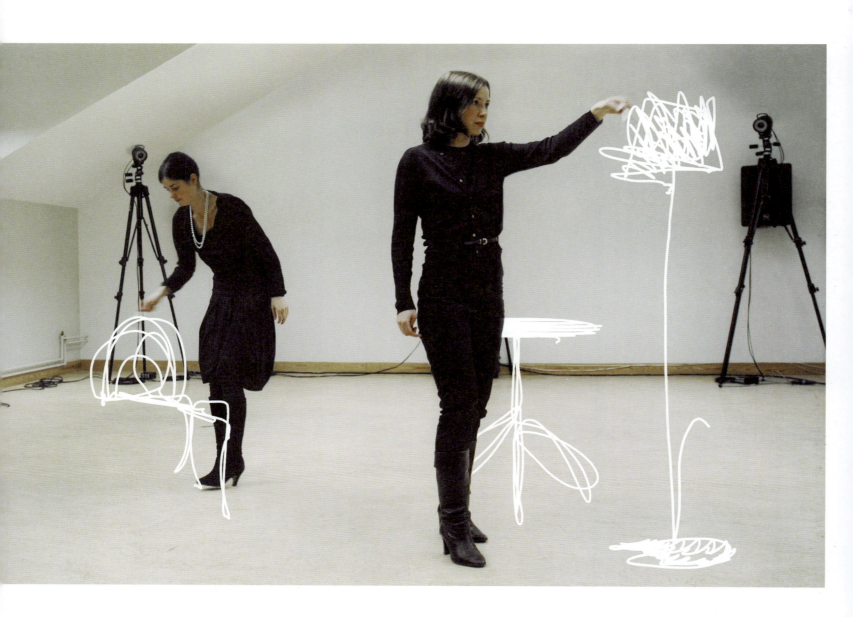

A fairy tale that can't possibly come true… or can it? The Swedish design team Front draw furniture in the air. Their airborne pen strokes are recorded by means of an animation process called Motion Capture, which turns the 'drawings' into 3D digital files. In another process, called rapid prototyping, the digital files are used to make real pieces of furniture.

Drawing the Line

SKETCH FURNITURE
2006
FRONT DESIGN

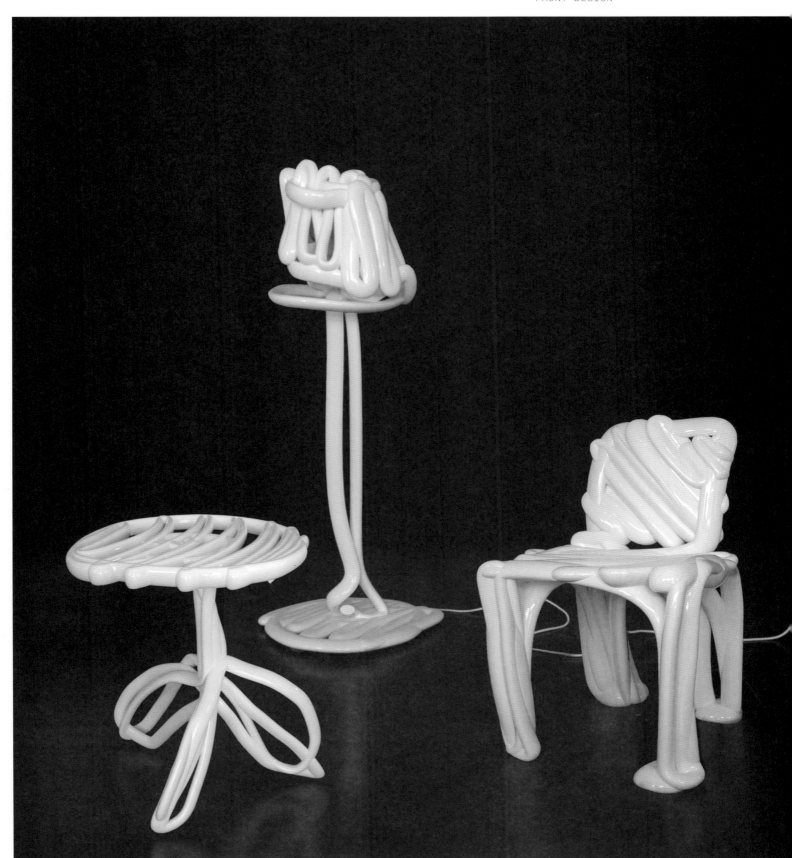

UPON WALL AND UPON FLOOR
2006
STEFAN DIEZ

Atmosphere

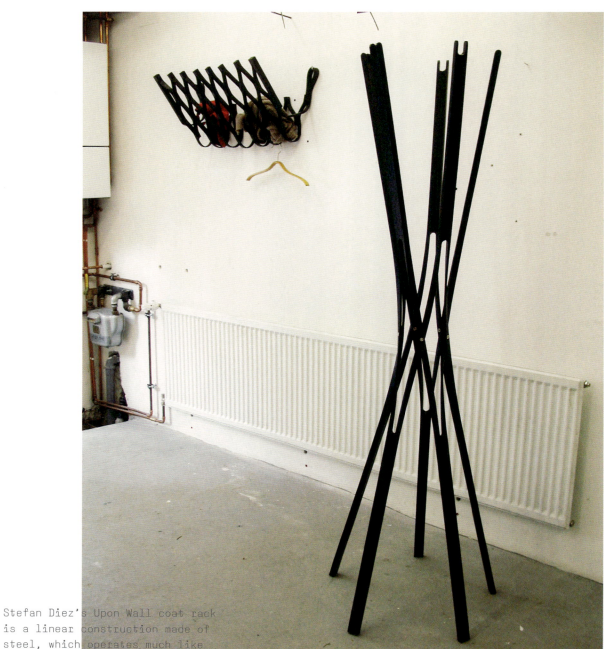

Stefan Diez's Upon Wall coat rack is a linear construction made of steel, which operates much like an accordion. Upon Floor projects five interlocking arms as if from a single unit. The design won the Cologne Interior Innovation Award in the Best Detail category.

SWAN
2006
KALEB DE GROOT

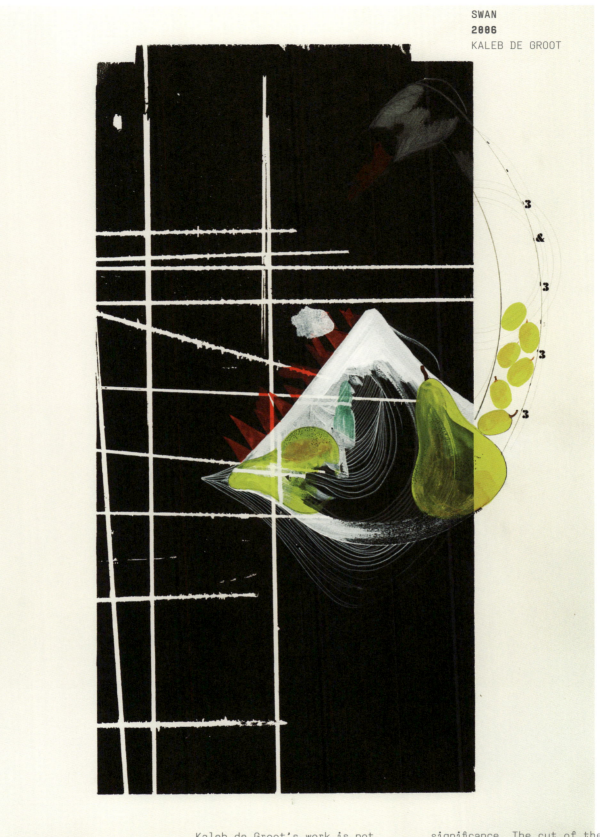

Kaleb de Groot's work is not limited to one medium. He uses all kinds of materials and human situations for his drawings, installations and performances. Prior to making Swan, he did research on saw cuts. The line made by the cut – a result of 'damaging' the material – has a symbolic significance. The cut of the saw was first printed, and slowly a slender swan evolved from a play of lines and the use of various techniques: relief printing, watercolour, pencil, and rub-on letters.

Atmosphere

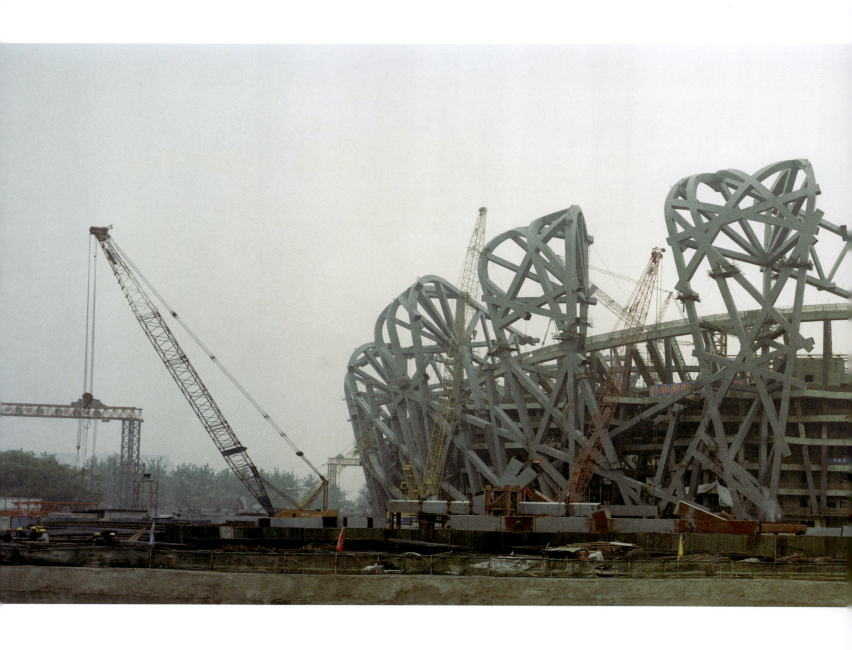

Drawing the Line

NATIONAL STADIUM
Beijing, China
2003-2007
HERZOG & DE MEURON
Photography by Markus Bollen

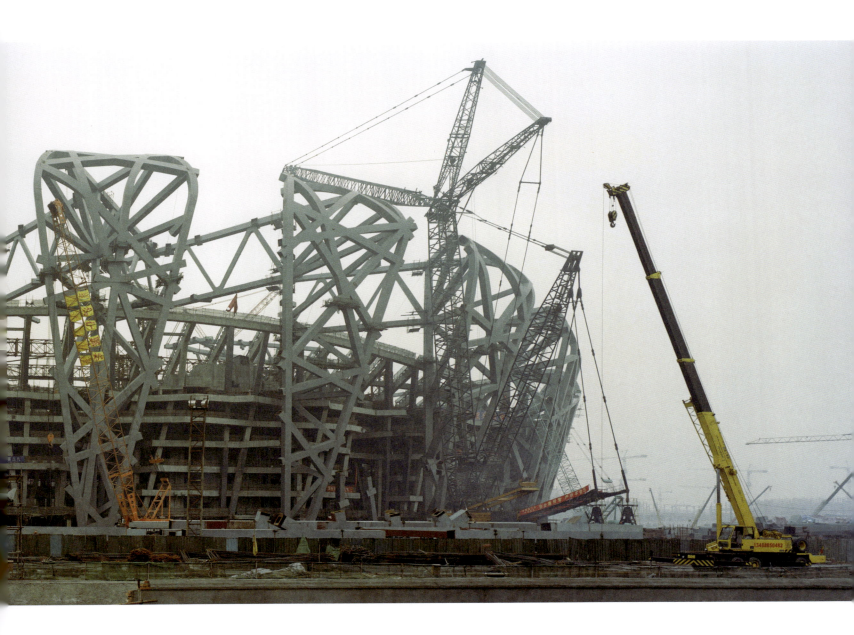

Herzog & de Meuron won an international competition for the design of a new national stadium for the 2008 Summer Olympics in Beijing, China. The Swiss firm proposed a lattice-like network of concrete strips, arranged in an apparently random way. These concrete components form the bowl-shaped stadium and, say the architects, resemble 'a 'bird's nest'.

WILSONART NEST CHAIR
2006
CHARLES BRILL

Atmosphere

Flat strips of laminated oak are layered and interwoven in a random sequence to create a three-dimensional object. The chair gently cradles the body, generating the feeling of protection one imagines finding in a nest.

Drawing the Line

CHAIR ONE
2004
KONSTANTIN GRCIC FOR MAGIS

87

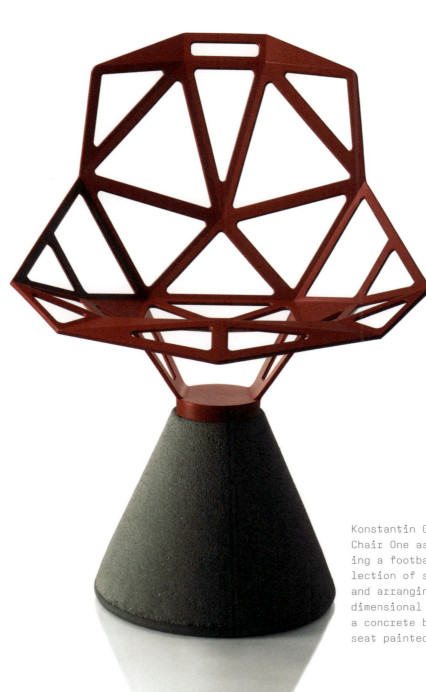

Konstantin Grcic constructed Chair One as though he were making a football, assembling a collection of small, flat components and arranging them into a three-dimensional form. Chair One has a concrete base and an aluminium seat painted in polyester powder.

FRACTAL CLOUD
2005
ARIK LEVY, LDESIGN
Photography by Florian Kleinefenn

Atmosphere

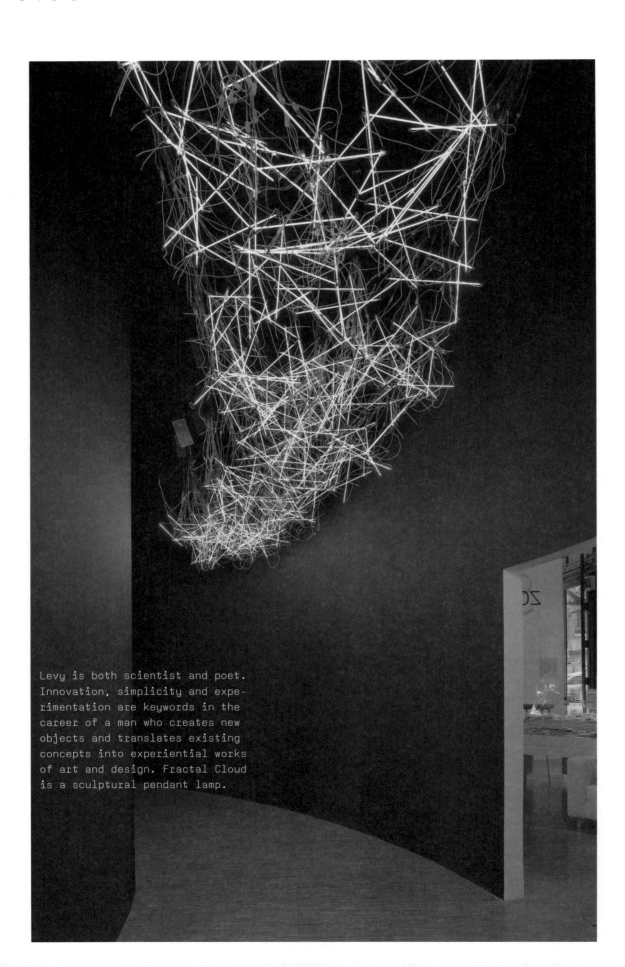

Levy is both scientist and poet. Innovation, simplicity and experimentation are keywords in the career of a man who creates new objects and translates existing concepts into experiential works of art and design. Fractal Cloud is a sculptural pendant lamp.

Drawing the Line

COSMOS 1 & 2
2006
NAOTO FUKASAWA
FOR SWAROVSKI CRYSTAL PALACE
Photography by Florian Kleinefenn

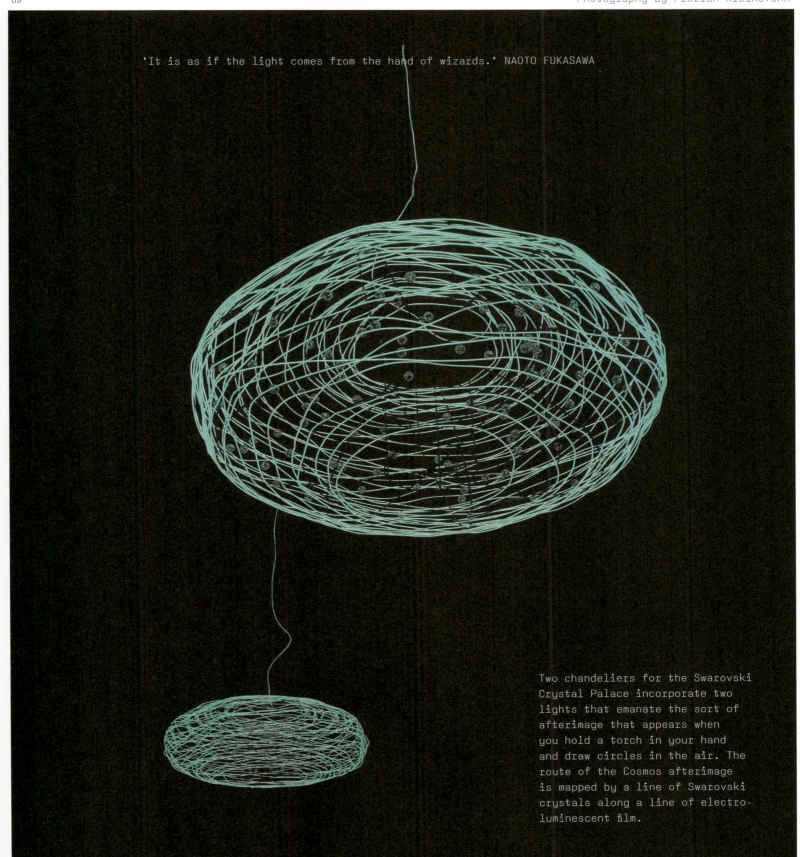

'It is as if the light comes from the hand of wizards.' NAOTO FUKASAWA

Two chandeliers for the Swarovski Crystal Palace incorporate two lights that emanate the sort of afterimage that appears when you hold a torch in your hand and draw circles in the air. The route of the Cosmos afterimage is mapped by a line of Swarovski crystals along a line of electro-luminescent film.

X LEXUS L-FINESSE
2006
TOKUJIN YOSHIOKA DESIGN

Atmosphere

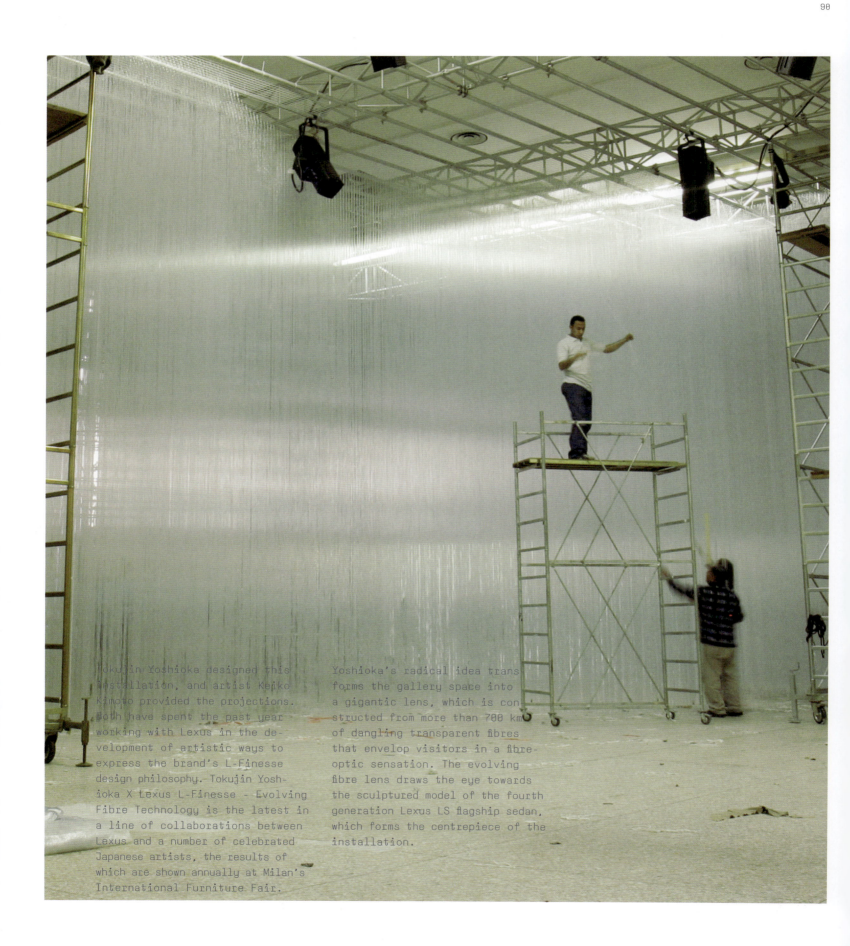

Tokujin Yoshioka designed this installation, and artist Kenko Kimoto provided the projections. Both have spent the past year working with Lexus in the development of artistic ways to express the brand's L-Finesse design philosophy. Tokujin Yoshioka X Lexus L-Finesse – Evolving Fibre Technology is the latest in a line of collaborations between Lexus and a number of celebrated Japanese artists, the results of which are shown annually at Milan's International Furniture Fair. Yoshioka's radical idea transforms the gallery space into a gigantic lens, which is constructed from more than 700 km of dangling transparent fibres that envelop visitors in a fibre-optic sensation. The evolving fibre lens draws the eye towards the sculptured model of the fourth generation Lexus LS flagship sedan, which forms the centrepiece of the installation.

Drawing the Line

SOLID C1
2006
PATRICK JOUIN
Photography by Thomas Duval

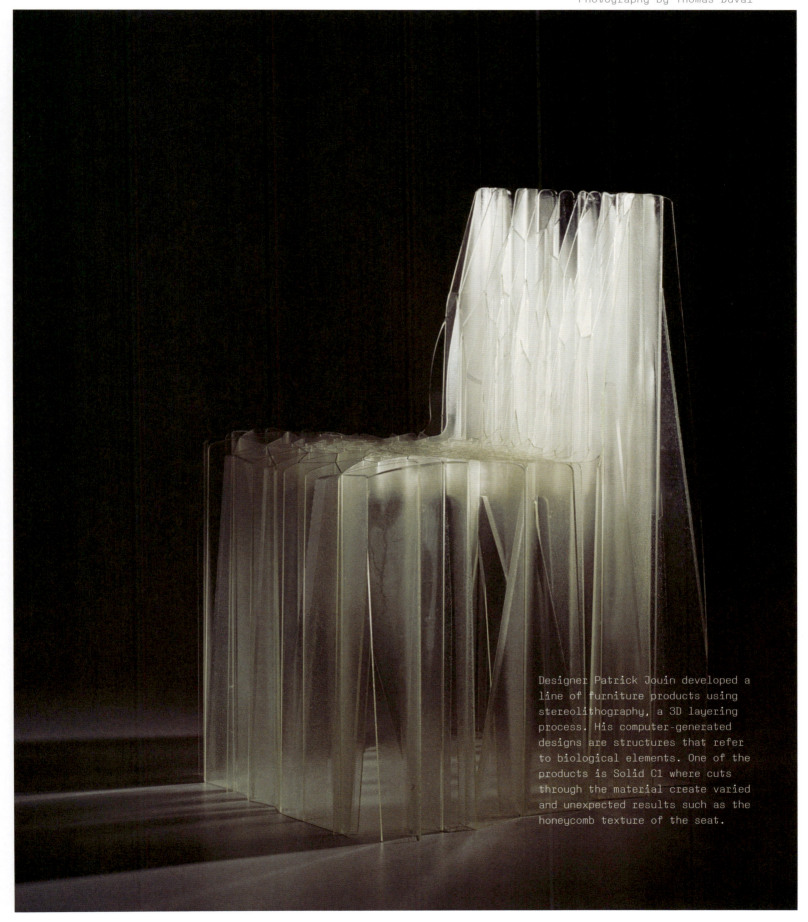

Designer Patrick Jouin developed a line of furniture products using stereolithography, a 3D layering process. His computer-generated designs are structures that refer to biological elements. One of the products is Solid C1 where cuts through the material create varied and unexpected results such as the honeycomb texture of the seat.

MINISTRUCTURE NO 16
Jinhua Architecture Park, China
2006
MICHAEL MALTZAN ARCHITECTURE
Photography by Iwan Baan

Atmosphere

Detail of a pavilion still under construction: the location is a park in Jinhua City, China. The park – a retreat where visitors can read, eat and meditate – is to feature a series of pavilions designed by various international architects. The concept of the project expands on the confluence between the book and architecture in Chinese history: in the third century B.C.E, a descendant of the philosopher Confucius concealed several of his texts in a wall after the emperor had ordered all Confucian writings burned. The texts, essential relics of China's culture, were not discovered until nearly four centuries later. Poised at this historic juncture of books and buildings, the central wall of the pavilion stretches out to form two cantilevered arms, each concealed within a public space. The shorter of the two wings contains a bookstore and a café: spaces organized into a series of terraces that rise to a framed view of the park to the west.

The pavilion is a bent, tapered form that appears to expand and contract, its perforated walls and openings creating an ever-changing montage of spaces between, within, and beyond the mini-structure and the viewer.

Drawing the Line

NAIS
2004
ALFREDO HÄBERLI FOR CLASSICON
Photography by Hans Buttermilch

'A sketch, an unfinished drawing, is something wonderful. While working on Nais, the chair was always in front of me — in graphite. The plan was to execute it in titanium, an idea that has persevered since the first sketch.' ALFREDO HÄBERLI

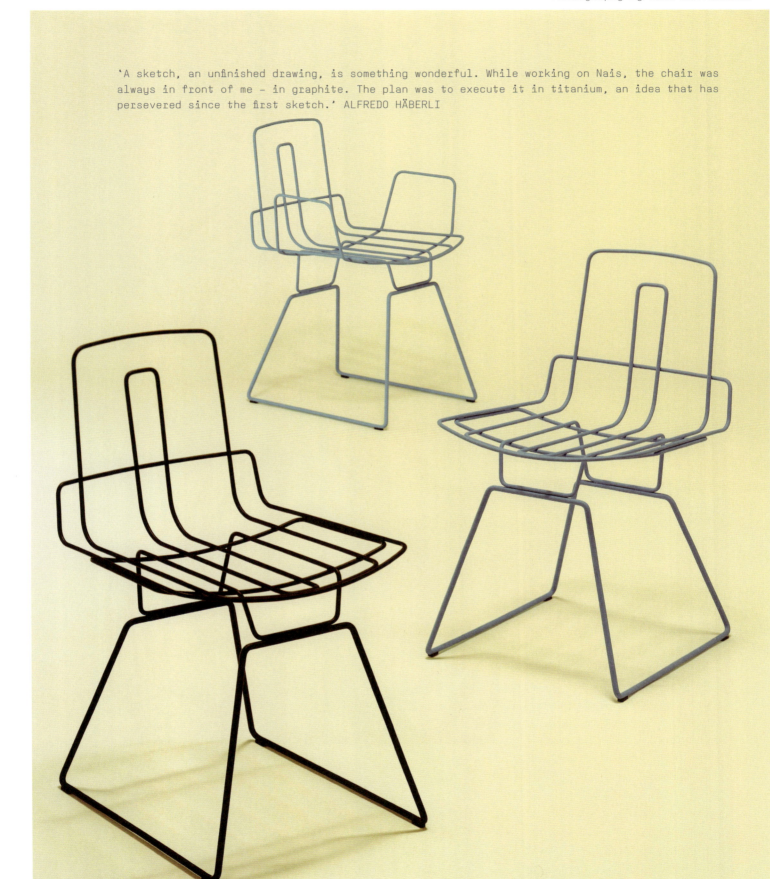

TWINS
Hasselt, Belgium
2004-2008
J. MAYER H. AND A20 ARCHITECTEN

Atmosphere

94

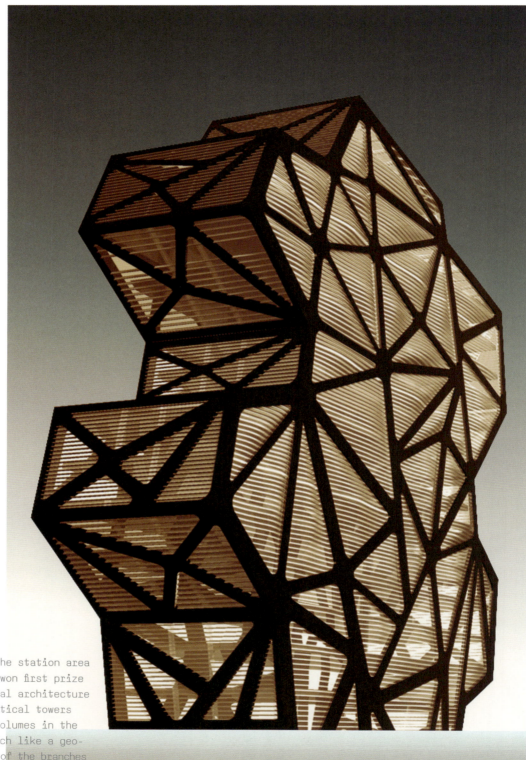

The urban design of the station area in Hasselt, Belgium, won first prize in a 2004 international architecture competition. Two identical towers made of steel – key volumes in the design – look very much like a geometric interpretation of the branches of a tree in a Mondrian painting.

Drawing the Line

ITTI & ETTE
2006
MAREIKE GAST

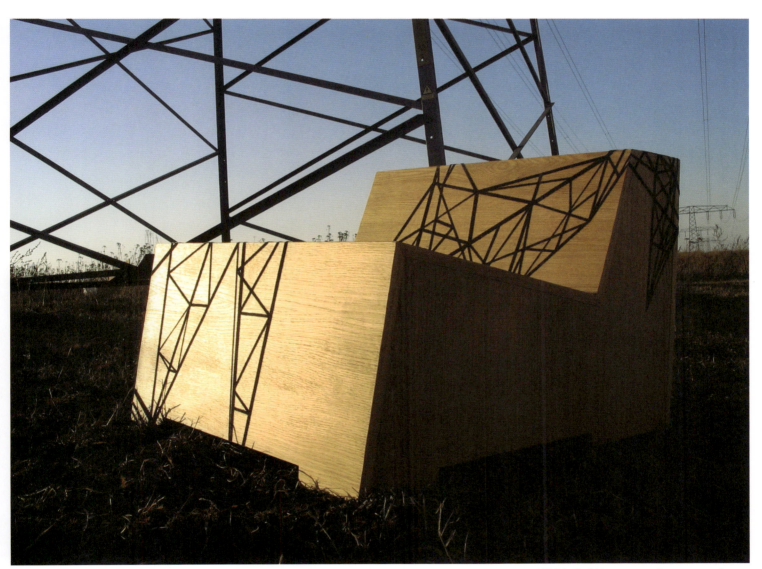

'Itti & Ette are oak-veneered chairs decorated with flocked yarn,' says the designer. The lines of yarn crossing one another make the seat softer and more comfortable. The chairs, which can be transported flat-pack style, are easy to assemble.

BLEND
2006
KARIM RASHID FOR HORM
Photography by Karim Rashid

Atmosphere

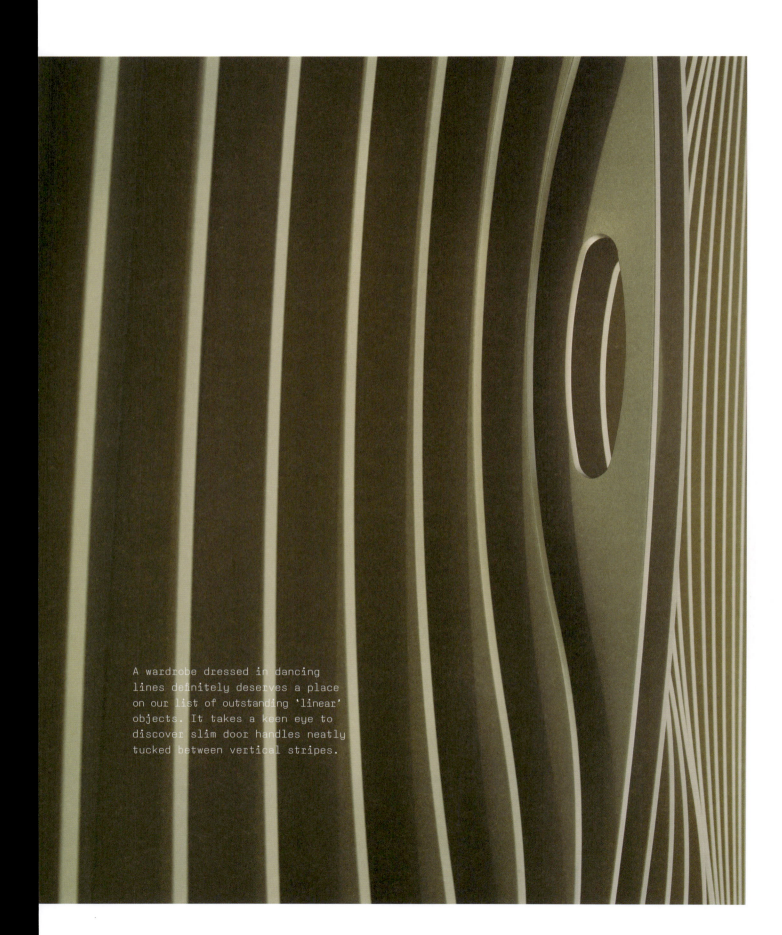

A wardrobe dressed in dancing lines definitely deserves a place on our list of outstanding 'linear' objects. It takes a keen eye to discover slim door handles neatly tucked between vertical stripes.

Drawing the Line

TIDE CUPBOARD
2006
KARIM RASHID FOR HORM
Photography by Karim Rashid

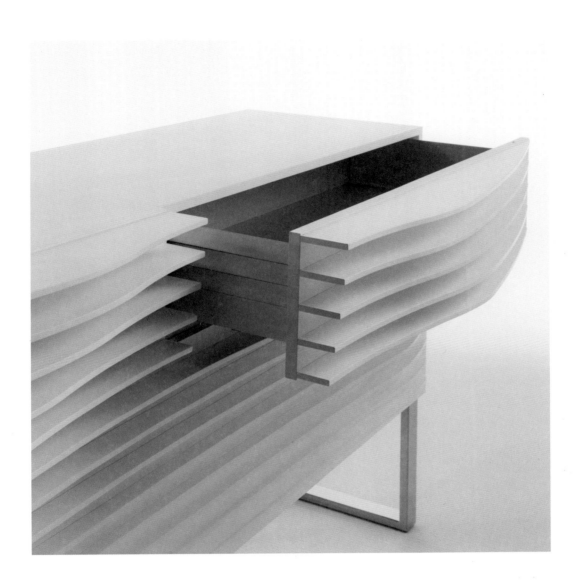

Rashid's Tide cupboard is another piece of the Blend collection. Here, too, wavy lines seem to reach out and ask to be touched.

IMPRESSION
2002
JULIAN MAYOR
Photography by Julian Mayor

Atmosphere

98

'I am interested in the contrast and contradiction of human and machine. From spending time looking at on-screen representations of 3D objects, I find that seeing the inside and outside of an object at once can be beautiful. I wanted to represent the lightness of a 3D computer model in a physical form and to contrast its computer-based development with a traditional material and manufacturing method.' JULIAN MAYOR

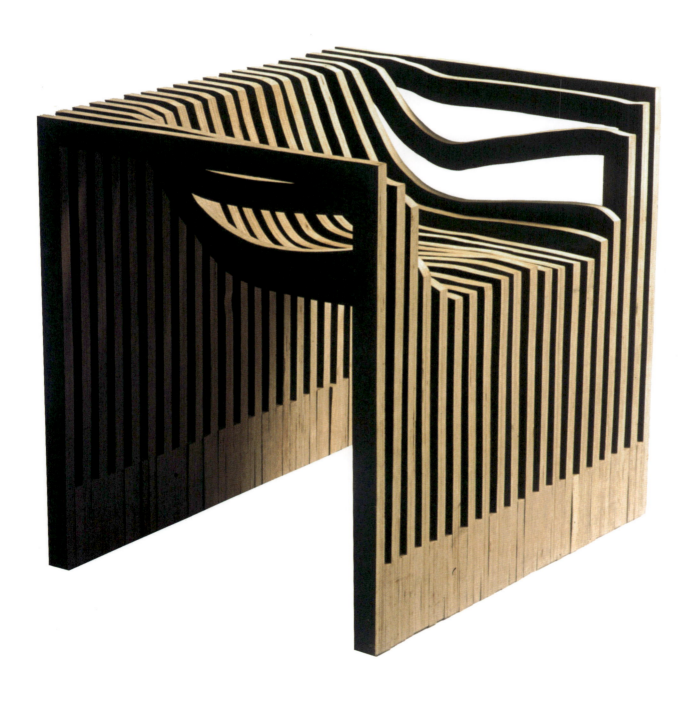

Drawing the Line

WELCOME CENTRE
Jinhua Architecture Park, China
TILL SCHWEIZER
Photography by Iwan Baan

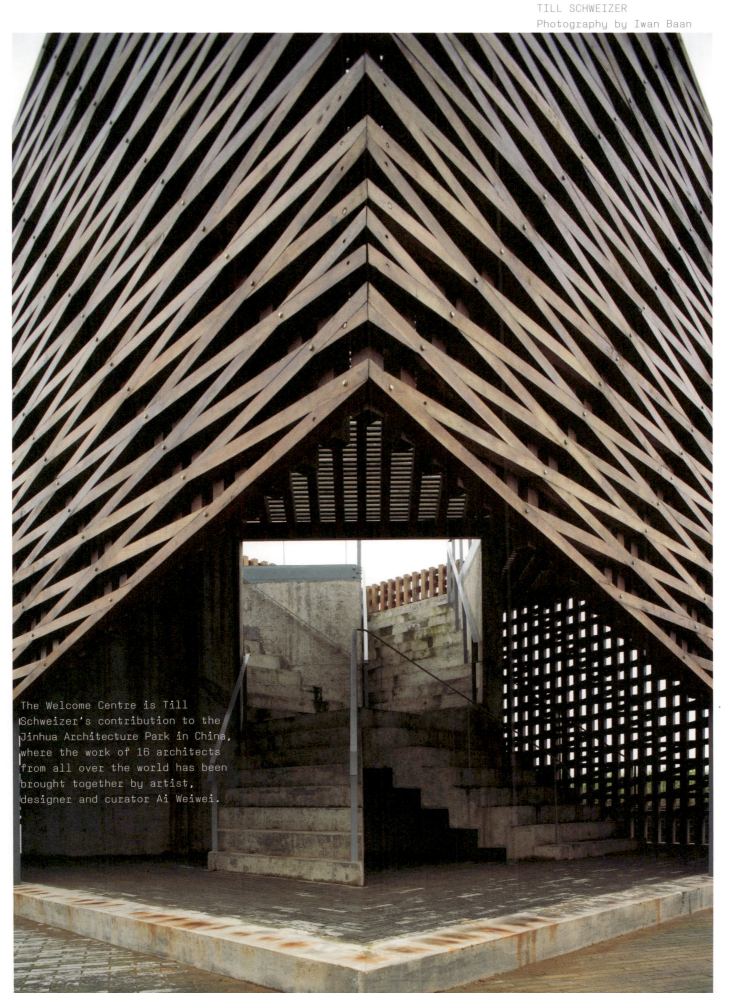

The Welcome Centre is Till Schweizer's contribution to the Jinhua Architecture Park in China, where the work of 16 architects from all over the world has been brought together by artist, designer and curator Ai Weiwei.

Atmosphere

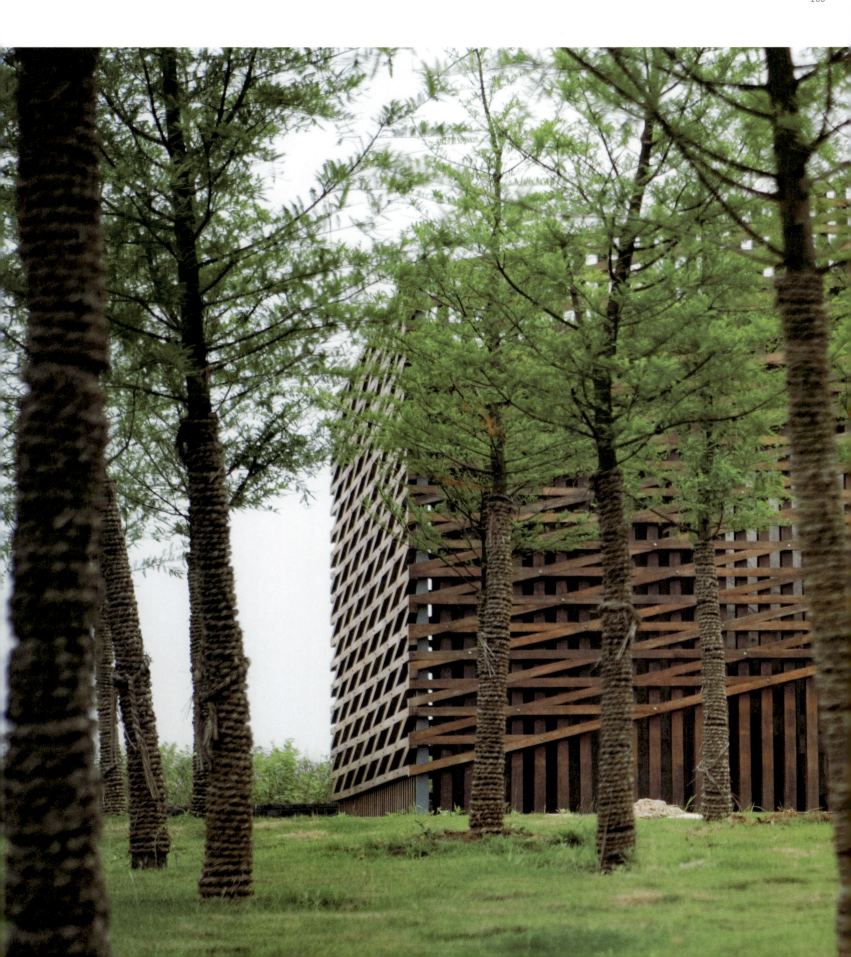

Drawing the Line

WELCOME CENTRE
Jinhua Architecture Park, China
TILL SCHWEIZER
Photography by Iwan Baan

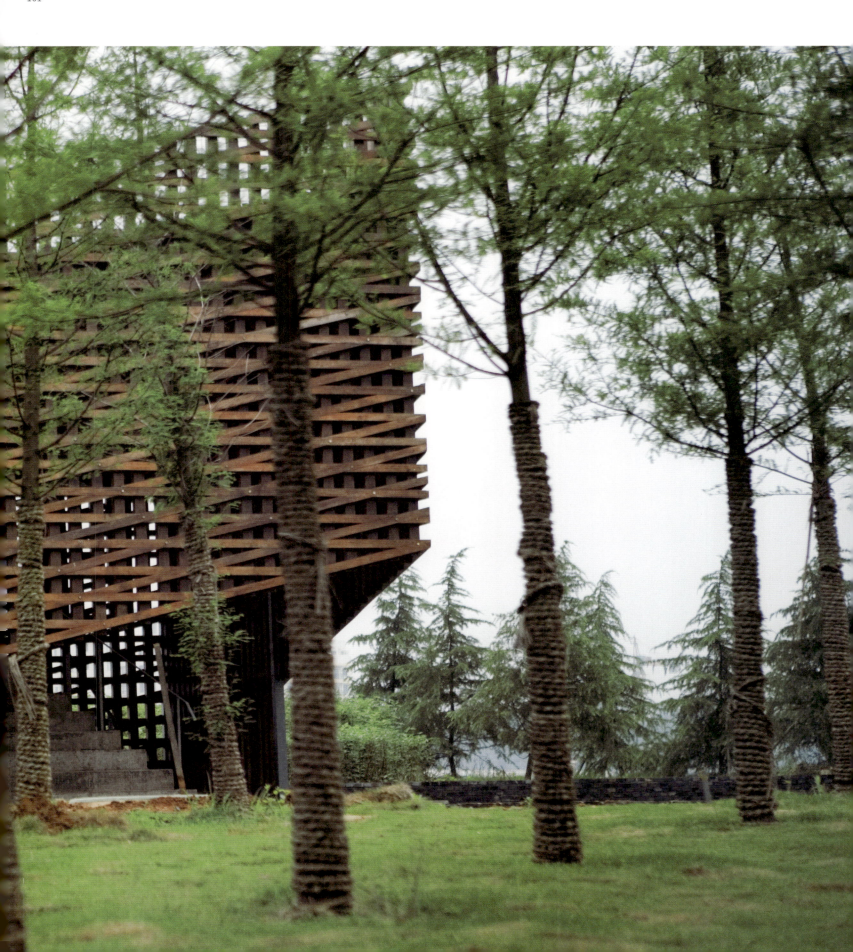

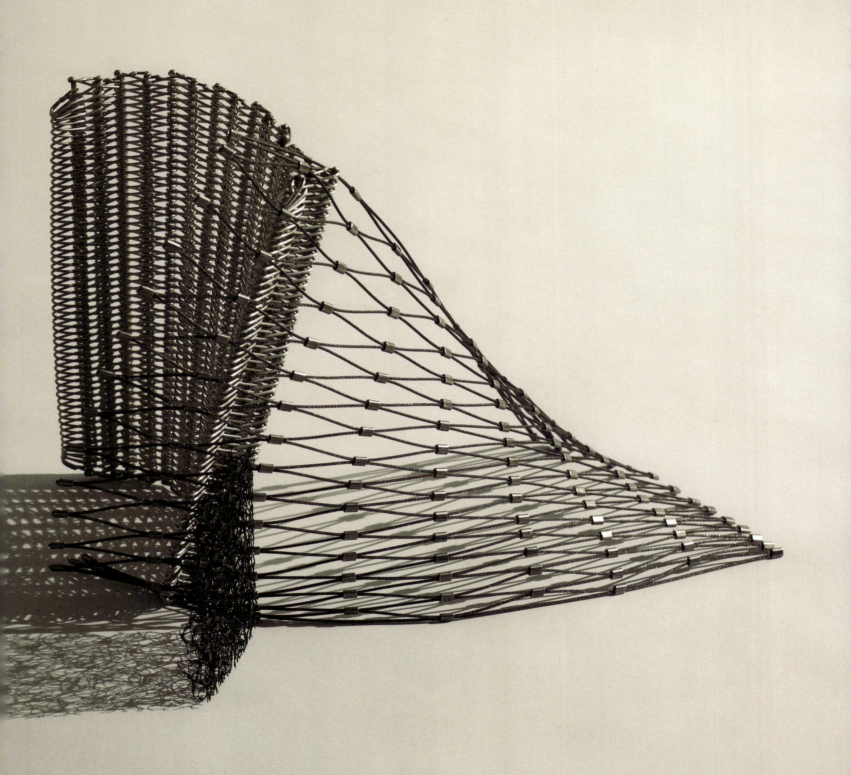

previous page:
MATERIAL
Photography by Blommers/Schumm

Right: X-Tend, a patented stainless-steel cable by CarlStahl.
Left: Perforated metal by Gantois.

Materials provided by Materia

Atmosphere

IN THE MIX

previous page:
POTATO
Photography by Blommers/Schumm

Atmosphere

In the Mix

A broken table leg, a seat in need of mending, a meaningless existence? You can take your damaged or unused items to a hospital for household objects run by 5.5 designers. Resolute, clad in white jackets and equipped with an assortment of bright-green 'prostheses', the furniture physicians prepare for surgery. With design as their main resource, they reanimate discarded and orphaned objects and prolong their lives. Unlike a normal restoration, here the green prosthesis remains visible, clearly denoting the repair that's been made and adding a bit of visual history to the object in question.

The same sort of Frankenstein-like charm is found in Grandmother's Treasures by Vika Mitrichenka. The shards that she's apparently gathered here and there to make her tea service seem to have been selected for their ability to clash with one another. Not only the decoration but also the forms of the various pieces fail to create a harmonious whole — and that failure is deliberate. In fact, the set is composed of whole cast pieces which only seem to be composed of fragments glued together. The result of this kind of 'restoration' is a series of objects that mixes shapes, styles, moods and emotions. The use of already existing products as part of the design process can be interpreted as a commentary on overconsumption and as a sign of the designer's displeasure with the ever-increasing mountain of 'designed' products. The turnover rate of such objects is considerable. Reworking them and putting them back into circulation is a good way to conserve raw materials. Then, too, used things have a special kind of beauty. With their faded colours and worn surfaces, they urge us to look at the past. They have a familiarity that's appealing. Happenstance has played an important role in the objects presented in this chapter, all of which are unique and which invite us to enter into a personal relationship with them. Singularity has also led to the success of Freitag, a brand whose bags are made from old lorry tarpaulins. Each bag is unique. A customer who visits the Freitag website can choose her own tarp and, subsequently, the exact sections of fabric she wants the company to use in making her bag. Freitag's new flagship store in its home base, Zürich, testifies to the firm's image as a champion of recycling. The shop is built from old sea containers stacked one atop the other. Like the company's bags, the building makes no secret of its origins and history. Rust stains, words and logos on the walls clearly show where the architects went to find these hulking volumes.

Collage, assembly, sampling, mixing and mashing are all techniques that have been put to the test for decades in the fields of art and music. And the same sorts of methods are being applied to an increasing degree in architecture, fashion and product design. Creative souls are coming up with new compositions — call them *objets trouvés*, if you will — by combining not only forms, materials and colours, but also historical styles and functions. In certain cases, the found object even interacts with the user. What makes this approach so attractive is the strong possibility of coincidence and unpredictability involved. The hybrid products born of such processes are an adventure for the eye. Often difficult to fathom at a glance, they sabotage one's expectations.

CLONE
2005
JULIAN MAYOR
Photography by Julian Mayor

Atmosphere

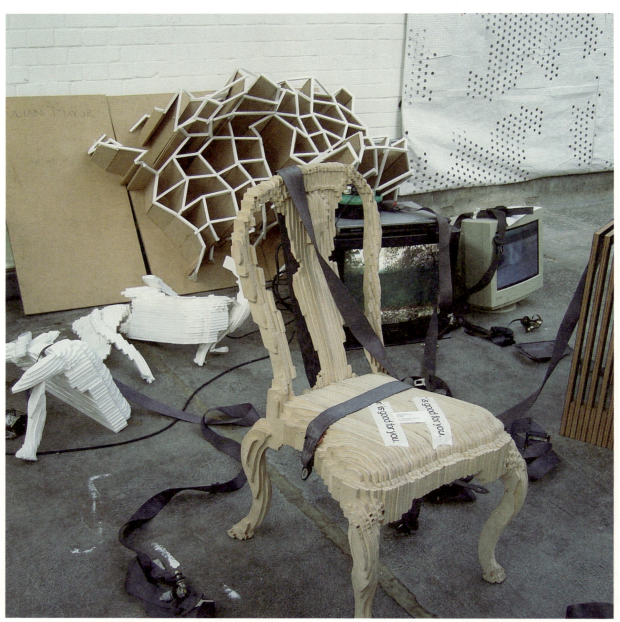

United within this 'Queen Anne' chair are its 17th-century style and the latest 21st-century technology. The chair, which is the result of laser scanning, is composed of many laser-cut slices of plywood. Together, the vertical layers form an amusing representation of the original chair: a seat assuming the role of a shimmering Fata Morgana.

In the Mix

ARCAM LECTURE
De Brakke Grond
Amsterdam, Netherlands
7 FEBRUARY 2006
VAN HERK & DE KLEIJN ARCHITECTS
Photography by Johannes Abeling

Architects Arne van Herk and Sabien de Kleijn often mix art, design and architecture in their work. They use all sorts of methods during the design process, experimenting with foam-rubber objects, flexible pieces of furniture and ultra-light, half-metre-high platform shoes. The architects gave a lecture in Amsterdam in combination with an exhibition of their work.

EMPEROR MOTH STORE
London, England
2006
AB ROGERS DESIGN
Photography by Morely von Sternberg

Atmosphere

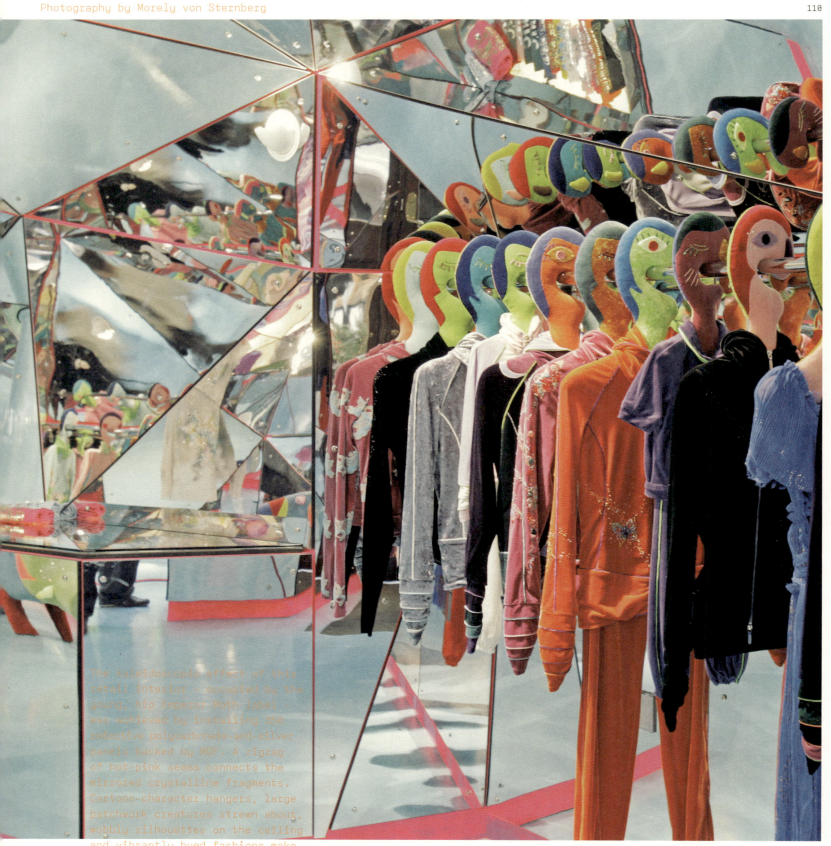

The kaleidoscopic effect of this retail interior — occupied by the young, hip Emperor Moth label — was achieved by installing 200 reflective polycarbonate and silver panels backed by MDF. A zigzag of hot-pink seams connects the mirrored crystalline fragments. Cartoon-character hangers, large patchwork creatures strewn about, wobbly silhouettes on the ceiling and vibrantly hued fashions make a visit to Emperor Moth a psychedelic happening.

In the Mix

TIDE CHANDELIER
2004
STUART HAYGARTH

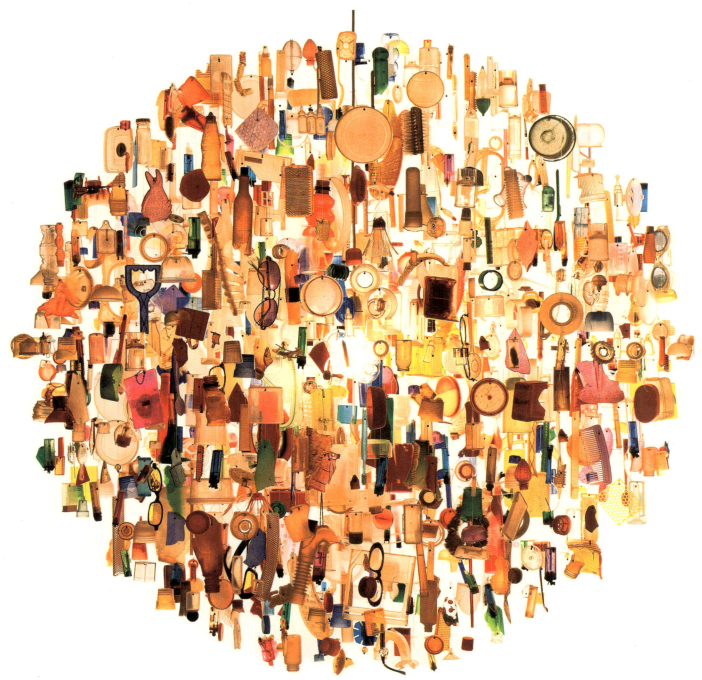

The original Tide chandelier is part of a larger body of work which comprises a collection of man-made debris that washes up on a specific stretch of the coastline in Kent, England. After collecting and categorizing the material, Haygarth made several individual pieces from his discoveries. The chandelier consists of transparent, translucent, primarily plastic objects. Although each is different in form, they come together to produce a sphere that Haygarth sees as an analogy for the moon, the heavenly body that affects the tides which in turn wash up the debris.

REVERSIBLE DESTINY LOFTS – MITAKA
(IN MEMORY OF HELEN KELLER)
2005
ARAKAWA AND MADELINE GINS
Photography by Masataka Nakano

Atmosphere

'This first completed example of procedural architecture put to residential use offers a whole new approach to home sweet home. Procedural architecture is an architecture of precision and unending invention. Works of procedural architecture function as well-tooled pieces of equipment that help the body organize its thoughts and actions to a greater degree than had previously been thought possible. […] Set up to put fruitfully into question all that goes on within them, they steer residents to examine minutely the actions they take and to reconsider and, as it were, recalibrate their equanimity and self-possession, causing them to doubt themselves long enough to find a way to reinvent themselves. These tactically posed architectural volumes put human organisms on the track of why they are as they are. To be sure, every loft comes with a set of directions for use. By virtue of how it is constructed, through how its elements and features are juxtaposed, each *Reversible Destiny Loft* invites optimistic and constructive action. What could be more optimistic and constructive than a living space that in every way both prods and coaxes its residents to continue living for an indefinitely long period of time?! That is what the term *reversible destiny* signals loudly and clearly. Each reversible destiny loft has structured into it the capacity to help residents live long and ample lives.'
ARAKAWA

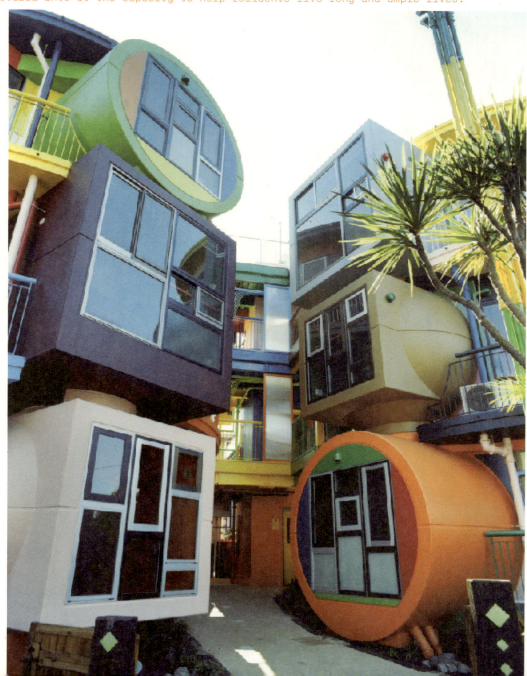

In the Mix

COLOURED POTS
2006
AI WEIWEI
Photography by Ai Weiwei

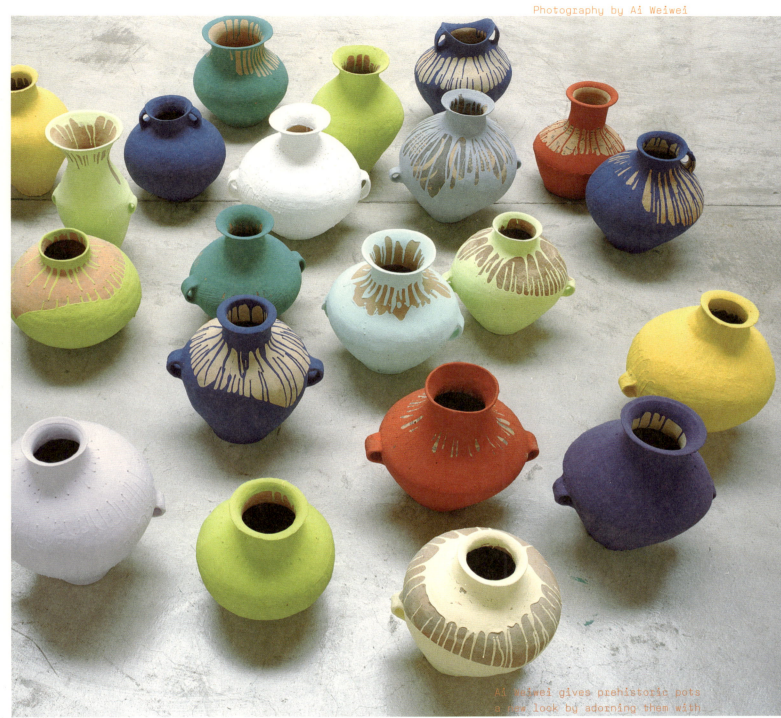

Ai Weiwei gives prehistoric pots a new look by adorning them with bold 'Andy Warhol colours'. He deconstructs traditions and icons in projects that fuse East and West. Ai Weiwei applied a Coca-Cola logo to a Han Dynasty urn, for example, and he also gave a performance in which he smashed to pieces another 2000-year-old vase.

SHOWTIME MULTILEG CABINET
2006
JAIME HAYÓN FOR BD EDICIONES
DE DISEÑO

Atmosphere

114

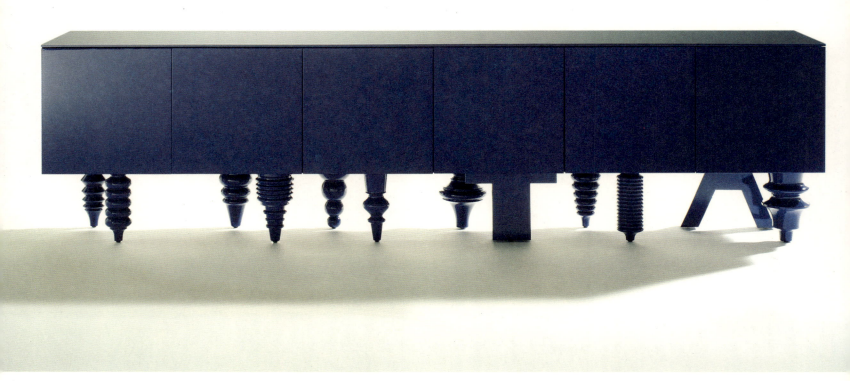

Any 'leg manufacturer' in search of a single piece to display his wares could make good use of Hayón's centipede. The designer used colour to integrate the plain, uniform storage volume with the exalted and varied collection of legs that walks away with all the honours.

In the Mix

BLOB
2004
STUDIO JURGEN BEY AND
TU EINDHOVEN FOR SKOR
Photography by J. Linders

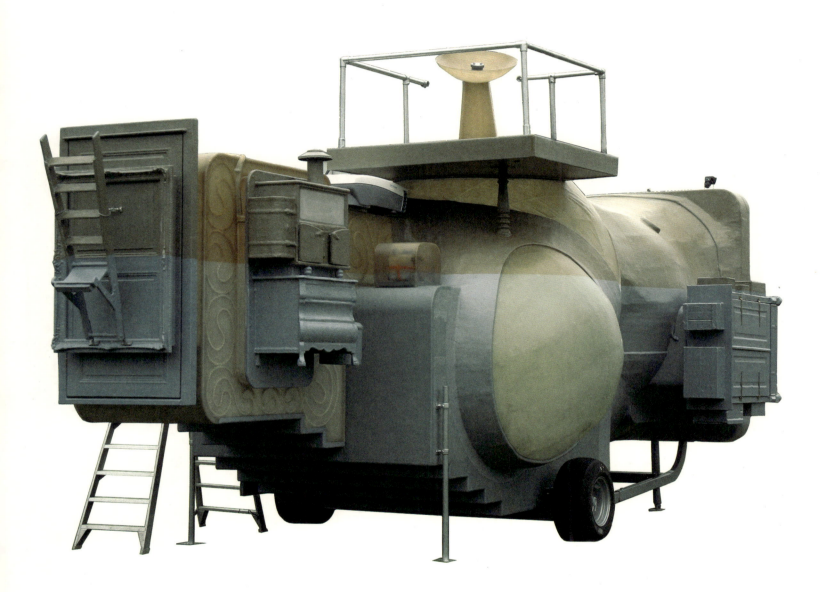

'Blob' (binary large object) is a term used to describe objects with complex, fluid forms. The object shown here relies on an experimental technique developed by Arno Pronk known as the 'blowing structure method'. Pronk's technology can be used to make architectural models from elastic materials like tights and balloons. A miniature prototype is scanned with a 3D scanner, the scan is enlarged, and the result is used to make a physical model. An endless number of shapes can be created in this way. Studio Jurgen Bey designed this pavilion, which combines blobs, turned table legs and other ornamented items of furniture.

KOKON FURNITURE
1997
STUDIO JURGEN BEY
FOR DROOG DESIGN
Photography by Bob Goedewaagen

Atmosphere

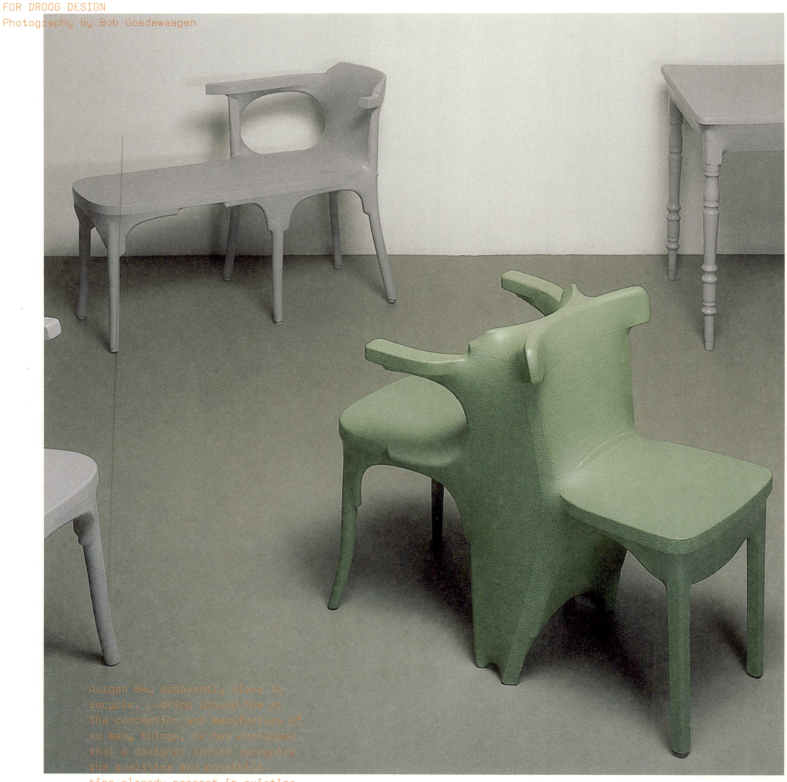

Jurgen Bey apparently lives to recycle. Looking around him at the conception and manufacture of so many things, he has concluded that a designer should recognize the qualities and possibilities already present in existing objects and should convert such objects into products that people want to use. Bey's Kokon furniture lends shape to his basic principles: by giving an existing item of furniture a new coat of PVC, he creates a hybrid object.

In the Mix

REANIM: MEDICINE FOR OBJECTS
2003
5.5 DESIGNERS
Photography by 5.5. designers

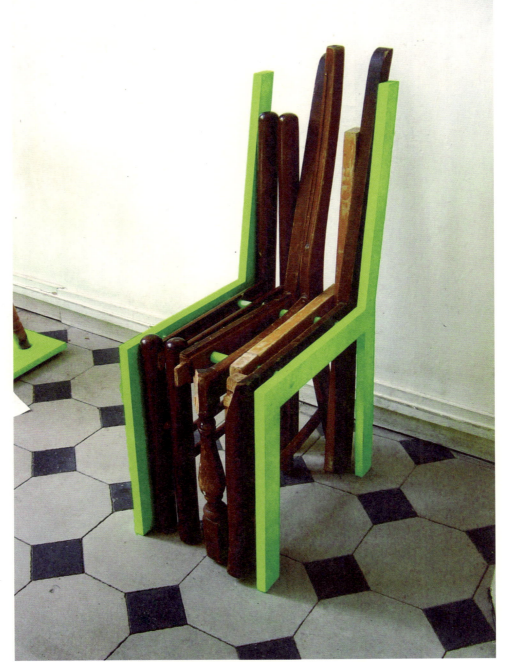

How to breathe new life into things discarded or forgotten? The team at 5.5 takes common objects – those found on rubbish tips, on the street, in homes and abandoned on warehouse shelves – and applies a 'standardized intervention' that neither restores the item to its original form nor changes its intrinsic function. Reanim, which is a hospital for household objects, has pitched its tents in Nîmes, Milan, Paris, Barcelona, New York and Montreal. In France, both pharmacies and dustmen employed by Propreté de Paris can be spotted sporting the same bright-green colour that 5.5 uses for its 'prostheses'.

CITY STRUCTURES
2004
BERTJAN POT
Photography by Bertjan Pot

Atmosphere

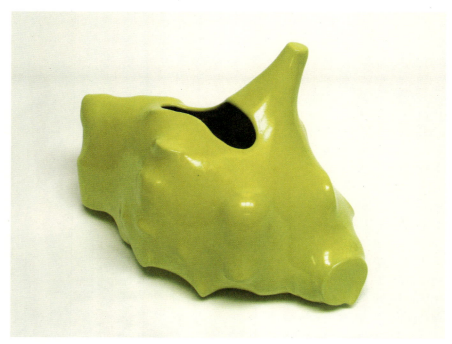

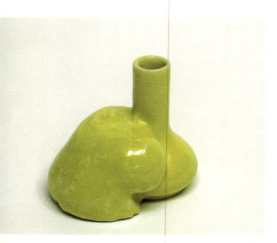

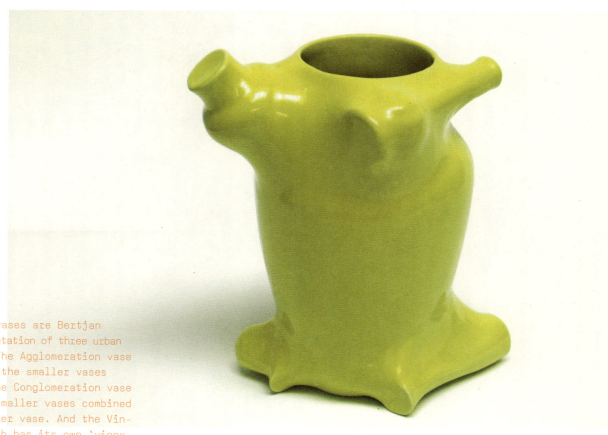

These three vases are Bertjan Pot's interpretation of three urban structures. The Agglomeration vase expropriates the smaller vases around it. The Conglomeration vase consists of smaller vases combined into one larger vase. And the Vinex vase, which has its own 'vinex location', is in the shape of a small cancer. ['Vinex' refers to a Dutch physical-planning policy that Pot obviously opposes.]

In the Mix

INSTITUTIONAL PROSTHESIS-2 (EACC)
Castelló, Spain
2004-2005
RECETAS URBANAS
Photography by Santiago Cirugeda

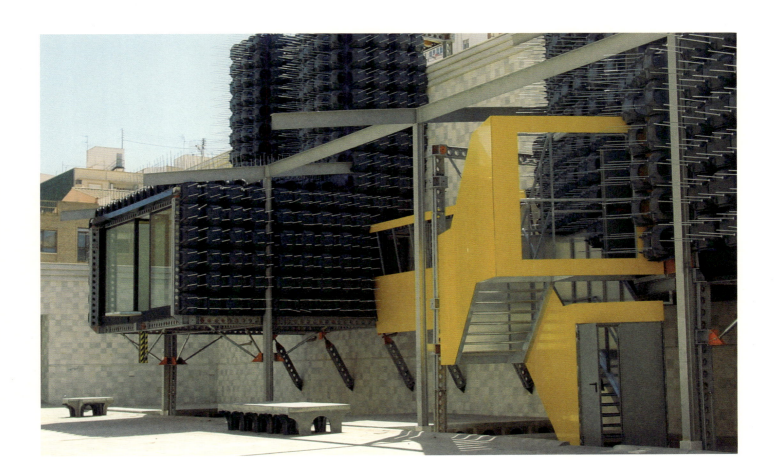

Santiago Cirugeda (of Recetas Urbanas) is out to expose abuses in municipal building policies. By carefully studying building regulations and cleverly using every available loophole he discovers, and by employing gentle persuasion as well as hard tactics, Cirugeda has managed to turn such regulations around and use them against their makers. Loopholes in the law often go hand in hand with gaps in the urban fabric. Cirugeda requests planning permission for scaffolding and, subsequently, fills such scaffolding with capsulate dwellings. On the façade of the Espai d'Art Contemporani de Castelló, Cirugeda hung two temporary rooms, which he clad with black-plastic formworks for concrete, installed in modules. The cells are connected to each other by a yellow staircase.

SHOWTIME POLTRONA ARMCHAIR
2006
JAIME HAYÓN
FOR BD EDICIONES DE DISEÑO

Atmosphere

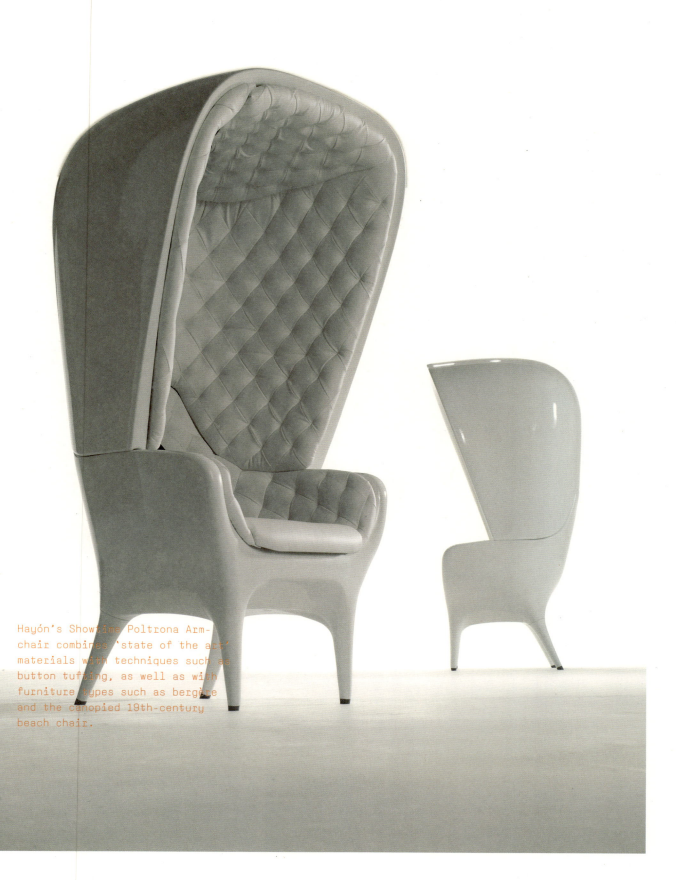

Hayón's Showtime Poltrona Armchair combines 'state of the art' materials with techniques such as button tufting, as well as with furniture types such as bergère and the canopied 19th-century beach chair.

In the Mix

HEY, CHAIR, BE A BOOKSHELF!
2005
MAARTEN BAAS
Photography by Maarten van Houten

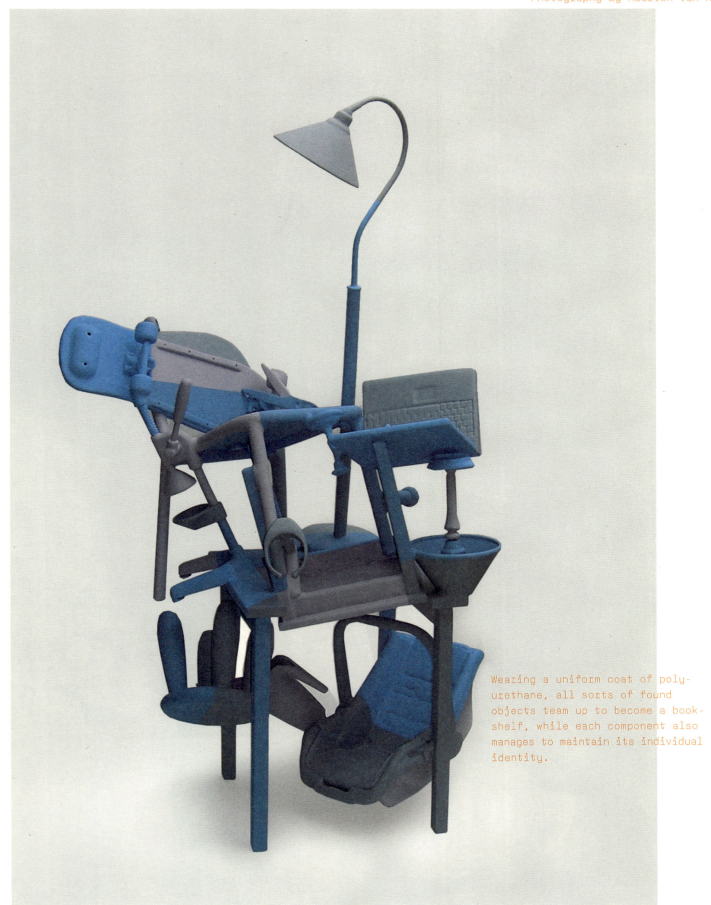

Wearing a uniform coat of polyurethane, all sorts of found objects team up to become a bookshelf, while each component also manages to maintain its individual identity.

Atmosphere

'Mutations of form, penetrations, deformations, simultaneities, breakdowns and variabilities have an effect on architecture. The resulting architecture is characterized by the interactions, the fusion and mutation of different entities constituting a new shape.' 'The future society will be a society of knowledge. We believe that the knowledge of the future will not be found within closed disciplines any more but rather at the intersection points between different fields of knowledge, such as the sciences, arts, economics and ethics. Timely education for the future, therefore, has to offer possibilities of crossings between different fields of knowledge. This is where High School #9 positions itself as a new flagship high school which includes the arts in public education and offers courses in the visual and performing arts next to the general education of language, mathematics, sciences and history.' COOP HIMMELB(L)AU

In the Mix

123

CENTRAL LOS ANGELES AREA
HIGH SCHOOL #9
Los Angeles, California, USA
2002-2008
COOP HIMMELB(L)AU

ASSEMBLAGE 3
2004
ROWAN & ERWAN BOUROULLEC
Photography by Paul Tahon

Atmosphere

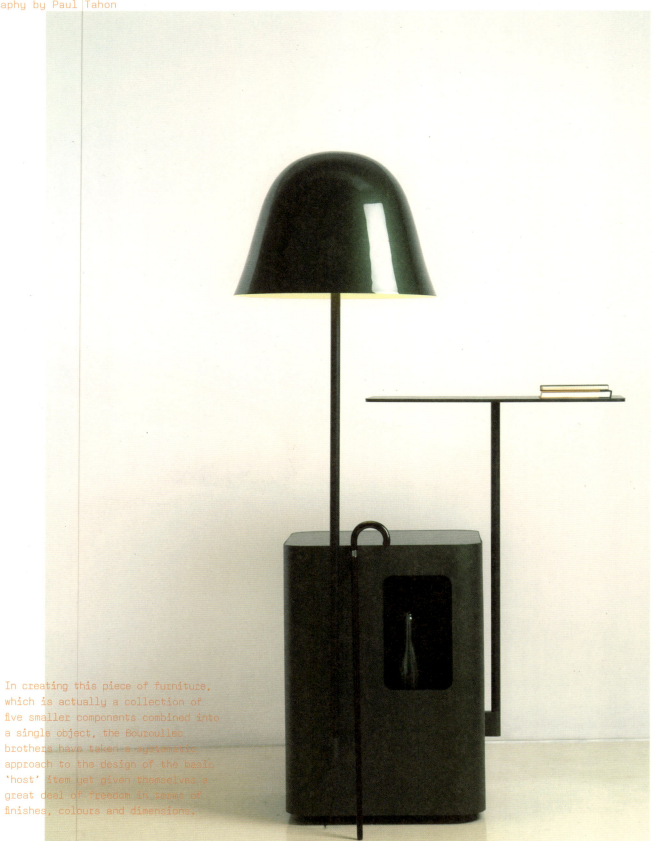

In creating this piece of furniture, which is actually a collection of five smaller components combined into a single object, the Bouroullec brothers have taken a systematic approach to the design of the basic 'host' item yet given themselves a great deal of freedom in terms of finishes, colours and dimensions.

In the Mix

125

BAGHDAD
2005
EZRI TARAZI FOR EDRA
Photography by Emilio Tremolada

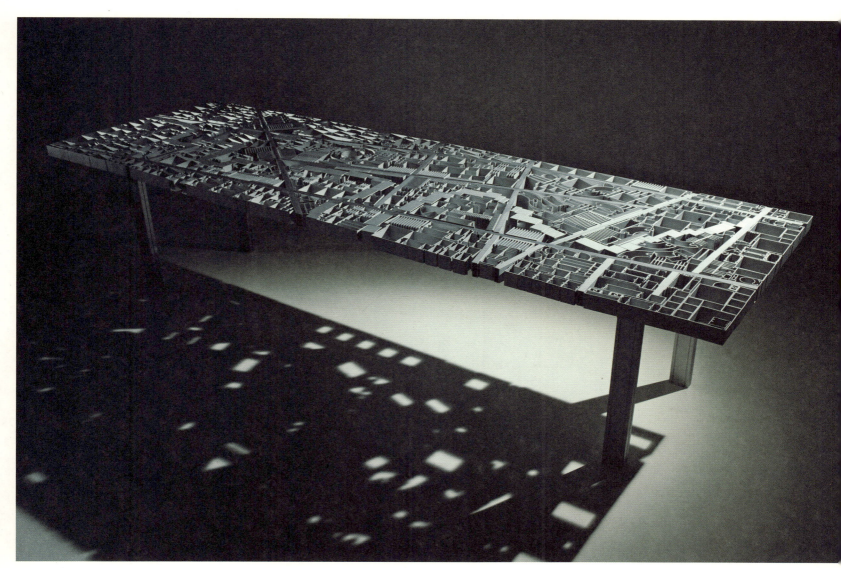

Tarazi used standard astructural aluminium section and tubing to make this table, merging the properties of the various components into a coherent city plan of the Iraqi capital of Baghdad.

TABLE ACCIDENT
2006
TJEP.
Photography by Tjep.

Atmosphere

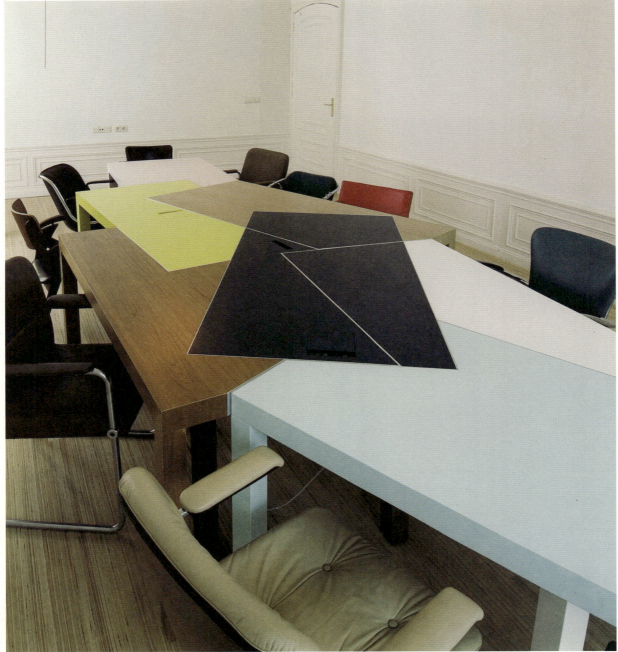

A controlled collision of seven tables marks the conference room of advertisement agency StrawberryFrog in Amsterdam, the Netherlands. Symbolized in the colours and forms of Tjep's design are a mix of viewpoints, cultures and motivations that collide with one another to become something new and powerful.

In the Mix

FREITAG FLAGSHIP STORE
Zürich, Switzerland
2006
ANNETTE SPILLMANN AND
HARALD ECHSLE

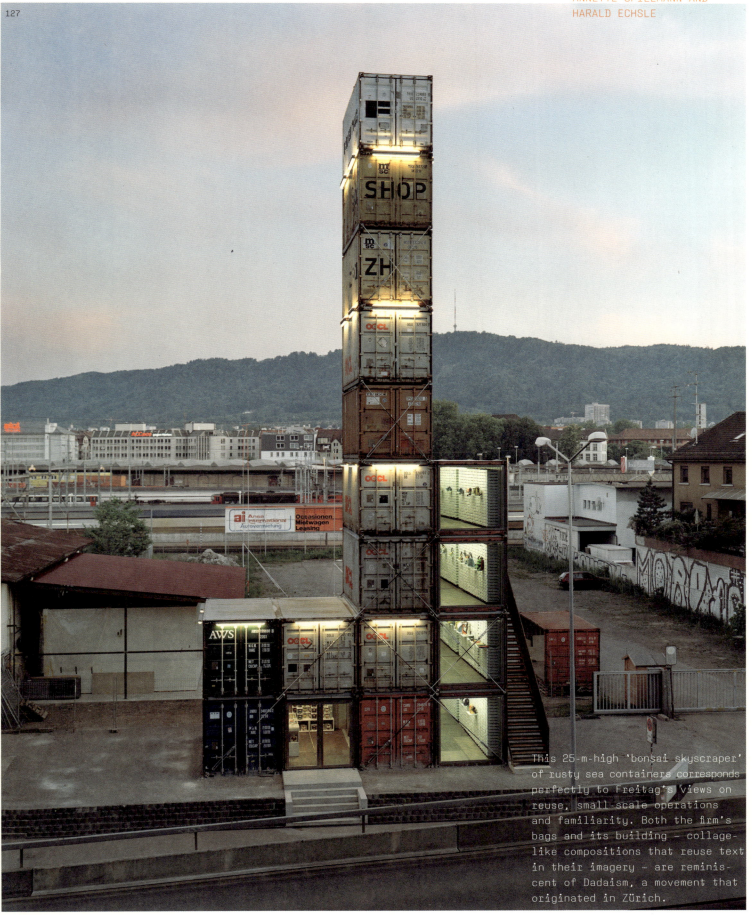

This 25-m-high 'bonsai skyscraper' of rusty sea containers corresponds perfectly to Freitag's views on reuse, small-scale operations and familiarity. Both the firm's bags and its building – collage-like compositions that reuse text in their imagery – are reminiscent of Dadaism, a movement that originated in Zürich.

GRANDMOTHER'S TREASURES
2005
VIKA MITRICHENKA

Atmosphere

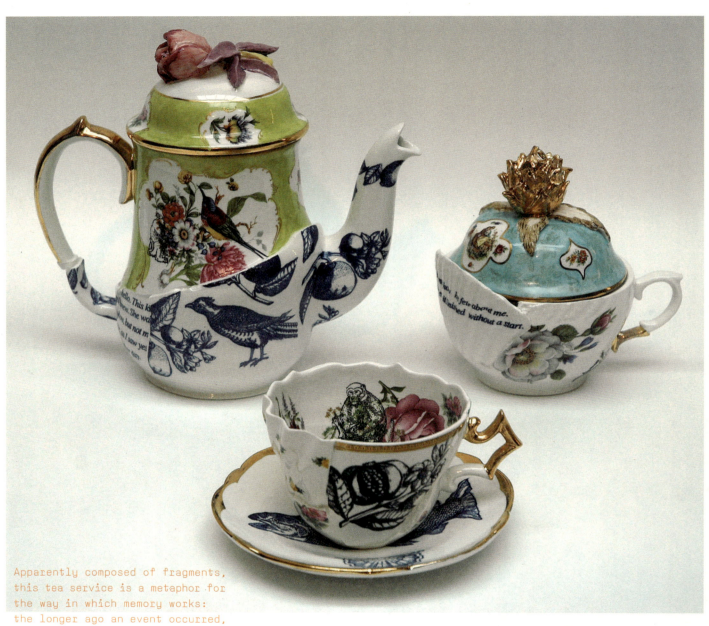

Apparently composed of fragments, this tea service is a metaphor for the way in which memory works: the longer ago an event occurred, the harder it is to unravel fact from fiction. Fragments of memory to which we add the figments of our imagination form our personal histories. Emerging from the shards of the past, which are often hard to fit together, is a brand-new story.

In the Mix

129

CAROUSEL
2005
TORD BOONTJE –
BOUTIQUE ALEXANDER MCQUEEN
Photography by Ed Reeve

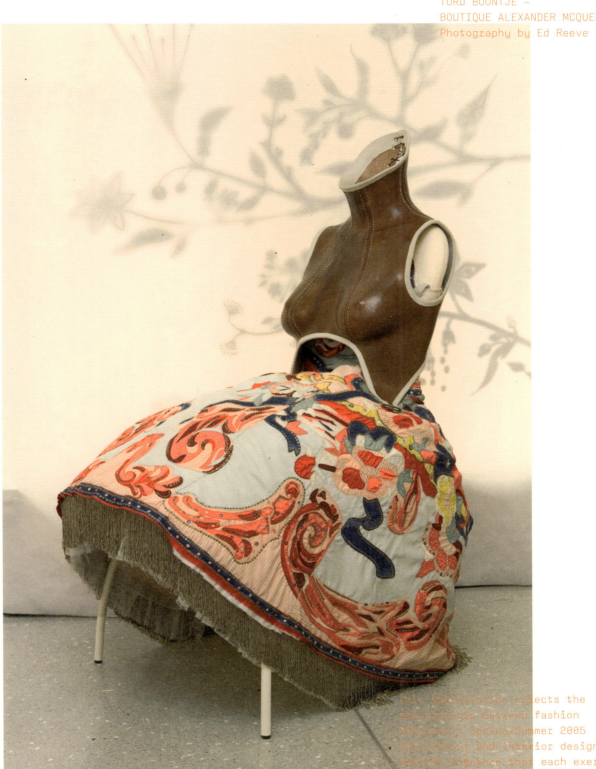

This installation reflects the relationship between fashion (McQueen's Spring/Summer 2005 collection) and interior design and the influence that each exerts on the other.

ARTVERTISING
Amsterdam, Netherlands
2006
TEUN CASTELEIN
FOR SANDBERG INSTITUTE
Photography by Nadine Hottenrott

Atmosphere

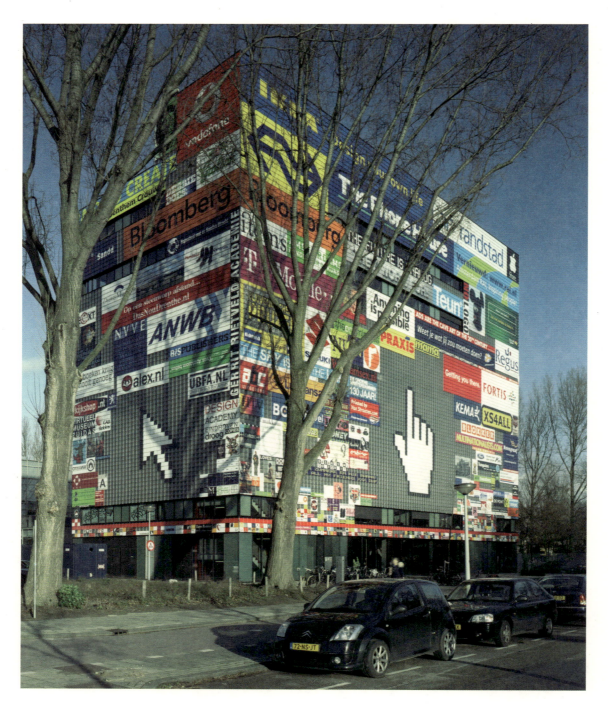

A spectacular work of art on the façade of the Sandberg Institute in Amsterdam consists of images representing more than 300 companies, organizations and individuals. This installation was inspired by *A Million Dollar Homepage*, a successful project in which a million pixels were sold for one dollar each. The façade comprises no fewer than 16,000 35-x-29-cm tiles, each covered with a printed plastic panel. The result is an awesome mosaic of colour and information – a project designed to shift the boundaries between commerce and art, between society and market processes, and between private and public spaces.

In the Mix

HIROMI YOSHII GALLERY
Tokyo, Japan
2006
AVAF (Assume Vivid Astro Focus)
Photography by Atsushi Yoshimine

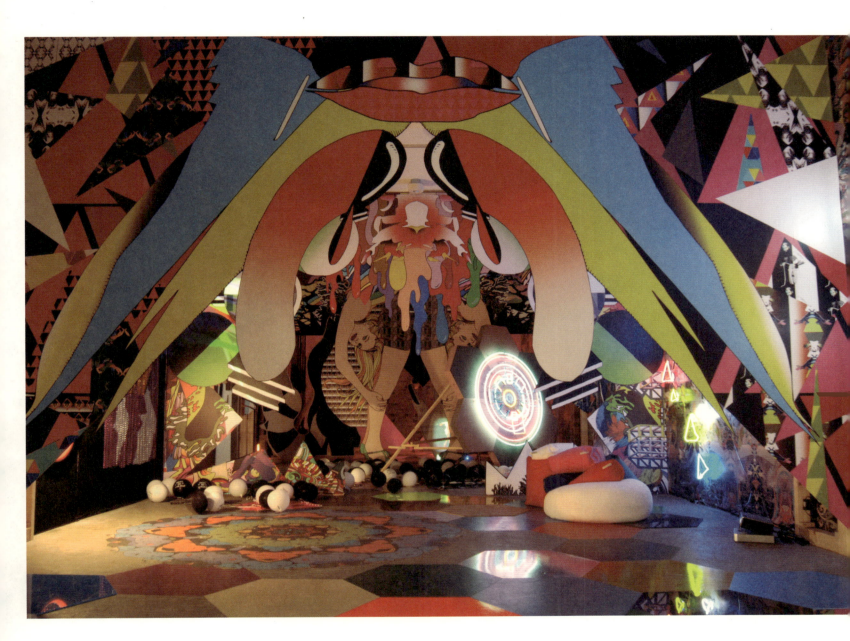

Assume Vivid Astro Focus (AVAF) is both the pseudonym of a New-York based Brazilian artist and the title given to the artist's wide-ranging aesthetic project. In AVAF's work, the sources are blended together, fused, overlapping, contaminated and contaminating. The generous nature of the work extends to observers, who are invited into and absorbed by the work, thus implicating them in AVAF's wider project.

'Theatre is a process about fabricating and presenting a spectacle; architecturally this process can be expressed with the industrial building. Minneapolis will discover that history continues to be made; that if industry born from the river contributed to its former prestige, culture has become an important part of its image and appeal today. This is why the architecture of the Guthrie, by its volumes and colours, can be read as a far-off echo of silos, and why the shared lobby advances like a bridge to contemplate the waterfalls; and why the lighted signs above the adjacent silos create a dialogue with those of the theatre; and why industrial bridges take the place of skyways, and why, finally, next to the avatars in incorporation of the thrust hall, two new theatres, one frontal, the other flexible, complete the industrial metaphor of the new Guthrie. The rest is just architecture, architecture without nostalgia, since these historic references are a perfect pretext for inventing and using the materials and techniques of the 21st century.' JEAN NOUVEL

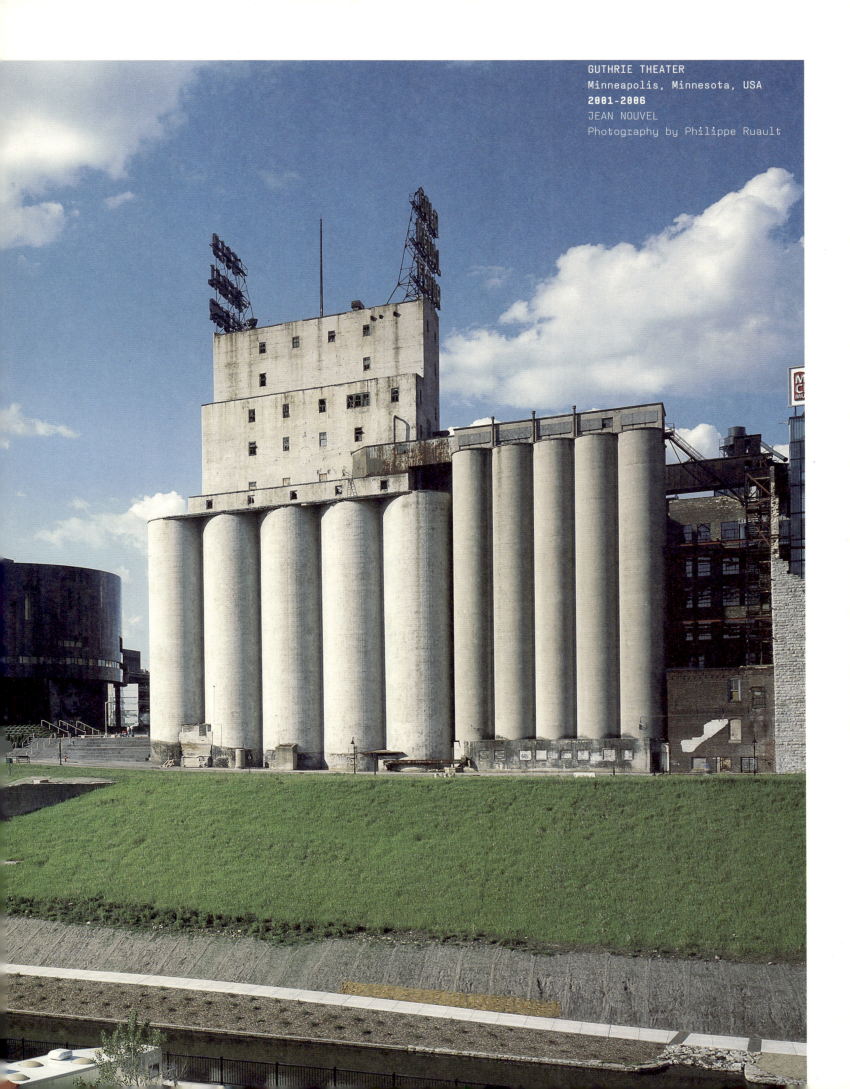

GUTHRIE THEATER
Minneapolis, Minnesota, USA
2001-2006
JEAN NOUVEL
Photography by Philippe Ruault

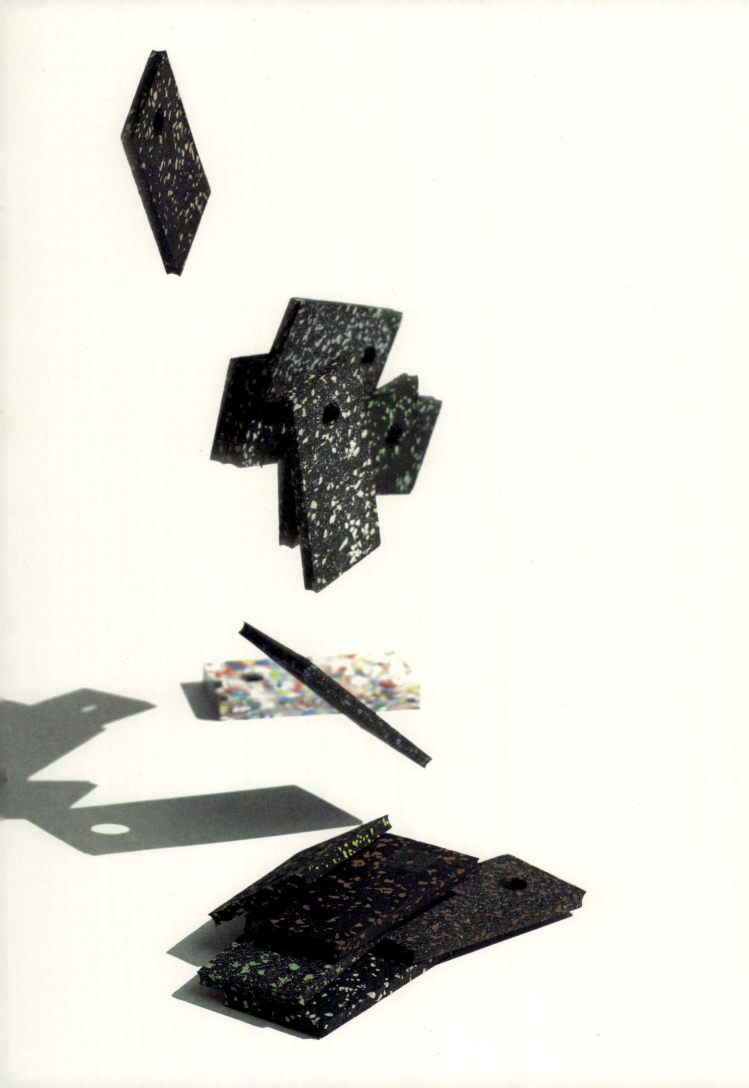

previous page:
MATERIAL
photography by Blommers/Schumm

Mobiles by Smile Plastics.

Materials provided by Materia

Atmosphere

FORM FOLLOWS FOLD

previous page:
POTATO
photography by Blommers/Schumm

Form Follows Fold

Despite the continuous appearance of newer media, paper is still a good vehicle for getting the creative juices bubbling. It can be a carrier of materialized concepts in ink or graphite or of collections based on ideas that are eventually discarded. Rejected plans on paper are often crumpled up and tossed into the wastepaper basket. But the sheet of paper itself can also be made into an object.

Josef Albers, who taught a course in preliminary design at the Bauhaus, had his students investigate the structural possibilities offered by paper: 'Economy of form depends on the material we are working with. [...] I want you to respect the material and use it in a way that makes sense – preserve its inherent characteristics. If you can do without tools like knives and scissors, and without glue, the better.' (As quoted in Rainer K. Wick, *Teaching at the Bauhaus*, Hathe Cantz Verlag, Ostfildern-Ruit, Germany, 2000.) Exercises modelled on Albers' advice and on other courses taught at the Bauhaus can still be found in the curricula of today's design academies. And products apparently resulting from such studies are being manufactured and sold in shops around the world.

Such objects explore myriad methods for transforming a thin, flat sheet of material into a spatial form. Sharp folds give the flat sheet rigidity. Incisions allow the designer to pull the sheet apart, thus enlarging the relative surface area. Cuts and perforations are also used for added flexibility. Designers who want folds that are not straight can score the material in various ways. Crumpling and crushing the material lends interesting texture to smooth surfaces.

Viewing these products, we're instantly reminded of all the paper boats and planes we made at primary school. Our childhood memories blur the sharp-edged folds, temper the slick surfaces, and fill us with a warm sense of nostalgia. We're also drawn to folded objects because the process of making them often appears to be so simple: after all, each and every one began as a flat piece of paper.

The entire thought process leading to the realization of these designs seems to be present in their final form. In our minds, we can retrace the steps that contributed to the end product, going all the way back to that initial sheet of paper. At the same time, we are impressed by the ingenuity of solutions that are defined by such narrow parameters. And, not to be forgotten, this is a method of construction whose top-notch efficiency makes for very little loss of material. Another advantage is that folded objects – which are able, at least theoretically, to resume their original flat forms – usually require a minimum amount of storage space.

A maniacal paper-folder has apparently been at work in the corridors and rooms that Plasma Studio designed for the Puerta America Hotel. The crystalline interior design, which features an interplay of angular planes, is not the result of paper prototypes, however. Polygonal models of the type that are made with 3D sculpting software inspire many designers to create eclectic concoctions that reproduce and often combine cubist, expressionist and baroque styles.

DRESS FROM THE BLANK PAGE COLLECTION
2006
SANDRA BACKLUND
Photography by Oscar Falk

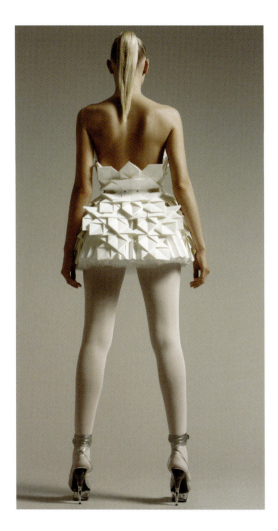
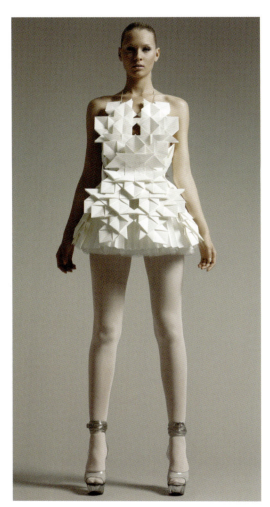

For most of her work, Swedish designer Sandra Backlund relies on the material for ideas. She turns, folds and manipulates various individual components to design her models. This dress is a good example of a folded Backlund creation.

Form Follows Fold

2FOLD & FOLD TO FIT
2005/2003
CHRIS KABEL
Photography by Daniel Nicolas

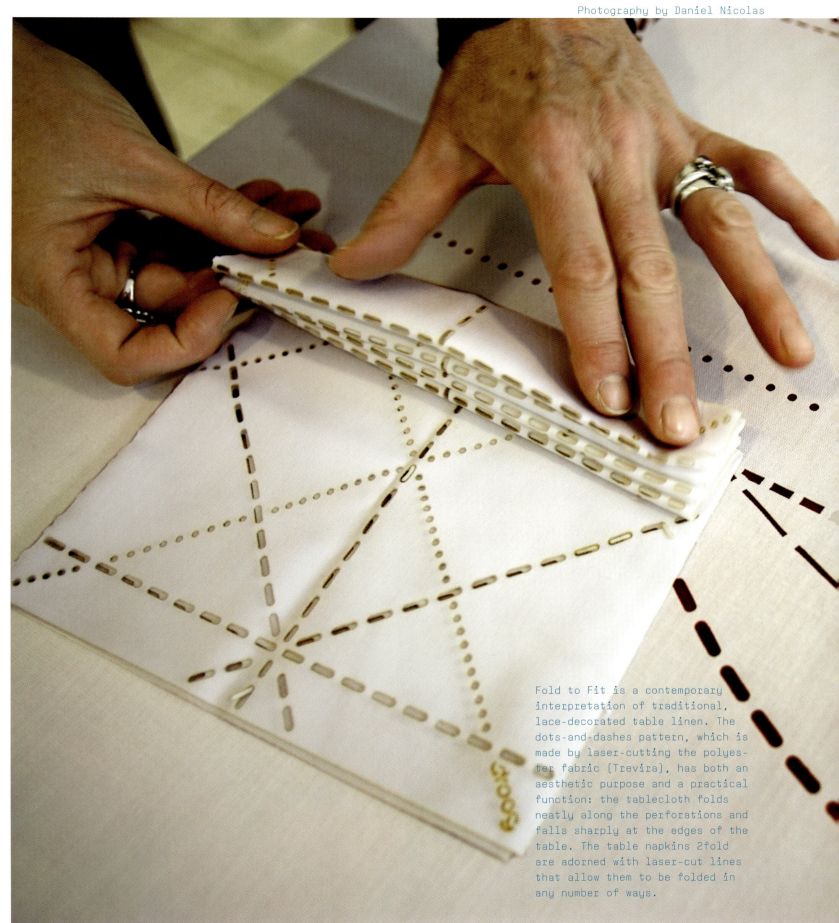

Fold to Fit is a contemporary interpretation of traditional, lace-decorated table linen. The dots-and-dashes pattern, which is made by laser-cutting the polyester fabric (Trevira), has both an aesthetic purpose and a practical function: the tablecloth folds neatly along the perforations and falls sharply at the edges of the table. The table napkins 2fold are adorned with laser-cut lines that allow them to be folded in any number of ways.

HONEYPOP
2001
TOKUJIN YOSHIOKA DESIGN

Atmosphere

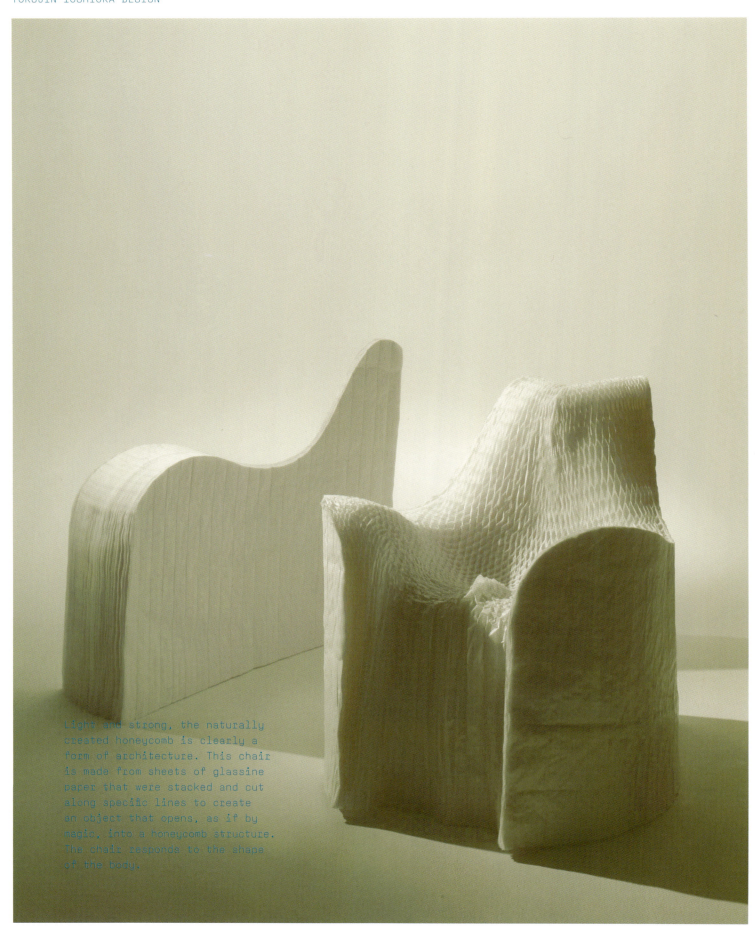

Light and strong, the naturally created honeycomb is clearly a form of architecture. This chair is made from sheets of glassine paper that were stacked and cut along specific lines to create an object that opens, as if by magic, into a honeycomb structure. The chair responds to the shape of the body.

Form Follows Fold

HONEYPOP
2001
TOKUJIN YOSHIOKA DESIGN

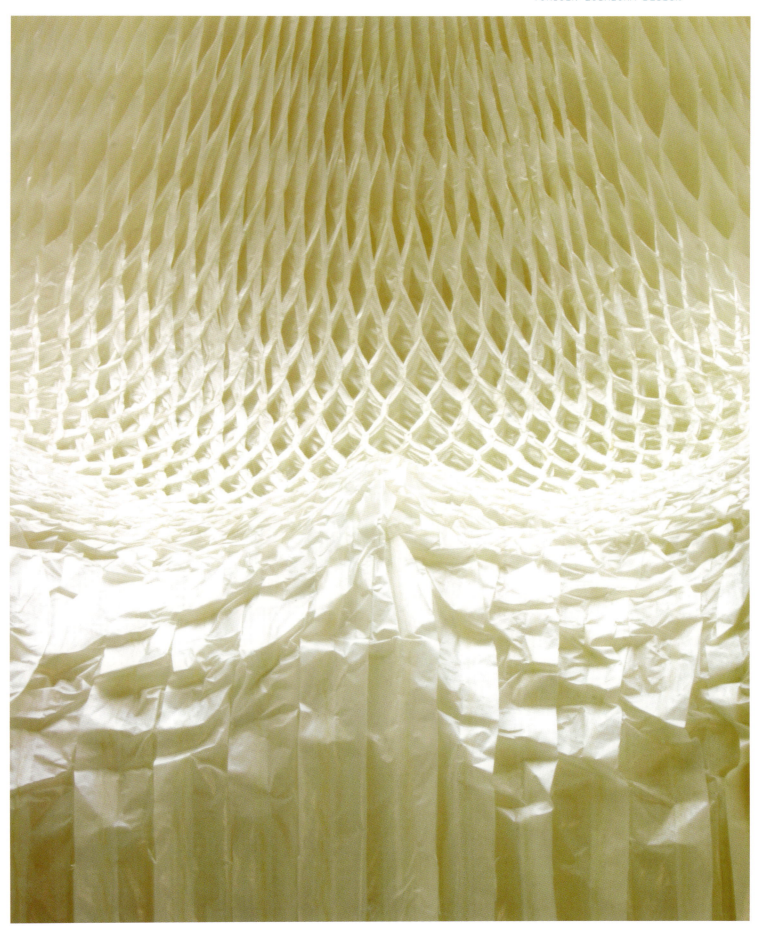

ROONEY ROSE TOWNHOUSES
Richmond, Australia
2006
NEIL & IDLE ARCHITECTS
Photography by Rhiannon Slator

Atmosphere

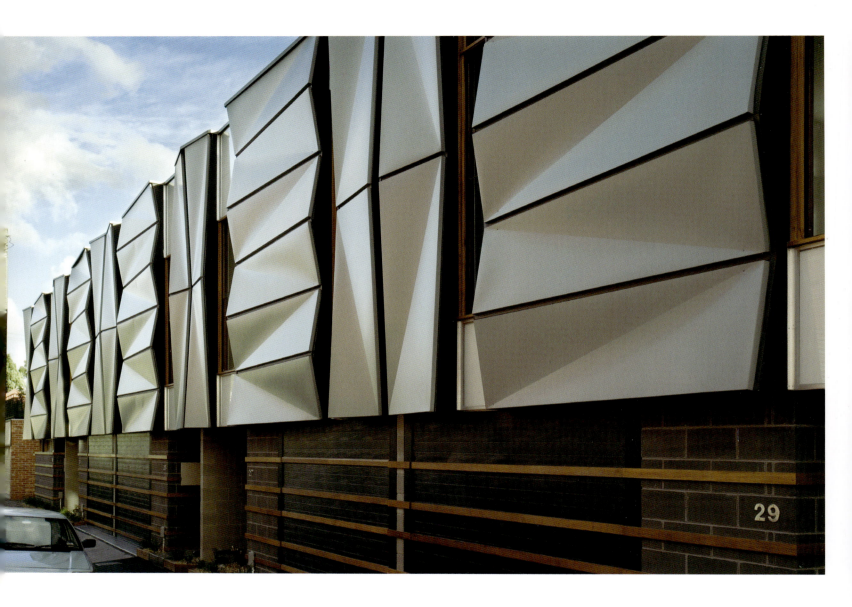

This development in central Richmond, Australia, consists of five one-bedroom townhouses. Surrounded by low-rise Victorian dwellings, the complex features traditional materials used in innovative and unexpected ways. An undulating steel element folds across the façade, lending formal coherence to the design. Speaking of the sculptural quality of the exterior — a look reminiscent of old farm tanks — Chris Idle of Neil & Idle Architects says that 'it has a machine aesthetic'.

Form Follows Fold

SPUTNIK
2005
DAVE KEUNE AND SANDER MULDER,
BURO VORMKRIJGERS
Photography by Raoul Kramer

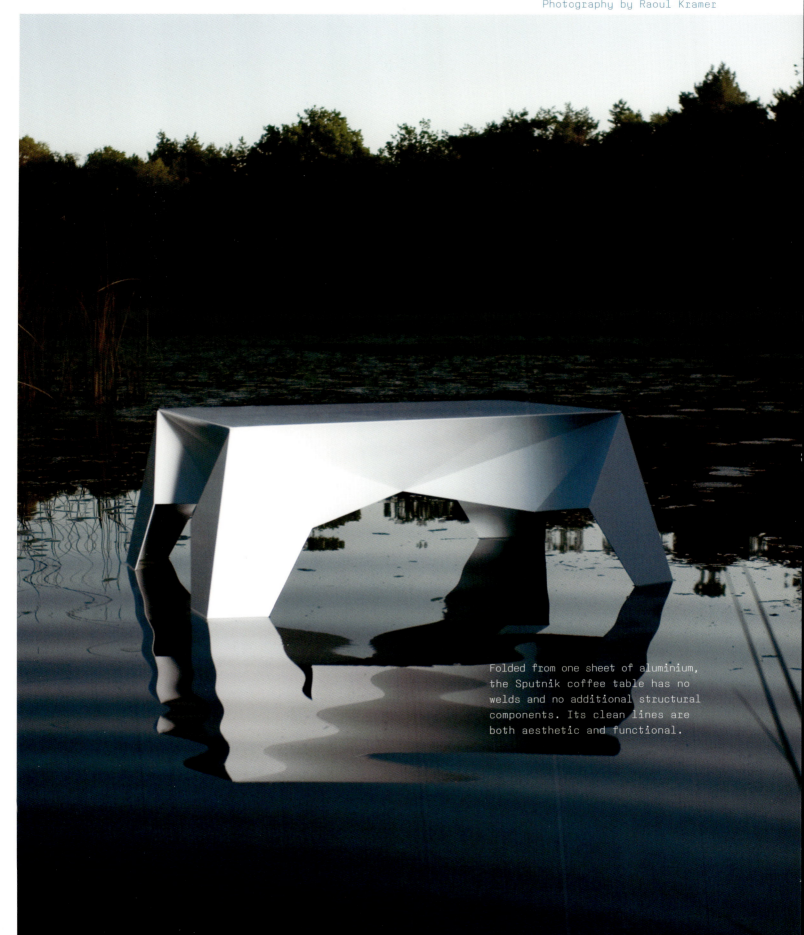

Folded from one sheet of aluminium, the Sputnik coffee table has no welds and no additional structural components. Its clean lines are both aesthetic and functional.

DIANA SIDE TABLES
2002
KONSTANTIN GRCIC FOR CLASSICON

Atmosphere

Grcic's occasional tables — identified by the letters A through F — are made from powder-coated steel sheet. The tables are a cleverly cubist way of lending definition to the contemporary interior.

Form Follows Fold

BENT
1999–2006
STEFAN DIEZ AND CHRISTOPHE
DE LA FONTAINE FOR MOROSO

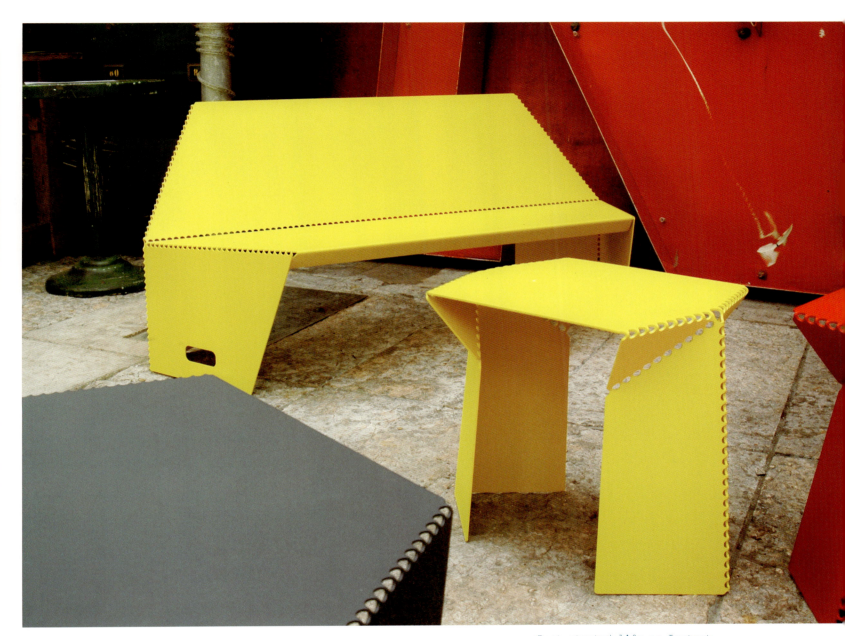

Bent started life as Instant Lounge, a disposable cardboard seating concept that was introduced at Anno 02, an exhibition in Belgium. The original version consisted of a flat piece of cardboard that could be folded 'instantly', time after time, into a comfortable sitting arrangement. In 2006 Instant Lounge was executed in 3-mm-thick perforated sheet aluminium and renamed Bent. Unlike its older sibling, Bent retains its functional shape; it is not made to be folded and refolded.

AGORA THEATRE
Lelystad, Netherlands
2005-2007
UN STUDIO

Atmosphere

148

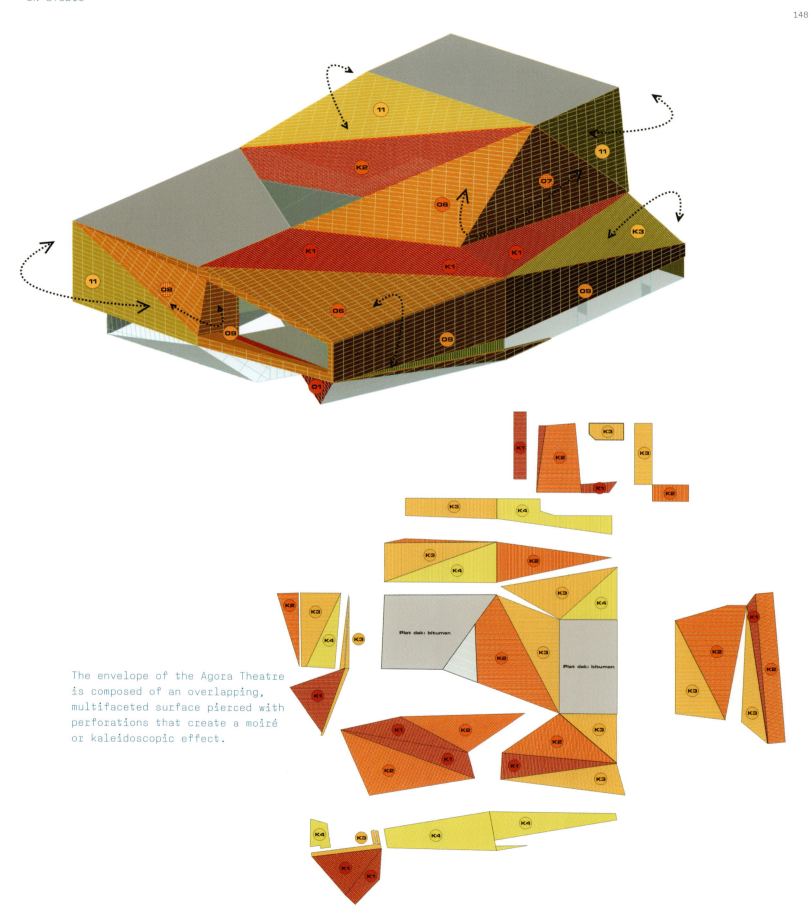

The envelope of the Agora Theatre is composed of an overlapping, multifaceted surface pierced with perforations that create a moiré or kaleidoscopic effect.

Form Follows Fold

MONOLITH
2005
SETSU & SHINOBU ITO
FOR I+I

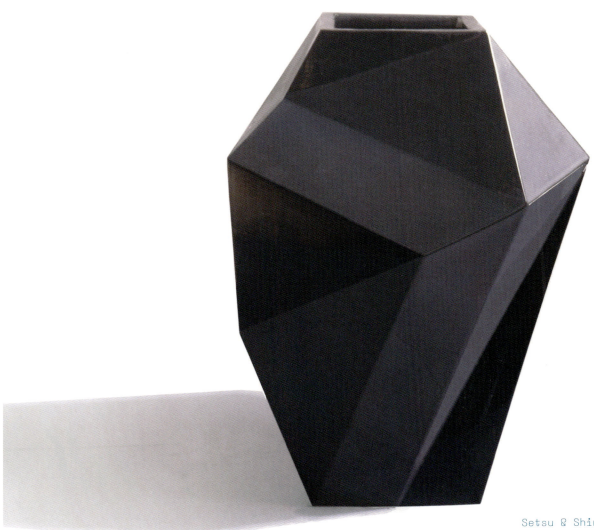

Setsu & Shinobu Ito's ceramic vase has a strikingly hard, sharp-edged form.

PONTE PARODI
Genoa, Italy
2001-2009
UN STUDIO
Photography by UN Studio

Atmosphere

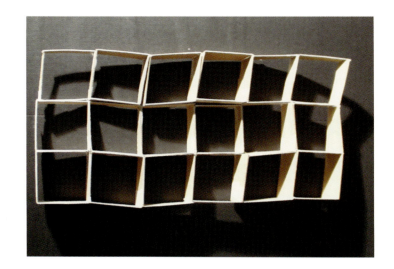
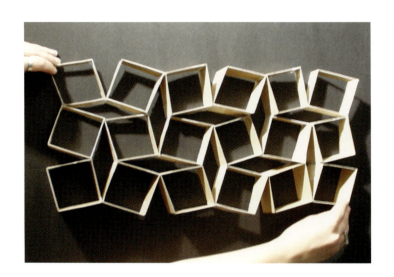
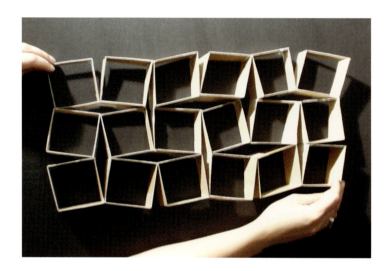
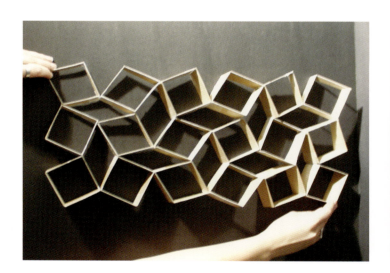

UN Studio is responsible for redeveloping a harbour pier in Genoa into a piazza complex with congress centre, terminal, restaurants, exhibition spaces and other facilities. The structural design is based on a conceptual device: a grid pulled apart produces diamond-shaped openings which, at Ponte Parodi, organize the vertical circulation, provide waterside views and enable daylight to penetrate the complex.

Form Follows Fold

GIVENCHY HAUTE COUTURE
Fall/Winter 2006-2007
2005
RICCARDO TISCI FOR GIVENCHY
Photography by Peter Stigter

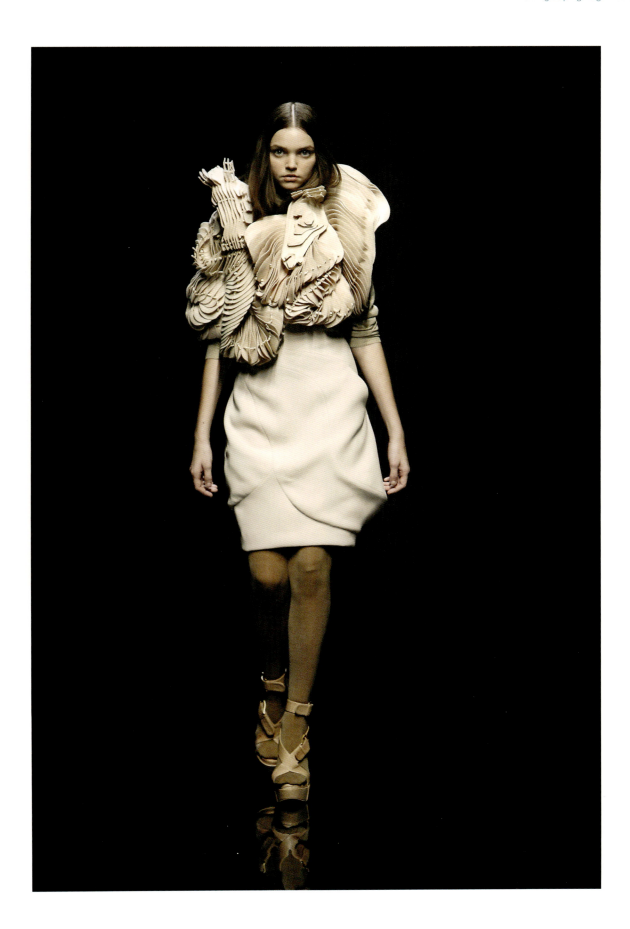

FOLDING GREENHOUSE
2006
DANIEL SCHIPPER

Atmosphere

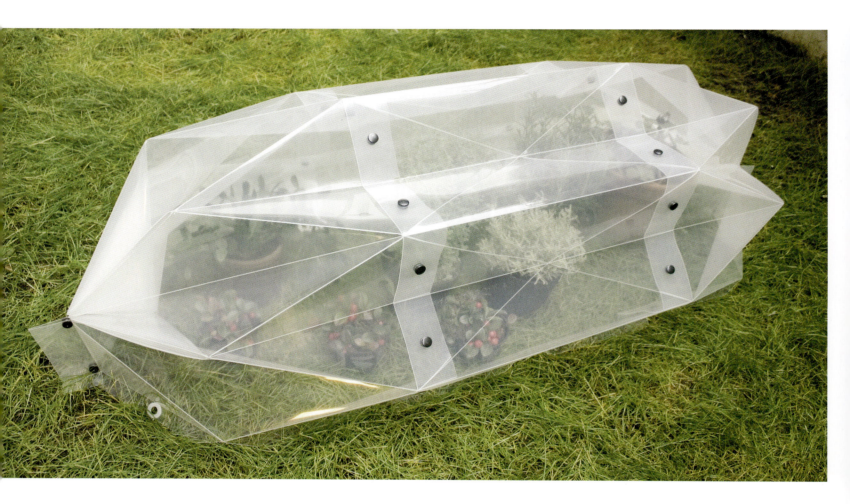

Many a city-dweller spends weekends outside the city in an allotment garden that satisfies the human need for Mother Nature. A greenhouse is essential for cultivating plants, especially vegetables, but a structure of this kind is often large, heavy and hard to transport. Once you set it up, it's there to stay. Daniel Schipper designed a light, flexible, modular greenhouse that is ideal for smaller sites like balconies, rooftop terraces and allotment gardens. It's a frameless folding structure whose various components are made from recyclable plastic. Because the greenhouse is able to assume various forms and shapes, it can increase in size along with the plants it contains.

Form Follows Fold

GREEN AND YELLOW STRIPED
MULTI-MEDIA DESIGN
2005
ELLA JANE ROBINSON
Photography by Alan Duncan

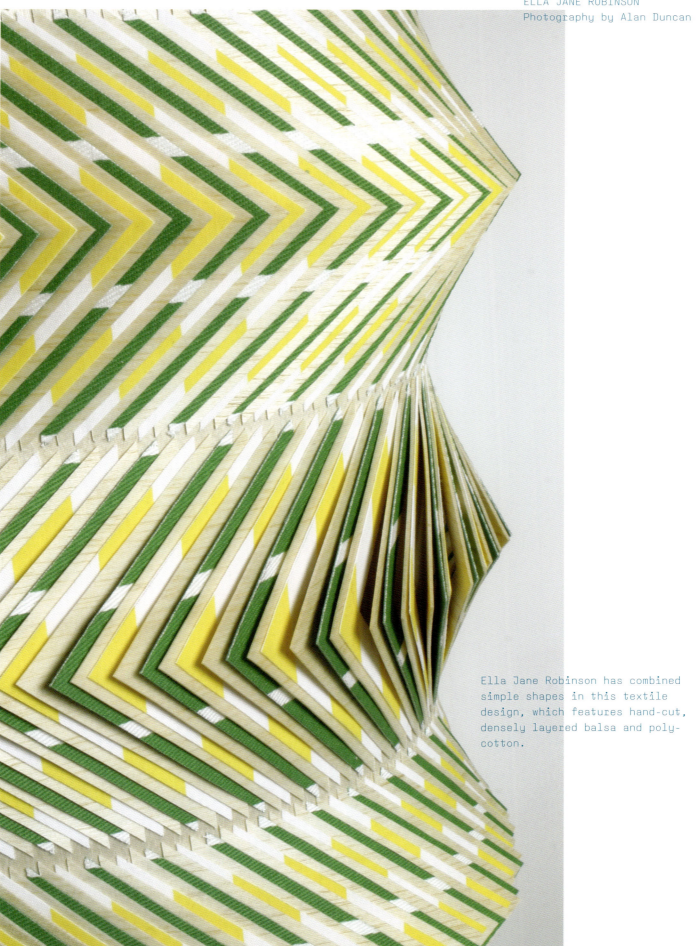

Ella Jane Robinson has combined simple shapes in this textile design, which features hand-cut, densely layered balsa and poly-cotton.

DRESS DILATE FROM PAPER FOLD
COLLECTION
2006
ALICE LODGE
Photography by Nick Dorey

Atmosphere

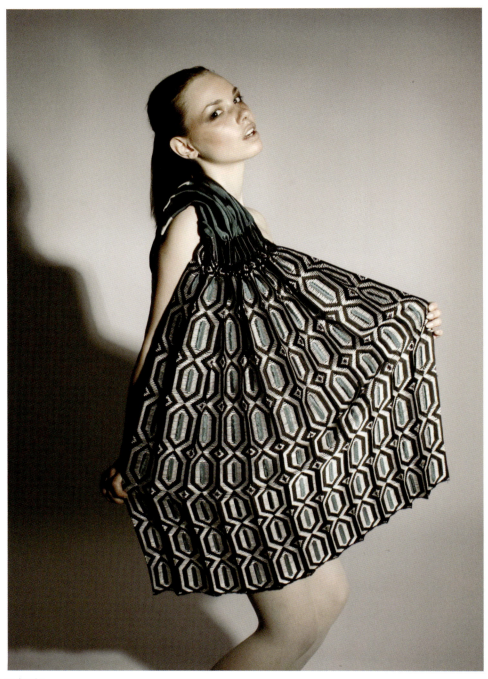

Alice Lodge, who studied at London's Royal College of Art, calls the technique she uses to make her fabric-to-form designs 'garment-engineered weaving'. The jewel-toned silks originate from one of the oldest mills still in operation in Essex. Lodge's work explores seamless woven garments engineered on the loom. Woven smocking effects create inherent shaping within the garment, removing the need for pattern cutting and stitching.

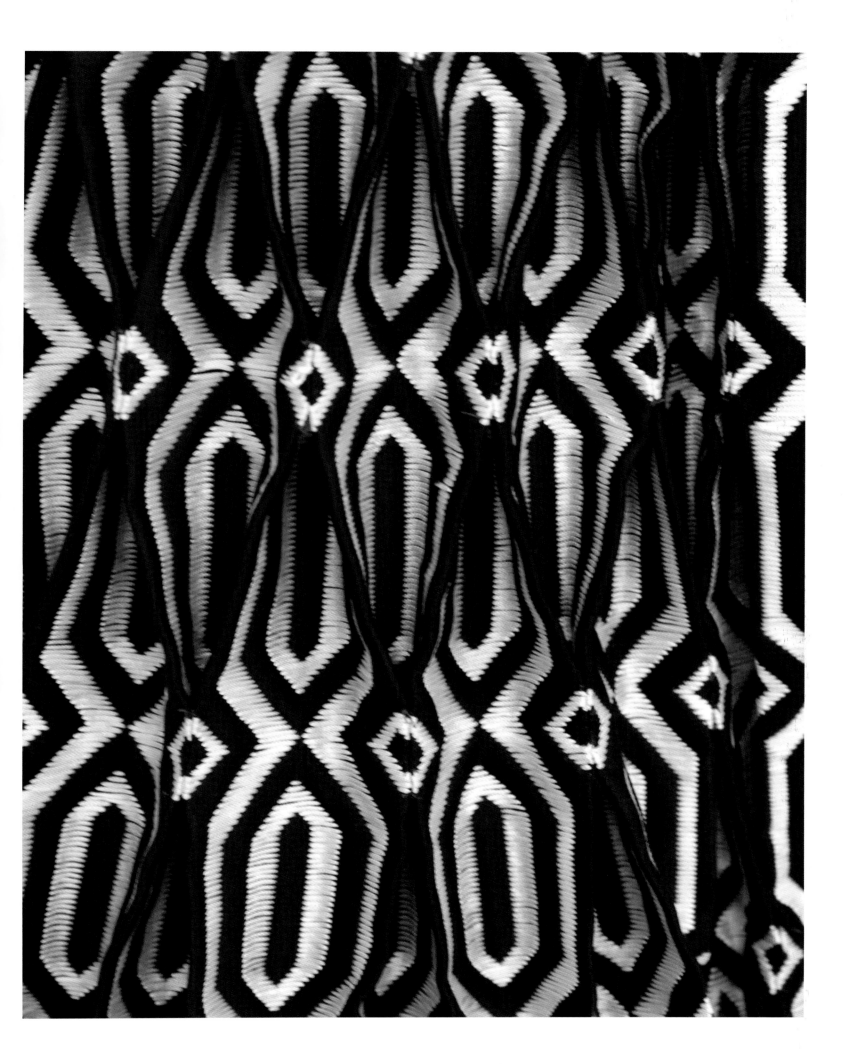

INTERIORS FOR PUERTA AMERICA HOTEL
Madrid, Spain
2005
PLASMA STUDIO
Photography by Peter Guenzel

'We avoid iconography, images and other semantic modes of communication while attempting the opposite: through abstraction, morphological shifts and an innovative use of material, we produce ambiences that are new, unusual, exotic. What appears abstract at first becomes part of a larger story through the active experience and discovery of the space.' PLASMA STUDIO

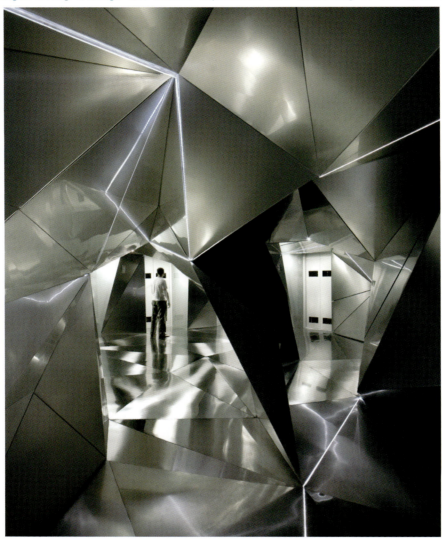

At Madrid's Puerta America Hotel, interiors designed by Plasma Studio are lined with large panels of stainless steel that have been cut and folded into angular shapes. The highly three-dimensional quality of Plasma's design stimulates the imagination and enlarges the concept of space. The experience is intensified by a colourful lighting scheme that includes LEDs, which line various folds featured in the interiors. Stainless steel is used not only in the fourth-floor corridor, but also in showers, baths, headboards and desks within the hotel rooms themselves.

Form Follows Fold

SEEBAD CALDARO
KALTERN, ITALY
2006
THE NEXT ENTERPRISE
Photography by Lukas Schaller

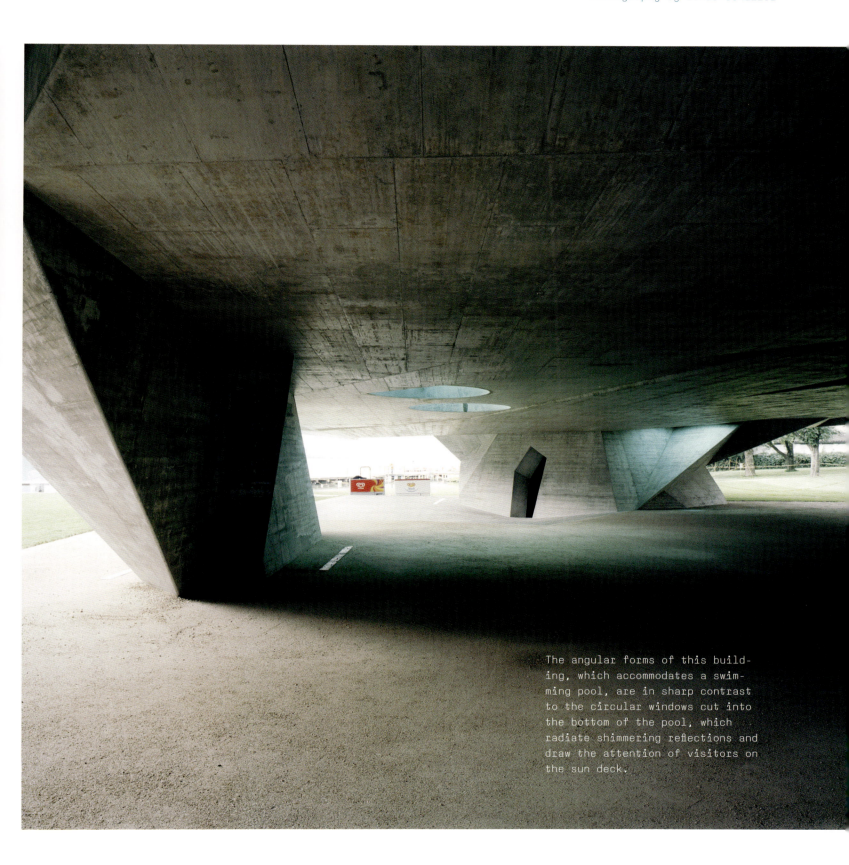

The angular forms of this building, which accommodates a swimming pool, are in sharp contrast to the circular windows cut into the bottom of the pool, which radiate shimmering reflections and draw the attention of visitors on the sun deck.

DUNE
2006
ULF MORITZ FOR DANSKINA
Photography by Rudolf Schmutz

Atmosphere

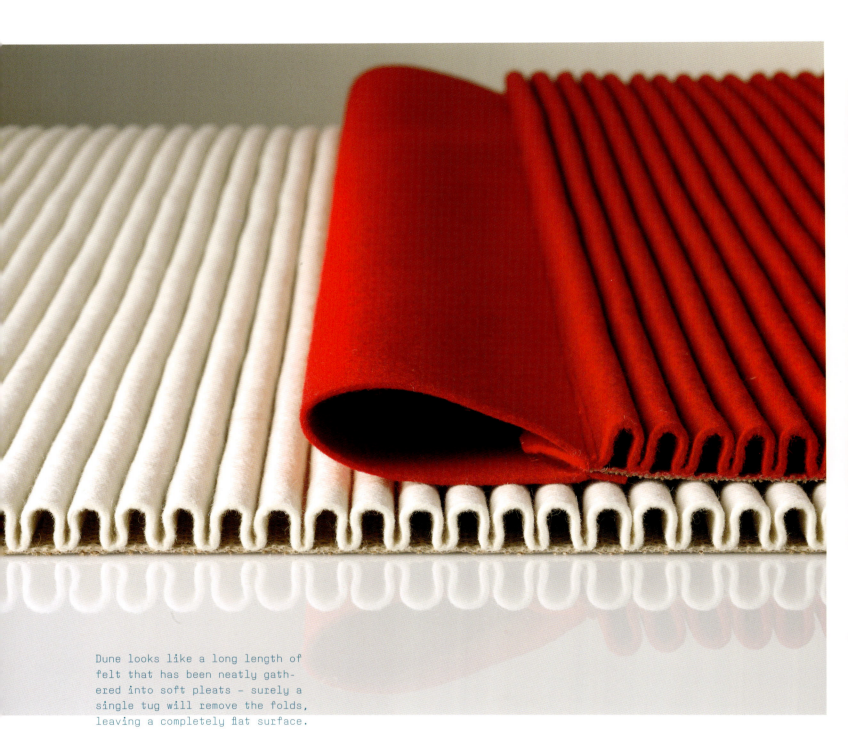

Dune looks like a long length of felt that has been neatly gathered into soft pleats – surely a single tug will remove the folds, leaving a completely flat surface.

Form Follows Fold

STEALTH
2004
YUDO KUROSAWA
Photography by Yudo Kurosawa

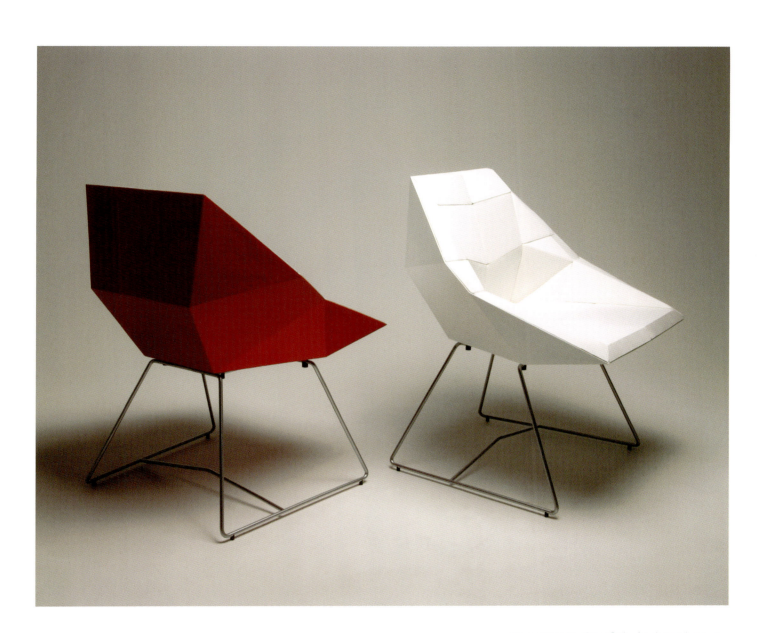

Kurosawa's Stealth is based on a study of ergonomic positions and, in particular, positions used by people who are interacting with other people. An object composed of seemingly hard, linear surfaces is, in fact, an ergonomically comfortable chair.

GENERAL DYNAMIC
2004
JULIAN MAYOR
Photography by Julian Mayor

Atmosphere

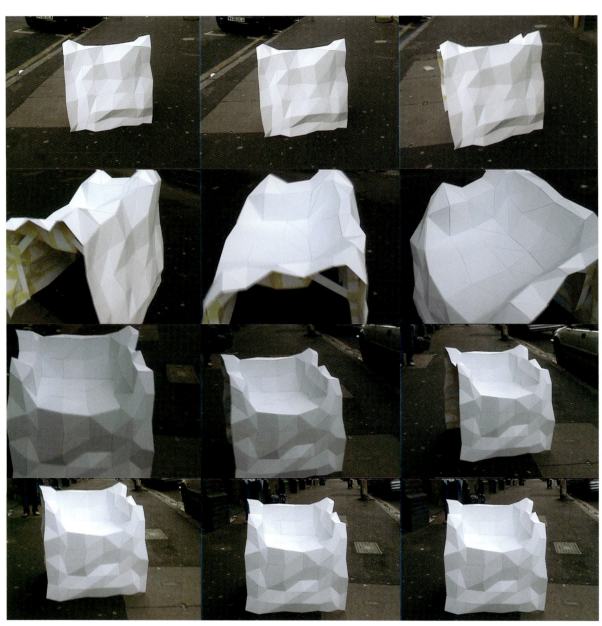

On second thought, that crumpled ball of paper might have some value after all. As he tugged at and played with the scrunched paper in his hands, Julian Mayor came up with General Dynamic, a chair that he ultimately made from fibreglass.

Form Follows Fold

PLEATED SHEET
2006
RICHARD SWEENEY
Photography by Richard Sweeney

'The transformation of flat sheet material into three-dimensional forms is my central motivation, and, working with paper and synthetic sheet materials, I take a hands-on approach. Using this process I can gain a better insight into the unique properties of a material and utilize this knowledge to develop form-making techniques for handcrafted and CNC-manufactured objects,' says Richard Sweeney. 'I'm highly influenced by natural form; structures in nature are very efficient; the maximum is achieved using the least material and energy possible,' he continues. 'Growth patterns produce forms that appear very complex yet have a basic underlying principle.' RICHARD SWEENEY

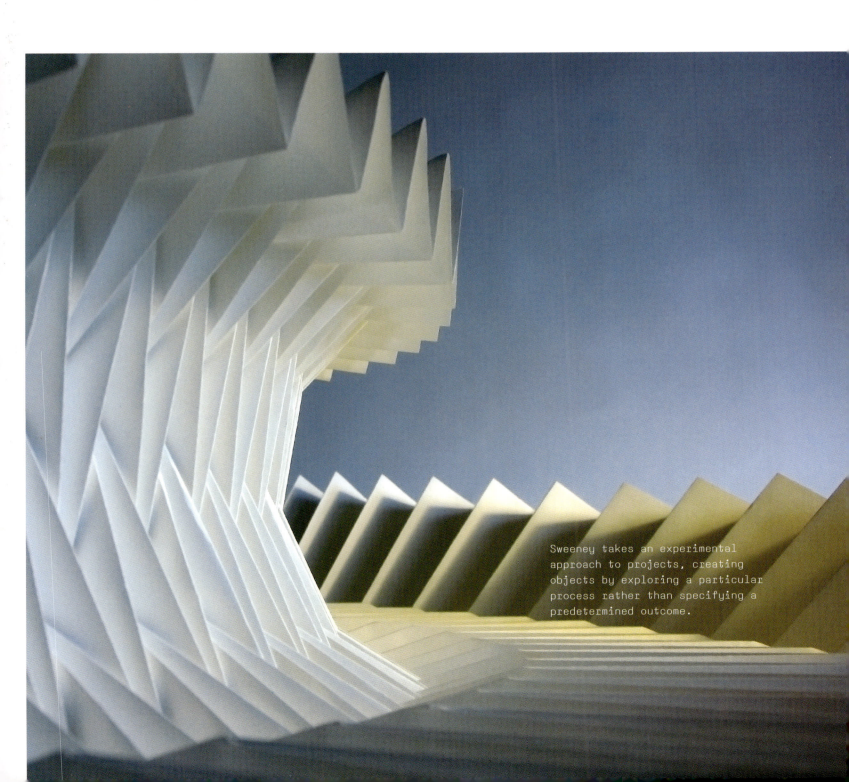

Sweeney takes an experimental approach to projects, creating objects by exploring a particular process rather than specifying a predetermined outcome.

FOLDING CASE
2004
MELLE HAMMER
Photography by Marcel Bakker

Atmosphere

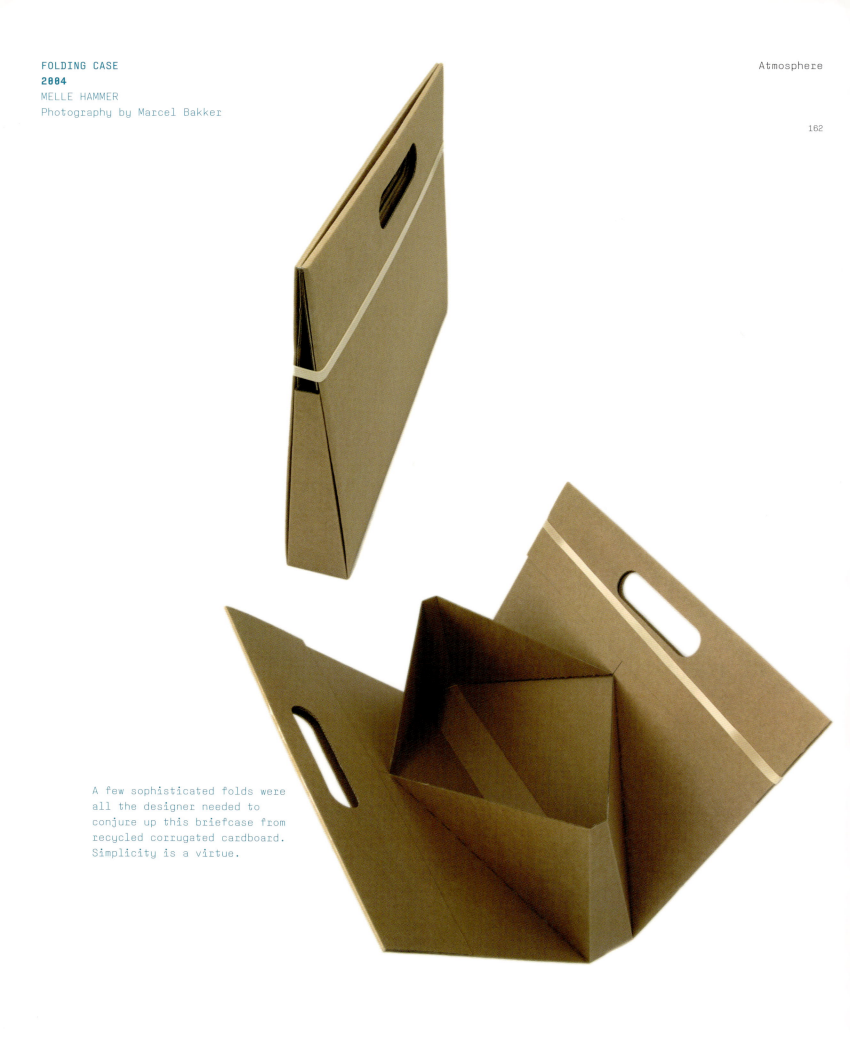

A few sophisticated folds were all the designer needed to conjure up this briefcase from recycled corrugated cardboard. Simplicity is a virtue.

Form Follows Fold

EX-BOX BENCH
GILES MILLER
Photography by Alan Duncan

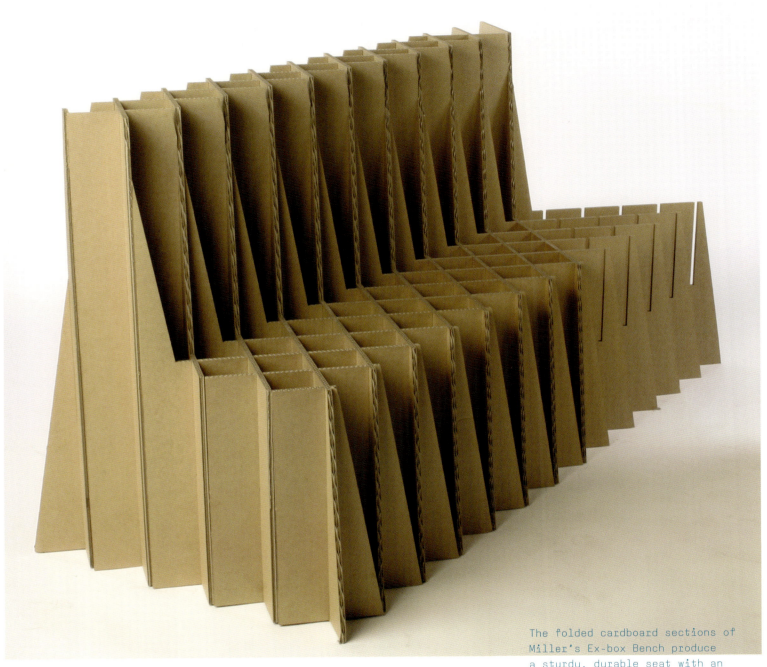

The folded cardboard sections of Miller's Ex-box Bench produce a sturdy, durable seat with an added bonus: light falling on the bench creates interesting linear shadows on surrounding surfaces.

Atmosphere

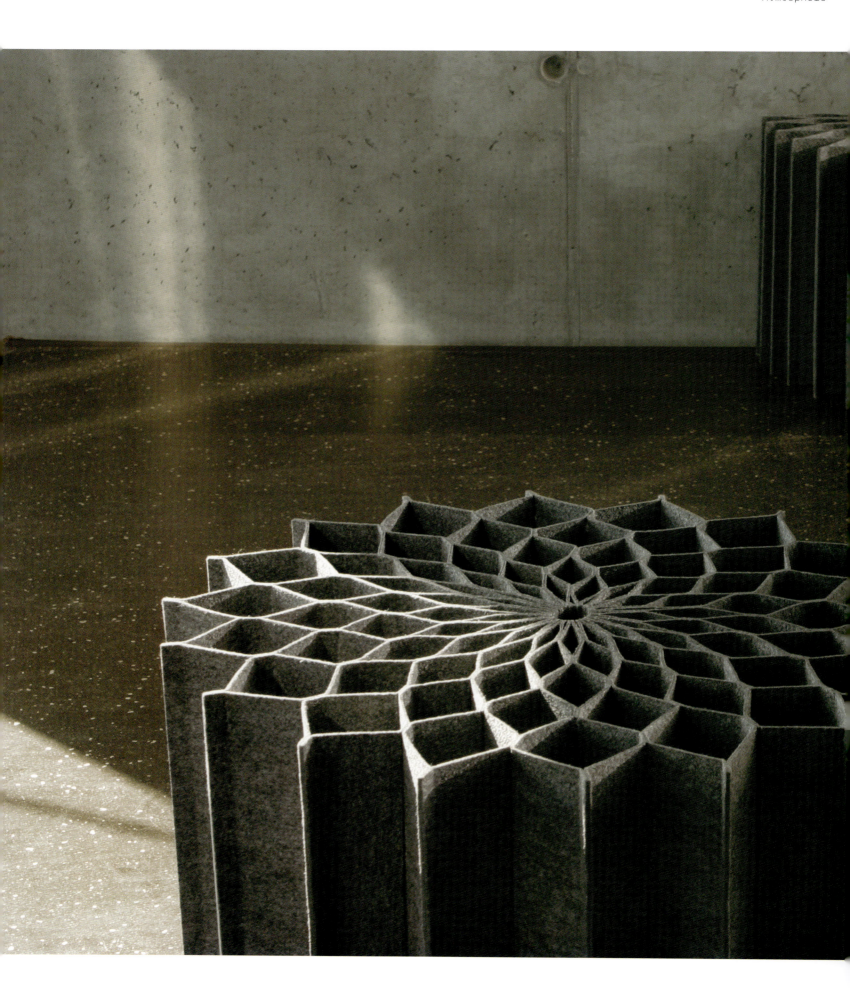

Form Follows Fold

DAHLIA
2004
KAI LINKE
Photography by Klaus Wäldele

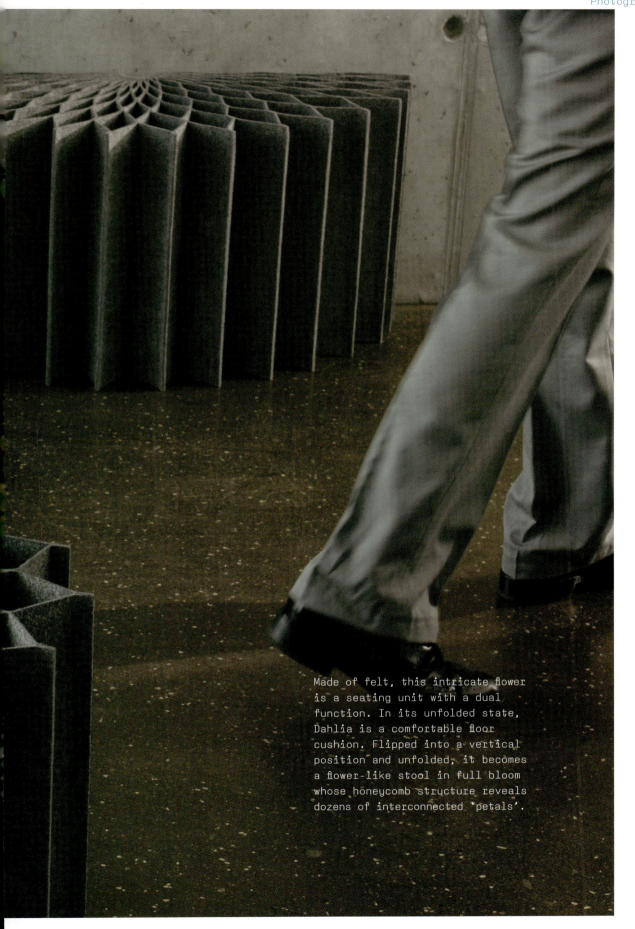

Made of felt, this intricate flower is a seating unit with a dual function. In its unfolded state, Dahlia is a comfortable floor cushion. Flipped into a vertical position and unfolded, it becomes a flower-like stool in full bloom whose honeycomb structure reveals dozens of interconnected 'petals'.

previous page:
MATERIAL
photography by Blommers/Schumm

Right: Beige wellboard by Well.
Bottom and back: Ribbed metal sheet in yellow and red by Gantois.
Top left: Golden-brown Ply wall tile by Showroom Finland.
Middle: Scrunch, a white Soundwave acoustic panel by Offecct.
Middle: Green sample of worked wood by Objectile.

Materials provided by Materia

HANDICRAFT 2.0

previous page:
POTATO
Photography by Blommers/Schumm

Atmosphere

Handicraft 2.0

Many of today's advanced technologies can be understood only by experts. Ordinary people find them impossible to comprehend. Traditional methods seem relatively simple, however. A little bit of practice is all that's needed to master the basic principles involved in any number of handicrafts. So chill out and knit. In cafés, tearooms and homes throughout Europe and America, Stitch 'n Bitch knitting clubs offer knitwits a chance to learn skills passed on by experienced knitters and crocheters. Tough guys tattooed from head to toe are soon clicking their needles with the best of them. Ever since Marcel Wanders crafted his Knotted Chair in 1996, the flow of 'traditional' products that freely interpret and experiment with mainly textile-related techniques has increased by the day.

The paradox clinging to our nostalgic appreciation of low-tech industry is that the manufacture of textiles was the first traditional handicraft to be industrialized. Machines were weaving fabrics as long ago as 1785. It was the textile industry, of all things, that threatened to eradicate the need for handicrafts. Adorning the façade of the future Musée de tla Dentelle in Calais is an enlarged pattern representing that on punch cards used in Jacquard machines (ca. 1803). This machine also made possible the industrial manufacture of lace. Punch cards kicked off a development that has followed a nearly direct line to the digital culture of the 21st century.

In the final quarter of the 19th century, many artists and designers responded to advancing technology by turning to traditional techniques and to textiles. Playing a major role in this development was architect and theoretician Gottfried Semper. In *Der Stil in den technischen und tektonischen Künsten oder praktischer Aesthetik: Die textile Kunst für sich betrachtet und in Beziehung zur Baukunst* (1860-1863), he concluded that the art of textile forms the foundation of all decorative arts. According to Semper, the origins of architecture and architectural ornament can be found in certain age-old techniques such as weaving, knotting, sewing, lacing and binding. He greatly appreciated the way in which native North Americans made articles of clothing by lacing together patches of animal skin with the use of feathers, intestines, tendons, and other fibres and filaments.

He called their work, in which construction doubled as decoration, an example of an elementary design principle: making a virtue of necessity. The synthesis of construction and decoration is essential in the case of textiles, and it is precisely this quality that appeals to contemporary designers. Like the leather garments described above, some designs – such as GloBe, a lamp made from knotted fibre-optic cables – carry the synthesis one step further, uniting construction, decoration and function. In the case of GloBe, light radiates from cracks in the cables. Textiles that take on a fresh look thanks to innovations such as new materials, greater dimensions and stiffeners like synthetic resins breathe new life into old techniques, while also providing designers with an ideal medium with which to indulge their recently acquired taste for ornament.

SILHOUETTE CHANDELIER
2006
STUDIO JOB
Photography by Jac Vanderfeesten

Atmosphere

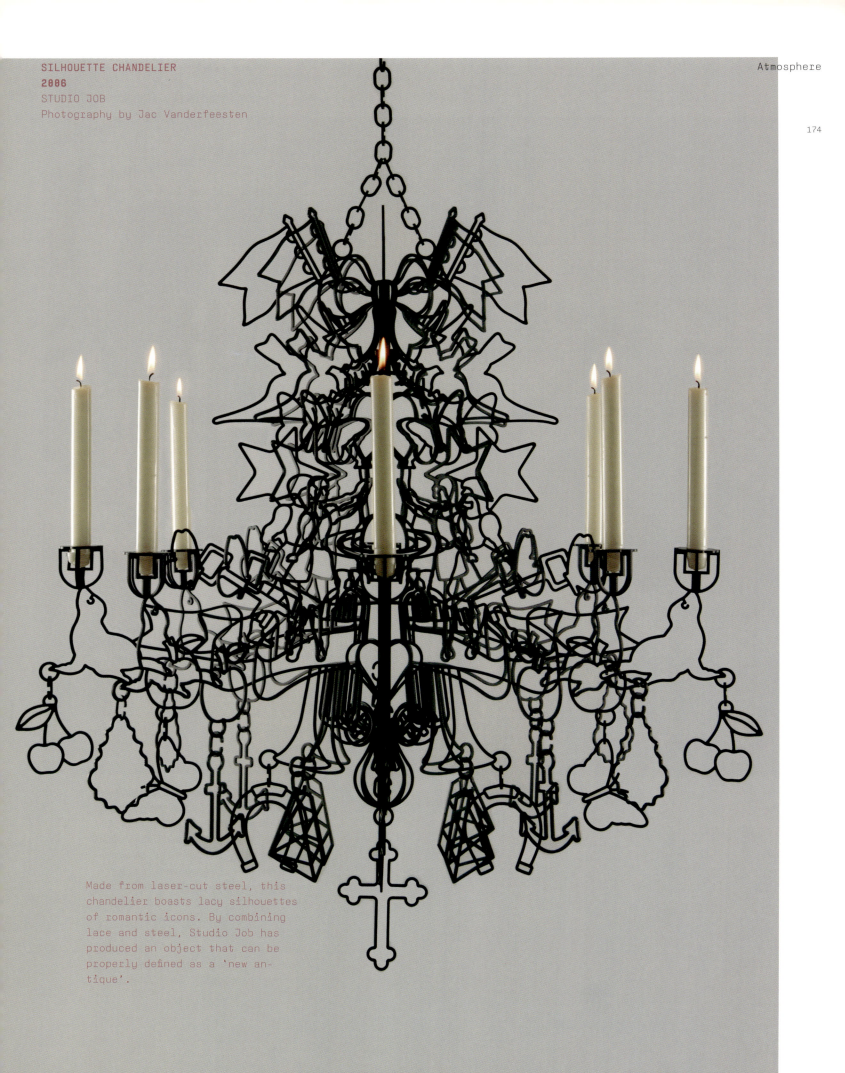

Made from laser-cut steel, this chandelier boasts lacy silhouettes of romantic icons. By combining lace and steel, Studio Job has produced an object that can be properly defined as a 'new antique'.

Handicraft 2.0

ARMADA
2006
DYLAN GRAHAM

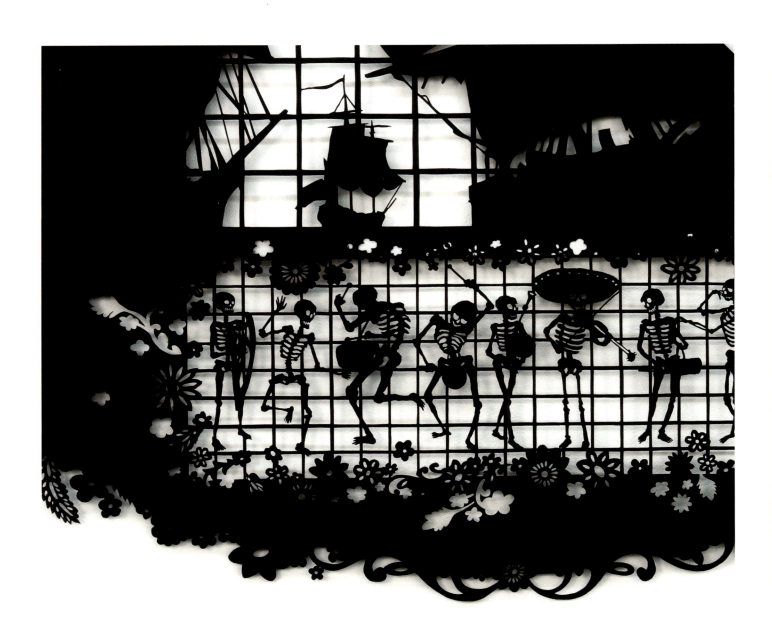

Graham's work is a commentary on both the ostensibly peaceable voyages of discovery made in the days of the Dutch East India Company and our present reality of refugees, adventurers and multinationals. Armada (91 x 245 cm) presents a combination of cultural imagery, super-decoration, low-art technique and elements taken from the Mexican tradition of *papel picado*: a folk art featuring cutouts and decorations commonly displayed during festivities. The cutouts show simplified silhouettes and shadows of three-dimensional forms that are held together by a repetitive grid with segments of filigree-style embellishments.

THE OLD LIE (DULCE ET DECORUM
EST PRO PATRIA MORI) II
2005
DYLAN GRAHAM

Atmosphere

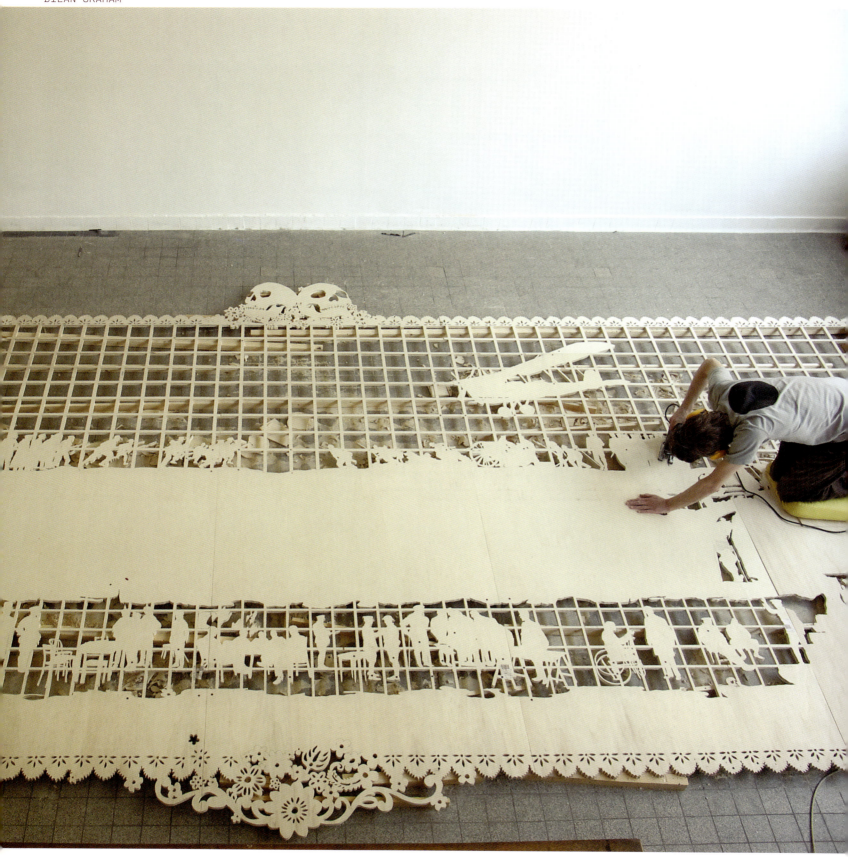

Handicraft 2.0

AMBROSIA FIELD COLLECTION
2005
VLADIMIR LAZAREVIC
Photography by Etienne Tordoir

Lazarevic based his collection on baroque images of centaurs: mythical creatures described as half man, half horse. In this collection, Lazarevic demonstrates a balanced silhouette combining man and beast, as well as a balance in his work between calculated craftsmanship and intuitive design.

VERY ROUND CHAIR
2006
LOUISE CAMPBELL FOR ZANOTTA
Photography by Zanotta

Atmosphere

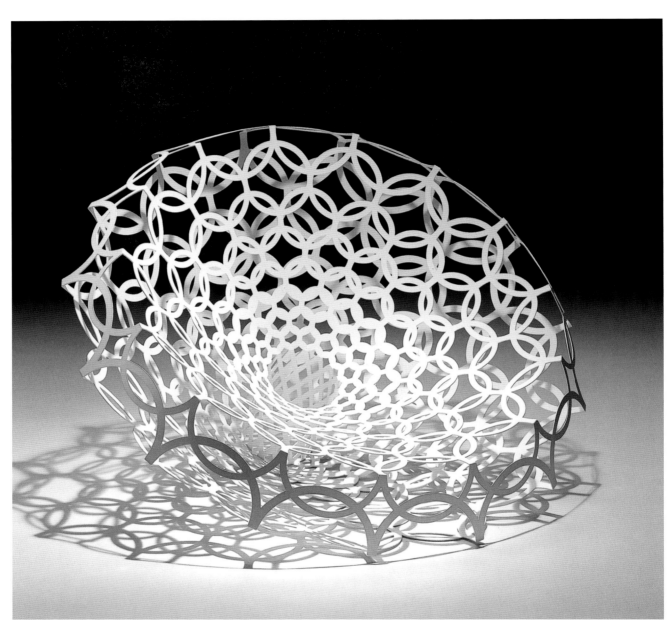

The forms and patterns of this laser-cut chair evoke thoughts of a wide range of traditional skills, from knotting and macramé to lace-making and paper-cutting

Handicraft 2.0

MINIMAL LAMP
2005
JED CRYSTAL
Photography by David Seaver

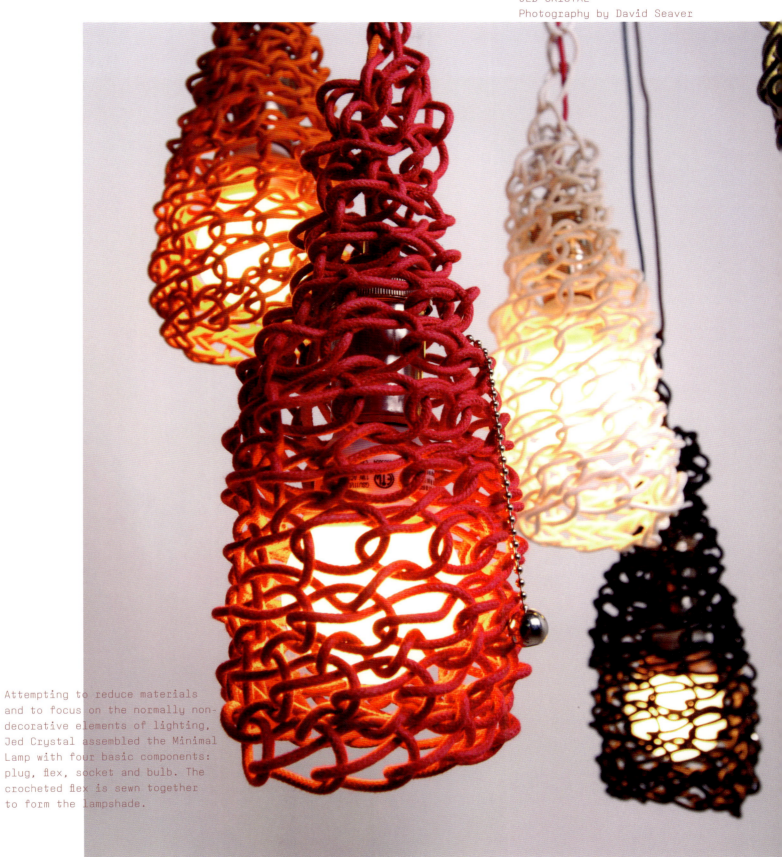

Attempting to reduce materials and to focus on the normally non-decorative elements of lighting, Jed Crystal assembled the Minimal Lamp with four basic components: plug, flex, socket and bulb. The crocheted flex is sewn together to form the lampshade.

GLOBE
2006
TORBJÖRN LUNDELL, GLOFAB

Atmosphere

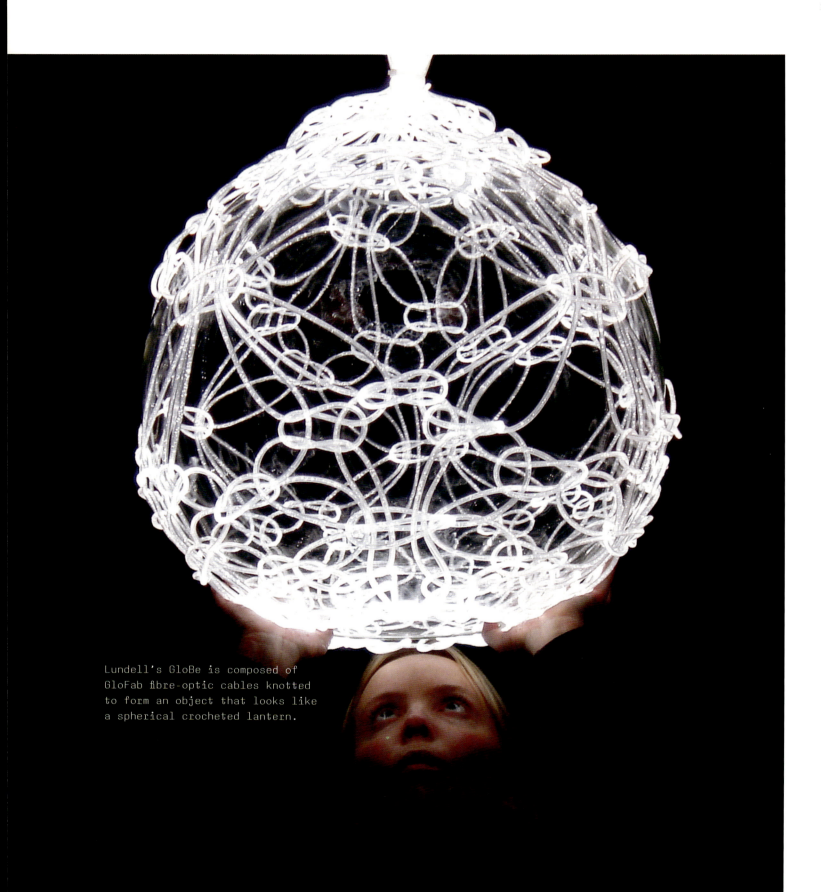

Lundell's GloBe is composed of GloFab fibre-optic cables knotted to form an object that looks like a spherical crocheted lantern.

Handicraft 2.0

CURTAINS AS ARCHITECTURE
Casa da Música, Porto, Portugal
1999-2005
PETRA BLAISSE, INSIDE OUTSIDE
Photography by Phil Meech

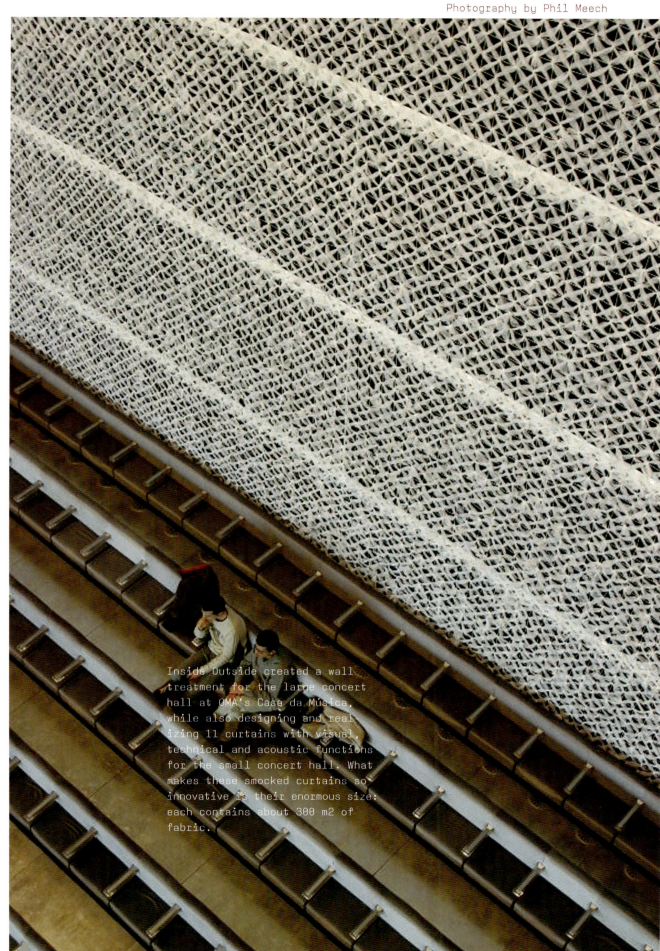

Inside Outside created a wall treatment for the large concert hall at OMA's Casa da Música, while also designing and realizing 11 curtains with visual, technical and acoustic functions for the small concert hall. What makes these smocked curtains so innovative is their enormous size: each contains about 300 m2 of fabric.

KNITTED WALLS
2005
ONTWERPBUREAU MUURBLOEM
Photography by Materia

Atmosphere

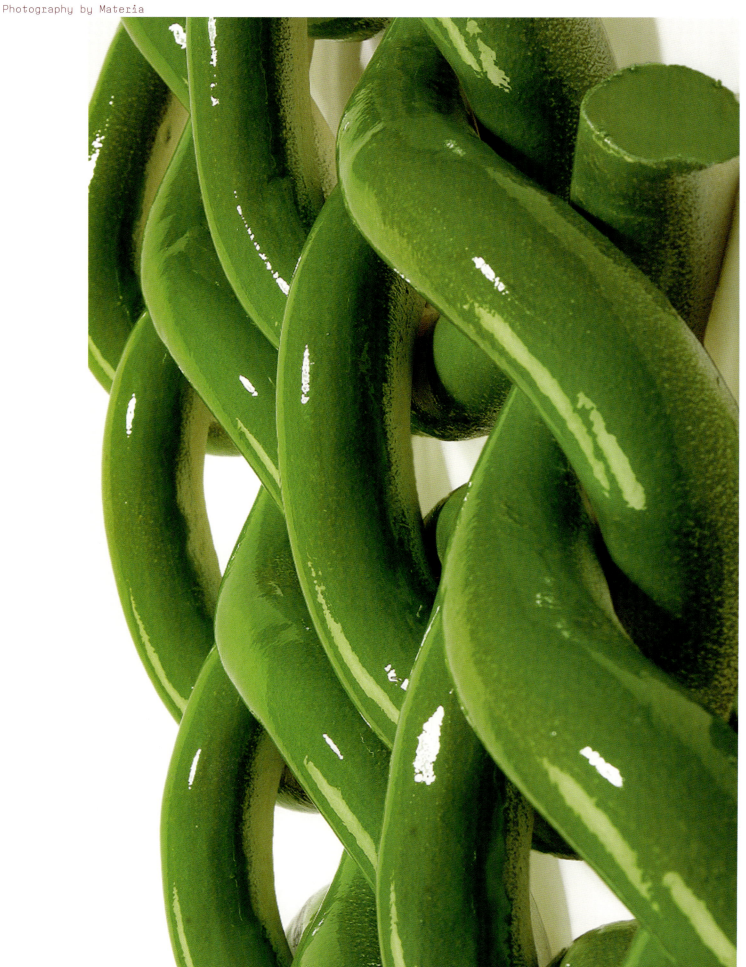

Handicraft 2.0

185

KNITTED WALLS
2005
ONTWERPBUREAU MUURBLOEM

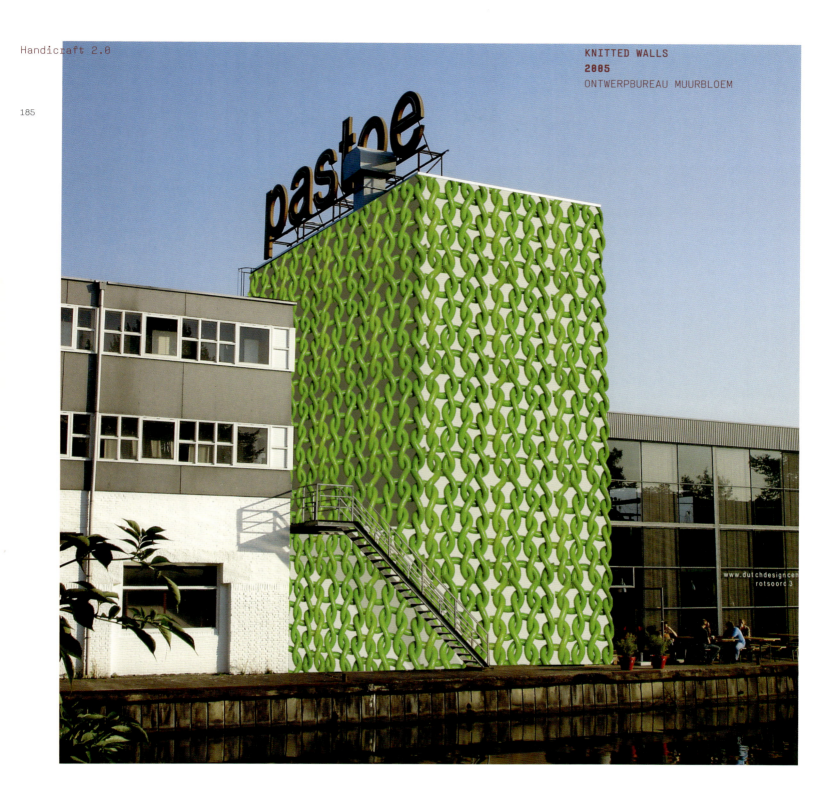

Having been invited to the EKWC, a ceramic centre in 's-Hertogenbosch, Dutch designer Gonette Smits investigated methods of adding texture to the ordinarily smooth surface of tiled walls. Her research led to a number of 'knitted' ceramic prototypes. These tiles are suitable for both indoor and outdoor use.

GLOCURTAIN L(ACE)
2006
TORBJÖRN LUNDELL, GLOFAB
Photography by Torbjörn Lundell

Atmosphere

Handicraft 2.0

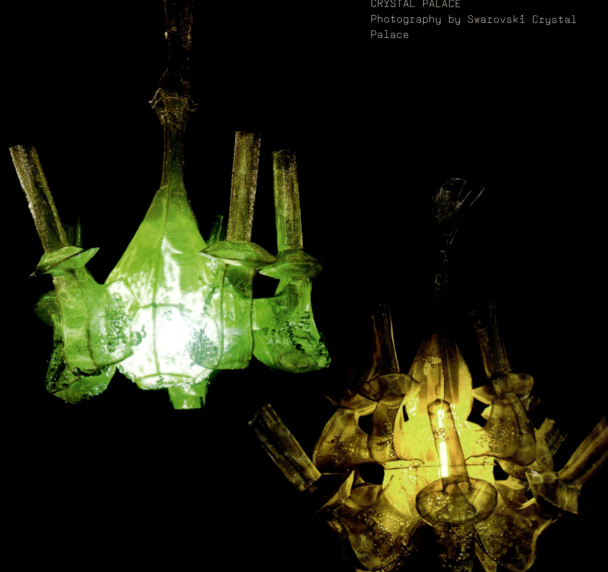

CINDERELLA AM & CINDERELLA PM
2006
STUDIO JURGEN BEY FOR SWAROVSKI CRYSTAL PALACE
Photography by Swarovski Crystal Palace

New developments in fibres and functional textiles are many, and designers are taking full advantage of the boom. The chandelier pictured here seems to be a revival of soft sculptures created by Claes Oldenburg in the 1960s, but this is design and not art. Jurgen Bey's pair of chandeliers are made from very fine steel gauze embroidered with Swarovski crystals in a pattern of 'night bugs'. Hematite and topaz-tinted crystals were chosen for their mysterious hues and transparent qualities. When the light is off, the chandelier is ghostly and almost nonexistent. When it's on, the crystals sparkle through the gauze.

STAGE PROPERTY # 00703 (left)
2000
TWAN JANSSEN

STAGE PROPERTY # 061002 (right)
2006
TWAN JANSSEN

Atmosphere

188

One of the more successful 'formats' that Janssen has developed in recent years is that of small canvases (usually white) that are tied with a ribbon of acrylic paint featuring ornamental curls. Instead of being used to form a composition on canvas, the paint is used to wrap the canvases as gifts. Art is presented here as a luxury, as an alluring commodity that might make a nice – and, admittedly, expensive – gift.

The catalogue work pictured here refers to Stage Property #00703. It's a catalogue in coarse-grained pixels: the closer you get, the harder it is to read. And it's not the work that's important; it's Twan Janssen once more playing a figure lingering on the periphery of art. The Dutch term *monnikenwerk* – 'monks' work' or 'sheer drudgery'– certainly applies to the art of Twan Janssen, who gives us a meditative resource with which to review work he's made previously and to anticipate work still to come.

Handicraft 2.0

189

ANTIBODI
2005
PATRICIA URQUIOLA FOR MOROSO
Photography by Alessandro Paderni,
Studio Eye

A patchwork of fabric flowers covers the stainless-steel frame of this lounge chair. The lightly padded petals, made from felt and wool, are sewn onto the upholstery in a star-like pattern consisting of triangles. A rather masculine model of the chair, with a more quilted look, features blossoms made from leather and wool fabric, their petals facing inward.

MUSÉE DE LA DENTELLE ET
DE LA MODE
Calais, France
2005-2007
ALAIN MOATTI AND HENRI RIVIÈRE
Picture by A. Deswarte

Atmosphere

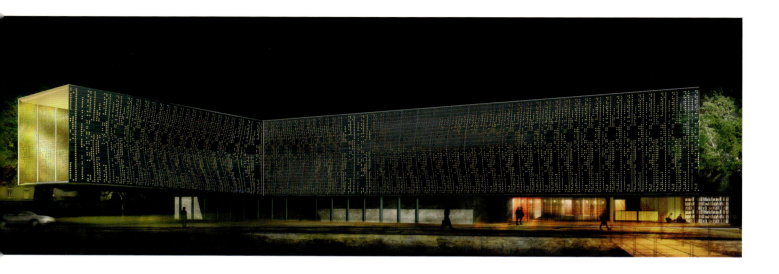

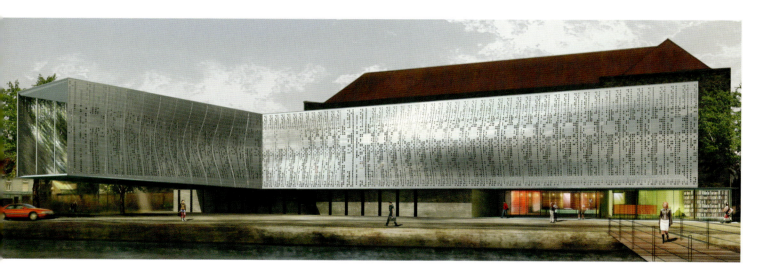

A lace museum in Calais will open its doors in 2008. The museum is to be housed in a large 19th-century factory complex, the Usine Boulart, where industrially manufactured lace was once produced. The undulating glazed façade will bear an image of a patterned Jacquard punch card of the type once used in the Leavers lace-making machine.

Handicraft 2.0

CERAMIC GLOW-LAMP
2006
GOCE CALOSKI
Photography by Goce Caloski

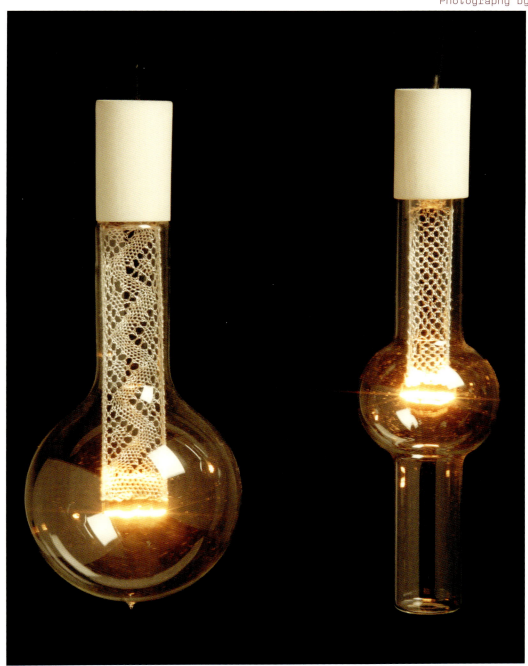

A lacy filament made of aluminium oxide is suspended from a ceramic filament holder. Reinforcing the 19th-century aura surrounding this product is a bulb shaped like an old-fashioned oil lamp.

PANE CHAIR
2006
TOKUJIN YOSHIOKA DESIGN

Atmosphere

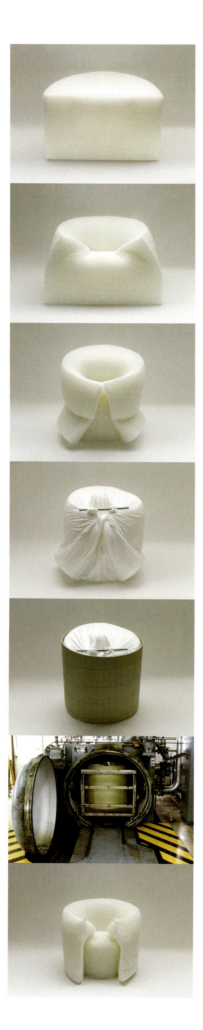

Handicraft 2.0

FAT HOUSE
2004-2006
ERWIN WURM
Photography by Simon Chaput

'I am interested in the object, in liberating it from its field, giving it a new validity and meaning. It is integrated in a different system of values and ideas: in that of art. In this way it loses its function and takes on another. I do not want to go so far as to say that the object is no longer recognized. Rather, I want to have the appeal of the recognition effect on the one hand and that of alienation on the other, which the object emanates.' ERWIN WURM

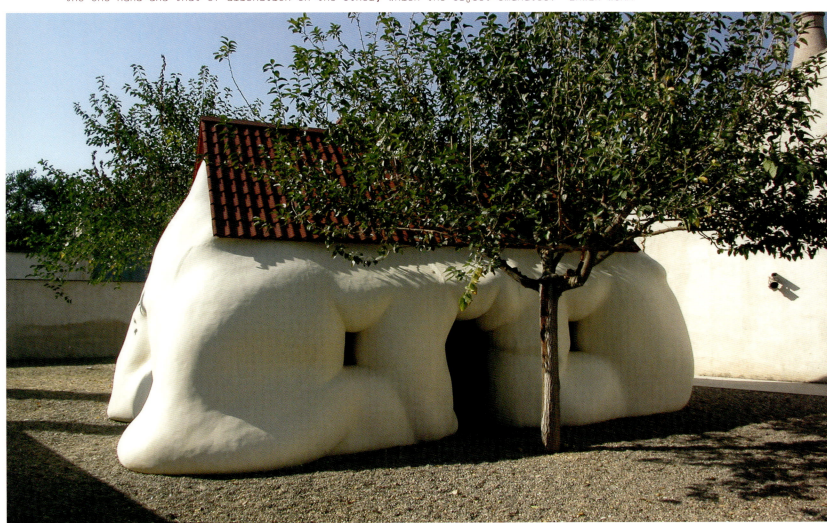

A lump of dough that has risen to gigantic proportions? An obese house? Presenting Fat House outside the context of a museum — on a city square or in a park — increases the alienating effect even more. Observers are not the only ones who don't know exactly what to make of Fat House. The object itself has huge doubts about its reason for existing and its identity. On a video shown inside the structure, Fat House presents an existentialist monologue on its essence and context, and philosophizes on art, architecture, and art criticism. 'Am I a house?' the chubby dwelling asks itself.

previous page:
MATERIAL
photography by Blommers/Schumm

Dacryl, a moulded PMMA module by Dacryl.

Materials provided by Materia

DOWN TO EARTH

previous page:
POTATO
photography by Blommers/Schumm

Atmosphere

Down to Earth

Cutting-edge technology enables us to create sleek, smooth shapes that approach the pinnacle of perfection. Yet many designers seem determined to use the latest methods available to do precisely the opposite: they let technology give their designs a rough, spontaneous, primitive and sometimes even battered appearance.

Along the coast of a seaside resort in Fujian Province, China, five stunningly high residential towers caress the clouds. Designed by Marazzi Architetti, these skyscrapers are clad in a type of granite which gives them an 'eroded' look that is intended to make them part of their surroundings. Thanks to their rough façades, the towers seem to be much older than they are. Staggered along the shore like totems, the structures evoke images of the huge stone statues discovered on Easter Island. The association with the remnants of a lost civilization reveals the idyllic undercurrent that gave rise to Marazzi's design — the romance of ruins left by vanished cultures, damaged by time and the elements, excavated by archaeologists.

Other contemporary designs that might well have come from an archaeological site are the handcrafted pieces that Maarten Baas calls Clay Furniture. The choice of material and the uneven surfaces, a result of the handmade character of the work, reinforce the impression that these objects once belonged to the people of a now-archaic culture. Visible in the skin of this furniture — apparently unfinished and slapped on in an impulsive manner — is 'the hand of the master' and thus the genesis of the design.

Texture is a vital aspect of these projects. Texture conveys ideas tied to traditional workmanship, authenticity and singularity. The tactility of the surfaces seems to invite us to become part of their history, in the same way that a walk through the Forum Romanum, for instance, can generate a feeling of connectedness to antiquity.

In the bricks designed by José Rojas, history lies in the future; Rojas added certain ingredients to the clay while baking his bricks to hasten the ageing process. Influenced by weather and use, they erode rapidly, changing in colour as well as in texture. He also developed bricks with protrusions that resemble fungi. Incorporated in a building, they give the structure the appearance of having been attacked by a mould of some sort and of being in a state of decay.

In 1830, British architect Sir John Soane had a picture painted that showed how his Bank of England building would look as a ruin some thousand years later. The Down to Earth objects will not have to wait a thousand years for time to leave its inevitable traces — history has marked them since birth.

CLAY FURNITURE
2006
MAARTEN BAAS

'My leitmotif for this series was something like "the less the thought, the greater the joy", so there's no story to be told here. It was just a matter of working the clay until the chair appeared.' MAARTEN BAAS

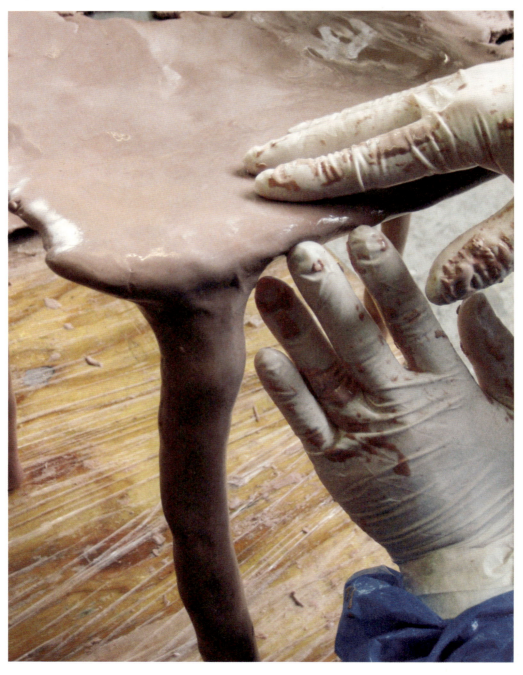

Down to Earth

CLAY FURNITURE
2006
MAARTEN BAAS

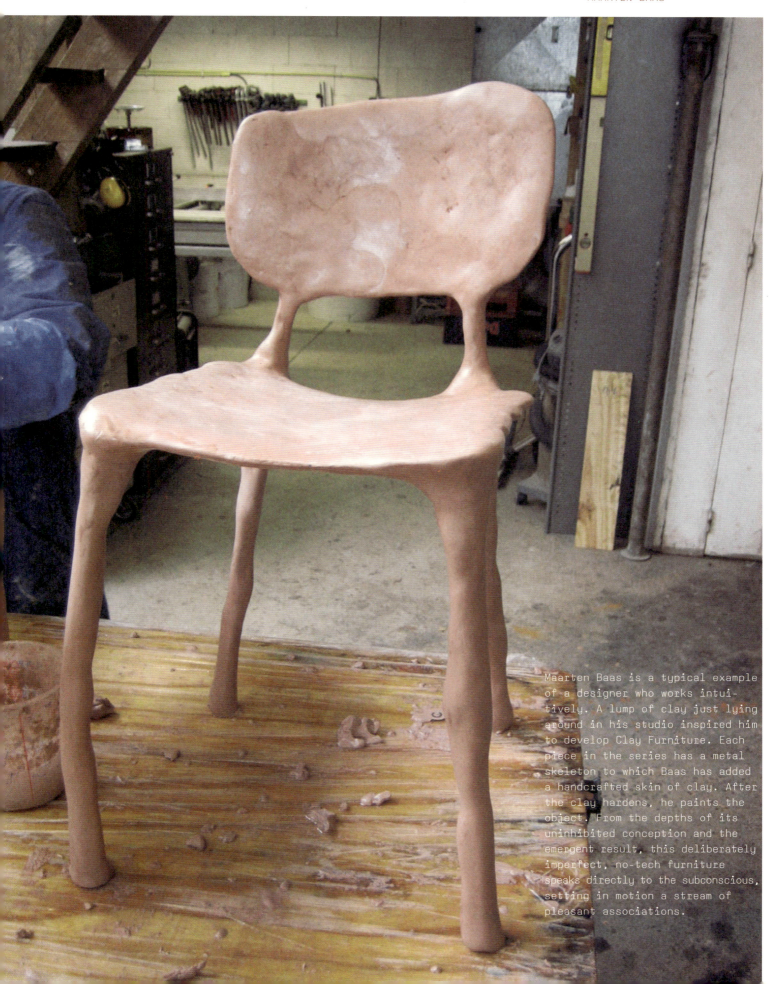

Maarten Baas is a typical example of a designer who works intuitively. A lump of clay just lying around in his studio inspired him to develop Clay Furniture. Each piece in the series has a metal skeleton to which Baas has added a handcrafted skin of clay. After the clay hardens, he paints the object. From the depths of its uninhibited conception and the emergent result, this deliberately imperfect, no-tech furniture speaks directly to the subconscious, setting in motion a stream of pleasant associations.

ARCHAEOLOGICAL ARCHIVES PAVILION
Jinhua Architecture Park, China
2005
AI WEIWEI
Photography by Iwan Baan

Atmosphere

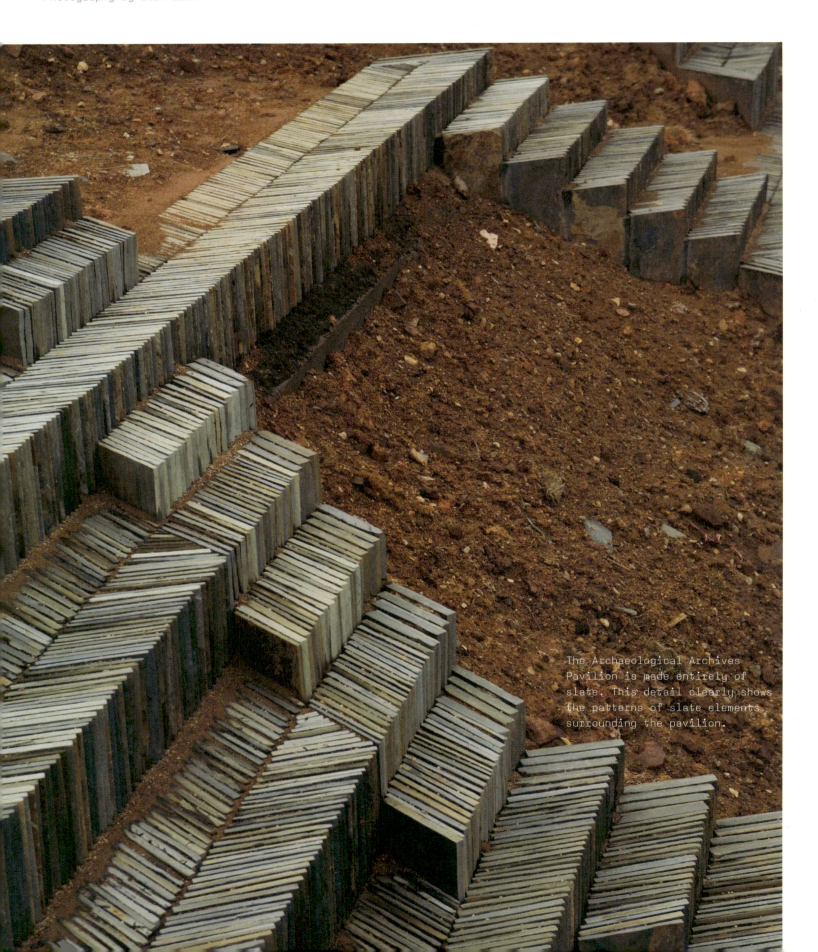

The Archaeological Archives Pavilion is made entirely of slate. This detail clearly shows the patterns of slate elements surrounding the pavilion.

Down to Earth

RACCONTI CON CASSETTE
2005
MICHELE DE LUCCHI

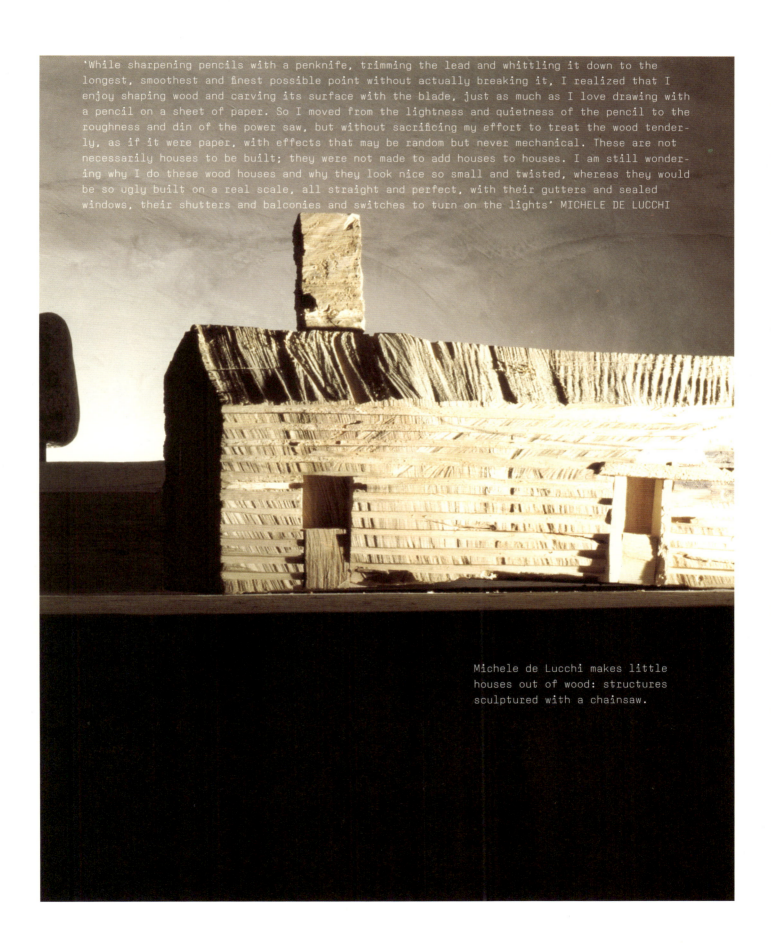

'While sharpening pencils with a penknife, trimming the lead and whittling it down to the longest, smoothest and finest possible point without actually breaking it, I realized that I enjoy shaping wood and carving its surface with the blade, just as much as I love drawing with a pencil on a sheet of paper. So I moved from the lightness and quietness of the pencil to the roughness and din of the power saw, but without sacrificing my effort to treat the wood tenderly, as if it were paper, with effects that may be random but never mechanical. These are not necessarily houses to be built; they were not made to add houses to houses. I am still wondering why I do these wood houses and why they look nice so small and twisted, whereas they would be so ugly built on a real scale, all straight and perfect, with their gutters and sealed windows, their shutters and balconies and switches to turn on the lights' MICHELE DE LUCCHI

Michele de Lucchi makes little houses out of wood: structures sculptured with a chainsaw.

CALIFORNIAN CONDOR
2000
EYLEM ALADOGAN
Courtesy Galery Fons Welters, Amsterdam

Atmosphere

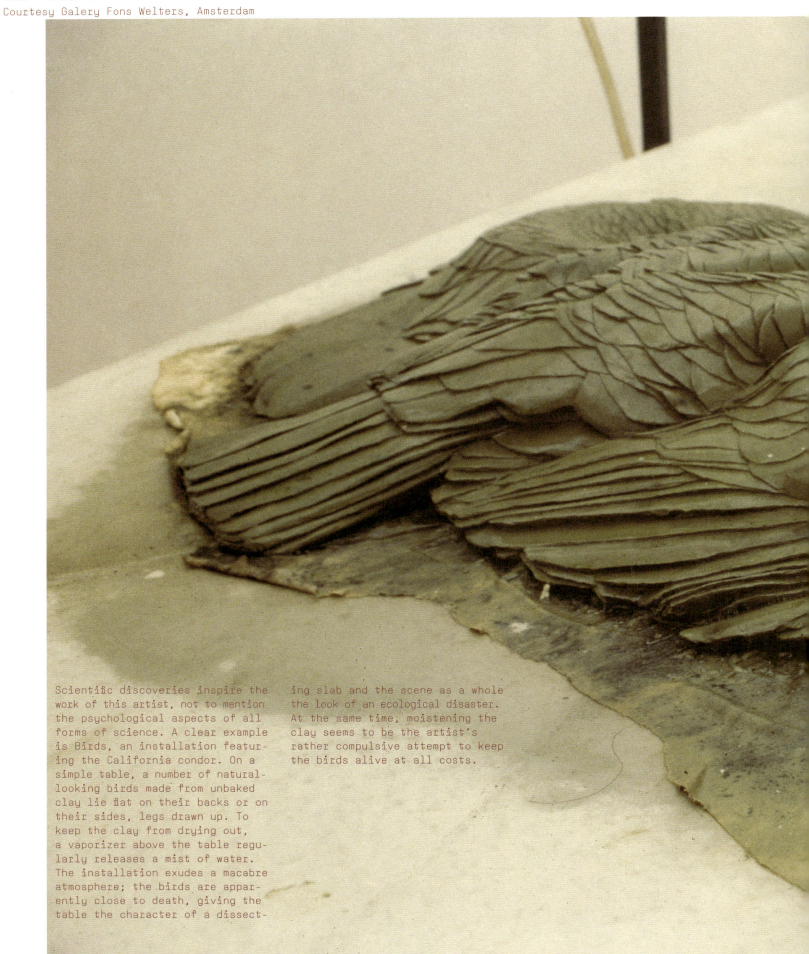

Scientific discoveries inspire the work of this artist, not to mention the psychological aspects of all forms of science. A clear example is Birds, an installation featuring the California condor. On a simple table, a number of natural-looking birds made from unbaked clay lie flat on their backs or on their sides, legs drawn up. To keep the clay from drying out, a vaporizer above the table regularly releases a mist of water. The installation exudes a macabre atmosphere; the birds are apparently close to death, giving the table the character of a dissecting slab and the scene as a whole the look of an ecological disaster. At the same time, moistening the clay seems to be the artist's rather compulsive attempt to keep the birds alive at all costs.

Down to Earth

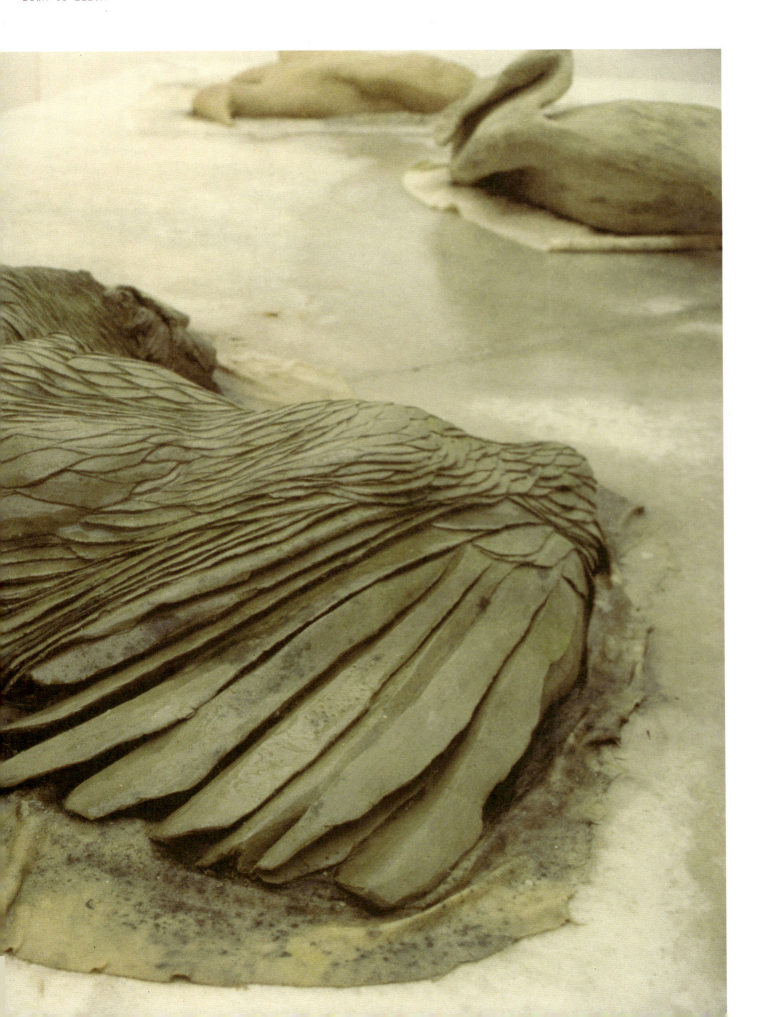

REST IN PEACE
2004
ROBERT STADLER
Photography by Patrick Gries

Atmosphere

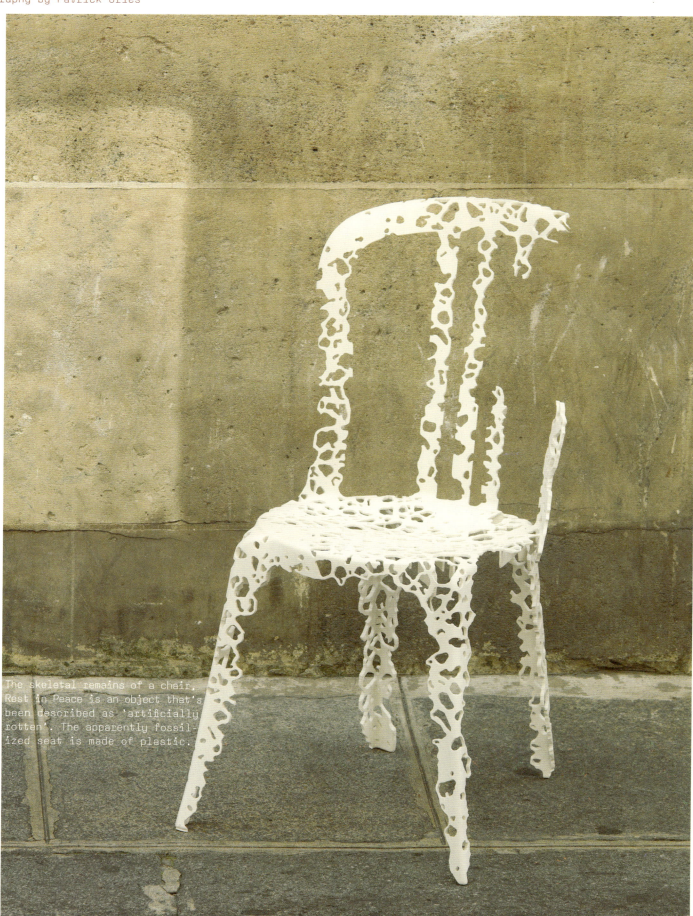

The skeletal remains of a chair, Rest in Peace is an object that's been described as 'artificially rotten'. The apparently fossilized seat is made of plastic.

Down to Earth

SCHAULAGER
Basel, Switzerland
2003
HERZOG & DE MEURON
Photography by Margherita Spiluttini

'A building is a building. It cannot be read like a book; it doesn't have any credits, subtitles or labels like picture in a gallery. In that sense, we are absolutely anti-representational. The strength of our buildings is the immediate, visceral impact they have on a visitor.' HERZOG & DE MEURON

A building whose function embraces a dual typological concept – referring, as it does, to both museum and depot – is Herzog & de Meuron's Schaulager, with its coarse-grained façade. A large, seemingly solid block, Schaulager features a long horizontal indentation that looks as though it has been cut away with a milling tool.

DIALECTS OF DESIRE
MASTER PIECES 2006
2006
TOMÁŠ GABZDIL LIBERTINY
FOR DROOG DESIGN
Photography by Sander Lucas

Atmosphere

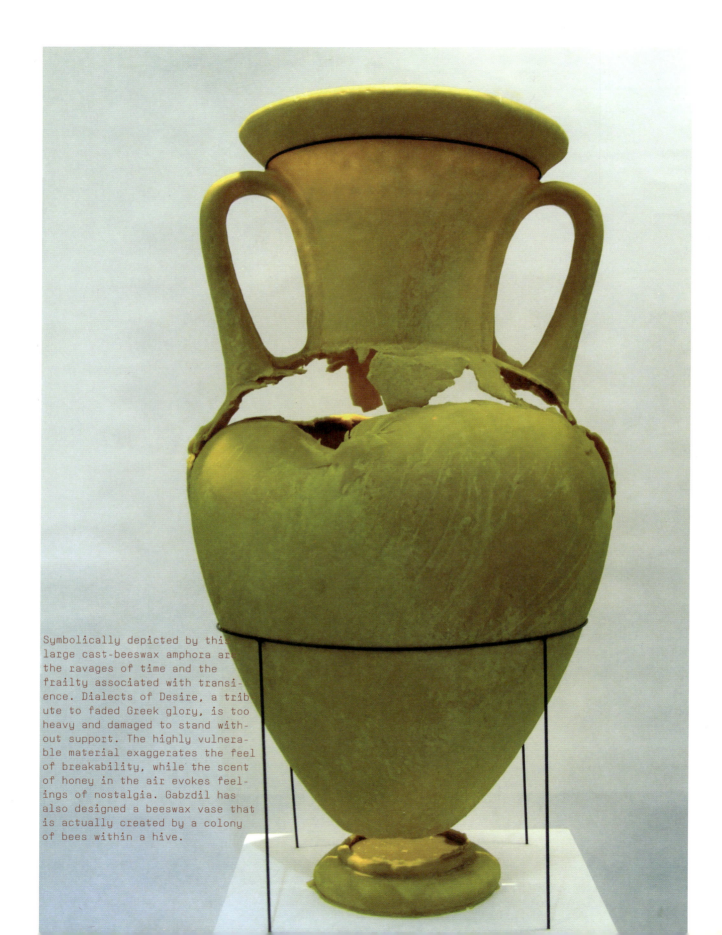

Symbolically depicted by this large cast-beeswax amphora are the ravages of time and the frailty associated with transience. Dialects of Desire, a tribute to faded Greek glory, is too heavy and damaged to stand without support. The highly vulnerable material exaggerates the feel of breakability, while the scent of honey in the air evokes feelings of nostalgia. Gabzdil has also designed a beeswax vase that is actually created by a colony of bees within a hive.

Down to Earth

BRICK REVIVAL
2006
JOSÉ ROJAS
Photography by Sander Lucas

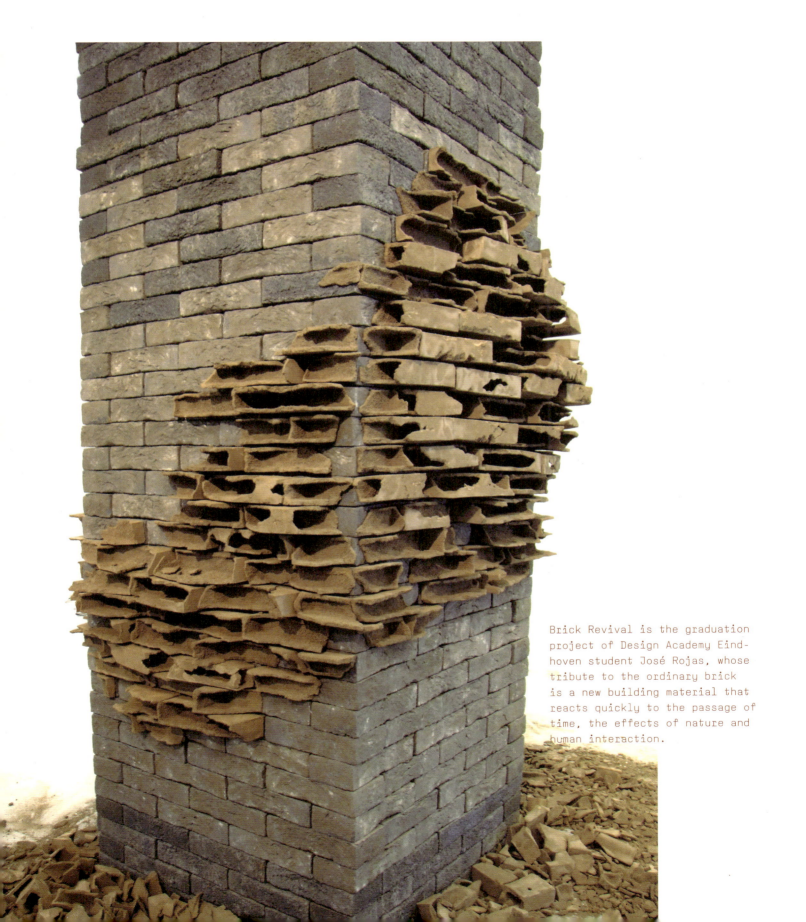

Brick Revival is the graduation project of Design Academy Eindhoven student José Rojas, whose tribute to the ordinary brick is a new building material that reacts quickly to the passage of time, the effects of nature and human interaction.

TRANSMUTATION
2005
BARBARA NANNING
Photography by Tom Haartsen

Atmosphere

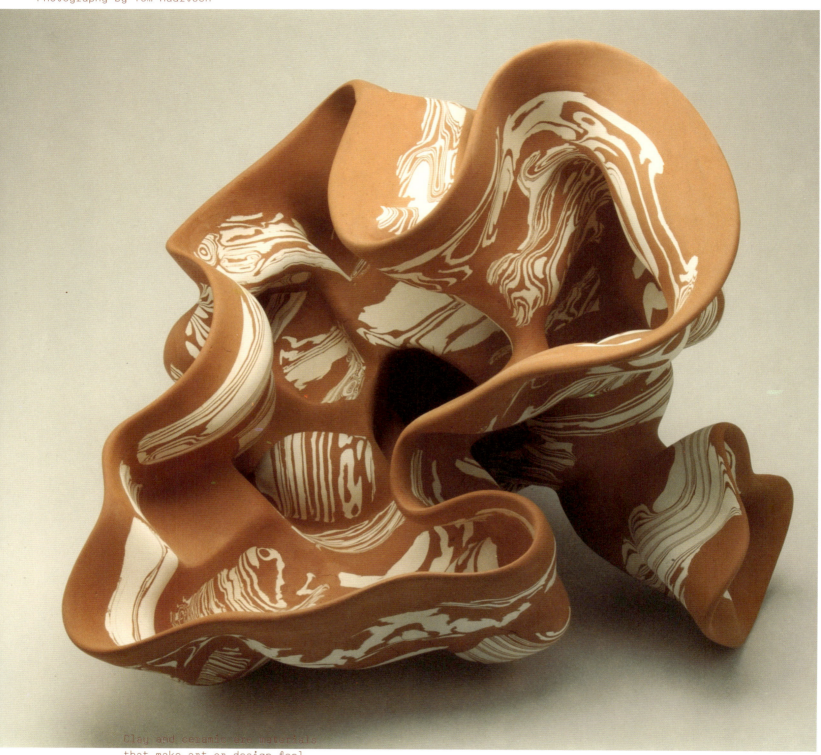

Clay and ceramic are materials that make art or design feel literally 'down to earth'. Barbara Nanning's Transmutation pieces look both spontaneous and carefully constructed.

Down to Earth

215

RAW
2006
TOMEK RYGALIK
Photography by Alessandro Paderni

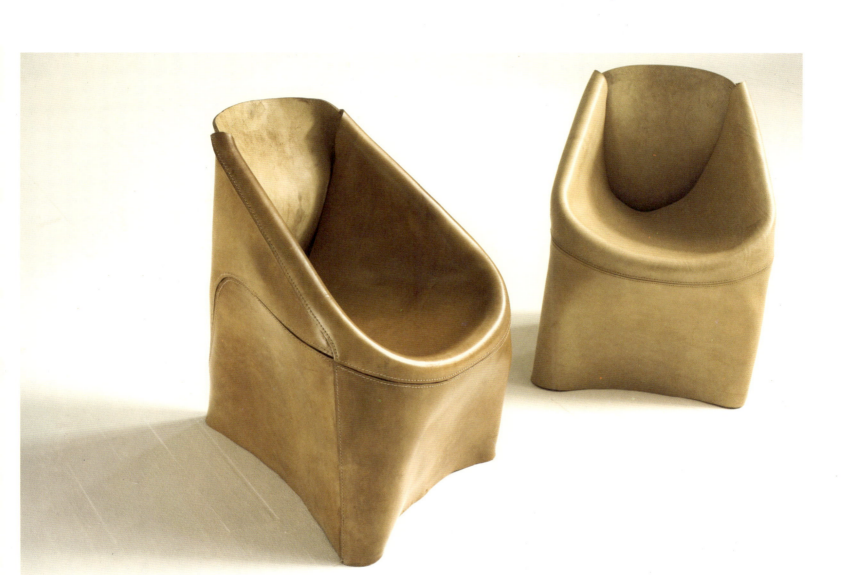

With no internal framework, Rygalik's Raw armchair is forced to rely on the cleverly designed assembly of its self-supporting leather structure, in which every stitch counts.

RED BEAVER
1986-2005
FRANK GEHRY
FOR VITRA
Photography by Andreas Süterlin

Atmosphere

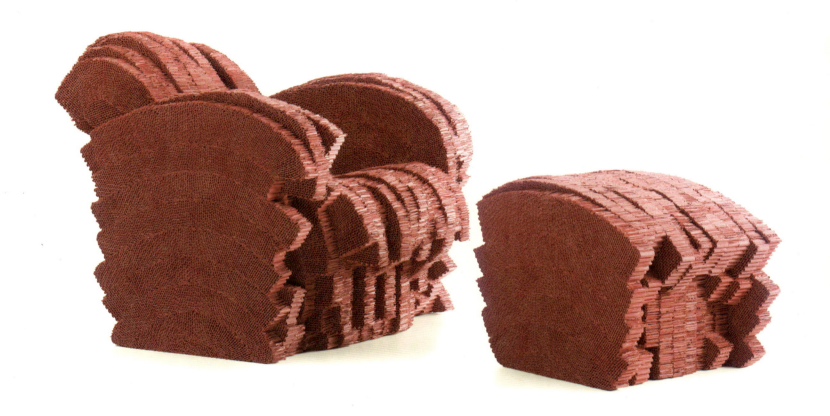

Red Beaver would be a cosy armchair like thousands of others were it not for the rather threadbare look of its contours, which send out a message of tired, worn-out furniture that has suffered the ravages of time. Made from sections of corrugated cardboard, the chair has been reissued by the manufacturer, this time in vibrant red.

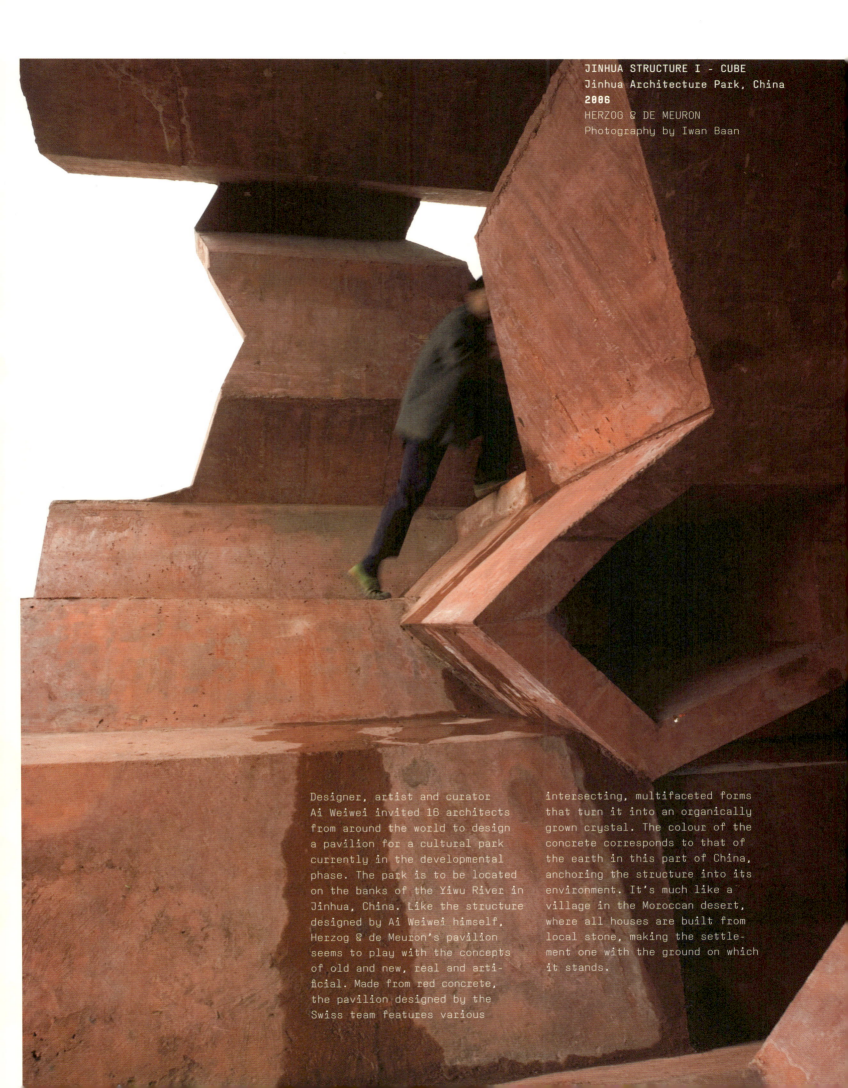

JINHUA STRUCTURE I - CUBE
Jinhua Architecture Park, China
2006
HERZOG & DE MEURON
Photography by Iwan Baan

Designer, artist and curator Ai Weiwei invited 16 architects from around the world to design a pavilion for a cultural park currently in the developmental phase. The park is to be located on the banks of the Yiwu River in Jinhua, China. Like the structure designed by Ai Weiwei himself, Herzog & de Meuron's pavilion seems to play with the concepts of old and new, real and artificial. Made from red concrete, the pavilion designed by the Swiss team features various intersecting, multifaceted forms that turn it into an organically grown crystal. The colour of the concrete corresponds to that of the earth in this part of China, anchoring the structure into its environment. It's much like a village in the Moroccan desert, where all houses are built from local stone, making the settlement one with the ground on which it stands.

JINHUA STRUCTURE I - CUBE
Jinhua Architecture Park, China
2006
HERZOG & DE MEURON
Photography by Iwan Baan

Atmosphere

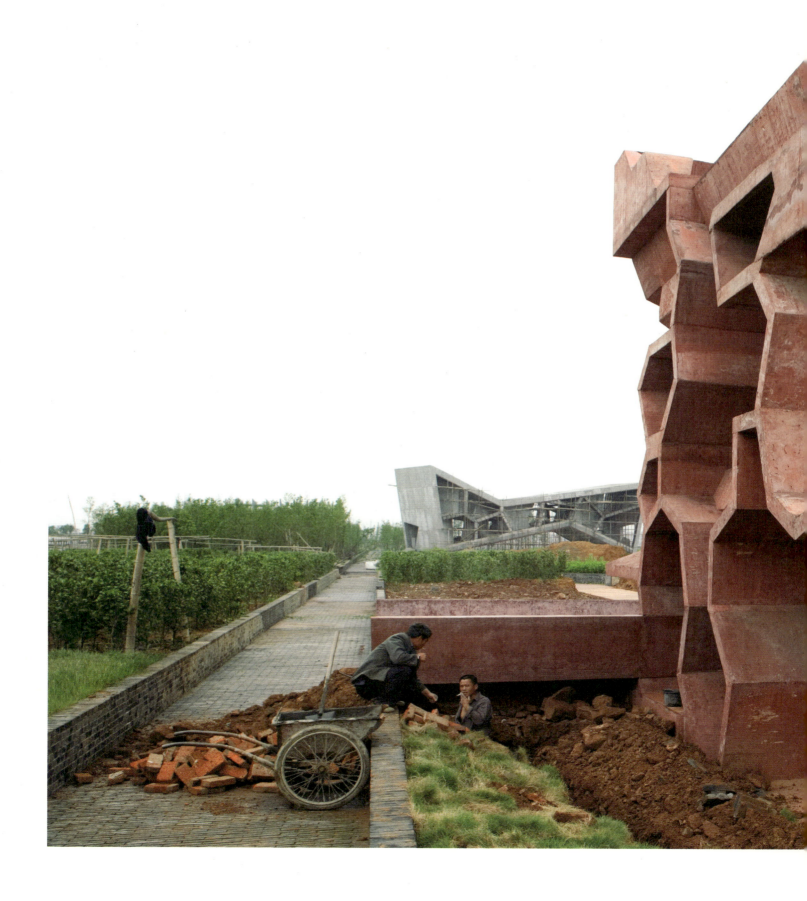

Down to Earth

LIVING LIBRARY
Utrecht, Netherlands
1997-2004
WIEL ARETS ARCHITECTS
Photography by Wiel Arets Architects

Atmosphere

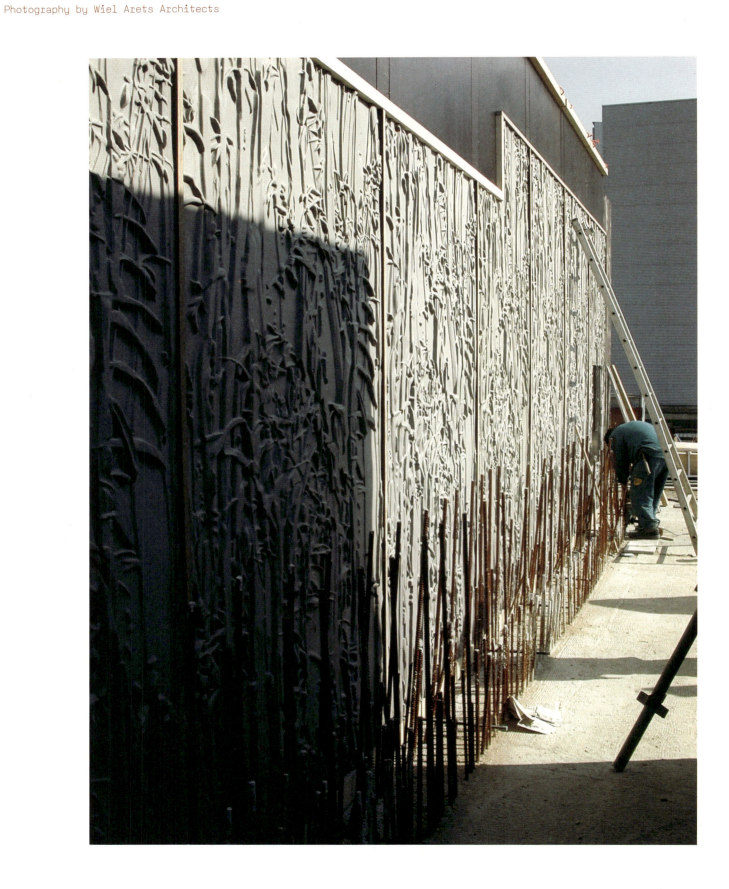

Down to Earth

LIVING LIBRARY
Utrecht, Netherlands
1997-2004
WIEL ARETS ARCHITECTS
Photography by Wiel Arets Architects

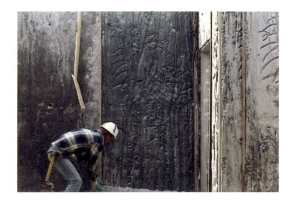

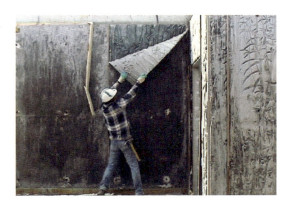

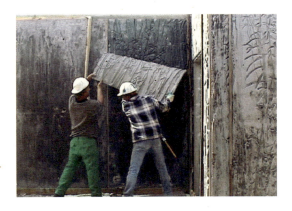

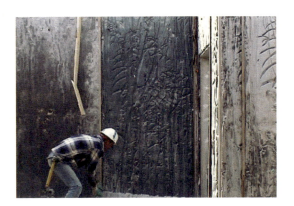

Visible on the black panels is a pattern in relief that was made by leaving an imprint of bamboo in wet concrete. The patterned panels create the sense of a building amidst a grove of trees.

MIMETIC TOWERS
Fujian, China
2005
MARAZZI ARCHITETTI

Atmosphere

'Begin at the beginning and go on until the end, then stop.' MARAZZI ARCHITETTI

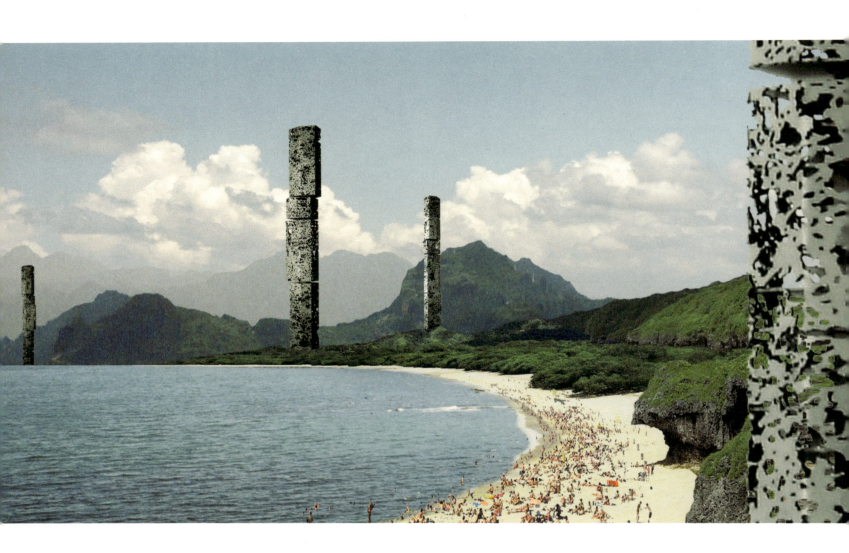

Marazzi Architetti designed the Mimetic Towers as part of the development of Fujian, China, into a destination for tourists. By spacing the compact but extremely high towers at intervals of at least 12 km, the architects have 'invaded' the natural environment as little as possible, while still contributing to large-scale tourism.
The towers consist of stacks of monolithic, irregularly shaped blocks of varying heights. In an effort to integrate these buildings into their surroundings in terms of both colour and form, the architects focused on the desired shade for exterior surfaces and on openings in these façades. The rather lacy, fragmented perforations in the skin follow patterns found in green bowenite, the type of granite used for the exterior, while giving the impression that subtropical winds and rain have eroded the towers.

Down to Earth

SHADOW + SHADOW PORCELAIN
2006
HIL DRIESSEN
Photography by Daniel Bosschieter

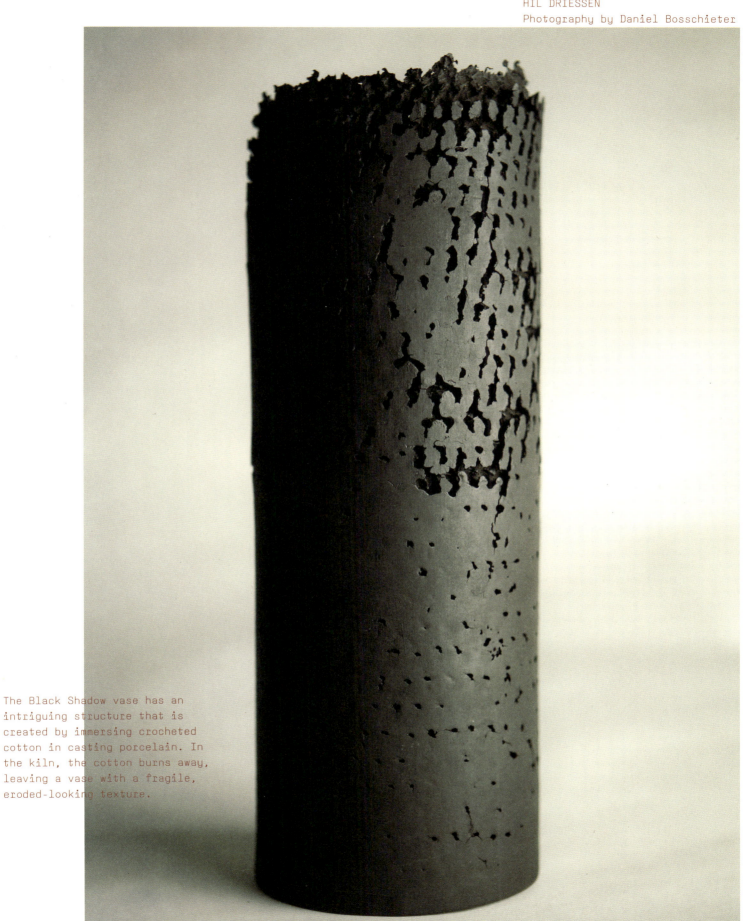

The Black Shadow vase has an intriguing structure that is created by immersing crocheted cotton in casting porcelain. In the kiln, the cotton burns away, leaving a vase with a fragile, eroded-looking texture.

BLACK LIGHT
2006
CHARLIE DAVIDSON
Photography by Toby Summerskill

Atmosphere

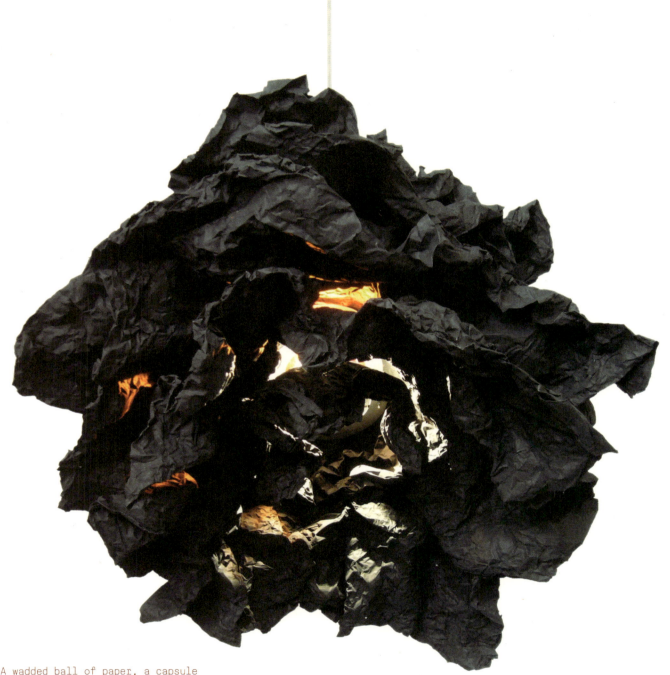

A wadded ball of paper, a capsule of ideas, burned to a crisp. Thoughts recede but smoulder, like the embers of a nearly extinguished crush of paper, weightless, propelled upwards by the heat of the blaze. An ominous black cloud, it hovers in midair. One tender tap and the charred hulk will disintegrate. Surely. The 80-cm Black Light is made from crumpled sheets of blackened foil. Designer Charlie Davidson used coloured illumination foil to create the inner glow.

Down to Earth

225

DICKIES
2004
ANTHONY KLEINEPIER
Photography by Maarten van Houten

Dickies are Anthony Kleinepier's way to raise questions – not to provide answers. He's out to blur the expectations and codes found in ordinary life. He wants each observer to wake up to the fact that he or she is entitled to a personal interpretation of everything viewed and experienced.

ICELAND UNDER ATTACK
2006
HILDUR YR JÓNSDÓTTIR
Photography by Shinji Otani

Atmosphere

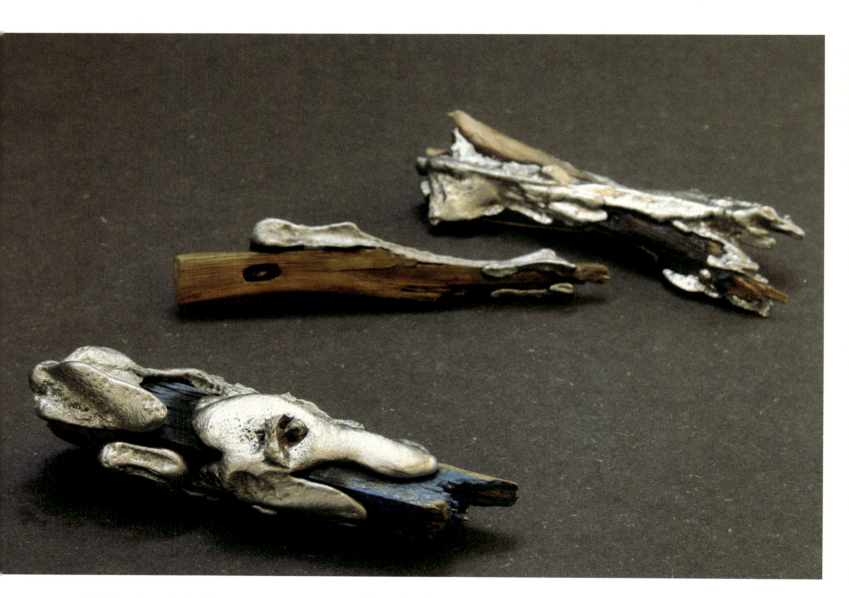

Driftwood washed ashore, overgrown with aluminium. The material looks like hot lava following a volcanic eruption – a coagulating liquid arrested mid-flow – and surely not designed. Nonetheless, this is a brooch, approximately 12 cm in size, with a pin on the back that blends invisibly into the material. Newly graduated from Amsterdam's Rietveld Academy, Hildur Yr Jónsdóttir is concerned about pollution in her native country of Iceland. Hence the name of her jewellery collection: Iceland under Attack.

Down to Earth

MR. BUGATTI
2006
FRANÇOIS AZAMBOURG
Photography by François Azambourg

Azambourg's Mr. Bugatti series features various chairs made from thin sheets of tin that have been crumpled and injected with polyurethane – the observer is forgiven for associating the resulting folds and wrinkles with the 'texture' of a car crash. Mr. Bugatti acquired his automotive moniker from the bright enamelled paints that are used to enhance not only these chairs, but also the most famous cars in the world.

Atmosphere

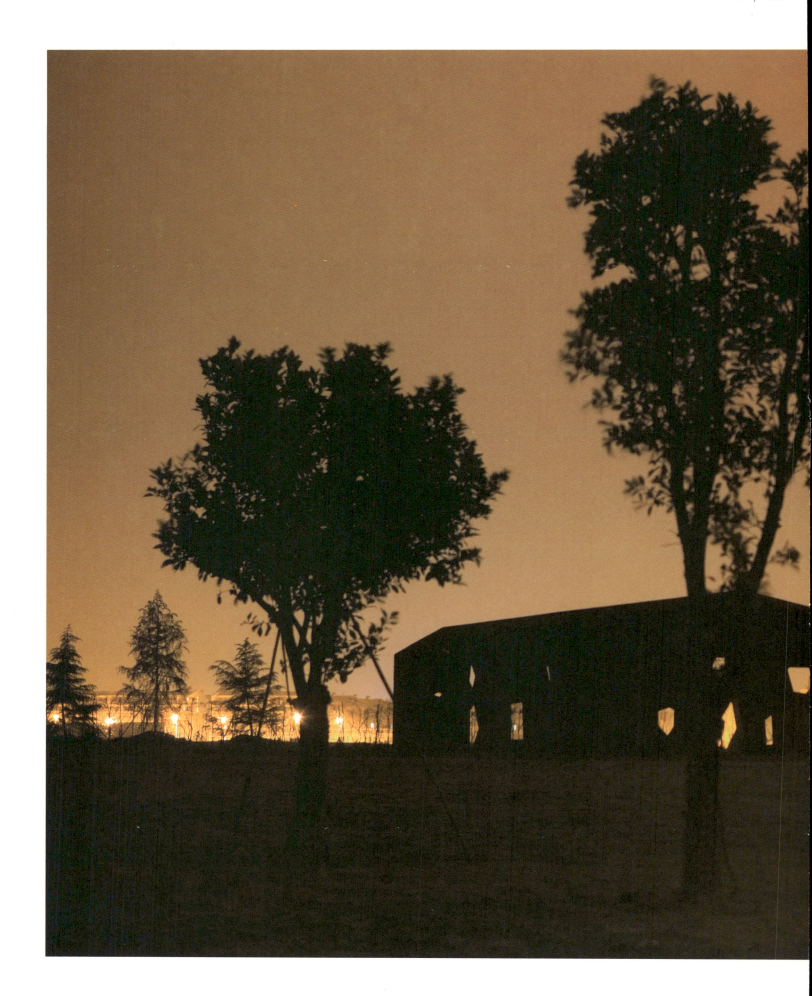

Down to Earth

BABY DRAGON: MINI STRUCTURE FOR CHILDREN
Jinhua Architecture Park, China
2005
HHF ARCHITECTS
Photography by Iwan Baan

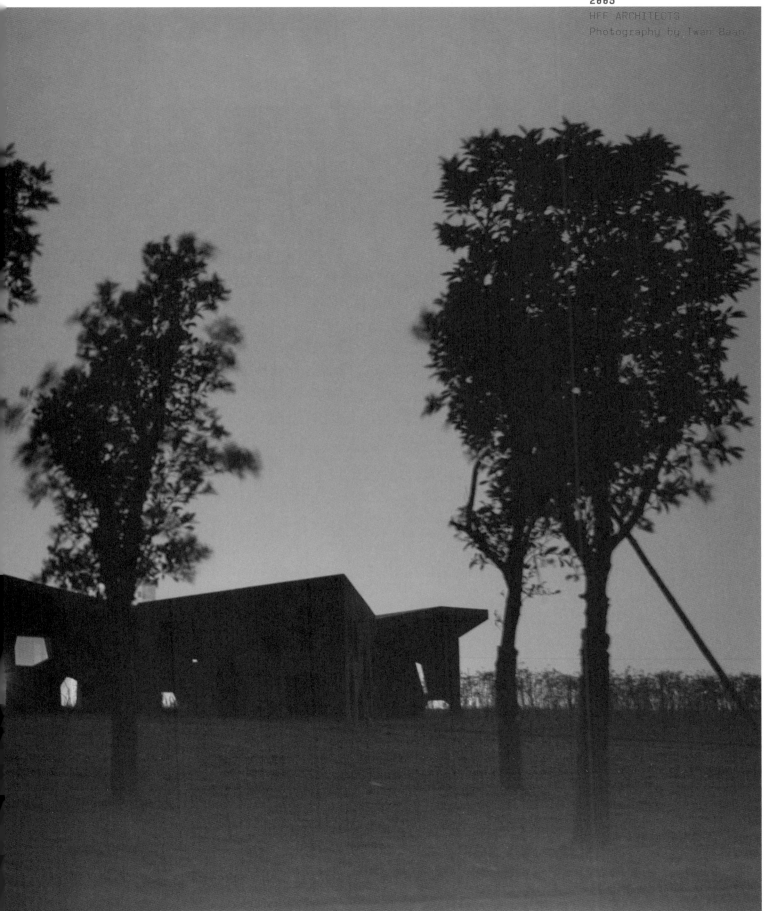

previous page:
MATERIAL
photography by Blommers/Schumm

Right and back: Yellow and red brick made by hand with special clay by Petersen Tegl.
Top right: Black Foamglas Insulation by Pittsburgh Corning Europe.
Middle: Grey Porocom (porous construction material) by Ten Berge Coating.
Left bottom: Grey and brown polymer concrete, an artificial material made with synthetic polymers instead of cement-lime mortar by PP Gevelbouw.

Materials provided by Materia

Addresses Architects, Designers and Artists

5.5 DESIGNERS
Reanim: Medicine for Objects
page: 117
www.cinqcinqdesigners.com

A2O ARCHITECTEN
Twins
page: 94
www.a2o-architecten.be

AB ROGERS DESIGN
Emperor Moth Store
page: 110
www.abrogers.com

AI WEIWEI
Archaeological Archives Pavilion
page: 206
Coloured Pots
page: 113
aiweiwei.fake@gmail.com

ALAIN MOATTI AND HENRI RIVIÈRE
Musée de la Dentelle et de la Mode
page: 192
www.moatti-riviere.com

ALFREDO HÄBERLI
Nais
page: 93
www.alfredo-haeberli.com

ALICE LODGE
Dress Dilate from Paper Fold Collection
page: 154-155
alicelodge@yahoo.com

ANNETTE SPILLMANN AND HARALD ECHSLE
Freitag Flagship Store
page: 127
www.search-arch.ch

ANNIKE LAIGO
Textile + Light
page: 26
www.annikelaigo.ee

ANTHONY KLEINEPIER
Dickies
page: 225
www.anthonykleinepier.nl

ARAKAWA AND MADELINE GINS
Reversible Destiny Lofts – Mitaka (in Memory of Helen Keller)
page: 112
www.reversibledestiny.org

ARIK LEVY, LDESIGN
Fractal Cloud
page: 88
www.ldesign.fr

ARUP LIGHTING
Serpentine Gallery Pavilion 2006
page: 36-37
www.arup.com

ASCAN MERGENTHALER
Reading Space Pavilion
page: 217-218-219

ATELIER DE SANTOS
Maquette Labirinto da Saudade
page: 182-183
www.projects.as

AVAF (ASSUME VIVID ASTRO FOCUS)
Hiromi Yoshii Gallery
page: 131
astrofocus@mac.com

BARBARA NANNING
Transmutation
page: 214
www.barbarananning.info

BATHSHEBA GROSSMAN
Quin
page: 23
www.bathsheba.com

BERTJAN POT
Carbon Cloud
page: 79
City Structures
page: 118
www.bertjanpot.nl

CARLOS MARTINEZ
City Lounge
page: 55
www.carlosmartinez.ch

CECIL BALMOND
Serpentine Gallery Pavilion 2006
page: 36-37

CHARLES BRILL
Wilsonart Nest Chair
page: 86
www.charlesbrill.com

CHARLIE DAVIDSON
Black Light
page: 224
www.charlie-davidson.com

CHRIS KABEL
Fold to fit & 2fold
page: 141
www.chriskabel.com

CHRISTOPHE DE LA FONTAINE
Bent
page: 147

CLAUDE CORMIER ARCHITECTES PAYSAGISTES
Blue Tree
page: 32-33
Orange Basin, Place des Arts
page: 68-69
www.claudecormier.com

CLAUS EN KAAN ARCHITECTEN
Mövenpick Hotel
page: 47
www.clausenkaan.com

COLIN FOURNIER
Kunsthaus Graz
page: 30

COOP HIMMELB(L)AU
Central Los Angeles Area High School #9
page: 122-123
www.coop-himmelblau.at

DAN YEFFET
Hidden.MGX
page: 12-13
www.jellylab.com

DANIEL SCHIPPER
Folding Greenhouse
page: 152
www.danielschipper.nl

DAVE KEUNE, BURO VORMKRIJGERS
Sputnik
page: 145
www.burovormkrijgers.nl

DYLAN GRAHAM
Armada
page: 175
The Old Lie (dulce et decorum est pro patria mori)
page: 176
www.dylangraham.nl

ELLA JANE ROBINSON
Green and Yellow Striped Multi-Media Design
page: 153
stripetastic@hotmail.co.uk

ELVIS POMPILIO
Hat From Bionic Collection
page: 21
www.elvispompilio.com

ERWIN WURM
Fat House
page: 197
studio.wurm@utanet.at

EYLEM ALADOGAN
Californian Condor
page: 208-209
www.eylemaladogan.com

EZRI TARAZI
Baghdad
page: 125
www.tarazistudio.com

FRANÇOIS AZAMBOURG
Mr. Bugatti
page: 227

FRANK GEHRY
Red Beaver
page: 216

FRONT DESIGN
Sketch Furniture
page: 80-81
www.frontdesign.se

GILES MILLER
Ex-box Bench
page: 163
www.farmdesigns.co.uk

GOCE CALOSKI
Ceramic Glow-Lamp
page: 193
www.gocecaloski.nl

HERMAN KUIJER
Light Object
page: 66
Light Installation
page: 48
www.hermankuijer.com

HERZOG & DE MEURON
Allianz Arena
page: 44-45-46
National Stadium
page: 84-85
Laban
page: 57-58
Jinhua Structure I - Cube
page: 217-218-219
Schaulager
page: 211
info@herzogdemeuron.com

HHF ARCHITECTS
Baby Dragon: Mini Structure for Children
page: 228-229
www.hhf.ch

HIL DRIESSEN
Shadow+Shadow porcelain
page: 223
www.hildriessen.com

HILDUR YR JÓNSDÓTTIR
Iceland Under Attack
page: 226
hilduryrjons@gmail.com

J. MAYER H.
Twins
page: 94
Potsdam Docklands
page: 50
Metropol Parasol
page: 18
www.jmayerh.de

JAIME HAYÓN
Showtime Poltrona Armchair
page: 120
Showtime Multileg Cabinet
page: 114
www.hayonstudio.com

JEAN NOUVEL
Guthrie Theater
page: 132-133
www.jeannouvel.com

JEAN PAUL GAULTIER
Jean Paul Gaultier Ready-to-Wear Spring/Summer 2007
page: 67
www.gaultier.com

JED CRYSTAL
Minimal Lamp
page: 179
www.jedcrystal.com

JETHRO MACEY
Lace Paving Slabs
page: 191
www.jethromacey.com

JOEP VERHOEVEN,
STUDIO DEMAKERSVAN
Detail Lace Fence
page: 172
Lace Fence
page: 173
www.demakersvan.com

JORIS LAARMAN
Bone Chair
page: 34
www.jorislaarman.com

JOSÉ ROJAS
Brick Revival
page: 213
jose@joserojas.info

JULIAN MAYOR
Clone
page: 108
General Dynamic
page: 160
Impression
page: 98
www.julianmayor.com

KAI LINKE
Dahlia
page: 164-165
www.kailinke.com

KALEB DE GROOT
Swan
page: 83
www.kalebdegroot.nl

KARIM RASHID
Blend
page: 96
Tide Cupboard
page: 97
www.karimrashid.com

KATRIN KORFMANN
Pink Wall
page: 60-61
www.katrinkorfmann.com

KIKI VAN EIJK
Hexagon Lace
page: 190
www.kikiworld.nl

KONSTANTIN GRCIC
Chair One
page: 87
Diana Side Tables
page: 146
www.konstantin-grcic.com

LIONEL THEODORE DEAN, FUTUREFACTORIES
Tuber9
page: 19
www.futurefactories.com

LOUISE CAMPBELL
Very Round Chair
page: 178
www.louisecampbell.com

Addresses
Architects,
Designers
and Artists

MAARTEN BAAS
Clay Furniture
page: 204-205
Hey, Chair, Be a Bookshelf!
page: 121
www.maartenbaas.com

MAARTEN VAN SEVEREN
Cupboard With Coloured Doors
page: 59

MARAZZI ARCHITETTI
Mimetic Towers
page: 222
www.marazziarchitetti.com

MARCEL WANDERS
Crochet Chair
page: 194
www.marcelwanders.nl

MAREIKE GAST
Itti & Ette
page: 95
www.mareikegast.de

MARK VAN DE GRONDEN
Cupboard of Plastic Crates
page: 53

MATERIA
Materials
page: 38-39-70-71-102-103-134-135-166-167-198-199-230-231
www.materia.nl

MELLE HAMMER
Folding Case
page: 162
www.vouwkoffer.nl
www.mellehammer.nl

MEREL BOERS
A Journey to Miss Blackbirdy's World
page: 77
www.missblackbirdy.com

MICHAEL MALTZAN ARCHITECTURE
Ministructure No 16
page: 92
www.mmaltzan.com

MICHELE DE LUCCHI
Racconti con Cassette
page: 207

MONIKA GRZYMALA
Transition
page: 76
www.t-r-a-n-s-i-t.net

NAOTO FUKASAWA DESIGN
Cosmos 1 & 2
page: 89
Infobar: Ichimatsa and Nishikigoi
page: 54
Ishicoro
page: 24
admin@naotofukasawa.com

NEIL & IDLE ARCHITECTS
Rooney Rose Townhouses
page: 144
www.neil-idle.com.au

NENDO
Bloomroom
page: 29
www.nendo.jp

NOËLLE CUPPENS
Transfer Two # VII
page: 78
www.noellecuppens.nl

OMA
Seattle Central Library
page: 51-52
www.oma.nl

ONTWERPBUREAU MUURBLOEM
Knitted Walls
page: 184-185
www.muurbloem.com

PATRICIA URQUIOLA
Antibodi
page: 189
www.patriciaurquiola.com

PATRICK JOUIN
Solid C1
page: 91
www.patrickjouin.com

PAUL COCKSEDGE
Styrene
page: 35
www.paulcocksedge.com

PETER BERTSCH
Hat From Bionic Collection
page: 21

PETER COOK
Kunsthaus Graz
page: 30

PETRA BLAISSE, INSIDE OUTSIDE
CURTAINS AS ARCHITECTURE
page: 181
www.insideoutside.nl

PIPILOTTI RIST
City Lounge
page: 55
www.pipilottirist.net

PLASMA STUDIO
Interiors for Puerta America Hotel
page: 156
www.plasmastudio.com

R&SIE(N) ARCHITECTS
Asphalt Spot
page: 16-17
Dusty Relief/B-Mu Design for a Contemporary Art Museum
page: 20
Hypnotic Room
page: 15

REALITIES:UNITED
BIX Façade Kunsthaus Graz
page: 31
www.realities-united.de

RECETAS URBANAS
Institutional Prosthesis-2 (EACC)
page: 119
www.recetasurbanas.net

REM KOOLHAAS
Serpentine Gallery Pavilion 2006
page: 36-37
Seattle Central Library
page: 51-52
www.oma.nl

RICCARDO TISCI
Givenchy Haute Couture Fall/Winter 2006-2007
page: 151

RICHARD SWEENEY
Pleated Sheet
page: 161
www.richardsweeney.co.uk

ROB GOULDER
Downtime Airport Hotel
page: 25
robgoulder@hotmail.co.uk

ROBERT STADLER
Rest in Peace
page: 210
www.radidesigners.com/robert-stadler

RONAN & ERWAN BOUROULLEC
The Tiles
page: 49
Assemblage 3
page: 124
www.bouroullec.com

SANDER MULDER, BURO VORMKRIJGERS
Sputnik
page: 145
www.burovormkrijgers.nl

SANDRA BACKLUND
Dress From the Blank Page Collection
page: 140
www.sandrabacklund.com

SASKIA OLDE WOLBERS
Trailer
page: 27
oldewolbe@aol.com

SETSU & SHINOBU ITO
Monolith
page: 149
www.studioito.com

Stefan Diez
Bent
page: 147
Upon Wall and Upon Floor
page: 82
www.stefan-diez.com

STEVEN HOLL ARCHITECTS
Simmons Hall
page: 56
www.stevenholl.com

STUART HAYGARTH
Tide Chandelier
page: 111
www.stuarthaygarth.com

STUDIO JOB
Silhouette Chandelier
page: 174
www.studiojob.nl

STUDIO JURGEN BEY
Blob
page: 115
Cinderella am & Cinderella pm
page: 187
Kokon Furniture
page: 116
www.jurgenbey.nl

TARA DONOVAN
Untitled (Plastic Cups)
page: 22

TEUN CASTELEIN
Artvertising
page: 130
www.sandberg.nl/artvertising

THE NEXT ENTERPRISE
Seebad Caldaro
page: 157
www.thenextenterprise.at

THOMAS GABZDIL LIBERTINY
Dialects of Desire
page: 212
www.studiolibertiny.com

TILL SCHWEIZER
Welcome Centre
page: 99-100-101

TJEP.
Shock Proof Blossom
page: 28
Table Accident
page: 126
www.tjep.com

TOKUJIN YOSHIOKA DESIGN
HoneyPop
page: 142-143
Pane Chair
page: 195-196
X Lexus L-Finesse
page: 90
www.tokujin.com

TOMEK RYGALIK
Raw
page: 215
www.tomekrygalik.com

TORBJÖRN LUNDELL, GLOFAB
GloBe
page: 180
GloCurtain L(ace)
page: 186
www.glofab.se

TORD BOONTJE –
BOUTIQUE ALEXANDER MCQUEEN
Carousel
page: 129
www.tordboontje.com

TWAN JANSSEN
Stage Property # 00703
page: 188
Stage Property # 061002
page: 188
www.twanjanssen.com

ULF MORITZ
Dune
page: 158

UN STUDIO
Agora Theatre
page: 148
Ponte Parodi
page: 150
The Galleria Department Store
page: 64-65
www.unstudio.com

URBANUS ARCHITECTURE & DESIGN
Gangsha
page: 63

VAN HERK & DE KLEIJN ARCHITECTS
Arcam Lecture
page: 109
www.vanherkdekleijn.nl

VIKA MITRICHENKA
Grandmother's Treasures
page: 128
mitrichenka@gmail.com

VLADIMIR LAZAREVIC
Ambrosia Field Collection
page: 177

WIEL ARETS ARCHITECTS
Living Library
page: 220-221
www.wielarets.nl

YUDO KUROSAWA
Stealth
page: 159
www.yodokurosawa.com

ZAHA HADID ARCHITECTS
Elastika
page: 14
www.zaha-hadid.com

Addresses
Architects,
Designers
and Artists

Atmosphere

238

Colophon

ATMOSPHERE
The Shape of Things to Come

PUBLISHERS
Frame Publishers
www.framemag.com
Birkhäuser Verlag AG
Basel • Boston • Berlin
www.birkhauser.ch

COMPILED BY Hanneke Kamphuis and Hedwig van Onna

EDITOR
Marlous Willems

CHAPTER INTRODUCTIONS
Miegiel Loeffen

TEXT
Hanneke Kamphuis, Miegiel Loeffen and Hedwig van Onna

GRAPHIC DESIGN
Roosje Klap
www.roosjeklap.nl

COPY EDITING
Donna de Vries-Hermansader

TRANSLATION
InOtherWords (Donna de Vries-Hermansader)

COLOUR REPRODUCTION
Graphic Link, Nijmegen

PRINTING
D2Print, Singapore

DISTRIBUTION
ISBN 978-90-77174-09-8
Frame Publishers
Lijnbaansgracht 87
1015 GZ Amsterdam
Netherlands
www.framemag.com

ISBN 978-3-7643-8387-9
Birkhäuser Verlag AG
Basel • Boston • Berlin
P.O. Box 133
CH-4010 Basel
Switzerland
Part of Springer
Science+Business Media
www.birkhauser.ch

© 2007 Frame Publishers
© 2007 Birkhäuser Verlag AG
Basel • Boston • Berlin

Library of Congress Control Number: 2007925728

Bibliographic information published by Die Deutsche Nationalbibliothek.
Die Deutsche Nationalbibliothek lists this publication in the Deutsche Nationalbibliografie; detailed bibliographic data is available in the internet at http://ddb.de.

Copyrights on the photographs, illustrations, drawings and written material in this publication are owned by the respective photographer(s), the graphic designers, the (interior) architects and their clients, and the authors.

This work is subject to copyright. All rights are reserved, whether the whole or part of the material is concerned, specifically the rights of translation, reprinting, re-use of illustrations, recitation, broadcasting, reproduction on microfilms or in other ways, and storage in data bases. For any kind of use, permission of the copyright owner must be obtained.

Printed on acid-free paper produced from chlorine-free pulp. TCF ∞
987654321

Atmosphere

240

Chile
COUNTRY OF WINES AND MOUNTAINS

© 2009 Versant Sud

Place de l'Université, 16
B-1348 Louvain-la-Neuve
info@versant-sud.com
www.versant-sud.com

All rights reserved.
No part of this publication may be copied,
entered into any databank or published in any form
whatsoever, whether electronic, mechanical,
by photocopy, photography or any other medium,
without the prior written approval of the publisher.

Photography credits
Unless otherwise specifically noted for images,
all photographs of this work are the work of Matt Wilson.

Graphics and Layout
Sébastien Vellut / Éditions Versant Sud

Printed in Italy

ISBN : 978-2-930358-48-2
Legal deposit: 2009
D/2009/9445/7

Chile
COUNTRY OF WINES AND MOUNTAINS

VOYAGE TO THE WINE COUNTRIES

Photography
Matt Wilson

Papianille Mura

WINES OF CHILE
VINOS DE CHILE®

Wines of Chile was established in July 2002 with the objective of positioning the image of Chilean wine in the world.

Its mission is to strengthen the category of Chilean wines in international markets, by increasing brand value and improving industry exports and returns through promoting diversity and the sale of higher priced wines.

Its vision is to establish Chile as the most impressive and dynamic source of premium quality New World wines.

For more information on Chile and its superb wines, visit:

www.winesofchile.org

To my father,

For his help and for being there when I needed him
For his encouragements
For teaching me about tolerance
For our adventures together in Chile and Brazil.

This book is ours.

TABLE OF CONTENTS

Preface and foreword — 9

Chapter 1
A BRIEF HISTORY OF CHILEAN WINE — 13

Chapter 2
SECRETS OF SUCCESS — 17

Chapter 3
BETWEEN DESERTS AND GLACIERS,
A WINE GROWING COUNTRY — 29

Chapter 4
BODEGAS,
FROM TRADITIONAL TO
AVANT-GARDE ARCHITECTURE — 71

Chapter 5
COLONIAL HOUSES,
LEGACIES OF THE PAST — 87

Chapter 6
VINEYARDS AND HORSES — 101

Chapter 7
INESCAPABLE PLAZAS DE ARMAS,
ARTISANS AND THE GENTLE LIFE — 115

Chapter 8
WINES AND CUISINE,
RENAISSANCE OF YESTERDAY'S FLAVOURS — 123

Chapter 9
VALPARAÍSO, JEWEL OF THE PACIFIC — 133

Practical Notebook — 139

Only twenty years ago, it was very difficult to read a book or a guide about the wines of Chile: it simply did not exist. Things have changed and, today, a wide range of them is available. The work we present here, however, offers an unprecedented view which urges the reading.

Chile, country of wine and mountains presents the world of wine in an original way: situating it within its cultural context. It does not only tell the history and landscapes of Chilean wine, as suggested by the title, but also reveals, smartly and concisely, the structures and customs which surround the vineyards.

A walk in the rural areas of the country brings one to discover the main historical buildings related to wine, which are witnesses of the traditional period of greatness of Chilean wine production, from the late nineteenth to the early twentieth century. A comparative trip from the traditional bodegas to the contemporary ones, with their modern architecture and high technology, introduces the reader to the true cosmology of Chile's wine culture, itself closely connected with such arts as cavalry, handicrafts and gastronomy.

Four major periods can be identified in the history of Chilean winemaking: the wine of the conquistadors and the colonial period, based on Spanish grape varieties (sixteenth to nineteenth century), the French revolution in winemaking by providing varieties, oenologists and technology mainly from Bordeaux (mid-nineteenth to mid-twentieth century), the decay of the cultivation of wine (mid to late twentieth century) and finally the modernization and internationalization of Chilean wine (from the late twentieth century to the present day).

This book is mainly focused upon this latest phase of wine production in Chile, a country which has become a major player in the wine culture worldwide. Chile is the eleventh wine producer in the world and the fifth largest exporter worldwide. Publications such as this one are not only an excellent way to promote the country's industry and image, but also constitute an important contribution to public interest in Chile and its wines.

Mariano Fernández Amunátegui
Minister for Foreign Affairs of Chile

It's impossible to take in a country like Chile. Papianille Mura has nonetheless attempted to rise to the challenge by presenting in this work the emotions, the atmospheres, the images, the landscapes and portraits, linked together as stories sharing the common theme of wine.

Any person who has the opportunity to take this book between their hands, even if only for a few minutes, can never again be happy with the official definition of wine - "product resulting from the natural fermentation of grape juice". Wine, and in particular Chilean wine throughout the pages of this book, reflects the essence of the culture and heritage associated with it.

Really, what is a wine lover looking for when he selects a good bottle? Pleasure, of course. He awaits his glass which delights the nose and enchants the palate. But beyond this satisfaction, he secretly hopes that the wine will speak to his soul, that it will make him dream, will tell him a story, a *vista* and finally will disclose his true identity to himself. Immersed between text and photos, the reader risks losing track of whether it's the book or the wine that is speaking to him.

Papianille Mura could have titled her book "Chile, Wine Country of Mountains and Valleys", but this title would have been redundant since Chilean viticulture is intimately tied to the Cordillera and its valleys. Without relief, Chile would have never known its winemaking epic, and mentioning the names of the Colchagua, Maule or Casablanca Valleys would not have brought a sparkle to the lovers of these great Chilean wines tasted from Tokyo to New York, via London.

It must be borne in mind that the dazzling success story of Chilean wines is very recent – it is no more than 20 years old, which pales in comparison to the generations of winemaking families who for centuries forged the reputation and excellence of the renowned wine regions of the ancient world such as Burgundy or the Douro Valley.

Like the pioneers who at the time of the Wild West Gold Rush were searching for the best vein, the Chilean œnologists are constantly prospecting, researching for new valleys or new *quebradas* that bring together the best plantation conditions appropriate to a particular varietal. Times have changed since the era when, for convenience, huge vineyards were planted around Santiago or close to an axis of communication. Today, the factors to consider for success of large vineyards are much more complex. Altitude, temperature range, the structure and nature of the soil, rainfall, the influence of ocean currents, humidity, sun exposure, labour, drainage, irrigation possibilities, risk of freezing, are just a few.

Given this equation with multiple unknowns, Chile offers infinite solutions. Alternatives are abundant between north and south, desert and the Antarctic, the Pacific and the Andean Cordilleras, coastal regions and the pre-Cordillera, irrigated regions or the *secano*, plains and valleys…

In this dynamic, Chilean wines are writing their stories, stories with an "s" because it would demonstrate ignorance to relate this story in the singular and not differentiate between the characteristics particular to each region and sub-region.

Page after page, the author leads us on and opens up to us a broad panorama which illustrates the many facets of the current reality of Chilean wine activities. A book to be enjoyed with a glass of carménère in hand, iconic grape and genuine flag bearer of Chilean wine growers.

Baudouin Havaux
Editor of *Vino Magazine*, Benelux
President of the *Concours Mondial de Bruxelles*

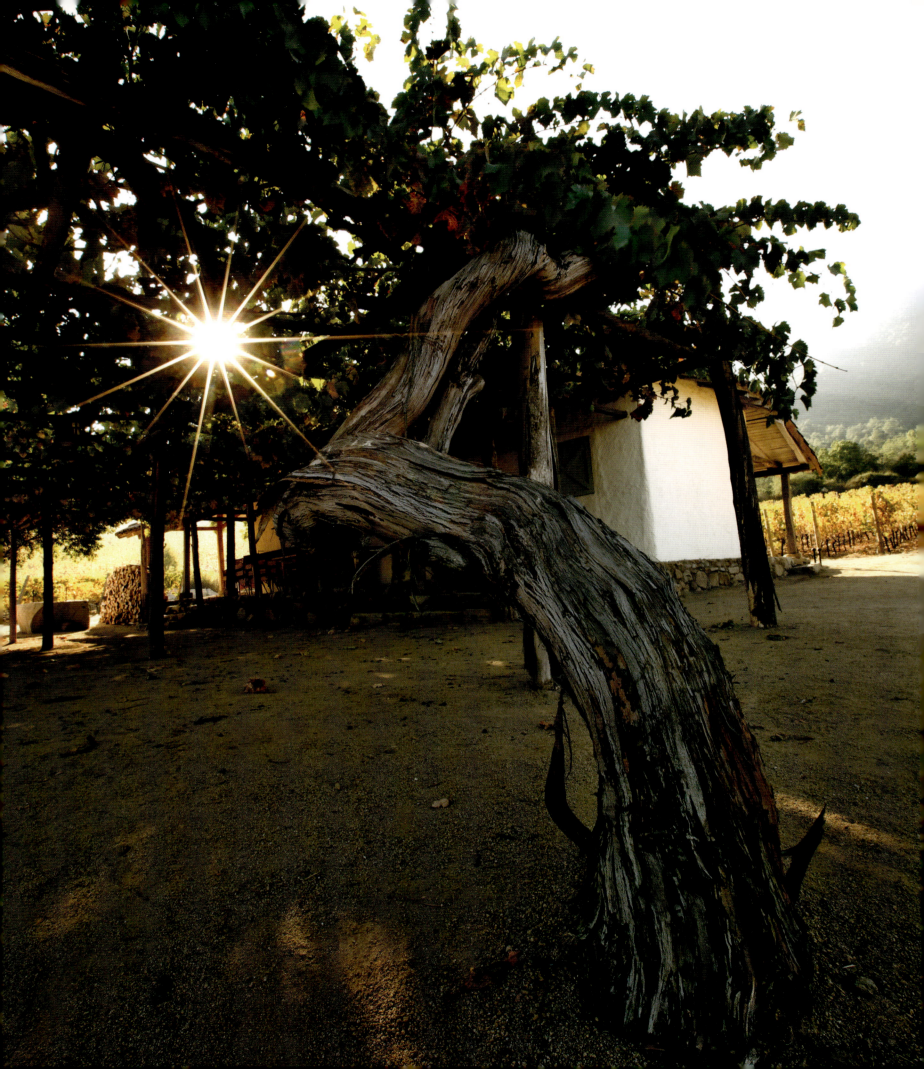

Chapter 1
A BRIEF HISTORY OF CHILEAN WINE

In Chile, wine arrived in the name of God. It was at the time of the Spanish *conquistadors* followed by missionaries that vines brought from the old continent took root in the country. The blood of Christ and the salt of the earth came together in this Promised Land.

◄ Hundred year old vines at the Lapostolle vineyard (Apalta property)

▼ Barrels in *rauli* (native wood species) once used for fermenting wine (Concha y Toro, Maipo Valley)

The priest Francisco de Carabantes, landing in 1548 in the little town of Concepción 435 km south of Santiago, planted the first vines to produce the wine needed for his communion. Local legend has it that the *conquistador* Francisco de Aguirre himself planted vineyards further north. For a long time, the essential cultures for producing wine for the mass were only found around churches and monasteries.

Starting from the beginning of the 17th century, vineyards spread outside monastic enclosures. Given the scale of production, the Spanish Crown became concerned about these

developments which were competing with the sale of Spanish wines in the New World. It ordered the Chilean plants to be uprooted. However, these measures were abolished in 1678 and the vine became firmly imprinted in the Chilean countryside.

Its cultivation spread from the Copiapó Valley in the north of the country to the limits of the Bío Bío River in the south. The wine, produced without much quality, was the product of a single variety of vine called *"pais"* or *"misión"*, in reference to the Spanish missionaries who had imported it.

There was at that time no operation specialising in cultivating wine and viniculture activity only represented a portion of the property's agricultural activity. Wine production was only destined for consumption by its producers and, even if it grew, it could not displace the *chicha*, the traditional alcoholic drink made from corn or apples.

When the independence of Chile was finally proclaimed in 1818, the economic emancipation in respect of Spain gradually encouraged the development of industrial initiatives. Revenues from natural resources (saltpetre and copper in particular) would be the wealth in the coming decades and saw the emergence of a new class of entrepreneurs.

It is thanks to the will and courage of Chilean families enriched by mining activity and motivated by a pioneering spirit that the first vineyards were established.

Sylvestre Ochagavía Errázuriz, an aristocrat known as "the father of Chilean vineyards", imported vines from the old country which he planted in the valleys near to Santiago. Cabernet Sauvignon, Merlot, Pinot Noir, Sauvignon made their entry into the country at this time. Wealthy entrepreneurs such as Cousiño Macul, Undurraga, Concha y Toro,

who already held the reins of political and economic power, invested heavily in the purchase of cellars and wine making equipment, and in hiring French œnologists. Their ambition was to emulate the Bordeaux model. The wine was quickly equated with elegance and luxury.

In 1883, for the first time, Chilean wines were medallists at the Bordeaux Exposition. This success crowned their quality and created a strong demand.

However, the Chilean government, anxious about increasing alcoholism, required owners to limit the production to 60 litres per inhabitant per year. This constraint, between 1938 and 1974, had a beneficial effect because the forced decline in output once again favoured research for quality.

In 1979, the rising fame of Chilean wine and its strong potential prompted the famed Catalan wine grower Miguel Torres to progressively purchase land around Curicó, south of Santiago. This was the first foreign investor to introduce innovative technologies into the country. He was rapidly followed by traditional Chilean producers and new investors.

The Chilean national market became too small for the quantities produced. It quickly turned to foreign markets, so that from 1990 Chilean wine became recognized internationally. This new success led producers to finally consider it as an export product, which is what it is today.

◀ Entrance to the Concho y Toro winery (Limarí Valley)

▼ Mythologically inspired mosaic (Santa Alicia, Maipo Valley)

A Brief History of Chilean Wine

Chapter 2

SECRETS OF SUCCESS

What then is the secret of Chilean wines? Thanks to which alchemy did they succeed in carving out a choice spot on the international scene since the 1990s? How is it that they managed to meet the needs of consumers?

It should be noted here the tireless commitment of producers to implement, at enormous cost in material and human resources, techniques and skills that were going to sit well with the already established reputation of a highly diversified vineyard.

It is just as the Chilean wine growers, in spite of their recognised wine growing traditions, have brought young European œnologists to manage their large domains and to bring to them a new historical and cultural experience. These were given carte blanche for developing or implementing new varieties, modifying techniques for vine sizes favouring quality over quantity, selecting plants or even perfecting traditional

◄ Cluster of Carménère grapes

▼ Working inside the Lapostolle bodega (Colchagua Valley)

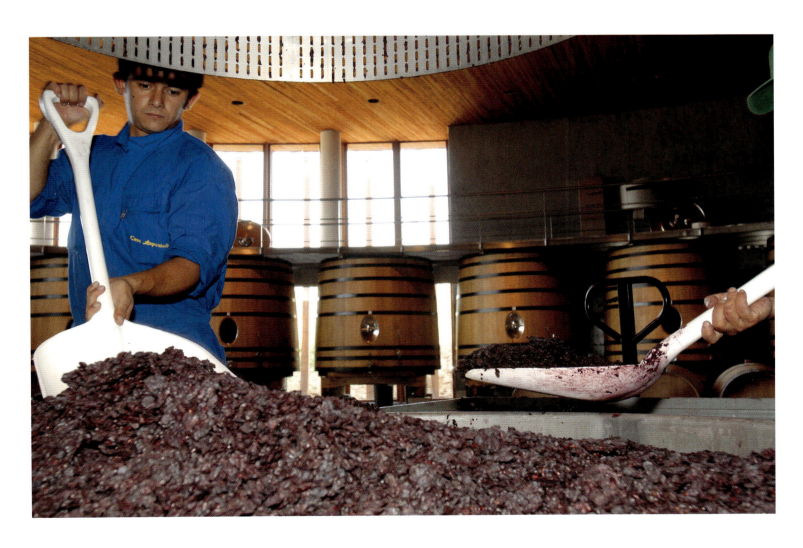

vinification techniques. These œnologists, employees or independent service providers, are taxed to the point that it would be inconceivable today in Chile to operate a vineyard without enlisting their services. Essential participants, they convinced their clients or employers that certain types of soils are better suited than others for the selected varieties. Over the last ten years, the plantations have since been reorganised within the properties. The same approach can be seen across several regions, where their natural aptitude to host some varieties rather than others have been discovered. So the recent development of the Casablanca Valley, between Santiago and Valparaiso, responds to the desire to draw its properties from the soil. Thanks to a cool maritime climate, it has been found to be an ideal place for Chardonnay and Sauvignon to be grown. They can fully develop their specific aromas. Casablanca is not the only region where this dynamic is asserted. With time, the identity of each wine region is refined, as is that of each piece of wine growing property in the valleys of Colcahgua, Cachapoal, Maule, Maipo, Curicó, Limarí or Elqui. The discovery of these characteristics opens the way for a commercial redeployment based on local taste characteristics. There is in this emerging trend a new challenge by Chilean wine to its competitors.

Recognition of the quality of Chilean wine finds its origins in the care given in its production. For a long time now the fermentation casks of *rauli*, native wood of southern Chile, have been replaced by stainless steel casks. Wood barrels selected from the best French or American suppliers have been systematically used for aging of wine. Some renowned

▼ Two types of barrels, in French or American wood, guarantee of quality and professionalism (Casa Silva, Colchagua Valley)

and perfectionist wineries only use these barrels one time for production of their fine wines. The almost sacred attention given to transmutation of musts into wine goes hand in hand with techniques to prevent any abuse or risk of alteration. Thus, the juice is transported by gravity rather than by pumping. The producer's cellars, large or small, have become "temples" where "priests", serving an absolute of quality, serve in a frequently refined world, carefully staged by the best architects. This gives the image of building a perfect and exceptional product. Visiting the splendid *bodegas* of the Colchagua valley gives at once, even before having tasted its wines, the feeling of having been called, by the grace of God and those who serve Him, to share in moments of uncommon gustatory beauty and emotion.

What then are these "priests" in the service of the pagan cult to the glory of Chilean wine? Who are they, who have risen to a now recognised level of quality and complexity?

Here, in the liturgy, everything differs from common practice on the old continent, where the standard is still that the wine grower is at once the owner of the exploited land, the skilled vineyard craftsman, the vinification engineer, the cellar master, the operation manager, the enlightened and jealous lover but also the active ambassador of "his" wine. In Chile, there is nothing comparable. Nearly all wine growing operations are designed according to an industrial mode. The area covered by vines is there for something. Here are vast

▼ Currently, fermentation tanks in stainless steel are increasingly replacing those in *rauli* (Casa Silva, Colchagua Valley)

▶ Transferring grapes to a lower level by gravity to avoid stressing them (Lapostolle, Colchagua Valley)

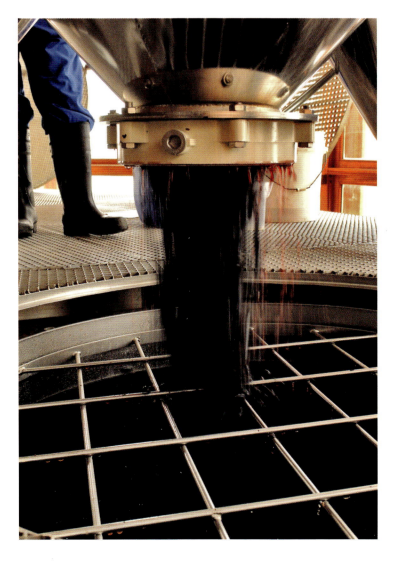

Secrets of Success 19

territories to be exploited, many hundreds of hectares in size - Concha y Toro manages 7,000 hectares of vines and Falernia, with its 300 hectares in the Elqui Valley, considers itself as an average operation. The division of tasks all the more demands that research for the quality needed requires real expertise in all production areas. Moreover, in order to answer to their client's tastes, differing from one country to another, producers demand dexterity in adaptation of their wines and product lines. It is especially to meet this challenge that the œnologists have captured a choice place. The profession is practised as much by women as by men. Mostly young, educated in Chile or other producing countries, they enjoy considerable autonomy with regards to the consortium of owners who employ them. They are masters of vineyard development in siting of vines, development of wine making methods and research into blends when it comes to creating a new wine. But the law of the market being tough, the artist-œnologist that confronts it is sometimes forced to give way to the marketing director who gives him a different direction for research. A compromise then must be struck between the desire to create a wine of excellence to the œnologists' taste and the need to invent a product that complies with the client's wishes. Nevertheless, the search for the essential quality of wine has brought together all Chilean production to its reputation for excellence.

▼ Montes vines and *bodega* in the Colchagua Valley

The Chilean producer, recognized since 1990 on the global wine market, has been given all the means for his success. This is all the more remarkable given that Chileans, with the exception of the most affluent, are only small consumers (15 litres per inhabitant per year, compared to 54 litres for France). Almost all production is therefore intended for export to one hundred and twenty countries. The selling points are the quality now acquired and the excellent value for the price. It is for good reason that the land area destined for wine growing doubled from 1996 to 2006 from 56,000 to 117,000 hectares. Planting of new varieties has greatly broadened the range of available flavours. Cabernet, Merlot and Carménère widely prevail up to the late 2000s.

We tend to describe Chilean wine as "grape wine", just as we present Bordeaux wine as "Châteaux wine" and that of Burgundy as "*clos* wine" *[the French word refers to the walled vineyards of Burgundy]*. Similarly, it is common in Chile to appropriate the vineyard into the brand that created the wine.

Production of Chilean wine is a drama of grape exchanges between producers. The cellars or cooperatives, to meet the

▼ Cabernet (Colchagua Valley)

▼ Merlot (Colchagua Valley)

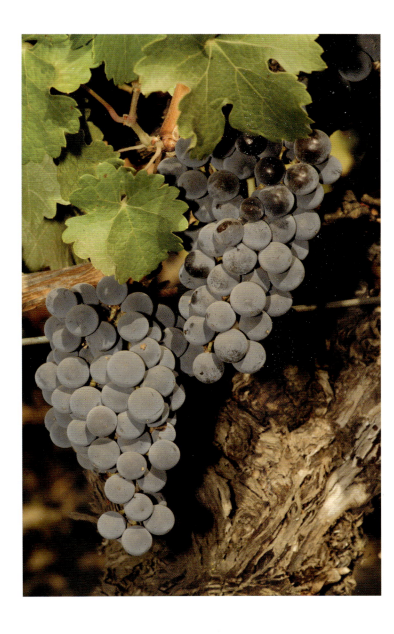

needs in well defined categories, sell all or part of the grapes produced on their land and buy others elsewhere. This results in a relative flexibility of supply in the desired quality, which allows the *bodegas* to produce several ranges of wines to meet the need of the moment without having to irreversibly change the grape varieties of the vineyard.

It is advisable today to do away with the perception that Chilean wine is only one variety of wine. Admittedly, there are within the wine producer's range many *"easy to drink"* wines with easily identifiable flavours and regular taste. But there also exists in almost all vineyards ranges of wines which mature for a period in oak barrels justifying various qualifications ranging from *Reserva* to *Premium*, at the discretion of the producer.

The wine *bueno, barato y bonito* (good, inexpensive and pleasant) has now given way to wines of the highest quality, easily recognized with the criteria shown on the labels: designation of origin or wine-producing valley, name of the grape, percentage of alcohol, net contents, crop year and sometimes the name of the vineyard (e.g., Apalta). From *easy to drink* to *easy to see*, so to speak…

But in all the major vineyards, Chilean œnologists, like their European counterparts, have developed blended wines (made with several grape varietals) both for the pleasure of creating them but also to differentiate their production from those of their competitors. The famous Carménère associated with other Bordeaux varietals (Merlot and Cabernet-Sauvignon) will find a place of first choice. The blend makes it possible to produce wines of great complexity, suitable for aging, with price and quality that meets those of the great classified wines of the Medoc.

Let us give here some examples of high technology described above and the know-how symbolising the union of the Old and New Worlds. The first is the *Clos Apalta* in the Colchagua Valley. Alexandra Marnier-Lapostolle, on the advice of the French œnologist Michel Rolland, and within a beautiful natural setting whose æsthetics have been thought out to the minutest detail, develops a wine of rare elegance. The second is that of Almaviva in the Precordillera area of the Maipo Valley,

Carménère is the emblematic vine of Chili. Imported from Bordeaux in France in the nineteenth century to enhance the colour of Chilean wine from other grapes, it was long confused at the time of import with the Merlot. During this time, in Europe phylloxera was definitely gaining the upper hand. All the same, today, and for the last two decades, this vine, so complex to work with because of the need to adapt to poor soils and the difficulty in bringing its grains through to maturity, has finally found its "letters of nobility" and has become a light-hearted ambassador of Chilean vineyards.

where the Bordeaux tradition represented by the house of Baron Philippe de Rothschild and the Chilean tradition by the house of Concha y Toro combines with exceptional soil to produce prestigious wines. We also include the great wines which are Seña (Errázuriz and Mondavi vineyards), Alpha M (Montes vineyard) and Lota (Cousiño Macul vineyard), etc.

This level of production excellence leads to exceptional wines that could not be attained in the last decade. Other less known "houses" could, with the same determination and using new techniques, also achieve an optimal degree of perfection and subtlety. In the coming years, we may think that the œnologists, freed from the urgency to focus on the quality which has now been acquired, will create wines with their own identity as are those of the Casablanca region, due to the nature of its soil and climate. Several Chilean university institutes are already working on the scientific basis for the balance between the nature of the soil, microclimates and specific grape varieties. Collaborating in this work are producers such as Casa Silva in the Colchagua Valley.

▼ Outstanding in the world of wine! Barrels of Carménère and Cabernet blend (Casa Silva, Colchagua Valley)

Another promising profile for the future is the ecological sector. Chile is very attracted by a reasoned, organic, biodynamic and even holistic viticulture. Organic cultivation principles are become increasingly widespread. As examples, and there are many others, the Emiliana and Lapostolle vineyards have a strong policy of communications about the organic cultivation of their vineyards.

Biodynamics came under the influence of the agronomist Rudolf Steiner. He developed the principle of fertilisation of the vineyard with "energised" compost, which gives it a greater receptivity to the "forces" of nature, natural and cosmic. According to the œnologist of Emiliana (Colchagua Valley), this biodynamic concept could give a new identity to Chilean wine and remove from it negative criticism that is made of it being a cloned wine…

Finally, the importance of another model should not be neglected, that of the independent wine grower, modest landowner, successful in producing a wine of quality and character on his soil.

Such is the bold and enterprising Dueña de Casa Marin (San Antonio Valley). Likewise are the Gillmores, a dynamic

▼ Biodynamic vineyards in enticing countryside (Lapostolle)

young couple who make their wine as a reflection of their character (Maule Valley).

Likewise the owner of the Reserva de Caliboro (Maule Valley) whose Erasmo wine is the product of a symbolic alliance between his European knowledge and his formidable passion for this little corner of the world which gives a complex wine, focused by the devotion of the craftsmen of the vine.

Likewise this enterprising young retired couple, Raymundo and Maria Luisa, who, in the Elqui Valley, decided to create from nothing, at twelve hundred metres altitude, a small vineyard of five or six hectares (Cavas del Valle) sufficient to produce three wines including a very dry muscatel of Alexandria and a *muy colorido y muy tinto* (deep ruby colour) Syrah. Their only clients are passing Chilean tourists and friends reached by word of mouth.

▼ Cavas del Valle, the small vineyard of Raymundo and Maria Luisa (Elqui Valley)

▶▶ Another approach to environmental concerns – the quiet charm of the Matetic vineyard (San Antonio Valley)

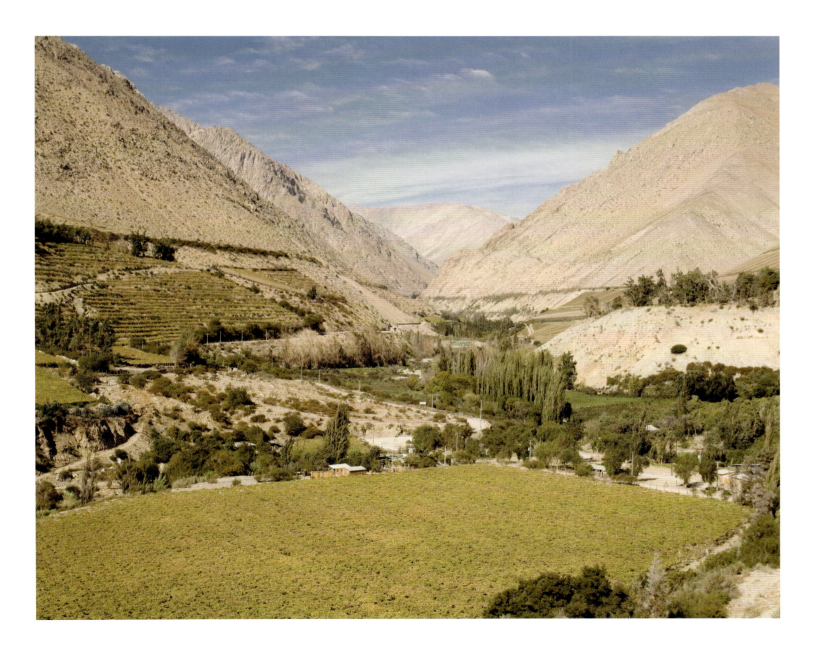

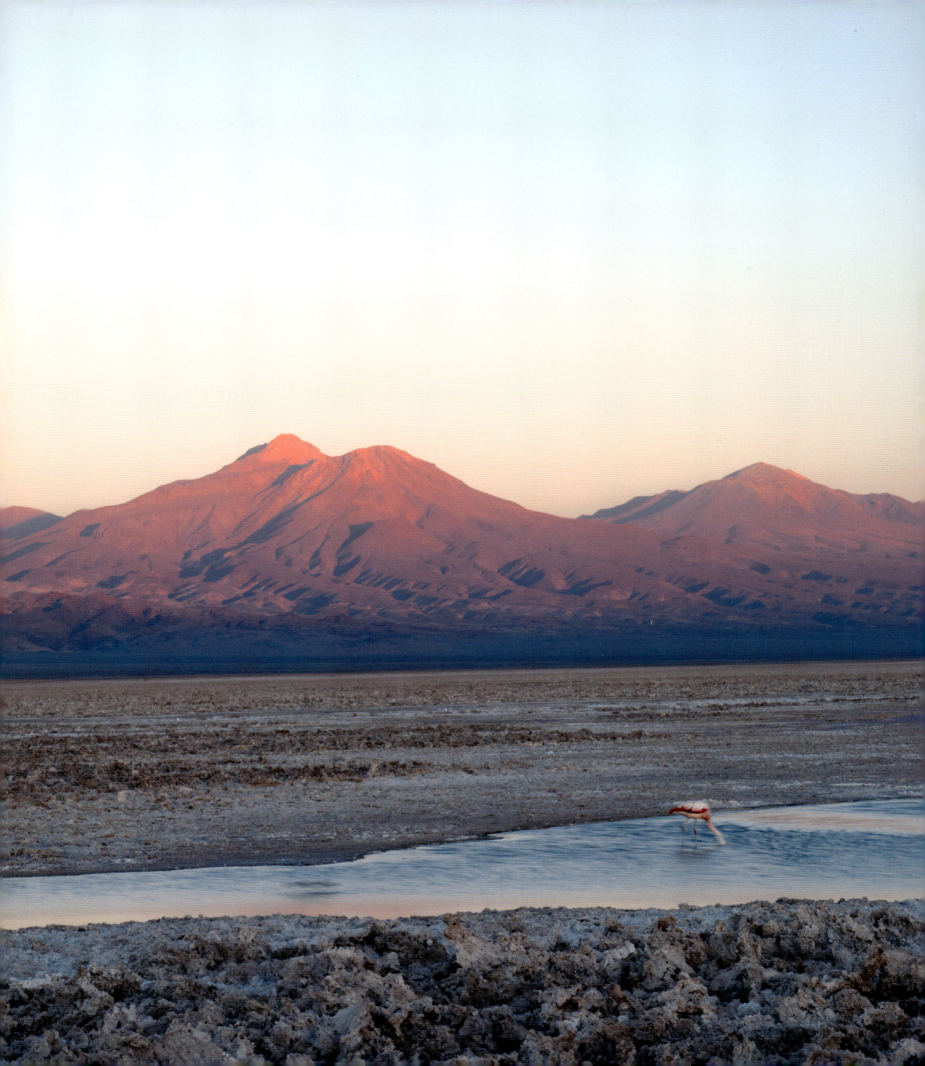

Chapter 3
BETWEEN DESERTS AND GLACIERS
A WINE GROWING COUNTRY

On the *Pan-Americana*, the 23,000 kilometre long highway connecting the Americas from Alaska to the gates of Patagonia, a veritable roadway backbone for Chile, a sign proudly proclaims at La Serena: Santiago 474 - Curicó 665 - Puerto Montt 1392.

Forever astonishing the traveller who faces the vastness of the omnipresent mountains, astonishment at the dimensions of this thread-like country, it is stretched out over more than 4,300 kilometres from north to south and embedded between the Pacific and the Cordillera at 300 kilometres wide at most.

In the middle, an Eldorado. Bordered by the Atacama Desert in the extreme north and the lakes and glaciers of the southern zone, geographers place it more precisely between the 29th and 40th parallels south. Surrounded by natural barriers, this vast territory with a thousand agricultural

◄ Atacama Desert

▼ Immense parcels in the mountains (El Olivar property, Viu Manent vineyard, Colchagua Valley)

►► Snowy gem nestled among the peaks for the Portillo ski resort

advantages was enriched with the culture of the vine on parcels that the European observer considered disproportionate, given that his eye was familiar with the small vineyards of the old continent. However, the landscape is anything but monotonous here, because as far as the eye can see these alignments shape a surprising geography, with market garden and fruit cultivations fed by salty Pacific air, rivers fed by Andean glaciers, fragrant eucalyptus groves, formidable candelabra cactus, protective poplars, or even indigenous trees such as the *boldo, peumo, litre* and also the famous *quillay* evergreen tree whose bark is still used today as a cosmetic.

Omnipresent, the Andean Cordillera plays the role of foster mother.

Its snow fed rivers bear exotic names such as the Maipo, the Maule, the Aconcagua, the Tinguiririca, the Elqui, the Bío Bío Their waters have been captured since the Inca period to form a clever irrigation system designed to overcome a near-absence of rainfall during summer. This network was modernised in the 1830s, modelling a new agricultural landscape of large horticultural, fruit and wine crops, or smaller parcels in terraces clinging to the slopes of the valleys. Today, these irrigation techniques are being gradually replaced by drip feed at the foot of the plantations.

The Cordillera continues to play the role of mother protector.

In the 1860s, phylloxera destroyed virtually all European grapes. To restock their vineyards, the ruined vine growers imported intact plants into Chile. These were grafted in such a way as to preserve them from the ravages of this insect. Even today in Chile, the majority of vines are not grafted, and it seems that due to irrigation and the natural barrier of the Andes this insect cannot reproduce. Nonetheless, as a precaution, new plantations are generally grafted when recourse to irrigation is reduced or nonexistent.

▼ Sunset on the *río* (river) Tinguiririca (Colchagua Valley)

▶ Rows of vines in the arid Limarí Valley (Tamaya)

▶▶ Autumn scenery in the Colchagua Valley (Lapostolle)

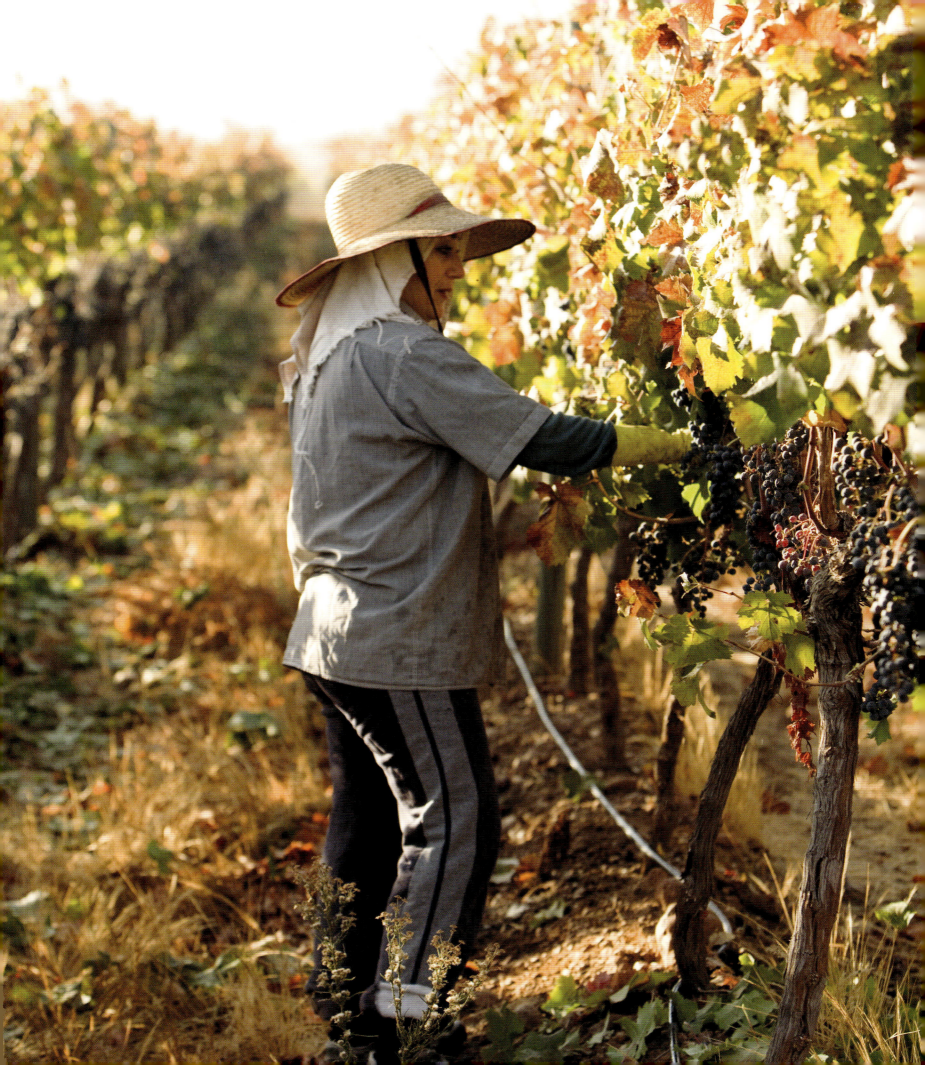

In the paradise of the Andes, the sun is king for eight months of the year, from October to May. This generous sunshine, which only occurs very rarely in other wine regions of the world, is ideal to give the grape an exceptional richness in sugar and tannin. However, there are climatic variations from one region to another. This is where œnologists come into play, in order to adapt the characteristics of some varietals to local climates. So in the coastal regions near to the waters of the Pacific cooled by the Humboldt maritime current, the cool and relatively dry climate is favourable for some varieties, while others, near the centre of the country, to reach their potential need a wide temperature range between day and night, favoured by the proximity of the Andes.

◂ Golden sun and harvest (San Pedro, Curicó Valley)

▾ Reddened nature and late vintage (Lapostolle, Colchagua Valley)

▸▸ Farmer and team in the Maule Valley

The scenery around the vine comes alive suddenly from March to May. While the sun still floods the plains and hillsides, cohorts of workers take to the lines of vines, armed with secateurs, from dawn until the sun slides behind the mountains. As in any country during harvest, the place becomes feverish, but with a fundamental difference - harvest lasts three months. The grapes from the Chardonnay and Sauvignon, the earliest to reach maturity, are harvested first. Those of the famous Carménère come last. Vans quickly move this heavenly treasure from remote parcels of the property to the *bodega* – sometimes over long distances. There, other workers take over and collect the harvest, handling it with utmost care, creating an exceptional energy in this quiet countryside where the autumn mists sometimes render it unreal. So prepares the happy marriage of human activity and the peaceful beauty of nature, which annually produces wonderful wines, the legitimate heirs of the work of man and the soil.

The harvest time is an ideal moment to experience the fruitful richness of this blushing nature. The traveller will find for himself the superlatives to describe his emotions facing this impressionist canvas. Let him discover and taste to his pleasure. To share so much inner joy, it will suffice him along his road to receive with simplicity the legendary hospitality of these *Chilenos* (Chileans), whose smile, kindness and attention always charm the visiting stranger.

The traveller will also enjoy his long visits to the *bodegas*. This tourist activity will amaze him. In the past decade, wineries are almost all equipped with cellars which are open to visitors, often with functional avant-garde architecture. The great names of Chilean wine, in order to provide their clients with a luxury image, have associated the quality of their products with frequently original æsthetics of the building for the vineyard operation. Their construction, always well integrated with the landscape, has been entrusted to architects of renown, Chilean or foreign. The materials are often chosen from among the most noble, as for the construction of cathedrals whose original æsthetics are put to practical use. But what we must not mistake is that the taste for beauty is associated with good taste, answering in these places the needs of a rationalised operation, which sets passion for wine on a level with the sacred. In these inspiring places, often built with the ulterior motive to develop a luxury œno-tourism, the traveller will always be welcomed. After his visit, he will be invited to taste the wines of the range. Timid at first and anxious to keep his rank of discerning amateur, he spits out the first taste-test like an Andean llama from the mountains. But very soon, attracted by the aromas, he cannot help but swallow the second. *"¡Yo me lo tomo!"* (I took it!), he'll say, delighted.

Sober, continuing on his voyage that leads him to other vines, the traveller will discover the profound imprint left by history on the landscape. An impressive range of tracts, a diversity of agricultural and viticultural production, everything here recalls the latifundial thinking of the first European farmers of the eighteenth century, barely touched by the independentist current unleashed in 1810 by Governor O'Higgins and successive agrarian reforms.

No doubt about it, his instructive stroll will lead him to discover the valleys and their wine routes. Let us accompany him throughout his journey to better grasp its harmonies.

▶ The serenity of the *Cajón del Maipo* and one of its *campesinos* (farmers)

THE ROAD OF CASABLANCA

From Santiago, the capital, head for Valparaíso, due west. This mythical name evokes both Paradise (*el paraíso*), the robust yachts of Cape Horn, sailor's bars and easy girls, pirate attacks, Pablo Neruda, whaling and nostalgia for times past.

But before reaching the misty ocean spaces, salty and sparkling, the road to Casablanca attracts the eye of the traveller. All at once, on the left, the first rows of vines appear, like the teeth of lopsided combs styling the face of the hills. A freshness takes hold of him. The vague fragrance of the Pacific will instruct him that in this valley, recently converted to cultivation of the vine, the taste of the ground and that of wine commune in the salty ambience of the neighbouring ocean.

In the place of honour here is the mischievous Sauvignon. Under the effect of ocean mists, its velvety and tanned flowers transform each year into golden bays, whose melting pulp becomes a wine distinguishable among all by its aroma of fresh boxwood and crushed blackcurrant buds.

Equally in the place of honour is the elegant Chardonnay, whose wines offer complex and intense aromas, with flavours of linden, peach-pear-lychee alongside those of brioche, hazelnut and straw on a base of citrus lemon, vanilla and roasted cedar.

These two grapes are found in this parcel of land, once lean pasture, and a haven that allows them to flourish. A tasting is required in the *bodegas* of architecture that is sometimes grandiose, a hybrid of European château and Hollywood temple. At *Veramonte*, *Indomita* and *William Cole* in particular, a friendly and caring welcome combines perfectly with the finesse and subtlety of the wines tasted.

▼ Typical Chardonnay alignment – two rows and a space

▶ The amazing "chateau" of the Indómita vineyard, perched atop a hill

THE ROAD OF MAIPO

Our traveller will leave here, this time, his coastal dream and retrace his steps. Just before Santiago, he will bear towards the south and enter into the Maipo Valley. Here, there is no doubt; the singular appearance of the houses tells him that he is in the historic cradle of Chilean wine.

It was in the early nineteenth century that families who had made their fortune in the mines and always wanting to go into business became interested in the vine. They saw a new way to build on their heritage. They imagined and conceived in this region not far from Santiago, on the gently sloping soils enriched with alluvia from the Maipo River, vineyard operations with an impressive area in comparison with the European model. The *Cousiño, Undurraga, Concha y Toro* families, among others, then embellished their residential operations enclosed in parks, often designed by French landscape architects. Sometimes they can be visited. What our traveller does not expect to see is wine making centres everywhere, which are often located in the south. He may however participate in tastings and have the pleasure of strolling through peaceful havens, close to the capital and at the foot of the Cordillera.

▼ Intimate patio (Santa Carolina)

► The good life in the guesthouse garden (Tarapacá)

►► Glints of dawn on the lake (Tarapacá)

THE ROAD OF COLCHAGUA

Regaining the Pan-American, the trip resumes. Towards the south, after crossing the city of Rancagua, celebrated for its *rodeos,* our traveller arrives at San Fernando and decides to head to the west, along the winding Tinguiririca River. This very well irrigated valley has an agricultural vocation, producing cereals, fruits and tomatoes. Since the introduction of the first vines by the Jesuits of the sixteenth century, the region has had time to assert its wine making destiny, producing wines sold in bulk to neighbouring regions, including the Maipo. It was in the 1990s that it became clear that this land was worth more than the simple use made of it previously. Large investors, already renowned in Chile or Europe for the quality of their wines, bet on the local climatic conditions and created exceptional vineyards. There are, for example, at the foothills of Apalte, not far from Santa Cruz, *Lapostolle, Las Niñas* and *Montes*. Then, later on in the valley, *Errázuriz Ovalle* and *Los Vascos* which, with a blend of Cabernet-Sauvignon, Merlot and Carménère, produce dream wines.

Tradition and modernism rub shoulders. It is not uncommon to cross paths with huasos, modern Andean cowboys with cell phone in hand and driving their 4x4s, or with *peones,* peasants. All, of course, wearing the traditional straw hat, the *chupalla.*

▼ Lapostolle Vineyard

▼ Montes Vineyard

Some *casas de campo* have been transformed into luxury hotels. Old restored colonial mansions, they welcome demanding tourists, lovers of wine and comfort. This might give an idea of how the landed aristocracy of the last century lived, admiring the objects and collections imported from Europe. If he has the urge to wander and see the country, he will be transported literally and figuratively by *el train del vino* which, towards Santa Cruz, a charming colonial village, winds its way through the Colchagua Valley.

▼ Superb location in the heart of the vineyards for the Mirador Restaurant at Lolol (Santa Cruz)

▶ *El tren del vino*, an initiation to travel in the Colchagua Valley

▶ Siesta in the vineyards (Viu Manent)

▶▶ Foggy winter morning in the Apalta vineyards

Between Deserts and Glaciers

THE ROAD OF CURICÓ AND MAULE

Head back once again towards the South, via the Pan-American. This time we approach a high point in the history of Chile, wine territory in affirmed traditions and complex geography.

It is impossible to bring this region to mind without beginning by recalling the struggle for autonomy by the Mapuche people in the middle of the sixteenth century. It is here that a young chief named Lautaro distinguished himself. Chosen by his people for a campaign against the invader, he distinguished himself by his warlike actions which were crowned with victory. With a strategic intelligence and exceptional guerrilla techniques, he diverted the enemy and, after having destroyed a number of his forts, providing the Mapuches possession of the territory in the south, in the region of the Bío Bío River. Unfortunately, he met a tragic end. Betrayed by one of his own men when he was preparing an attack on Santiago, he was assassinated at the age of twenty-two years. Even today, this historical personage is the symbol of hope for the Mapuche people in their struggle for recognition of their rights and cultural traditions, violated especially during the dark days of dictatorship.

▼ Horse drawn cart in the Maule Valley

It is also impossible to ignore the fact that in this region, the struggle for the independence of Chile, led by the *Libertador* O'Higgins against the Spanish monarchy, ended at Talca with the signing of the Act of Independence on February 1st, 1818.

Once having passed Curicó, our traveller, continuing his way down the Pan-American, will devote himself to visiting the vineyards along the highway. Among the medium sized operations that characterise this region, the most emblematic of the pioneering spirit is undoubtedly that of *Miguel Torres*.

In 1979, this entrepreneur of the vine from Catalonia decided to buy land around the city to plant vineyards, with a commercial vision that we would call globalisation today. The traveller will continue his way further south still, to the Maule Valley. On both sides of the Pan-American stretch a mainly verdant countryside, decorated with eucalyptus forests, Oregon pines and rows of olive trees. In this setting, the vineyards were lost in the expanse. The priest Carabantes had already planted the first vines in this cradle of the Chilean vineyard, in the sixteenth century.

▼ Mystic atmosphere around the ruins of this adobe house

▶▶ Horse hitch for the *huaso* rider

The small farm reigns. Winemakers still make their wine from *país* grapes, as they still make the *chichi* for their family's consumption. This intimate geography provokes a hardier winemaking lifestyle than further north, which makes it deeply endearing.

The regions by the coast, near Concepcíon, constitute the "*secano*" zone. On poor soils, the *país* and *carignan* grape varietals offer their profuse thanks to the rain which is sufficiently abundant to permit "*en secano*" viticulture, that is, without irrigation.

The *Gillmore, Caliboro* and *Bouchon* winemakers, with their passion for authenticity and the expertise of their wine growers, highlighted the spirit of the "terroir".

A charm emanates from their country house in colonial style which is still authentic. One of them belongs to the University of Chile and holds the seat of the Association of the Maule Wine Route.

Our traveller, full of history and aware of the link that naturally exists between the vine, man and the terroir may, with a little perserverance, continue his journey. He will turn back on a new road and this time head North. There, he will be able to taste his wine under the stars.

▼ J. Bouchon Vineyard

► San Pedro Vineyard

►► Early morning at Molina (San Pedro)

INTERVIEW WITH ANDRÉS SANCHEZ, ŒNOLOGIST OF THE GILLMORE VINEYARD IN THE SECANO ZONE

Papianille Mura: What are the characteristics of the Secano area?
André Sanchez: This region is close to the Pacific coast. The poor soils and regular rainfall of between 700 and 1,000 mm allow viticulture without irrigation. Recall that the conquistadores arriving near to Concepcíon planted the first vines there. Sprinkled by the rain, they are remarkably suited to the red soils in the gentle surrounding hills. This area was long forgotten. It continued to develop discretely, however, by using the país grape to which was added the Carginan and Italia.
PM: What is the wine growing profile in this region?
AS: The wine growers are owners of parcels that are sometimes less than one hectare. They have preserved their hundred year old vine stock there, cultivated according to practises similar to those used at the arrival of the conquerors. Some visionary winegrowers believe profoundly in the features of this region, while grafting noble grapes onto these hundred year old vines and experimenting with wine growing practises that have not been usual in Chile in the last decades.
PM: What's special about these wines?
AS: These are wines of great concentration, low acidity, strong character and high aging potential. The Carignan is legendary because, being well adapted to this region, it has had such development that it has become an emblem. It produces elegant wines with a Mediterranean character.
PM: What do you think is the future of this area?
AS: While in the rest of the country there is a trend to produce gentle and mature wines in response to global demand, here, thanks to the soil, we can produce wines of a character which combine the secano and vintner's spirit.

Between Deserts and Glaciers

THE ROAD OF LIMARÍ

From south to north, we must again follow the unavoidable Pan-American.

However, there is a change of scenery, as the Pacific is very close and the strong salty tang is felt far inland. All the more so as a morning mist, the *camanchaca,* having been born in the cold expanses, regularly sleeps in late there, leaving time for the plants to soak up its beneficial and sticky moisture. Some distance from the *Fray Jorge* National Park where the Limarí River joins the ocean, all manner of fruits and vegetables thrive, sometimes in *quebradas,* a kind of irrigated and fertile canyon.

On the north/south highway, frequented by enormous colourful trucks, merchants of *camarones* (shrimp) are trying to attract the attention of hungry drivers by waving oversized wooden lures, suggesting a miraculous catch. Leaving this area, it is recommended that we move into the interior toward the Cordillera to Ovalle if we want to take the measure of the richness and diversity of the fruit crops.

Several wine growing properties have been successfully established in this area by playing with its peculiar climates. So it is that Tabalí set up its vineyards and *bodega* close to the Enchanted Valley (*Valle del Encanto*), in a *quebrada* (canyon)

▼ A vendor, like many others, along the Pan American Highway

oriented towards the ocean to reap its salty and moist benefits. This site contains remains of the *El Molle* Indian civilization which, at least two millennia ago, lived in these places, hunting and gathering. There are anthropomorphic and zoomorphic figures engraved on the rocks. Here and there, in the very centre of the Tamaya vineyard, are *tacitas,* little basins for domestic use carved from stone by the *El Molle* Indians, decorating the wine grower's ground.

In autumn, the traveller seeking the road to visit a *bodega* will be amazed to see, without understanding the cause, the hills redden in the distance. What he took to be poppy fields are actually fields of red pepper. Harvested elsewhere, they are set out in lines to dry for a few days, before being crushed and used as a condiment. Under a laughing sun, young women, ravishing in their colourful clothes, work happily in this crimson environment. They unpack, return, and slide this windfall of superheated fragrant spices into bags.

▼ A sea of red peppers carpets the valley

▶▶ The Tamaya Vineyard thrives in the heart of this otherwise arid region

Between Deserts and Glaciers 61

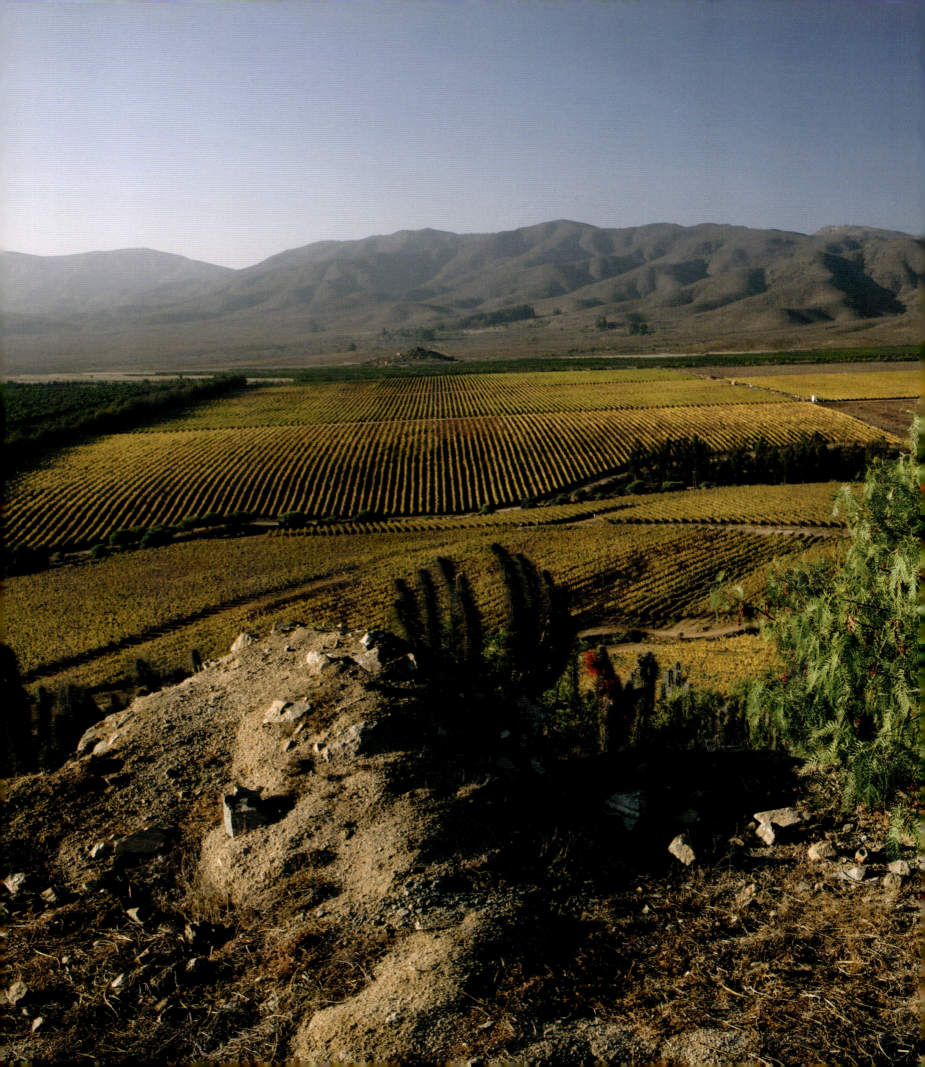

THE ROAD OF ELQUI

To complete his œnological and touristic journey, our traveller is headed north. Along the roadside he may discover, almost everywhere in the country, *animitas,* a sort of small cenotaphs in the shape of houses.

He will cross La Serena, a small seaside town with bourgeois style, to sink into the fertile Elqui Valley, famous in more than one way.

This valley, which receives the cold waters of the Elqui *río* (River), is a haven of peace with a light and transparent atmosphere. It is at once a place of meditation for nostalgic hippies with a craving for a form of spirituality, stellar observatory, verdant oasis in the heart of steep cliffs, natural home of Gabriela Mistral, and chosen land of the *pisco,* which bears the name of the village at the bottom of the valley.

The table grape intended for export and the *pisco* grape have been able to be established through irrigation. The table grape vines have been protected from the wind by installing palisades covered with tight mesh nets, which give them the appearance of an entrenched military camp. As for the *pisco* vineyards, a brandy obtained by distillation of Muscat wine, a very popular cocktail in Chile and Peru, they are dominant to the extent that the unaccustomed eye confuses them with the "finest" of the wine vineyards.

◄ The church in Pisco, nestled in the valley

▼ The rushing waters of the Elqui

An *animita* is born of mercy in a place where a "bad death" has happened. This is a place where the soul and memory of the deceased is honoured while his body rests in the cemetery. These shelters can be found along the railways of the North, on the shores of turbulent torrents, at dangerous turns in the road, and on the rocks at beaches. They are in the shape of houses or miniature chapels. All have crosses on which are hung pieces of fabric which shiver in the wind like flags. They are decorated with natural or plastic flowers. Their purpose is to make vows. This is why they are placarded with letters, cards, religious images and all sorts of supplications. They can be visited on any day, but preferably on Mondays, Wednesdays, Saturdays, and especially the 1st and 2nd of November.

The culture of the vine can rise, in Chile, to more than 1,500 metres altitude. But at the price of what efforts! Not far from Vicuña, Italian immigrant families from after the Second World War undertook to divert the Rio Elqui. They dammed it at the foot of the mountain to use the space and, after removing the round stones that made its bed, made a 250 hectare thriving vineyard where strong Syrah prevails especially. This is the *Falernia* vine, managed with a thoroughly Italian austerity and authority by one of the descendants of this historic epic.

In total contrast, at the end of this valley which the Chileans compare with paradise, close to Pisco, *Cavas del Valle* promises the informed and discerning amateur wines that are born of the marriage of the high altitude vine and the soil blessed by the stars. It is here that the atmosphere is so clear and pure that astronomers from around the world have focused their telescopes on the celestial constellations.

A detour is commanded by the stars, going at night to visit one or the other of these observatories located at 2,200 metres altitude: el Tololo, el Pangue or Mamalluca. A grand existential vertigo will stun the budding astronomer who, shivering with cold or perhaps emotion from the stellar beauty, will return to sleep in his hotel in Pisco, an observatory dome.

As a farewell to this enchanting place, why not read *in situ,* at the end of this voyage, a poem of Gabriela Mistral, poet born at Vicuña and Noble prize-winner for literature in 1945, who was said to be "woman of Elqui, Chilean and American"? The memory that will remain will evoke a gentle nostalgia.

▼ Table grape vineyards, protected from the wind by nets

▶ Not to be missed for any reason, an evening of wonders in one of the observatories of the valley

Chapter 4
THE BODEGAS, FROM TRADITIONAL TO AVANT GARDE ARCHITECTURE

We cannot be interested in Chilean wine, its history, the landscape that the vineyards shape, without showing a certain curiosity for the *bodegas*. These constructions, some dating back more than a century, some very recent, which we translate as "wine cellars" or "*chais*" in French, are home to both the winery activities, vats for fermentation of musts and barrels for conservation of wines.

The traveller traversing the wine route will not fail to visit them. He will discover the pride and respect for the traditions that have inspired the producers in the singular care and æsthetics brought to their architecture. He will sometimes find avant-garde dispositions.

The building used for production and conservation of wine must now address the need to bring together in one place all the processes, while providing sufficient space for technological

◄ Lapostolle: great architectural success evoking the frame of a burst barrel

▼ Casa Silva: typical historic architecture

innovations. Beyond its functionality, the building must represent to the visitor's eyes a symbol of the treasures which it houses, both in its form and construction materials used.

Innovation placed at the service of the good and originality at the service of the beautiful are now combined under one roof.

Because of this evolution, the meaning of the word *bodega* itself seems to have changed. Up until the middle of the twentieth century, it designated the cellars of the vineyard, real subterranean chapels, intended for storage and conservation of wines in barrels and bottles.

Today, the term *bodegas* often designates a more extensive construction and sometimes not subterranean. It houses, often on several levels, all the production operations from destemming grapes during harvest to shipping the bottles to customers. Almost always, *bodegas* contain administrative headquarters for the operation and are luxurious venues for importers from around the world, for whom a good impression must be made. The amateur and the passing visitor will also be very well received.

However, each *bodega* that you might visit presents, in comparison with its neighbour, characteristics which go beyond their simple architectural differences. To help the traveller

▼ The cellars of Concha y Toro lined up as far as the eye can see

▼ Mystic ambience at Santa Carolina

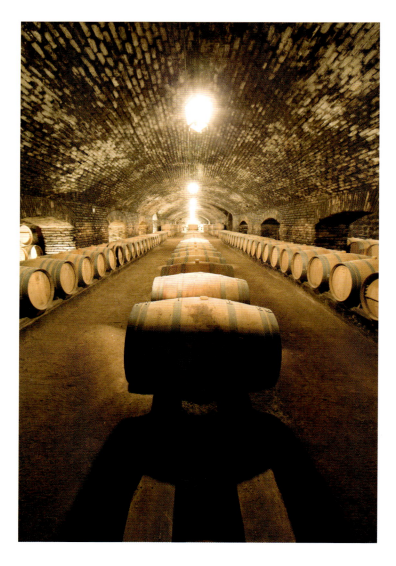

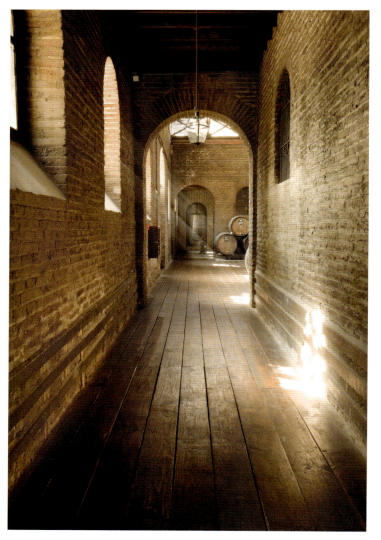

understand, let us try to establish a classification of it. As well as the traditional *bodegas*, there would be classics restored on the basis of old architecture, modern ones created with a historical theme, and finally the most recent, monumental.

Who does not succumb to the charm of *bodegas* built in the mid-nineteenth century by architects, for the most part French, steeped in medieval art.

Like crypts collecting relics of a saint, these obscure places at constant temperature no longer conceal, under their brick arches jointed with lime and egg white, any other treasure than the wine grower's memory; vessels in *rauli* with outdated scents, acrid whiffs of tannin clinging to old barrels, tools made sacred by the patina of hands, giving these places the aspect of a museum. Among these traditional *bodegas* we include, without this list being exhaustive:

Cousiño Macul (Maipo Valley), a family business where we like to show that the knowledge has been passed down from generation to generation. The collection of various objects related to wine production attests to it, even as the capacity of the old exposed vats shows the visitor with pride the significance of the quantities produced in the past and today.

Santa Carolina, (Maipo Valley), which prepares for the aging of its future fine wines in the impressive silence of its vaults, classified as a historical heritage. The *rauli* barrels, once commonly used, have been replaced by French or North

▼ In the holy of holies of the bodega (Santa Carolina)

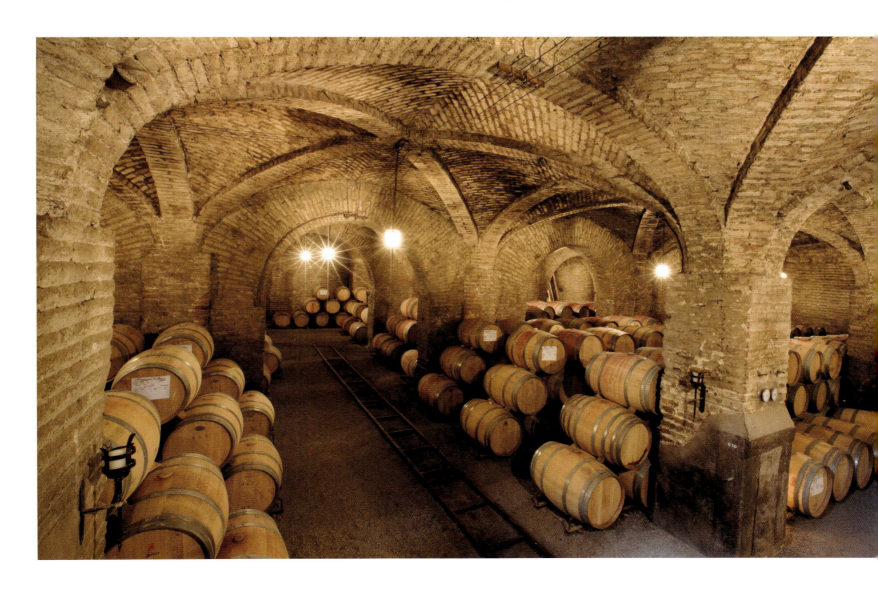

The Bodegas

Casillero del Diablo

American made drums, for the enjoyment of consumer's palates, which do not spoil the viewing pleasure for the visitor.

In the group of *bodegas* which have based their image on a historical or legendary theme, we can include:

Concha y Toro (Maipo Valley), which cultivates its own legend to arouse the curiosity of the visitor. So we learn that on certain nights we could cross the devil in the cellars of Don Melchor. It was only a masquerade of the Marquis de la Casa Concha - dressed in a black cape, torch in hand, he hit upon this stratagem to turn out his dishonest workers who, after nightfall, had a strong tendency to come and empty a few bottles… And so the legend of the *Casillero del Diablo* was born. It is still used, as the symbolic image of this devil is included on the labels of bottles for a large part of the range, sold in supermarkets around the world.

Santa Rita (Maipo Valley), which houses, in addition to its subterranean cellar and colonial house, a museum containing a collection of objects from the Mapuche people, which belonged to its former owner Ricardo Claro. There are displayed jewellery in silver and precious stones, pre-Columbian ceramics and accessories, and equally remarkable Chilean equestrian art.

Santa Cruz (Colchagua Valley) combines tourism, culture and architecture. This trend in wine growing regions gives œnological and touristic itineraries a considerable added value. One of the instigators of this movement is certainly Carlos Cardoen, astute businessman, who works, with originality, to enhance the cultural identity of Chile. At the top of a hill, in the heart of his vineyard, he has reconstructed a village featuring

◀ This alarming inscription recalls the legend of Concha y Toro

▼ In the darkness of the Santa Rita cellars

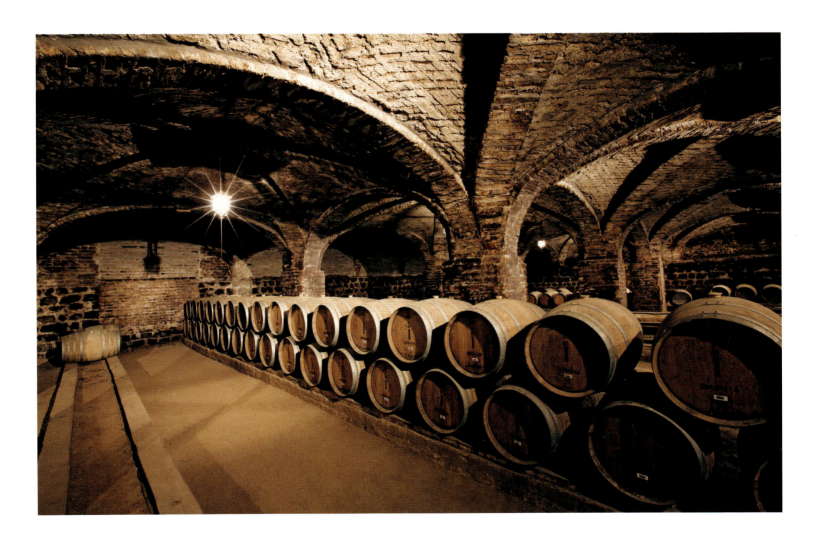

the lifestyles of the Mapuche, Rapa Nui and Aymara, Chilean peoples who, before the arrival of the *conquistadors*, lived in perfect harmony with nature.

Tabalí (Enchanted Valley, *Valle del Encanto*), far north of Santiago and not far from the Pacific, built, in a *quebrada* (ravine) towards the ocean, a quite remarkable *bodega*, half outdoors and half buried. The vinification vats are placed on the surface under a canopy with a rolling wave shape. They feed on salty air giving unique aromas to the wines. This symbolic architecture helps in comprehension of the taste. Similarly, El Molle Indian petroglyphs, a kind of engraving in the rocks in the heart of the vineyard, opens an understanding of the very special identity of this vineyard. These portrayals from about thirteen centuries ago, pertaining to the history of Chile, are used as a graphic identity of the brand. They go down until they become a major decorative motif in the basement of the *bodega*, intended to show the visitor the link that exists between the vineyard and the history of these places.

The renovators form a third group.

Neyen de Apalta (Colchagua Valley) happily added contemporary style cellars to the existing traditional architecture of wood and adobe.

Undurraga (Maipo Valley), a vineyard which recently was transferred to a new consortium, has recently reinvented its range of products, bottle labels and especially its *bodega*. An immense bay window now reveals the stainless steel vats of its new wine storehouse, on a classic building set into a screen of hundred year old trees. This sought after contrast brings with it all the communication of the company – a scientist balanced between tradition and modernity.

▼ Tabalí, modern setting in memory of the El Molle Indians

► The legendary Chilean hospitality at the Underraga estate

Finally, the group with the most innovative architecture consists of vineyards that deliberately display their modernity.

This warrants some explanations. In their quest for expansion of the area devoted to wine growing, in order to ensure both the rationalisation of their operation and the quality of their wines the large landowners have had to completely rethink production organisation by incorporating the inevitable concepts of profitability. Chilean wine gradually becoming a luxury product, it became necessary in recent years to sustain this success by constructing buildings which were sometimes monumental, in line with the æsthetic marketing image of the winery property.

Viñedos Emiliana (Colchagua Valley) combines harmony and ecology. The vineyard, a subsidiary of the Concha y Toro empire, works primarily with organic wines. Its objective is to establish its own exclusivity. The vines are grown and wines produced following natural principles. In addition, the architecture of the *bodega* was conceived in perfect symbiosis with the surrounding natural environment. The use of local natural materials such as wood, adobe and stone further strengthens the brand image in the eyes of the customer.

Lapostolle (Apalta/Colchagua Valley), at the foot of a hill, erected in 2006 a veritable work of art to the glory of wine with a discretion, an elegance and an exemplary refinement required by their owners Alexandra Marnier Lapostolle and her husband Cyril de Bournet. This edifice, whose façade emerges quietly from the hillside covered with leafy trees,

▶ View from the top of the imposing staircase of Lapostolle

▼ Emiliana. Firmly focused on organic production

▶▶ The impressive personal cellar of the owner of Lapostolle

evokes the arched frame of a huge exploded barrel. The hill was excavated to contain an immense subterranean cathedral, perfectly integrated into the surrounding vegetation. A spiral staircase in an elliptical shape crosses six levels, up to the secret holy of holies which is the personal cellar, worthy of James Bond, of the lady of the house. Everything here is exceptional. The discreet luxury and perfection assures the visitor that such places and such exceptional means can only give dream wines.

Casa las Niñas, neighbour of Lapostolle and backing on the same hill, opted for a different architectural design. The *bodega* is constructed of a simple horizontal metal hangar, whose north face exposed to the southern sun is adorned with simple opacifying wood slats. The young Chilean architect Mathias Klotz designed this building with nothing but a cellar composed of two volumes including one small one in concrete, perfectly ventilated by convection, intended for storage of the wine barrels while aging, and for tasting. At night, the Plexiglas south face transforms this hangar into an immense lantern illuminating the outside.

Montes, neighbour of Las Niñas, with a background of the same landscape, left his architect Samuel Claro to design a temple built on the principles of Feng Shui. The vital energy is called on to circulate positively throughout the building and to promote fermentation leading to the transmutation of the grape into a dream wine. This achievement will take place after the wine has rested in barrels deposited religiously in sanctuaries, where Gregorian chants are broadcast to ensure serenity. The building was designed on a principle of vertical flux. The raw material arrives by elevator to the terrace where the workers triage and destem the grapes. Handled with the greatest of care, the harvest is then transferred smoothly downwards, in fermentation vats. The juice drawn then flows by gravity to its resting place. This Zen atmosphere envelops the whole *bodega* in a setting of freshness. Pools adjacent to the building decorate it with watery reflections, as if the water and wine of these places were celebrating.

▼ Las Niñas, a beacon in the night created by the architect Mathias Klotz

▶ Montes, the quest for harmony by the architect Samuel Claro

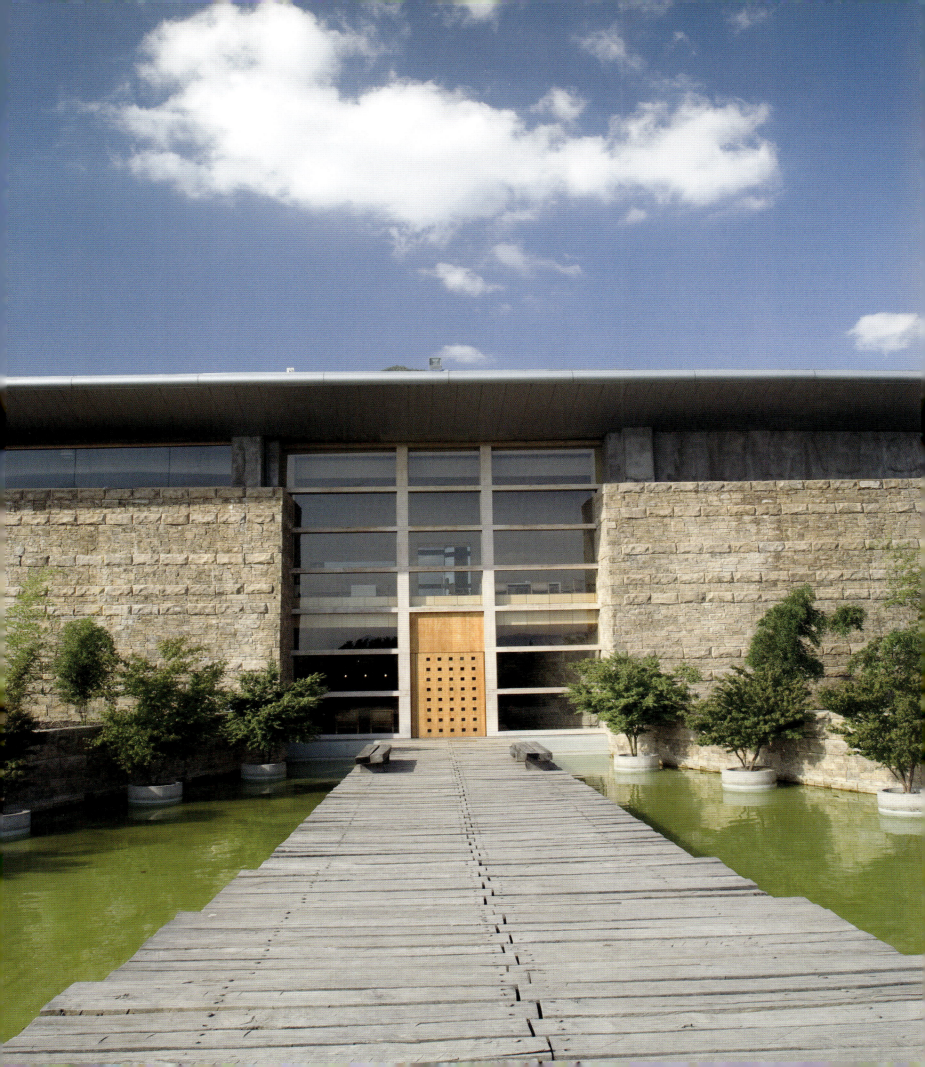

Matetic (San Antonio Valley), built a discreet *bodega* at the top of a hill in the coastal mountains at the bottom of the small Rosario Valley (equidistant between the Pacific and the Casablanca Valley). You are immediately seduced by the union of building and landscape, as if we had wanted an architectural ellipsis which, contrary to what usually happens, enhances its environment. Local stone and wood used for construction facilitate further dialogue with nature. Before entering this temple of discretion, the visitor has the feeling that he will live through an inner experience. Instead of going toward the sacred in the sense of a climb, by humility it is reached by descending as if into a crypt. But here, there are no relics to obscure. On the contrary, it is nature alive and flooded with light which asserts itself through an immense bay window. The wine is born here, on these baptismal fonts, in the presence of its patrons, the ocean and mountains.

In accomplishing this voyage, our traveller will have understood what efforts are required for producers to give the consumer not only the taste of its wines, but especially the image which he then will associate with this taste. We better appreciate a canvas when we have seen how the painter does his work. Likewise, our traveller will only really understand the wine offered for tasting when drinking on the spot, eyes wide open, and when he returns home again, the sensations remaining firmly engraved in his memory.

▼▶ Matetic, barrels under the spotlight and a radiant *bodega*

Chapter 5
COLONIAL HOUSES, LEGACIES OF THE PAST

The agricultural history of Chile is inseparable from the latifundia system established during the colonial period which then lasted for several centuries. Anxious to occupy the conquered lands, the Spanish Crown rewarded its high ranking soldiers by giving them large tracts of land. Through their work, they made *haciendas,* immense agricultural domains of 30,000 to 50,000 hectares, managed by large affluent families and passed from generation to generation without significant changes in the system of management or lifestyle of their operators. Devoted to cereal crops and livestock, these *haciendas* cultivated small scale vineyards, the wine being reserved only for consumption of the owner's families. These wealthy individuals usually resided outside their property, entrusting the administration to a right-hand man. Life within these *haciendas,* commonly called *casas patronales,* strongly resembled that of a community.

To get a clearer picture, you can visit, in the Colchagua Valley, the old hacienda *San José del Carmen* of El Huique. It is now transformed into a museum and its past perfectly reflects the latifundium mode of management where around 2,000 employees (*inquilinos*) lived and worked under the tutelage of a former colonel of the Crown.

◀▼ El Huique, memento of the latifundia

In the imagination, the *casa patronal* evokes a large residence of Andalusian architecture, comfortable and luxurious. In reality, it looked more like a simple farm. The section reserved for the family dwelling, the *casona*, was often built in a closed square, forming a central *patio* surrounded by an open gallery with wood columns. This was a good place to keep cool in hot weather or to be protected from rain, in fall. Not far from the *casona* are the structures of buildings reserved for stables, mills, cellars, sheds, etc. Further on, the operations administrator's house, the huts of the workers, and, almost always, a chapel where the inhabitants of the property came to perform their devotions. Around, the fields are lined with rows of poplars.

These bare-floored buildings, with whitewashed facades, were built of cob. Their thick walls, their rafters in carob, *canelo*, or oak woods, and their red tiled roofs give an austere appearance, characteristic of Chilean homes until the middle of the nineteenth century.

To relive the past of these homes, some owners of today are trying to exhume anecdotes, stories and sometimes legends which constitute a cultural heritage even richer than the walls which surround them. Commercial appropriation makes way for this renaissance. So it is that many *casas patronales* that have survived earthquakes have been converted into hotels, restaurants or museums.

◄ The welcoming shade of a patio (Santa Carolina)

▼ Idyllic setting for the Concha y Toro Vineyard

Colonial Houses

Likewise, at Huilquilemu, starting point on the Maule wine route, a pleasant restored colonial residence became a museum (Huilquilemu cultural villa).

Likewise, near Rancagua, the luxurious hotel-hacienda *Los Lingues*, one of the first to specialise in rural tourism, is a fine example of colonial architecture in the heart of a vast park with hundred year old trees. Used for its construction were adobe, *cal y canto* (stone with lime/egg white mortar), local Pelequén stone, exotic woods and ceramic tiles. Now restored, the house is a sought out resting place, in particular allowing horse riding by its guests.

Majadas, half-stable and half-inn, that once accommodated herds and herdsmen for one night, have been converted into luxurious residences. You can stay in one at the *Bisquertt* vineyard (Colcahgua Valley), which is decorated with precious family artefacts. This latter, of French Basque origin, has been located in Chile since the end of the nineteenth century. It is now invested with great taste in wine tourism.

The *Santa Carolina* vineyard is owner of a *casona* classified as a national monument. Since the extension of the capital, it is now in the heart of the city. A visit to this house-museum, built around the classic patio, reflects the lifestyle of a grand bourgeois family of the eighteenth century with a passion for wine.

▶ Enclosed patio of the *casona* of the Santa Carolina Vineyard

▼ Bisquertt House, pleasing restoration of an inn as a luxurious residence

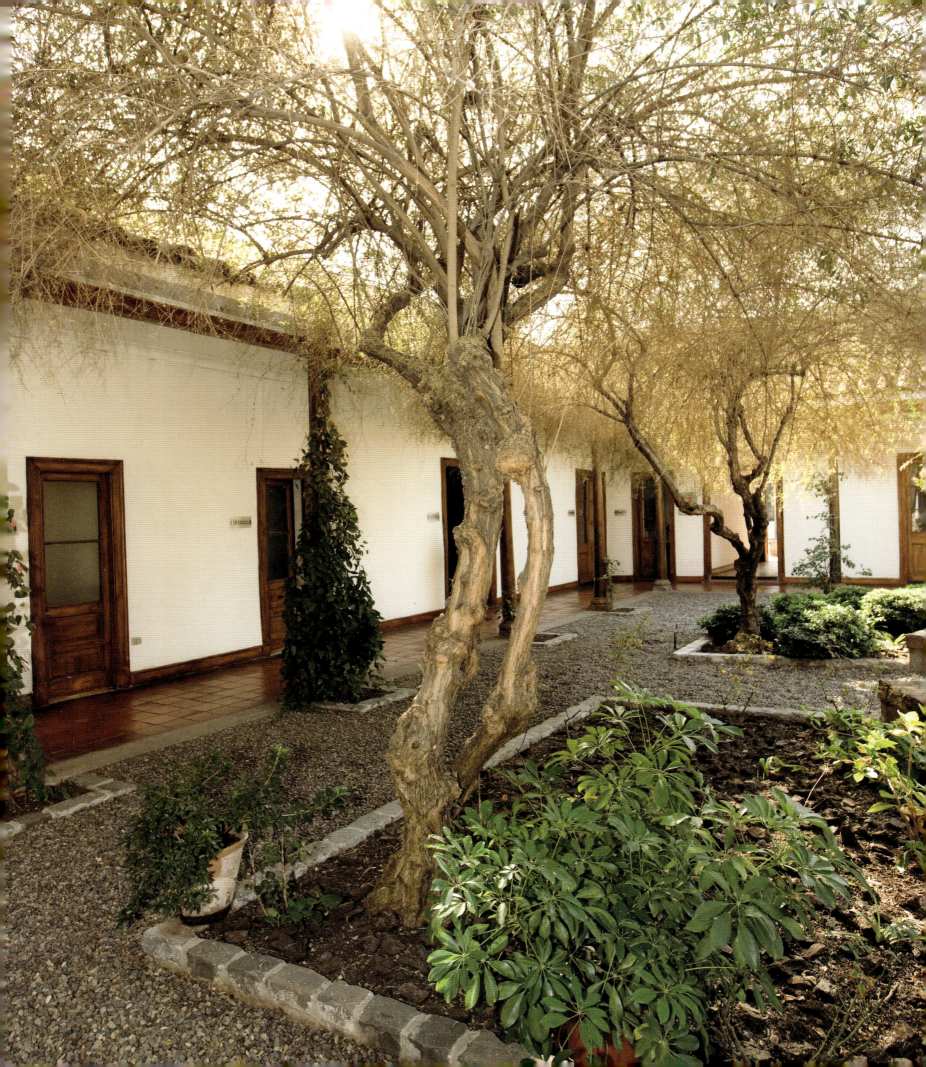

At the heart of the *Santa Rita* vineyard in the Maipo Valley, you can enter the charming *casona* of Doña Paula, recently transformed into a restaurant. In 1814, this house was the refuge of General O'Higgins and one hundred and twenty of his soldiers after a crushing defeat against the Spanish troops. Santa Rita has appropriated this historical fact and has made "120" the appellation of one of the wines in its line.

In the Maule Valley, on the Constitución route, in the heart of a rolling countryside decorated with rows of vines, appears the rustic *casa colonial* of Julio Bouchon. His great-grandfather, Emilio, left Marseille for adventure in Chile. In these places, he bought land and founded a winery operation. His *casona* was built according to the classic Chilean model. The simplicity of decoration, white walls and furnishings of noble unstained woods create an atmosphere of calm conducive to letting the host tell the history of his family, his passion for Chilean ground, the wines of the Maule region and his quest for life in a country of intimate contours.

During the second half of the nineteenth century, the architectural style of the houses of the high bourgeoisies of the country went hand in hand with their enrichment, primarily due to the prosperity of the copper and nitrate mining industries which they controlled. These families bought lands with a desire to diversify their vine cultivating activities. They then built, in the heart of the newly planted vineyards, luxurious and refined residences attesting to their financial and social success.

▼ A *casa colonial* in all its simplicity and authenticity (J. Bouchon)

▶ Witnesses of the years of the country's splendour and wealth in the nineteenth century, upper-class houses are found throughout the country, from Arica to Punta Arenas. Here is that of the Cousiño Macul family.

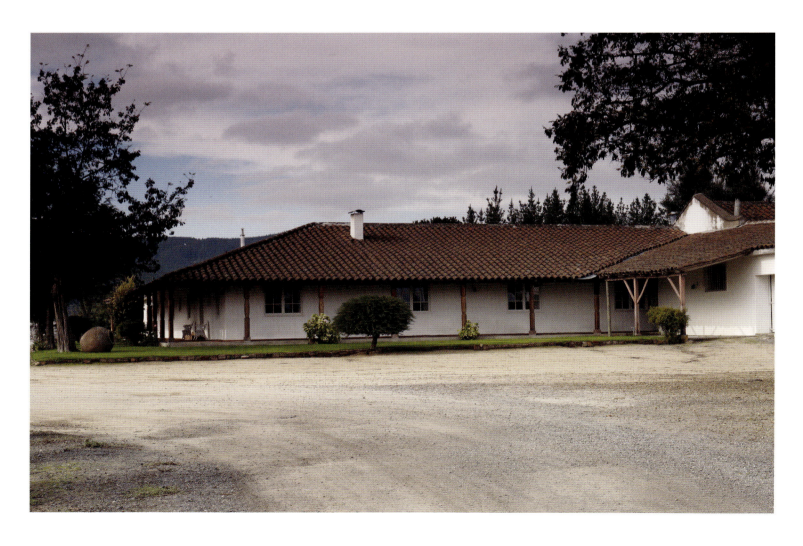

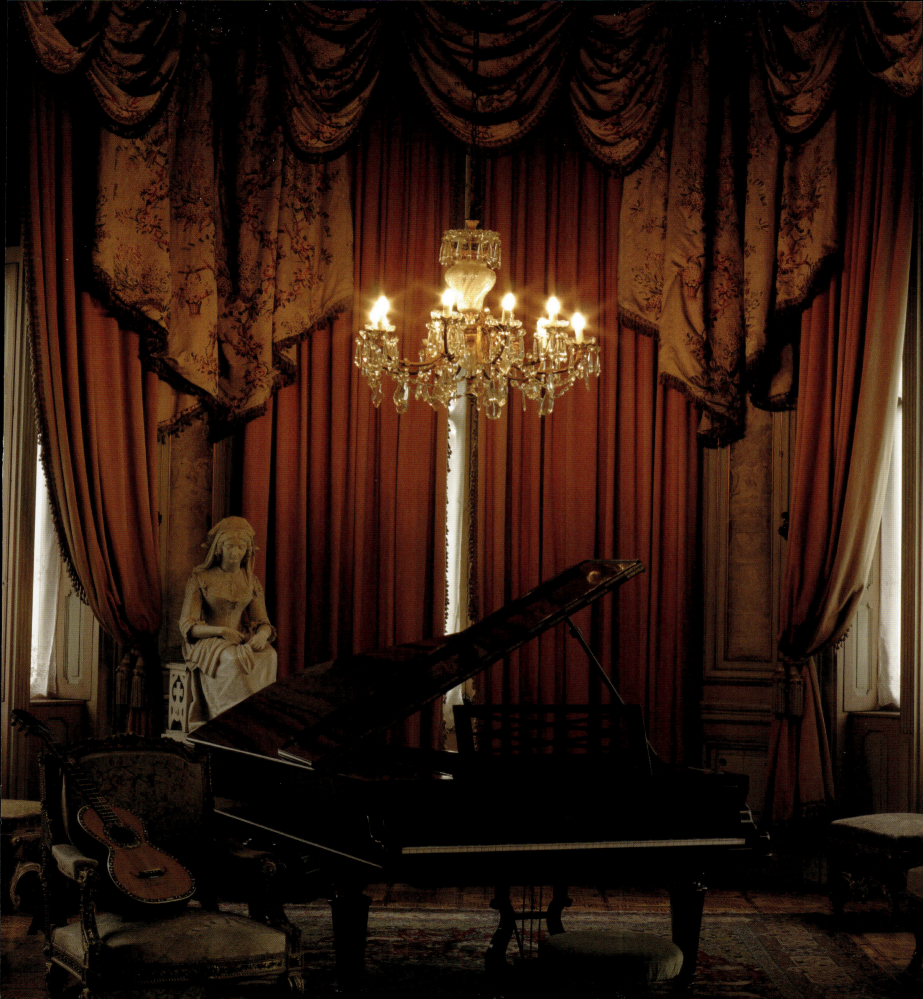

In the 1860s, the Cousiño family built, on their vineyard in the outskirts of Santiago, a substantial residence made with materials imported from Europe and decorated with European taste. This construction achieved an objective of recognition. The European elites were role models to be imitated – the family, at the end of its travels in the old continent, imported, at great cost, furniture, lamps, paintings, books and tapestries, etc. This gave to their residence the appellation of "palace".

To assist them in their ambitious projects, these families often make use of French and Italian architects. These make a clean slate of the previous hispanico-rustic model, symbolised by the patio style house. The modern house is no longer an enclosed square. It expands, taking the form of a U like a European château, sheltering spacious glazed galleries intended for grand receptions. The political future of Chile takes shape there. The ceilings rise to a height like the social successes of their owners.

However, the European architectural references are not always very well assimilated. Sometimes they are disparate – neo-Gothic, neo-classical, Renaissance, even Pompeian, according to the taste of the sponsor. French style gardens generally embellish the residence, structured plant decors confirming the solemn aspect of the whole

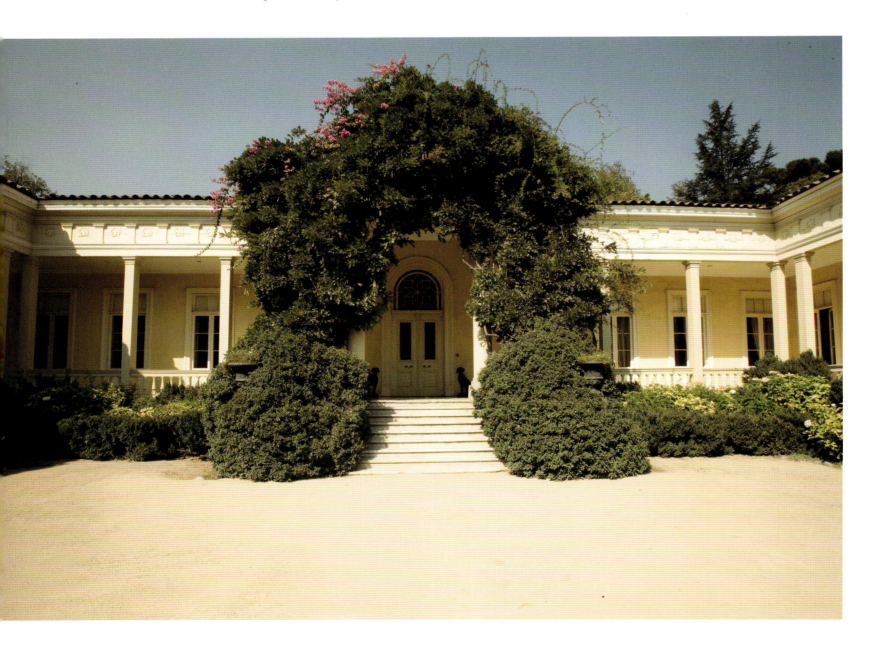

Parks designed by French landscape architects merit a visit, especially those of *Concha y Toro*, *Santa Rita de Alto Jahuel* and *Undurraga*.

The *Casa Real* built in the heart of the *Santa Rita* vineyard (Maipo Valley) is undoubtedly the most representative example which at once brings together architecture, lifestyle, social representation, and maintaining of the traditions. Behind an imposing adobe wall hides the landlord's house Domingo Fernandez Concha, built in 1883, a hybrid colonial house with patio and Pompeian villa. This residence is enthroned in a majestic park designed by the French landscape architect Gustave Renner. Pools, fountains, statues and a labyrinth brighten a rich verdant background embellished by araucarias, cedar, chestnut, olive, Chilean palm and almond trees. Connected to the house by a footbridge, a neo-Gothic chapel, built in 1885 by the German architect Trodor Burchard on the wedding of the daughter of the very pious Concha family, surprises one by its magnificence.

Finally, to understand up to what point the taste for comfort and splendour of the owners was pursued, the visit will be

◀ From magnificent staircase…

▼ …to luxurious terraces of the *casa colonial* of Concha y Toro

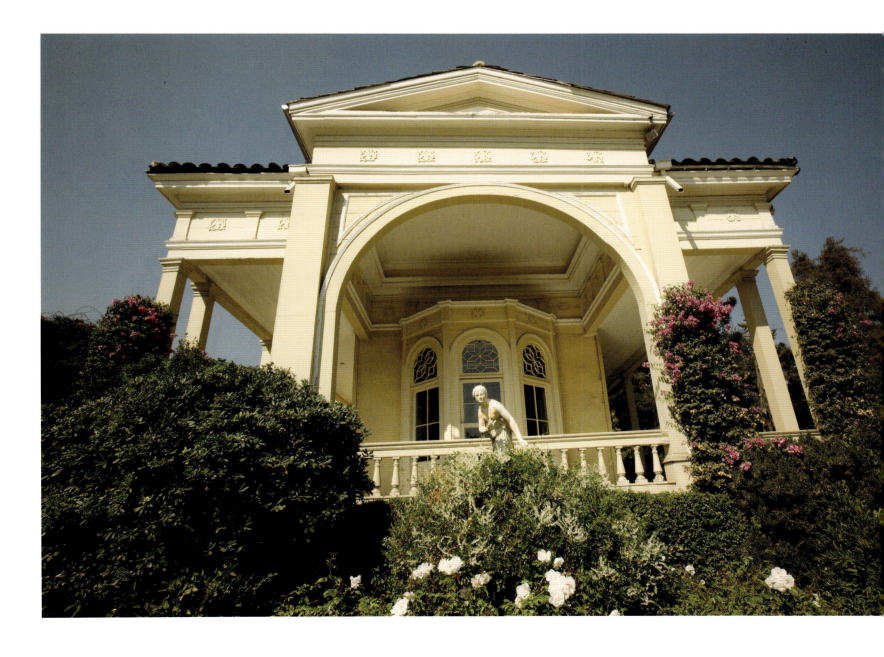

completed, on condition of staying at least one night in this residence-become-luxury hotel, by the discovery in a shed of a little train that was once used at harvest time to transport grapes and, the rest of the time, for family outings.

Between tradition and modernity, the wine regions evidently have excellent potential to attract curious visitors whose travel is not only based on the discovery of wines. They make it possible to respond to other motivations, such as an interest in equestrian sports, gastronomy, crafts and the arts.

▼ The gardens of the *Casa real*, designed by the landscape architect Gustave Renner

►► The neo-Gothic chapel was built by the architect Teodoro Burchard

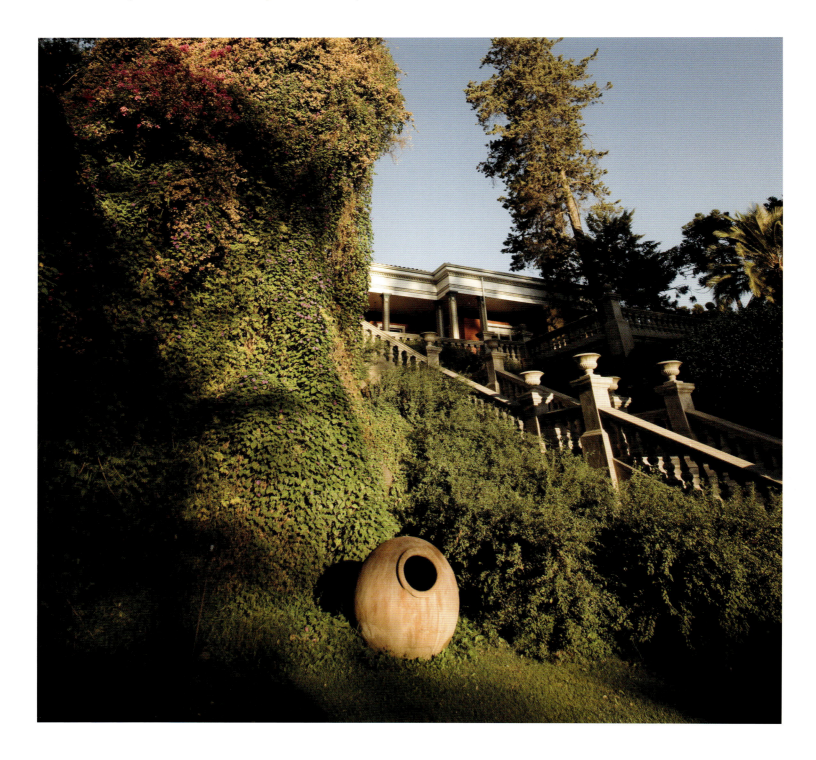

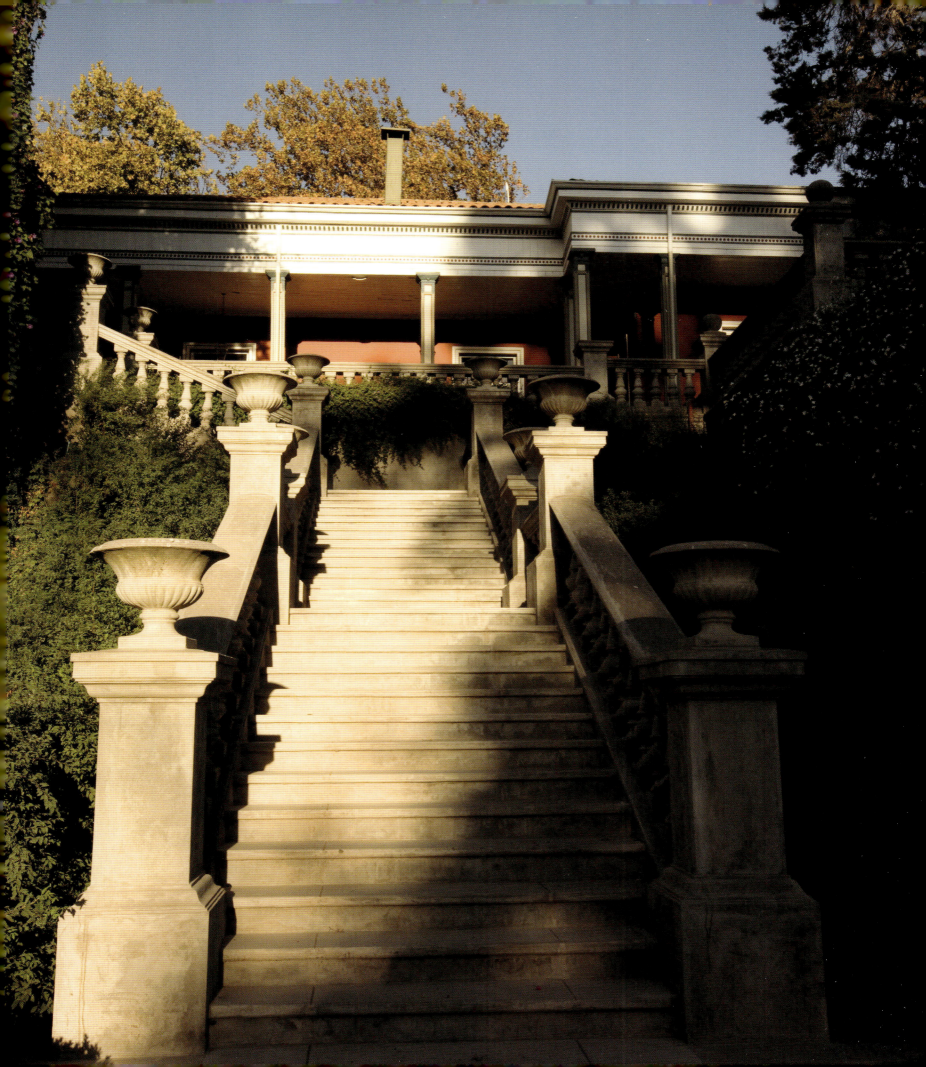

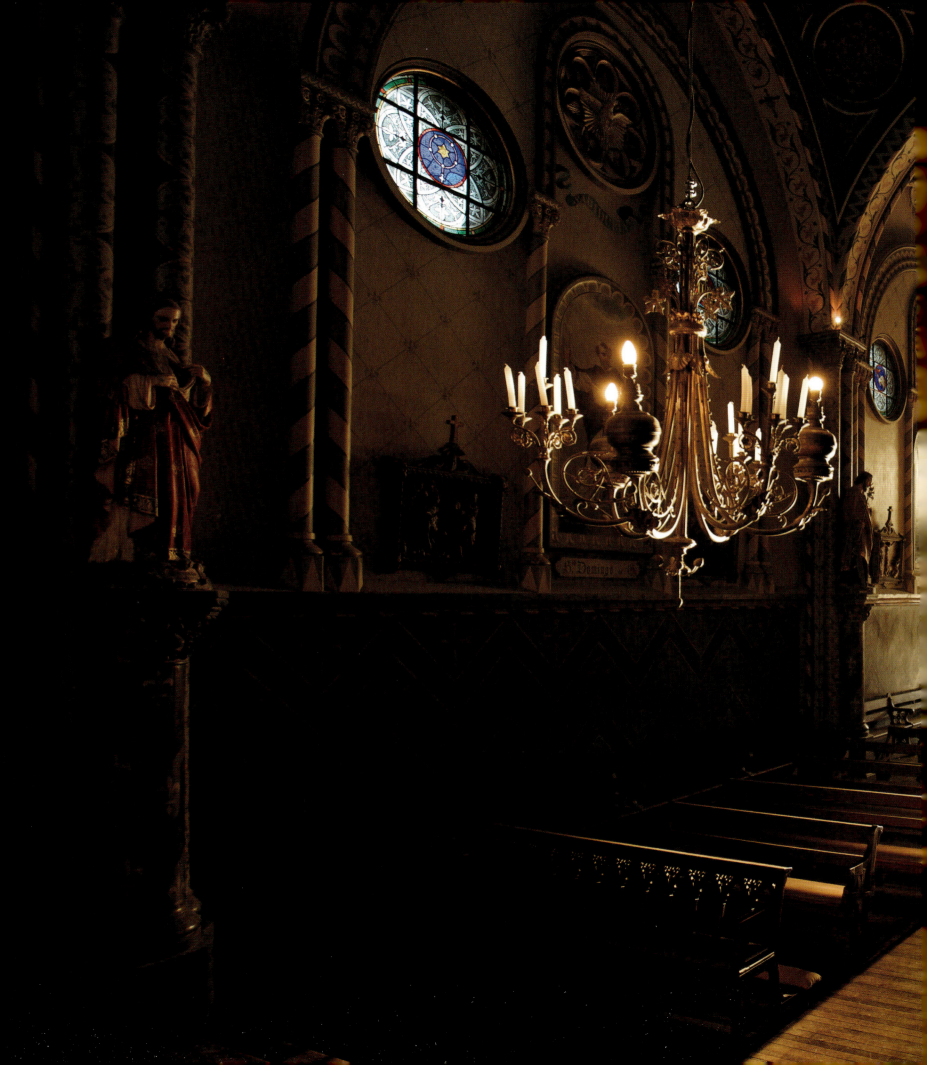

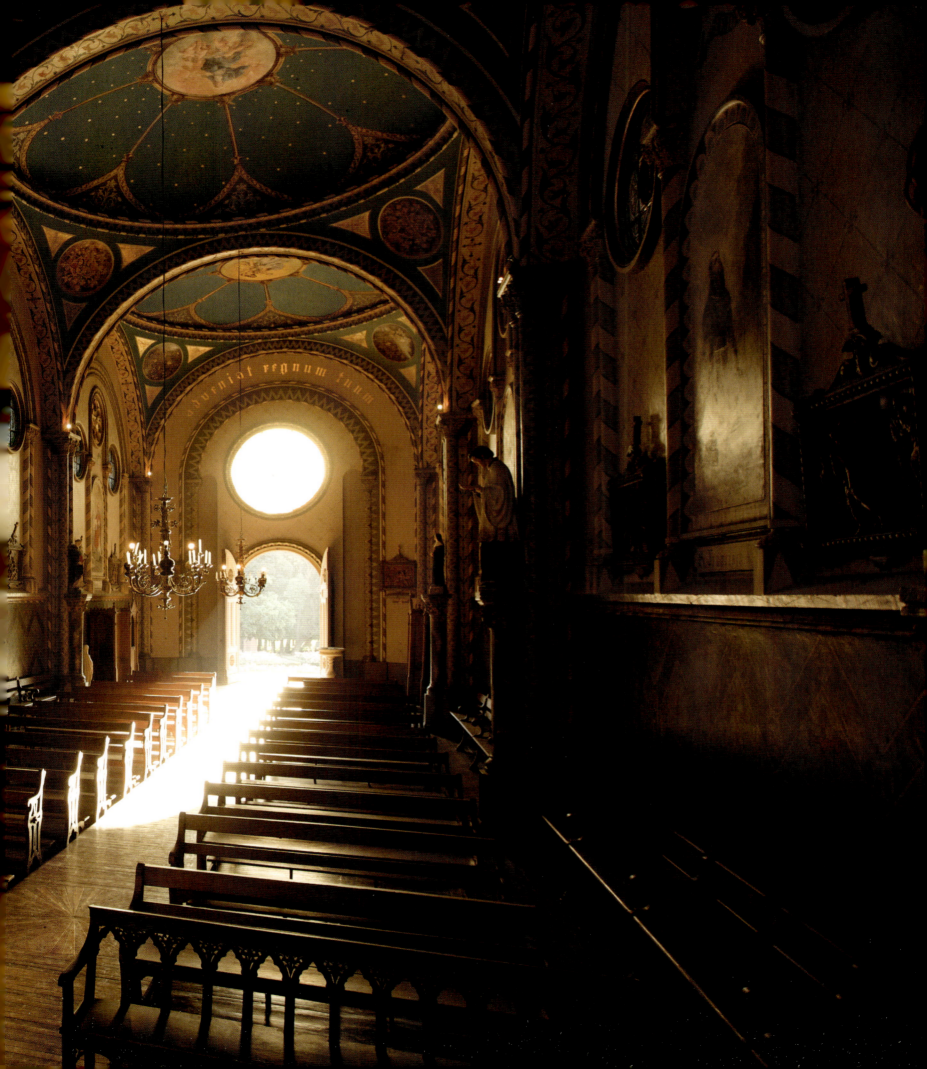

Chapter 6
VINEYARDS AND HORSES

It was not just the wine that the conquistadors imported into Latin America, but their horses also, of course, which were sturdy steeds on which they went on to conquer the New World. It was in 1540 that Pedro de Valdivia left Cuzco, the recently conquered Inca capital, heading for the South. Leading an expedition with a hundred men, he crossed the Andes and the terrible Atacama Desert. When he arrived at the Mapocho River, near the 33rd parallel, he was attracted by the mild climate and the hospitality of the place. He stopped and founded a city, Santiago, the centre of today's Chile. During this expedition, the Spanish horses were superbly resistant to the altitude, cold and drought. Their qualities having been tested, a natural selection ensued, and they adapted permanently to the Chilean terrain.

These tough little horses with thick hair, the *criollos,* were quickly trained for war against the Indian tribes. One of these, the *Mapuches*, who had previously had llamas as a means of

◀ The horse is still one of the means of transport in the vineyards (Lapostolle)

▼ In the paradise of the Andes, the *criollos* are kings

transport, realised that they could appropriate horses that had escaped from the Spanish enclosures. They learned to mount them and used them in turn in the war against the invader.

As with the vines, the natural frontiers of the country protected these horses. Nothing could affect the purity of their race. In working the land, they were hard working and faithful partners of the conquistadors' descendants. This close union gave rise to a colourful character, inseparable from his mount, a sort of dark-skinned cowboy of the Andes. This

◀ The *huaso*, his *chupalla*, and his *manta* (Maule Valley)

▼ The *huaso* and his faithful companion (Casablanca Valley)

▶▶ The courage of the *criollos* put to the test in the Elqui Valley

was the *huaso*. Exceptional horseman, an Indian-European métis, he still embodies traditional values of honour and sense of family, with virility, who founded in their time the moral basis for Chilean society.

Given that livestock lived in complete freedom in unenclosed *haciendas*, it was soon necessary to take inventory. Around the 1550s, cattle began to be rounded up to be branded each year, on San Marco's Day, in the Plaza de Armas in Santiago. To do this, the *huasos* of farming operations guided, on horseback, the calves of the year against a palisade at the bottom of the enclosure, where they were pinned to be marked. This act of skill and precision performed repeatedly increased the standing of the horsemen. The virile activities of these men, some of whom became renowned for their expertise, gave rise to a competition called the *rodeo*.

Vineyards and Horses 105

The *rodeo* became a national sport and an opportunity for celebration. Today farmers, wine growers, entrepreneurs, all practise this discipline that perpetuates the family tradition and country festivity.

The Silva family, of the Casa Silva vineyard (Colchagua Valley), has been passionate about the *rodeo* for several generations. It sponsors, at great cost, teams in its colours who participate, from September to March, in national competitions. In the heart of the vineyards, you can attend the intensive training of these teams. The objective is to attain the highest spot on the podium in the annual Rancagua finals, a national event that draws crowds.

The show begins. From the tops of the bleachers, you can only see the tops of the *chapullas* (straw hats) of the men. When the Chilean colours are hoisted, all the opponents are gathered in a circle in the arena. With the National Anthem, the emotion of the crowd is palpable. A patriotic shiver transfixes it.

The competition begins.

Dressed in their short *manta* and arrayed in vivid colours, their wide-brimmed *chapulla*, their worked leather boots on which are set enormous spurs clicking with each step, the *huasos* have a proud gait on their impetuous *criollos*.

▼ Live from a *rodeo* at Lolol, of the *atajada* to immobilization of a calf

Two by two, braided lasso attached to the saddle, they prepare for their entrance. The *media luna,* a semi-circular arena, will be the place of their exploits. The challenge: to lead a calf, which leaves an enclosure, by driving it at a jog-trot sideways, along the wall of the *media luna* to finally pin it against a padded wall.

The decisive moment, the *atajada,* is precise. At this point there is a quick charge by the riders on the calf to immobilise it. Success requires perfect harmony between the riders. The art lies in the mastery of the *criollos* at the moment of impact with the calf since, instinctively, these little lively horses participating in the game tend to "flatten" the calf too early against the wall.

A good *atajada* provokes "Ha" of joy, a poor one "Ho" of disappointment. The riders are judged according to strict rules. Points are awarded depending on the part of the beast touched to force it to immobility. The breast brings the highest. Also judged are the riders' dress and the æsthetics of their gestures.

The stands are then at the height of jubilation. Once the trials are over and prizes awarded to the winners, another festival begins. Traditionally, families gather near to the arena to have something to eat at the time of an *asado* along with *empanadas,* in the pure country tradition. Of course, local wines are featured. But the celebration would not be complete without bringing out the handkerchiefs to dance the *cueca*. This is also the *huaso* spirit.

The love of horses surpasses the taste for the *rodéo*. It connects that of world renowned thoroughbred breeders and the passion of wine growers for their production.

▼ Sculptured tribute to the horse, full of life (Haras de Pirque)

A visit to the Pirque stud farm, in the Maipo Valley, illustrates this union between wine and horse. This stud farm is also a horseshoe shaped *bodega* built at the foot of a hill overlooking a vast vineyard. Pureblood horses are raised and trained in a private racetrack. Prevailing in these luxurious places are both the special ambience of horse racing and that more festive of a wine growing property. Here the pureblood buyer can ask to see the coveted horse run while sipping excellent red wine from the property…

▶▶ Spirited gallop at the racecourse of the Pirque stables

A folk dance, the **cueca** is practiced throughout the country. It is a very popular dance with the public. The dancers mimic seduction, rhythmically thumping the ground while waving their handkerchiefs and trying to win the favour of their partner. The man is the rooster that will seduce the hen according to a precise choreography, composed of *escobillados*, sweeping movements, and *zapateos*, stamping the feet. The cueca has several regional variations. There is also the cueca patronal and another *campesina*, the difference being mainly in the dress. The cueca is generally rocked with poetry, sung by women accompanied by guitar.

Vineyards and Horses

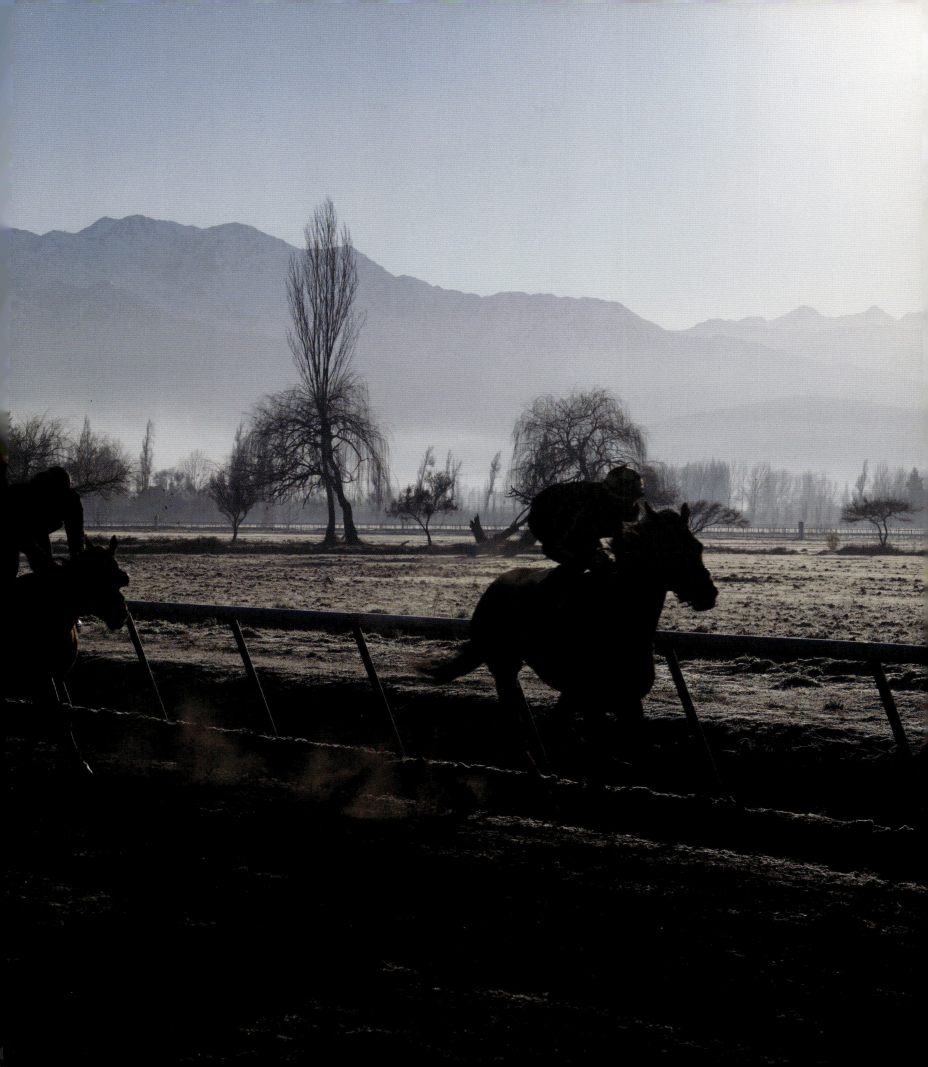

Chapter 7
INESCAPABLE PLAZA DE ARMAS ARTISANS AND THE GENTLE LIFE

There is no Chilean village or town that does not have its military square. Our traveller will have quickly noticed. Naturally, he will be found there resting on a bench in the shade of trees of a variety of species, such as palm trees, jacarandas, magnolias, orange and cedar trees. New fragrances will assert themselves upon him at siesta time, while the flavours of wines tasted have not yet left.

The military square recalls that the Spanish conquerors set their encampments in the centre of occupied villages. Ever since, like the Spanish *plaza,* this square open space is lined with buildings. Merchants, residents and administrative offices are established there, showing with pride their local abilities. At the end of the square is the required church, often in an indeterminate style. In the centre is a fountain, a kiosk, a statue of a hero or a monument commemorating an event in the history of the village or country.

◄ Tribute to the *Libertador*

▼ Ready for musicians

Our traveller will not be the only one enjoying passing the time. By the end of the afternoon, the locals, young and old, come to chat peacefully with friends in this centre of the world, around which life unfolds as if they were only distant spectators. This paradise is so conducive to quiet thought that chess players set up their tables, away from the tumult all around. Although all built on the same model, each square is distinct by the architecture of its houses, the style of its church, the plantings and statues which contribute to its *décor*. Sometimes, small towns, such as Paihuano in the Elqui Valley, near Pisco, surprise visitors with the beauty of their original statues tastefully set in their tiny central square. Some medium towns, like Curicó, make this place a proud symbol of the greatness of the city, with oversized palm trees and ornate wrought iron kiosks. Others, with more modest decors, exhibit naturally a sought after tranquillity. This is the case in the little town of Vichuquén, not far from Curicó, where time stands still.

If these places are habitual resting places, they occasionally host all manner of festivities and ceremonies, including those of harvest time in the producing regions. Artisan markets also set up there on the weekends. Some tourist towns have permanent local artisan shops set up on the periphery. A visit to these boutiques and galleries should not be discounted, because the goods sold there are unrelated to cheap visitor's souvenirs but much rather are the products of the cultural heritage. For example, ponchos and tapestries fashioned of llama wool, ceramic pottery, utilitarian objects carved from wood, basketry, lapis lazuli and agate jewellery, and copper items will constitute the important discoveries of the traveller.

◄▼ Places for craftsmen and games (Pisco, Elqui Valley)

► Traditional harvest celebration (Colchagua Valley)

He will pay particular attention to the *huaso* outfits, including the *manta,* a sort of short poncho with colourful stripes. By ensuring that it comes from a workshop in Doñihue, near Rancagua, he will have the certainty that this *manta* was hand woven using traditional methods. And if he wants to leave dressed like a real *huaso,* he will complete his purchases with the acquisition of a *chupalla,* flat brimmed hat woven with fine wheat straw, and spurs cut in wood.

As in all countries, artisan work disappears due to obsolescence of the artefacts made and is then reborn after a period of neglect, when the memory requires reviving the skills which characterised an era or a region. And so the owners of the *bodegas*, possessors of the works of past artisans, invite their own employees to reproduce them or fashion them after the model of their personal pieces. This is the case at Santa Alicia, where the employees are trained in ceramics and carving on barrels.

The visitors will discover the ceramic wall panels illustrating the phases of wine preparation and various objects fashioned or carved from the wood of ancient vats. These reminders will make him think optimistically of Chile, where standardisation of utilitarian objects did not permanently obliterate the taste for manual labour.

▼ The *huaso* range, available from a craftsman (Maule)

▶ Wicker craftsman caught at work (Chimbarongo)

▶▶ Sure success at the woodworking shop at Santa Alicia

JESUS VIVE:

- COSTILLAR a HORNO
- ARROZ
- CARNE al JUGO
- CANOTONES
- ARROLLADO
- PAPAS COCIDAS
- POLLO ASADO
- ENSALADAS
- CAZUELA VACUNO

Chapter 8
WINE AND CUISINE
RENAISSANCE OF YESTERDAY'S FLAVOURS

The reputation of Chilean cuisine did not cross the Cordillera, just as phylloxera did not cross in the other direction. It does not follow that Chilean gastronomy, even if it has not been imitated in the rest of the world, is of no account. It would be even more inaccurate to say that the pleasure of the table is not a fundamental part of Chilean culture.

As proof is the praise of Pablo Neruda in his *Odes Elémentaires.* Worldwide, he was a convincing ambassador for Chilean cuisine, praising the essential ingredients of all culinary compositions, such as bread, corn, olive oil, lemon, wine, tomato, onion, potato, salt, …

As further proof is the regular practise of *asado,* without which Chilean society would no longer be what it is in its friendly manner of sharing. A social act of national scope, the *asado* is both a way of preparing meat and a friendly meeting

◄ A typical *almuerzo* in Santiago

▼ Just caramelised *pastel de choclo*

at lunch hour, which may continue until late into the night. It is practised in the family on Sunday, with friends, on the national holiday – *las Fiestas Patrias,* September 18 and 19 – and at every good opportunity to meet neighbours, colleagues or passing visitors. It is a kind of Pantagruelian barbecue prepared at home. Men share their recipes, oversee cooking of the meat and drink wine or a *pisco sour,* while the women prepare the salads. The Chilean identity is wholly in this consensual act.

To begin an *asado,* guests are offered, ahead of the grilled beef and mutton, the famous *empanada de pino.* This is a pastry stuffed with ground meat, pine nuts, olives, a quarter of a hard-boiled egg and sometimes dried grapes marinated with white wine and cumin. The *empanada* is traditionally cooked in a dome shaped earth oven heated by a wood fire. It is consumed warm and lightly browned, accompanied by a Cabernet-Sauvignon or, perhaps, a well chilled Chardonnay.

It would be pointless to speak of Chilean cuisine without mentioning the variety of fresh product that comprises it.

"On this island, everything grows", the Chileans proudly describe their production of fruits and vegetables. A large orchard in the centre gives everything one can dream of, apples, plums, peaches, lemons, kiwi, cherries, red fruits, papaw, kakis, and delicious sun-ripened avocados. The Europeans are familiar

▼ *Empanada* to taste without delay

with most of these products which furnish their market stalls during their cold and rainy winters. Table grapes, as well as papaya and figs grown in the Elqui Valley, are the gems of fruit production. You can hardly resist the urge to make off with some branches or to engorge yourself when they have just been slightly dried to preserve them.

The Pacific is also a generous giver. Fish and crustaceans, dripping fresh from the market, are the infinite basis of a light cuisine with lively taste of salt and marine plants. To swallow a mouthful of *ceviche,* a raw fish dish macerated in lemon juice, pimento and onions, is to be enriched with marine sensations, to appropriate the Pacific, to understand the sea.

Ode to the conger, and also the *corvine,* the *reineta,* the *albacore,* fish which are only found in this region of the Pacific.

Ode to the *mariscales* (sea fruit): *loco, macha, erizo, ostión*

Chilean cuisine also recounts its history, influences and legacies.

The Indians ate, according to the group to which they belonged (hunter or fisherman) meat or fish. There remains to their heritage a common basis consisting of *choclo* (corn), potato, beans, *piñon* (pine fruit) and *quinoa* (a cereal of Peruvian origin). The Spanish introduced wheat, pork meat, spices and wine. All these ingredients were integrated into a typical

◀ On the menu: salty scent of *mariscos*…

▼ …or tangy freshness of the traditional *ceviche*

Wines and Cuisine 127

cuisine, called *criolla*. In its composition of certain popular dishes, corn is still an ornamental base of Spanish flavours.

Likewise, the *humita,* corn leaf papillote stuffed with freshly milled corn and onions, baked in a container filled with water, and consumed salted or sweetened.

Likewise, the *pastel de choclo,* pre-cooked ground chicken, mixed with hard-boiled eggs, covered with a corn purée and pine nuts with milk, eggs, butter, basil, spices, olive oil, the whole powdered with sugar and baked in the oven until the corn purée is slightly caramelised.

Likewise, beans of the "*con pirco*" grain, which Pablo Neruda was particularly fond of. Pirco is a term of Araucanie, in the Temuco region, which designates a mix of beans and pumpkin cooked in water, along with a corn purée seasoned with garlic, pepper and cumin. Also popular is this Mapuche stew of dried beef with vegetables and potatoes called *Charquicán*. Before beef was introduced by the settlers, this dish was made with llama meat.

With time, European immigration introduced other recipes and other tastes. Thus German pastries are now established and themselves have their supporters. We cannot ignore the *kuchen,* a fruit cake greatly appreciated in the Lakes region and in that of Puerto Montt.

Compared to its neighbours, Mexican, Argentine and Peruvian, Chilean cuisine is quickly forging an exceptional reputation for refinement and lightness that seems to be sought

▼ Tasty filet mignon Chilean style...

out elsewhere in the world. Gradually, chefs have imposed their label by opening fine restaurants in Santiago. Having become fashionable, they have raised new vocations.

A new multicultural cuisine has been born of the marriage of traditional products and Chilean wine. Two paths opened. Either the wine was incorporated into the cooking ingredients giving them new flavours, or tasting of local wines obliged new chefs to be more imaginative than their predecessors by inventing subtle taste alliances.

With wine, there is now a Chilean cuisine that has nothing to envy from those countries known for the inventiveness of their chefs. Just open a guide of restaurants in the area to be convinced that Chilean cuisine has reached a level of enviable quality and originality to be discovered without delay.

Not to be missed under any pretext:

Salmon with wheat grain and pine nuts cooked with red wine and coriander / Lamb stew, quinoa and Syrah sauce / Smoked meat stew with aroma of carménère / *Maridaje*. Tasting small quantities of refined dishes along with appropriate wines.

▼ ...and *quinoa* gastronomical style

© Casa Silva

Wines and Cuisine

For Chileans, the **pisco** is Chilean. For the Peruvians, the pisco is Peruvian. Without entering into the debate on the original designation of Pisco, lets say that it is above all a brandy obtained by distillation of the entire cluster of grapes, Muscat, Pedro Ximénez or Torontel.

In Chile, the pisco grape is cultivated in the Elqui Valley. This brandy is traditionally enjoyed in a cocktail called Pisco sour, whose most recent recipe is the following:

3 measures of Pisco
1 measure of lime juice
3 tablespoons of sugar
1 beaten egg white

In a mixer, beat the egg white with sugar until dissolved. Add the Pisco, lemon juice and crushed ice. Mix together. Serve in a glass, gently, so that the pisco sour is covered with a cap of foam.

Refreshing and relaxing after a hot day! Remedy to be used in emergencies to combat *soroche* (altitude sickness)!

Chapter 9
VALPARAISO, THE JEWEL OF THE PACIFIC

You are a rainbow of multiple colors,
you, Valparaíso, principal port;
your women are all white daisies,
plucked lovingly from your shores.

Upon arriving at the port of my adoration, the way down slowly reveals the colors of a life of stress, of a present hoping to regain a nostalgic and glorious past, of promenades and passer-bys, while the aromas of the sea fruits begin to surface, as well as the smiles crafted by the labour of each day. Valparaíso is a journey in time, where the wreckage of salt on metal and the lemon-like flavour of tasty shoe clams sprinkled with Parmesan cheese merge onto the streets and its people. Down by "the flatland", the rackety geography expresses Valparaiso's income distribution. The shops, offices and monuments of what was a principal port at the beginning of the industrial age give the place a special character, that of being inside a photograph tinted with age as one's gaze travels down from the hills. If, however, we contemplate the landscape from the pier and onto the nooks and infinite stairwells that make the picturesque houses which seem as though they are built on top of each other, it is as though we are in front of a city full of life trying to build itself a new future on every corner.

Looking at you from Playa Ancha, oh my lovely port,
you can see the ships that come in and then must go;
and the city's sailors chant you this selfsame song:
I cannot live without you, oh my adored port.

Walking towards the pier, close to Echaurren Square, where the bay opens its jaws to swallow the port whole, one can breathe the hard work of the men and women. Machinery and metallic marine monsters with rounded windows and flags of exotic places move constantly, day and night, in the cargo loading port. There is not one moment when this activity stops, even if it is only a faint glimmer of a once illustrious past. In Cerro Alegre one can enjoy a good wine at the Brighton Restaurant while delighting in the ocean view and never-ending blue skies, admiring how restlessly cargo comes and goes, how transport moves back and forth and how peaceful the warships seem.

From Los Placeres hill I walked over to Barón,
I came to the Cordillera in search of your love.
You went to Cerro Alegre, and I followed like an encore;
oh beautiful porteña, don't make me suffer anymore!

A city of travelers, of students, of transients. To live in the port means to go through its hills, always searching and finding new delightful corners. Many are just passing by, yet always hungry for more they keep coming back again and again, until unwittingly they find themselves residents, painting their roofs with new colors and striving to realize their dreams…

The Plaza de la Victoria is a social place to meet,
Avenida Pedro Montt, you are single and unique,
yet with all my heart, it is you of which I sing,
Torpederas of my dreams, Valparaíso, my love!

Part of Valparaiso's population stays faithful to its customs and another part blends in with its foreign traditions. Amidst this, the port city nights are a time for social gathering, where regardless of how much you plan ahead chance always plays a part in its improvised bohemian charm, of spontaneous conversations and interminable adventures. Bar hopping is one of the city's favorite activities, drinking wine or beer in each place and meeting new people, greeting familiar faces, eyeing visitors or chatting with anyone who shows interest in knowing about your life and who you are. There are several bars of many styles, with typical nostalgic decor as well as trendy European-style ventures with a local touch.

The *porteño* night has that relentless Latino flavour of the offspring of adopted faraway cultures adapted to the local necessities and interests of the region.

Throughout my early years I sorely tried to find
the story of your hills while I used to fly my kite;
as butterflies fluttering among the roses
I journeyed through your many hills until the very end.

Porteño people are proud. They are born and die in their port. They respond with an open smile on their faces whenever asked about their origins and exalt their virtues every time they can: they are hard-working, good drinkers, merry, daring and many are poets. They show their city as though it was the most precious object. They will take you from Argentina Av. to the Torpederas beach on the other side of Playa Ancha. They will take you to the Barón pier, telling you the story of the San Francisco Church, from where the port's nickname originates (Pancho, as it is tenderly known by many); they will take you to the Ecuador promenade and close by to Aníbal Pinto Square, next to the Cumming walkway, another typical location to start a night of drinking; they will tell you about Arturo Prat in Sotomayor Square, while at the same time roguishly commenting about the statue of Justice near the Peral elevator stop; in the Artillería elevator they will invite you to gaze at one of the most impressive views, and once up there the adventure begins to soar. They will board you on bus O to go around Alemania Av., traversing the hills and their varied characters: Cerro Cordillera as one of the oldest, Cerro Alegre as one of the most famous and pretty, Cerro Cárcel because it houses the most important cultural center in the region and Cerro Bellavista due to its fabulous Open Air Museum as well as one of Neruda's most spectacular houses, La Sebastiana.

I went away and left you, dear port,
and see you whene'er I come back.
Seamen call you Jewel of the Pacific
I just call you enchantment, like Viña del Mar.

Visiting places such as Café Color, J Cruz, el Picante, el Trole or El Pajarito; eating the fruits of the sea at the Cardonal Market or Membrillo Cove; walking and traver-

sing the stairwells of Valparaíso; riding up and down the Polanco, Espíritu Santo or Concepción elevators, talking with and enjoying a people always willing to be kind; they all make me sing this song, as I drink my last glass of wine, sitting in front of the Pacific and contemplating the sun coming down in the distance. This journey is over. I can now go to sleep and dream of new roads to discover.

Vania Berrios
Text freely inspired by the song
"La joya del Pacífico" (quoted in italics)

PRACTICAL NOTEBOOK

The journey continues! Throughout this practical guide book, you will find 39 vineyards that we wanted to highlight. Arranged valley by valley, they will lead you through the country from north to south. Subjective and not exhaustive, this selection presents a burgeoning wine industry and a wide range of œnotouristic activities.

For each vineyard, a history (**H**), specifics (**S**), an iconic wine (**W**), and a tourist service (**TS**) is given. Horseback riding or mountain biking, carriage rides, picnics in the vineyards, gourmet meals… On leaving, the traveller will have found something inspiring in his tour of the Chilean bodegas that make it unforgettable.

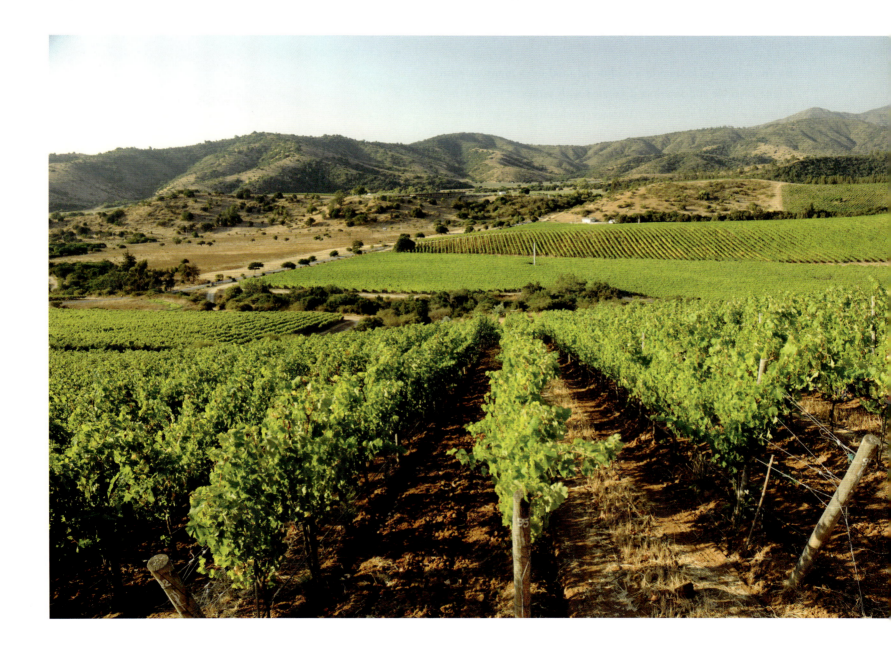

Elqui Valley
(www.valledelelqui.cl)

CAVAS DEL VALLE WWW.CAVASDELVALLE.CL

H : Small boutique winery located in the hills of the Elqui Valley (an area known for the production of *pisco* grape brandy). This vineyard was founded by a retired couple who have rebuilt their lives around a new project: to produce quality wines with organic grapes. Much of the 6-hectare (14 acre) vineyard is planted with the Syrah strain, which grows perfectly in this area.

S : The cellars are located in a traditional mud-brick mansion, with a long corridor and interiors decorated with pieces of modern art. There is a marked coexistence between modernity and the antiques, which are still used to create the wines.

W : Alto del Silencio, blend of 80% Syrah and 20% Cabernet Sauvignon. Maroon colour, aroma with notes of wood, berries, honey, pollen, vanilla and chocolate.

TS : Claiming to be just like their wines, "very colourful and very red", this proud retired couple warmly welcomes visitors and provides fun and light-hearted wine tastings. Free visit. Monday to Sunday from 10:00 am to 8:00 pm. English/French/German.
Tel. (56-51) 451 352

Elqui Valley
(www.valledelelqui.cl)

FALERNIA WWW.FALERNIA.COM

H : Aldo Olivier came to Chile with his Italian family in 1951. First he specialized in the production of table and *pisco* grapes. In 1998, he discovered the potential of the valley to produce quality wines and founded Falernia. He planted several strains in this semi-desert region, such as Riesling, Viogner, Syrah, Carmenère, Pinot Noir and Sangiovese with the support of his cousin Giorgio Flessati, winemaker from the region of Trento, Italy.

S : The gorgeous landscape surrounding the vineyard, located on the banks of the Puclaro reservoir at the foot of the majestic mountains of Elqui.

W : Syrah Reserve 2006, bright crimson red and black pepper notes.

TS : Visit to the cellars and the vineyard. Price per person: around €8 (USD$11).
Tel. (56-51) 412 260

Limarí Valley

TABALÍ
WWW.TABALI.CL

H : Viña Tabalí, meaning "passage of water" in the Molle Language, started in 1993 with its first plantations in this very promising valley. It has 160 hectares (395 acres) of strains such as Chardonnay, Sauvignon Blanc, Syrah, Carmenère and Pinot Noir. Today it belongs to businessman Guillermo Luksic and the San Pedro Tarapacá Wines group.

S : Its spectacular cellars built at the foot of the gorge, whose "passage of water" resounds in the landscape with its gliding free-falling sound over the Pacific. Elegant and modern, the cellar was designed to depict the life of the Molle culture, the ancestors of northern Chile who inhabited the bottom of the gorges in order to protect themselves from the intense heat and to procure water, vegetation and shade. They left a legacy of many pictographs and stone cups in a semi-arid stream. Inside, the magic of the valley extends amidst the gigantic corridor that runs through the underground landscape.

W : Chardonnay Special Reserve, with fresh fruit and citrus notes, pineapple and honey.

TS : Visits take place in the spectacular wine cellar, followed by a walk through the vineyard and ending with a tasting of the wines. Not far from the cave is the "Valle del Encanto" ("Valley of Enchantment"), where the petroglyphs and pictographs from the Molle culture (0 to 800AD) can be found. Monday to Sunday from 10:30 am. Prices from €20 per person (USD$28), according to the chosen tour.
Tel. (56-2) 477 55 35.

Limarí Valley

TAMAYA
WWW.TAMAYA.CL

H : Tamaya is owned by Don Rene Merino Blanco and his wife Lorena Raimann Tampier. The vineyards date from 1997 and cover 160 hectares planted with Chardonnay, Sauvignon Blanc, Viognier, Carmenere, Syrah, Cabernet Sauvignon, Merlot, Sangiovese and other varieties. The production plant, with a capacity of 1,600,000 litres, was constructed in 2001 and is equipped with all the technology necessary to produce high quality wines.

S : In the Diaguita language (pre-Columbian culture) Tamaya means "high lookout point", a name also given to the highest peak in the area where there is an impressive view of the fruit trees and the vineyards. Traces of the Diaguita people have been found in the lands belonging to the vineyard, who settled in the area between the VIII and XV centuries. Among the highlights of these findings are the stone cups, named for the number of holes carved into their surface where food and minerals were ground and rainwater was preserved.

W : Special Reserve, blend of Chardonnay, Viognier and Sauvignon Blanc. Pale yellow colour with wooden and fruity notes, a palate of tropical fruit, citrus and a mineral background.

TS : Does not offer tourism services yet. Project in development.

Casablanca Valley
(www.casablancavalley.cl)

VERAMONTE
WWW.VERAMONTE.COM

H: Family vineyard established in 1990 by Augustin Hunneus, which began to market its wines in 1996. It has approximately 450 hectares (1,111 acres) with strains such as Chardonnay, Cabernet Sauvignon, Merlot and Sauvignon Blanc.

S: The imposing mansion with its terrace offers a panoramic view of vineyards. The cellar was created by architect Jorge Swinburn and was inaugurated in 1998, boasting more than 7,800 square meters (84,000 square feet). The spectacular vineyard located in the horseshoe-shaped sub-valley that traps the morning mist contains a beautiful Chilean native tree, a Molle of about 200 years. There is also a deep forest at the foot of the hills, which provide shade for the strains of white grapes.

W: Primus 2005 harvest, blend of 51% Merlot, 32% Cabernet Sauvignon and 17% Syrah. Deep red colour with aromas of black and white pepper, notes of mocha, exotic spices and ripe fruit.

TS: Visit to the cellar where there is a privileged view of the vineyards. You can also see a small lake with 24 different species of birds. Tours in English and Spanish, Monday through Friday at 10:30 am, 12:30 pm and 3:00 pm. Saturday and Sunday at 10:30 am and 12:30 pm. Price: approx €10/person (USD$14). Duration: 40 minutes.
Tel. (56-32) 232 99 24

Casablanca Valley
(www.casablancavalley.cl)

WILLIAM COLE
WWW.WILLIAMCOLEVINEYARDS.CL

H: The successful American businessman William Cole, dedicated to software design, came to Chile in the 1990s in order to find good quality fruit to export to his country. Enchanted by the beauty of this valley and interested in the topic of wine, he finally undertook one of his most personal adventures. In the late 90's, he established his vineyard, which has 130 hectares (321 acres), focusing on production of white and Pinot Noir vines.

S: The cellar, surrounded by mountains with peaks covered with snow in winter, was built in 1999 under the architectural influence of Baja California. It evokes the old Chilean missions and the buildings of the Indians of southwestern North America.

W: Bill Limited Edition 2008, Sauvignon Blanc, of soft yellow hues with herbal notes and aromas of asparagus and peaches, with wooden and citrus flavours.

TS: Visit to a Sauvignon Blanc quarter, then the winery and finishing with a tasting of premium wines. Tours in English/Spanish from Monday to Friday, from 9:30 am to 4:30 pm. Price per person: €10 approx (USD$14). Duration: 1 hour.
Tel. (56-32) 215 77 77

Casablanca Valley
(www.casablancavalley.cl)

INDÓMITA

WWW.INDOMITA.CL

H : Founded in the late 90's and then passing through various hands, the vineyard now belongs mostly to the Bethia Group, part of the holding of well-known businesswoman Liliana Solari, who owns 200 hectares (494 acres) in this valley and another 400 in the Maipo valley.

S : The big white house looks like a palace located in the valley and can be seen from the road. It is a sophisticated restaurant with markedly minimalist style decorations in wood, iron and wicker, which offers upscale Chilean cuisine using typical ingredients and preparations.

W : Zardoz, Cabernet Sauvignon, red with violet hues, an aroma of violets, red fruit and an exquisite smoky flavour, with hazelnuts, cocoa and hints of mint.

TS : The tour is conducted by the sommelier. The tasting is finalized with a tour of the valley and its beautiful landscapes, highlighting the Arab horse stable belonging to the vineyard. They also do tasting courses and horseback riding towards a lookout point and under the full moon from October to March. The price per person ranges from about €8 to €46 (USD$11-65). Monday to Friday from 10:30 am to 4:30 pm, Saturday and Sunday from 11:00 am to 5:30 pm. There is also the possibility of having lunch in the restaurant of chef Oscar Tapia. Suggestions include the lightly seasoned Patagonian king crab roll, covered with an avocado, red beet and ginger dressing, and Chilean sea-bass fillet with wild mushroom tapenade on a roll of native potato and river shrimp. Average price per person: €25 (USD$35). Monday to Sunday from noon to 4:00 pm.
Tel. (56-32) 275 44 00

Casablanca Valley
(www.casablancavalley.cl)

VIÑA MAR

WWW.VINAMAR.CL

H : Set in the north of the Casablanca Valley to enjoy the benefits of proximity to the Pacific, this vineyard has 274 hectares planted with Sauvignon Blanc, Chardonnay, Pinot Noir, Merlot, Cabernet Franc and Carménère.

S : The ocean is at the heart of the Viña Mar brand. With its graphic style of yachting, it seamlessly combines wine and the ocean.

W : Reserva Especial, Cabernet Sauvignon and Carménère 2007, blend of 55% Cabernet-Sauvignon, 40% Carménère and 5% Syrah. Deep ruby, with aromas of red fruits and spices.

TS : Guided tours, tasting optional. Monday to Saturday, from 10:00 am to 2:00 pm and from 3:00 pm to 5:00 pm. Sunday from noon to 5:00 pm. Boutique with wines and souvenirs. Luxurious San Marco restaurant.
Tel. (56 32) 2754 300

San Antonio Valley

MATETIC WWW.MATETICVINEYARDS.COM

H : This vineyard was founded in 1999 by the Matetic Family, who decided to enter the world of wine believing in the good climate and soil of this valley. It has 90 hectares (222 acres) planted with Chardonnay, Pinot Noir, Sauvignon Blanc, Merlot and Syrah, based on principles of organic production.

S : Situated in a perfectly closed valley perpendicular to the ocean, with remarkable lighting. The winery, modern in style, was designed by the team of this vineyard under the guidance of architect Laurence Odfjell. It contains French oak barrels with a capacity of 300 thousand litres (79,252 gallons). There is a special emphasis in the process of winemaking and the protection of the environment.

W : Syrah Matetic 2005, deep dark red with aromas of fruit, herbs, dairy, damp soil, spices and chocolate, among others.

TS : Visit the vineyard and its facilities choosing among three different routes, ending with a tasting. Prices range from €9 to €17/person (USD$12-24). From late February you may participate in the harvest alongside the tour host. There is also the possibility of horseback riding through the canyons and hills with panoramic views of the area. This vineyard has an excellent restaurant and lodging in a colonial style mansion that has been recently renovated. The kitchen is led by chef Matias Bustos. As a starter, we recommend the house ceviche (raw fish marinated in lemon juice and spices) with pieces of Chilean sea-bass, avocado, red onions, red peppers and a cashew nut sauce. For the main course, try the leg of lamb and rösti potato rolls. Average price per person: €20 (USD$28). Tuesday to Sunday from 12:30 pm to 4:00 pm.
Tel. (56-2) 595 26 61

San Antonio Valley

CASA MARÍN WWW.CASAMARIN.CL

H : Tenacious agronomist Maria Luz Marin started her own vineyard in the year 1998 to produce varied wines with character. Passionate about wine and boasting more than 25 years of experience in the business, she works with 25 hectares (61 acres) of varieties such as Pinot Noir, Sauvignon Gris, Sauvignon Blanc and Gewurztraminer.

S : The cellar is decorated with unique mosaics made by her sister, which create a welcoming atmosphere in the midst of stainless steel tanks and French oak barrels. Capacity of 200 tons and 1,500 litres (396 gallons) of wine. Its location has a beautiful ocean view.

W : Lo Abarca, Pinot Noir, with cherry aromas and red fruit, raspberry and vanilla flavours.

TS : Tour through the vineyards highlighting the concept of "vineyard designated", meaning that every quarter is developed independently. Visit to the cellar and wine tasting. Visitors can be received by the owner and tour the vineyard with her. Prices per person from €12 to €90 (USD$17-127). Tours in English and Spanish, Monday through Friday from 10:00 am to 5:00 pm.
Tel. (56-2) 334 29 86.

Aconcagua Valley
(www.aconcaguavinos.cl)

ERRÁZURIZ
WWW.ERRAZURIZ.COM

H : Family vineyard established in 1870 by Maximiliano Errazuriz. Don Maximiliano brought the finest clones from France, transforming this terrain into a very important vineyard of global status. Eduardo Chadwick, a direct descendant of Don Maximiliano is currently in charge of this vineyard and represents the sixth generation of the family linked to the wine business. The vineyard has over 1,000 hectares (2,471 acres) divided into 8 vineyards located in different valleys.

S : Possessing very traditional cellars, the owners have implemented innovative approaches to produce beautiful vineyards, dazzling visitors with the panoramic views of the valley.

W : Maximiano Founder's Reserve, a blend of 82% Cabernet Sauvignon, 8% Cabernet Franc, 5% Petit Verdot and 5% Shiraz, deep red ruby colour with aromas of cassis, truffles and black fruit, balsamic notes of black pepper, green olives, a hint of chocolate, and blackcurrant and blackberry flavours.

TS : Visits to the cellar, walk through the vineyards with beautiful views and the centennial cellars; finishes with a tasting. Price per person: approx €18 (USD$25). Tuesday to Saturday from 10:00 am to 6:00 pm.
Tel. (56-2) 339 91 00

Maipo Valley
(www.maipoalto.com)

SANTA ALICIA
WWW.SANTA-ALICIA.CL

H : In 1954, Don Máximo Valdés -businessman and minister of agriculture in 1935 – founded this vineyard on the fertile lands near the capital, calling it at first "La Casa de Pirque" (the House of Pirque) and 30 years later Santa Alicia, a name of family tradition. Its owner has plantations in Pirque, Maria Pinto and Melipilla, with Cabernet Sauvignon, Merlot, Sauvignon Blanc, Chardonnay, Cabernet Franc, Syrah, Petit Verdot and Carmenère strains.

S : Its large carved wooden barrels provide charm and originality to this cellar, which has been transformed into a veritable living museum. The European-style mansion is reminiscent of those of the Swiss Alps. Its exterior walls were designed with ceramics made by the employees of the vineyard.

W : Carmenère Gran Reserva, ruby red colour, with aromas of spices and menthol

TS : Visit to the vineyard and cellar. Price per person: approx. €18 (USD$25). Duration: 1 hour.
Tel. (56-2) 854 60 21

Maipo Valley
(www.maipoalto.com)

HARAS DE PIRQUE
WWW.HARASDEPIRQUE.COM

H : : In 1990 Eduardo Matte acquired these lands and called them Haras de Pirque, dedicated to raising thoroughbred horses. In 1992 he decided to plant the vineyards, stretching across 145 hectares (358 acres) and located at the foot of the mountains. It grows primarily Cabernet Sauvignon and, in lesser quantities, Carmenère, Merlot, Chardonnay, Sauvignon Blanc, Cabernet Franc, Syrah and Petit Verdot.

S : The only vineyard that combines wine and thoroughbred horses, and to emphasize it the owner built the cellars in a horseshoe shape, showing the two worlds that coexist in this farm. Even the labels of their wines bear the shape of a horseshoe. The facilities at Haras are fabulous, with a colonial house and a great race track where you can see the training of horses.

W : Albis 2004, blend of 75% Cabernet Sauvignon and 25% Carmenère. Deep red colour, elegant in the palate with fruit flavours, balsamic notes, dark chocolate and mint.

TS : Visit to the cellar and vineyards, including a tasting and a beautiful collection of 18 horse carriages. Monday to Sunday from 9:00 am to 8:00 pm. Duration: 1h 30 min. Price per person: approx. €18 (USD$25).
Tel. (56-2) 854 79 10

Maipo Valley
(www.maipoalto.com)

SANTA CAROLINA
WWW.SANTACAROLINA.CL

H : Don Luis Pereyra Cotapos, a man of great vision, founded the vineyard in 1875 in the name of his wife, Mrs. Carolina Iñiguez. Originating in the Bordeaux region of France, the vines are Cabernet Sauvignon, Merlot, Sauvignon Blanc and Chardonnay. He also brought with him French winemaker Germain Bachelet, grandfather of the current President of the Republic, Michelle Bachelet.

S : Located in the heart of Santiago, the ancient underground cellars were built in two phases in 1877 and 1898 of *"cal y canto"* (stone with lime/egg white mortar), and is regarded today as one of the most representative buildings of the era. Tradition and modernity meet in this place. In 1973, it was declared a historic monument for its architectural beauty and its excellent state of preservation.

W : VSC 2003, blend of Cabernet Sauvignon, Syrah and Petit Verdot, ruby red coloured, with aromas of red fruit and tobacco, dark chocolate and caramel.

TS : Very accessible visit, since the vineyard is located in the Macul district, easily reached on the metro (subway), Rodrigo Araya Station (line 5). The tour includes a visit to the winery and the mansion of the founder, as well as a wine tasting in a cosy bar. Prices range between €9 and €18 (USD$12-25) per person. Duration: 1 hour. Tours in Spanish/English, Monday to Saturday.
Tel. (56-2) 450 30 00

Maipo Valley
(www.maipoalto.com)

UNDURRAGA
WWW.UNDURRAGA.CL

H : Don Francisco Undurraga, a great entrepreneur, created this vineyard in the Santa Ana estate and personally brought vines from France and Germany. He developed the vineyard's first wines with Cabernet Sauvignon, Sauvignon Blanc, Merlot, Pinot Noir, Riesling and Gewurztraminer vines. Currently they possess more vineyards in the Colchagua Valley and San Antonio.

S : Recently, a new consortium has given this traditional vineyard a new edge, by seeking new terroirs, product lines and labels. The cellars, which have been recently renovated, further enhance the facilities located in a wonderful XIX century park, designed by French landscape architect Pierre Dubois. There are statues of the Mapuche tribe, honouring the history of Chile and its people. The underground cellars built in the year 1885 have been partly transformed into a museum, giving this visit a special charm.

W : Altazor, blend of 55% Cabernet Sauvignon, 18% Syrah, 15% Carmenère and 12% Merlot. Violet red, with aromas of black fruit, berries and cedar.

TS : Visits to the centennial park, the modern and ancient wine cellars dating from the nineteenth century, ending with a tasting. Price per person: 10€ approx (USD$14). Duration: 1 hour and 15 minutes. Monday through Friday from 10:00 am to 3:30 pm. Saturday and Sunday from 10:00 am to 1:00 pm.
Tel. (56-2) 372 29 00

Maipo Valley
(www.maipoalto.com)

TARAPACÁ
WWW.TARAPACA.CL

H : Businessman Francisco de Rojas y Salamanca founded the vineyard in 1874 at the foot of the Andes Mountains with vines brought from France. Later, Antonio Zavala received the vineyard in compensation from divorcing his wife. These procedures were carried out by attorney Arturo Alessandri Palma, two-times President of the Republic and also known as "The Lion of Tarapacá", from where the place gets its name. When Rojas turned 90 he acquired the Rosario de Naltagua estate, which has over 2,600 hectares, making it one of the largest and most important wineries in the market. Currently the vineyard is in the process of merging with Viña San Pedro.

S : Possesses a comfortable house of traditional architecture and contemporary decor to welcome visitors, and a beautiful park of 10 hectares. It is one of the leaders in wine production and the cellar has a capacity of 15 million litres per year, making it one of the largest in the country.

W : Zavala, red blend of 40% Cabernet Franc, 30% Cabernet Sauvignon and 30% Syrah. Intense purple red colour, notes of leather, ripe cherries and brambleberry, as well as sweet and toasted notes.

TS : This vineyard offers a private tour with a minimum of 10 people (reservation required). This includes a visit to the vineyard and the cellars, showing the production of red and white wines, and ends with a tasting of two of their wines. Price: €9/person (USD$12). Duration: between 1h and 1h30 in English/Spanish. It has a nice guest house with 19 comfortable rooms, which combines traditional architecture and contemporary decor. Price for a double room: approx. €200 (USD$283).
Tel. (56-2) 819 27 85

Maipo Valley
(www.maipoalto.com)

COUSIÑO MACUL WWW.COUSINOMACUL.CL

H : Vineyard founded in 1856 by Don Matías Cousiño. It is one of the few wineries that still remain in the hands of the founding family, which had an important role in the Chilean wine industry of that time. Over 60% of production is concentrated in different varieties of reds, such as Cabernet Sauvignon, Merlot, Syrah, Cabernet Franc and Petit Verdot. They also have Chardonnay, Sauvignon Gris, Sauvignon Blanc and Riesling.

S : The basement was built in 1870 at a depth of 7 meters (23 feet) by French architects with the "*cal y canto*" technique (stone with lime/egg white mortar). The impressive barrels and vats of wine, produced using traditional methods, retain the memory and the customs of that era. In the Cousiño Macul family business, know-how is passed on from generation to generation. When visiting the winery, visitors can see how the wine was produced in the nineteenth century.

W : Lota 2005, blend of 75% Cabernet Sauvignon and 25 % Merlot. Deep ruby red with aromas of blackberries and plums, notes of salvia and spice, and a palate of blackberries, raisins, cocoa, soy and sweet oak spices.

TS : Visit to the winery with an explanation of the winemaking process, ending with a wine tasting. Price per person: €10 (USD$14). Duration: 1 hour. Tours in English/Spanish, Monday through Friday from 11:00 am to 4:00 pm and Saturday from 11:00 am to noon. Tel. (56-2) 351 41 35

Maipo Valley
(www.maipoalto.com)

CONCHA Y TORO WWW.CONCHAYTORO.CL

H : When the production of wine had just recently started in Chile, Don Melchor Concha y Toro –a prominent politician and businessman–, founded the winery in 1883 with strains that he ordered from the Bordeaux region in France. It has more than 7,000 hectares (17,298 acres) planted with Cabernet Sauvignon, Merlot, Syrah, Cabernet Franc, Carmenère, Pinot Noir, Chardonnay, Sauvignon Blanc, among others. Concha y Toro has acquired a global reputation with its emblematic "Casillero del Diablo" line, currently Chile's most widely sold wine around the world.

S : In the Pirque tourist centre there is a beautiful Pompeian style mansion, the residence of the founder's family. This is the cellar where, for over 100 years, the legend of the famous wine "Casillero del Diablo" (the Chapter of the Devil) –named by Don Melchor– was born. In this place they kept their best wines, some of which mysteriously disappeared. Research and development of Carmenère as well as the pursuit of terroirs are also carried out here.

W : Don Melchor 2005, blend of 97% Cabernet Sauvignon and 3% Cabernet Franc, with aromas of chocolate, black cherries and plums that merge with aromas of coffee and cassis and a palate of red fruit.

TS : It is certainly the most visited winery in Chile. The vineyard has a beautiful terrace where you can eat and taste good wines. Visit to the cellar and walk along the park where the centennial mansion is located. Price per person: €10 approx (USD$14). Duration: 1h. Monday to Sunday from 10:00 am to 5:00 pm.
Tel. (56-2) 476 52 69

Maipo Valley
(www.maipoalto.com)

ALMAVIVA
WWW.ALMAVIVAWINERY.COM

H : Vineyard established in 1997 by Baroness Philippine de Rothschild, president of the Advisory Board of the Baton Philippe de Rothschild Company, and Eduardo Guilisasti Tagle, president of the vineyard Viña Concha y Toro, under the technical supervision of both partners. Almaviva is the happy outcome of the meeting of French and Chilean cultures. Chile offers its soil, its climate and its vineyards, while France brings its expertise and traditions.

S : Located in Puente Alto, this bodega was created by the Chilean architect Martín Hurtado. With undeniable æsthetic quality, it is recognized as an example of design and functionality. It is built of wood native to southern Chile and fits perfectly into the typical landscape of the central valley. Its interior decoration is inspired by ethnic motifs of the Mapuche culture.

W : Almaviva 2006, a blend consisting of 63% Cabernet Sauvignon, 26% Carménère, 9% Cabernet Franc and 2% Merlot. Deep and opaque ruby colour. Deep ruby, with aromas of cassis, plum and blackberry.

TS : Visits by appointment, followed by a tasting. Monday to Friday, 9:00 am to 5:00 pm. Price/person: approx. €22 (US$30).
Tel. (56-2) 270 4200

Maipo Valley
(www.maipoalto.com)

WILLIAM FÈVRE
WWW.WFCHILE.CL

H : After working for over thirty years in the French wine industry and becoming well known in production of Grands Crus de Chablis, William Fèvre left to explore the Chilean terroirs. At this time, he joined one of the oldest wine cultivating families of the Maipo Valley, the Pino-Arrigorriaga. This alliance between French and Chilean expertise gave rise to the William Fèvre vineyard in 1991. Its bodega and principle vineyards are found at Pirque, at the foothills of the Andean Cordillera.

S : Planted with Savignon Blanc, Chardonnay, Pinot Noir, Merlot, Cabernet Sauvignon, Carménère and Cabernet Franc, the vineyards of William Fèvre reflect a constant search for quality. This is reflected both in the choice of locations for planting of the vines and in the collection of the clusters.

W : Cabernet Sauvignon Reserva Misión, blend of 85% Cabernet Sauvignon and 15% Cabernet Franc. Deep ruby, with aromas of black currant, dried plums and vanilla.

TS : Tel. (56-2) 853 10 26

Practical Notebook

Maipo Valley
(www.maipoalto.com)

SANTA RITA WWW.SANTARITA.CL

H: In 1880 Don Domingo Fernández Concha, an outstanding public man and entrepreneur of the time, founded this vineyard introducing fine French vines and winemakers. A century later the vineyard was sold to the Claro group, which turned it into one of the largest in the country. This area is excellent for red strains, especially Cabernet Sauvignon.

S: Possesses different cellars, which include one founded in 1880 with French technology in mint condition. It also possesses the Museo Andino museum, which displays 1800 pieces of pre-Columbian art. The beautiful "Casa Paulina" colonial house –a national monument– was transformed into a cosy restaurant. In this house General O'Higgins (liberator of Chile) and his 120 soldiers took refuge against the Spanish crown. In his honor they created the 120 line of wines, which enjoys great recognition in the market.

W: Casa Real Chardonnay, brilliant yellow colour with notes of lemon and aromas of tropical fruit.

TS: Tour of the main plant explaining the winemaking process, followed by lunch with wines included at the Doña Paula restaurant. The tour ends with a visit to the museum. Price per person: €50 approx (USD$71). Possibility for lunch in a restaurant led by chef Felipe Castillo, highlighting the dill ceviche and orange duck (average price per person: €20 (USD$28). Possesses a Pompeian-style mansion (Hotel Casa Real) transformed into a hotel with 16 cosy rooms. Approximate price for a double room: €250 (USD$354). Tel. (56-2) 362 25 20

Cachapoal Valley

TORREÓN DE PAREDES WWW.TORREON.CL

H: Born in the mythical island of Chiloe, Don Amado Paredes founded this vineyard in 1979 in the town of Rengo, after having worked in sectors as diverse as education and metallurgy. Combining family management and the use of better technologies, Torreón de Paredes was firmly implanted in the Cachapoal Valley. The company now has 150 hectares of vineyards planted with Cabernet-Sauvignon, Merlot, Carménère, Syrah, Pinot Noir, Chardonnay, Sauvignon Blanc, Gerwürztraminer, Viognier

S: In its facilities, Torreón de Parades has sought to respect, restore and perpetuate the colonial architecture of central Chile. It includes, among others, classic colonnades and adobe walls, and a garden where quietness and the gentle life can be enjoyed.

W: Don Amado 2005, blend of 80% Cabernet-Sauvignon, 10% Merlot, 5% Carménère and 5% Syrah. Rich black with purple reflections, aromas of truffles, spices, tobacco and dark chocolate.

TS: Tel. (56 72) 512 551

Colchagua Valley
(www.colchaguavalley.cl)

BISQUERTT
WWW.BISQUERTT.CL

H: Family vineyard established by Osvaldo Bisquertt in 1970. Currently it has about 750 hectares (1,853 acres) of Cabernet Sauvignon, Merlot, Carmenère, Chardonnay, Syrah, Malbec and Sauvignon Blanc from vineyards in the Colchagua Valley.

S: Interesting visit, which includes a very old cellar, car collections, a room with saddles and huaso (Chilean cowboy) garments for the traditional Chilean rodeo, and gardens. The vineyard owns "Las Majadas", a charming guesthouse restored in 1998 that boasts colonial architecture and that still retains its original frescoes. The house is decorated with antique furniture and vintage woods brought from Europe. One of the most important exhibits is the main dining table, constructed of native wood in one long piece. The house is located in the middle of a park planted with Chilean palms more than 100 years old. It is truly a journey into the past of an aristocratic life.

W: Casa La Joya Grand Reserve Merlot 2006, intense colour with black olive tones, spices and cherry liquor, harmonizing with the wood that provides tones of dark chocolate and vanilla.

TS: Monday to Saturday from 10.00 am to 12.00 pm and 3.00 pm to 5.00 pm. Sundays from 10.00 am to 1.00 pm. Prices per person from € 10 (USD$14) with La Joya wine tasting and local cheeses. Possibility of staying in the "Las Majadas" guesthouse. Average price per person in double room: €130 (USD$184), including breakfast and lunch.
Tel. (56-2) 756 25 08

Colchagua Valley
(www.colchaguavalley.cl)

CASA SILVA
WWW.CASASILVA.CL

H: Emilio Bouchon came to Chile in 1892 from Bordeaux, with the dream of being a pioneer in the planting of vines in the valley. Today the vineyard is in the hands of the fifth generation, who has continued Bouchon's legacy.

S: The vineyard has the oldest cellar in this valley in terms of history and tradition, yet it is also technologically one of the most modern in the country. 100% of their wines come from this valley. It possesses an exclusive hotel and restaurant that recaptures the tradition of the Chilean countryside. The guesthouse has polo fields and a rodeo crescent where you can enjoy polo matches and rodeos that are very typical of the area.

W: Altura 2001, blend of 60% Carmenère, 20% Cabernet Sauvignon and 20% Petit Verdot. Intense ruby colour with aromas of ripe red fruit, blackberries and prunes.

TS: Performs different types of tours: classic, rustic and premium. An unforgettable visit in an antique chariot through the vineyards, leading to the polo field and the rodeo crescent. Prices from €10 to €15 (USD$14-21) depending on the chosen tour. Monday to Sunday from 10:00 am to 6:00 pm. The old family house was refurbished into a charming hotel that is tastefully decorated. Price per double room: €200 (USD$283).
Tel. (56-72) 913 091

Colchagua Valley
(www.colchaguavalley.cl)

LAPOSTOLLE WWW.LAPOSTOLLE.COM

H : Founded in 1994 by the Marnier Lapostolle family from France and the Rabat family from Chile, it is now fully owned by the Marnier Lapostolle family, descendants of the creator of Grand Marnier liqueur. Today it has a total of 350 hectares (865 acres) of Cabernet Sauvignon, Merlot, Carmenère, Syrah, Sauvignon Blanc and Chardonnay.

S : At the foot of a hill covered with leafy trees curved staves of a burst barrel constitute a six storey building-cellar where the wine runs down by gravity and at whose peak the view is lost in a sea of vines edged by mountains at the horizon.

W : Clos Apalta 2006, blend of 45% Carmenère, 21% Cabernet Sauvignon, 30% Merlot and 6% Petit Verdot. Red purple colour with aromas of black fruit, berries, together with a touch of mocha and vanilla.

TS : Does visits with tastings; optional lunch included. Prices per person range from €25 to €50 (USD$35-71). You can also go hiking and/or have a picnic in an old vineyard next to a charming country house, ideal for summer days. Possibility of accommodation in fully equipped cabins with a spectacular view of the valley. Average price per night: €400 (USD$565).
Tel. (56-72) 953 300

Colchagua Valley
(www.colchaguavalley.cl)

MONTES WWW.MONTESWINES.COM

H : Two men with great experience in wines, winemaker Aurelio Montes and businessman Douglas Murray, established the vineyard in 1987. In 1988 new partners Alfredo Vidaurre and Pedro Gand joined the project. This vineyard was initially dubbed Discovers Wine, a name that resounded in more than 75 countries. In 2007 they inaugurated a modern winery in the valley of Apalta. In this valley they planted Cabernet Sauvignon, Carmenère, Merlot and Sauvignon Franc, among others.

S : The cellars, based on Feng Shui, were built with all the elements: water, metal, wood, etc. to ensure harmony and a positive atmosphere, with beautiful parks and gardens. It has a capacity of 2 million 300 thousand litres (608,000 gallons) and is technologically one of the most modern wineries.

W : Montes Alpha M, blend of 80% Cabernet Sauvignon, 10% Merlot, 5% Cabernet Franc and 5% Petit Verdot. Intense red colour with a pleasant blend of fruit and wood from French oak barrels.

TS : Tour through the vineyards and cellars, followed by a tasting. Duration: 1h30. Prices per person: €15 (USD$21).
Tel. (56-72) 82 54 17

Colchagua Valley
(www.colchaguavalley.cl)

LAS NIÑAS WWW.VINALASNINAS.CL

H : When the French Daure family took a trip to Chile and Argentina in 1996, they were convinced that Chile was the next Promised Land, as the culture was similar and the language familiar. After studying the soils, they chose the valley of Apalta because they believed it possesses one of the best terroirs. The vineyard is now in the hands of 8 French women, with 160 hectares (395 acres) of Syrah, Mauvedre, Carmenère, Cabernet Sauvignon, Merlot and Chardonnay.

S : The winery was designed by famed architect Mathias Klotz in the shape of a cube of 2,700 m (8,858ft) with a semi-transparent façade, equipped with state-of-the-art technology.

W : Tacón Alto Tinto, blend of Syrah and Merlot of a dark red colour, with aromas of eucalyptus and blackberries, and notes of raspberries and cranberries.

TS : Visits to the vineyard and cellar. In spring and summer, you can appreciate the tranquillity of the countryside and the vineyard by having a picnic and climbing the hills on a mountain bike to enjoy the view over the Apalta valley. Prices per person: from €5 to €10 (USD$7-14). Duration: 1 hour. Monday to Sunday at 11:00 am, 3:00 pm and 5:00 pm.
Tel. (56-72) 321 600

Colchagua Valley
(www.colchaguavalley.cl)

EMILIANA WWW.EMILIANA.CL

H : In the year 1986 the Guilisasti family founded the winery under the name Bodegas y Viñedos Santa Emiliana. In 1998 they realized an important project, which was to make wine from the valleys of Casablanca, Maipo and Colchagua by incorporating organic and biodynamic agricultural methods, thus creating Emiliana Orgánico, the only such winery in Chile and a pioneer in Latin America.

S : In this place vines are treated according to the lunar cycles, harnessing the power of the constellations and planets, creating harmony with the forces of nature. The visitor travels through the bottom of the valley, crossing beautiful flowered vines surrounded by llamas, geese, chickens, etc.

W : G, blend of 30% Syrah, 24% Carmenère, 24% Cabernet Sauvignon and 16% Merlot. Plum red colour, with aromas of ripe black fruit, cassis and berries.

TS : Tour of the vineyards learning about organic farming, followed by a visit to the cellars and ending with a wine tasting. They also offer introductory wine tasting courses and the in the Spring-Summer season you may also have an outdoor picnic in the beautiful vineyard. Prices per person: from €10 to €20 approx. (USD$14-28). Tuesday through Sunday from 10:30 am to 4:30 pm.
Tel. (56-9) 327 40 19

Colchagua Valley
(www.colchaguavalley.cl)

GRACIA DE CHILE WWW.GRACIA.CL

H : Gracia de Chile belongs to the Córpora holding company. Built in 1996 in the Rapel Valley, its bodega includes stainless steel tanks with a capacity of 9.5 million and 4,000 French oak barrels.

S : This vineyard combines Chilean and French traditions through its two œnologists, Antonio Vásquez and Louis Vallet. It emphasises the fruity character of its wines.

W : Temporal Chardonnay, refreshing, pale straw colour, with aromas of pineapple, papaya, passion fruit and toasted almonds.

TS : A variety of tours are offered, including vineyard discovery followed by a tasting (about 2 hours), bicycling through the vineyards, leading to a viewpoint overlooking the Rapel Valley and followed by a tasting (about 3 hours). Something to eat may be found at Gracia Kitchen. Reservations 4 days in advance.
Tel. (56 2) 240 76 78

Colchagua Valley
(www.colchaguavalley.cl)

LUIS FELIPE EDWARDS WWW.LFEWINES.COM

H : Descendant of a London doctor who emigrated to Chile in the early 19th century, Luis Felipe Edwards founded his vineyard in 1976. The first winemaker of his family, it has become a tradition of the Edwards.

S : Their operation includes an organic wine labelled "White Rose" as it is lined with opulent roses. These serve a function of preventing certain diseases, and are uncommon in the valley.

W : Doña Bernarda, blend consisting of 50% Cabernet-Sauvignon, 30% Carménère, 15% Petit Verdot and 5% Cabernet Franc. Deep red, with aromas of dried plums, blackberries and violets.

TS : Tel. (56-2) 433 57 00

Colchagua Valley
(www.colchaguavalley.cl)

NEYEN WWW.NEYEN.CL

H : The story of Neyen de Apalta began in 1890 when vines of Carmenère and Cabernet Sauvignon were planted in a corner of this unique valley, surrounded by the horseshoe-shaped hills that gave fame to the terroir. It was in 2002 that Raúl Rojas and his family gave life to the Neyen wine project at the foot of the mountain and its foothills with 125 hectares (309 acres) of only red strains.

S : It possesses the oldest cellar in Apalta, built of adobe and dating from 1890. It underwent a restoration process in order to add value to the place where the wine broth used to be produced and stored. Original items were rescued, such as wooden pillars, walls and old Oregon pine doors. At a later stage, architect Jorge Swinburn undertook the construction of a neighbouring cellar that respects Apalta's surrounding environment and landscape. The virgin forest and native wildlife complement the natural setting of this 1,300 hectares (3,212 acres) enclosure.

W : Neyen, Blend of 70% Carmenère and 30% Cabernet Sauvignon. Intense ruby red colour with notes of black fruit, cassis and red fruit.

TS : Guided by the host of the vineyard, you will tour the centennial vineyards, the charming wine cellar and then finish with a wine tasting. There is also a night tour, which, in addition to touring the vineyards, lets you see the fully illuminated cellars in one of the most striking vistas of the valley. For nature lovers, they offer horseback riding or hiking, during which you can see the native flora and fauna, and oak forests. You come out to a natural pool where a snack is served with cheese, nuts and drinks. Monday to Sunday from 10:30 am. Price per person: from €20 (USD$28), according to the chosen tour.
Tel. (56-2) 240 63 00

Colchagua Valley
(www.colchaguavalley.cl)

SANTA CRUZ WWW.VINASANTACRUZ.CL

H : In 2003, the Grupo de Inversiones Cardoen group decided to invest in the wine industry, creating this vineyard in the Lolol area. It has 80 hectares (197 acres) planted exclusively with red strains, such as Cabernet Sauvignon, Malbec, Carmenère, Merlot, Petit Verdot and Syrah. The cellar contains French, Italian and German machinery, with stainless steel vats and French oak barrels.

S : At the heart of the vineyard, a cable car takes visitors to the top of a hill where they have created replicas of the villages of 3 different indigenous tribes (Rapa Nui, Mapuche and Aymara), showing their rituals, customs and traditions. This open-air museum allows a wonderful view over the valley.

W : Tupu, blend of 98% Carmenère and 2% Syrah. Violet red colour and a fruity background, predominantly sweet fruit.

TS : Visit the replicas of the indigenous villages accompanied by a guide. It also has 6 astronomical telescopes to observe the valley's starry nights, a wine museum and a gift shop with handcrafts from around the country. Price/person between €10 and €20 (USD$14-28). They also have a hotel located in the heart of Santa Cruz, with 113 fully equipped rooms. Average price for double room: €180 (USD$254).
Tel. (56-2) 221 90 90

Colchagua Valley
(www.colchaguavalley.cl)

VIU MANENT WWW.VIUMANENT.CL

H : Family business founded in 1935 by Miguel Viu García and his two sons Agustín and Miguel Viu Manent. Initially specialising in packaging and resale of wines, it started into winemaking in 1954, led by Miguel Viu Manent. He consolidated the brand image of the company, including a slogan that became very famous in Chile: *"¡Salud con vinos Viu!"*

S : Currently managed by José Miguel Viu Bottini, the company focuses on its family and traditional character, while surrounding itself with experts from around the world, such as their New Zealand œnologist Grant Phelps, and following the latest technological innovations. In 2008, the Viu Manent operation increased to 270 hectares.

W : Viu I, blend of 94% Malbec and 6% Petit Verdot. Deep purple, with aromas of blueberry and coconut, it is produced only during exceptional years when nature gives it its best.

TS : Provides a comprehensive tour, crowned by a tasting. Opportunity to ride through the vineyards in a carriage. Duration: 1 hour. Languages: English and Spanish. Every day at 10:30, 12:00, 3:00 pm and 4:30 pm. Includes an equestrian club offering a good range of activities, a boutique and a café. Restaurant by reservation (open daily from noon to 6:00 pm), whose menu is inspired by a book of family recipes.
Tel. (56-72) 858 751

Curicó Valley
(www.rutadelvinocurico.cl)

MIGUEL TORRES WWW.MIGUELTORRES.CL

H : Vineyard belonging to the Spanish Torres family, who has worked in the wine industry since the seventeenth century. In 1979 Don Miguel Torres Carbo bought a small winery in Curico, being among the first foreigners who bet on the central valley of Chile. Today the vineyard has 445 hectares (1,099 acres) planted with various strains, such as Cabernet Sauvignon, Merlot, Carmenère, Sauvignon Blanc, among others. Its state-of-the-art wine cellar contains 2,000 French oak barrels.

S : Their modern cellar is built in a colonial architectural style. This vineyard also has a harmonious mixture of red brick houses with a corridor made of native wood. The vineyard sampling garden where you can taste different types of grapes is remarkable. It has a welcoming and modern visitor's centre with facilities that reflect the tradition of Chilean wine.

W : Manso de Velasco, 100% Cabernet Sauvignon, dark cherry coloured with aromas of red and black fruit and spicy notes.

TS : Showing of a corporate video in several languages, then a visit to the facilities finishing with a tasting of their Santa Digna range. Price per person: €7 (USD$10). In spring / summer: daily tours, 10:00 am to 7:00 pm. Autumn / winter: until 5:00 pm. It has a gift shop and a restaurant with large windows amidst the vineyards. Elegant and minimalist decor. A recommended highlight is the oysters and vegetable "chupe" stew, served with *merquén* spice and oregano toast.
Tel. (56-75) 564 100

Curicó Valley
(www.rutadelvinocurico.cl)

SAN PEDRO WWW.SANPEDRO.CL

H : This vineyard began when the Correa Albano brothers, fifth generation of their family, acquired the land planted by their ancestors and began to make their first wine with local grapes, which were later replaced by vines brought from France and Germany. Today the vineyard is in the hands of a large group (CCU SA). They have 1,200 hectares in this valley and a total of 2,500 hectares (6,178 acres) along the Central Valley.

S : It is one of the largest vineyards in the country. Their main cellar is located in this valley with a capacity of 38 million litres (10,000 gallons), where 2 thousand bottles are produced per hour. It also has a very pretty underground cellar of 550 square meters (5,920 square feet), built around 1865 in cal y canto (stone with lime/egg white mortar).

W : Cabo de Hornos, 100% Cabernet Sauvignon. Very intense colour, concentrated and dark, with spicy aromas mixed with wood, coffee and black fruit.

TS : Different types of tours are available, such as horseback riding through the vineyards and the adjacent hills, including a picnic basket with wine, water, sandwiches, etc. Duration: between 1 hour and 3 hours. Prices range from €11 to €40/person (USD$15-56). Tuesday to Saturday from 11:00 am.
Tel. : (56-75) 491 517

Curicó Valley
(www.rutadelvinocurico.cl)

VALDIVIESO WWW.VALDIVIESOVINEYARD.COM

H : The story of the vineyard began in 1879, when Don Alberto Valdivieso founded Champagne Valdivieso, the first producer of sparkling wine in Chile and South America. A century later, in 1980, they began producing wine in Lontué. Since 1947 the vineyard has been in the hands of the Mitjans family.

S : Possesses a park with centennial trees from the region. It is the most representative Chilean sparkling wine producer.

W : Caballo Loco, blend of Cabernet Sauvignon, Cabernet Franc, Malbec and Merlot. Deep red colour with sweet and spicy aromas, nutmeg, cinnamon and vanilla. The first Caballo Loco was created with many reserve wines available at the time. 50% of the blend was bottled and the rest was kept for a year in oak barrels. The following year's wine was made using this wine and blending it with the best wines of that year, and so forth.

TS : Possibility of visiting the vineyard (previous reservation required).
Tel. (56-75) 471 002

Maule Valley
(www.valledelmaule.cl)

J. BOUCHON

WWW.JBOUCHON.CL

H : A native from Bordeaux, Frenchman Emile Bouchon came to Chile in 1892. The current president, Julio Bouchon (his grandson) is a winemaker from the University of Bordeaux and is passionately devoted to his 370 hectares (914 acres), on which strains of Cabernet Sauvignon, Merlot, Carmenère, Malbec, Syrah, Sauvignon Blanc and Chardonnay can be found.

S : A vineyard with a lot of character, built in the image of its owner. Led by Julio Bouchon, who handles the place with both a family and a business vision. Closely tied to their land, he has been looking for Australian and French technology, as well as new markets as far away as Russia. The cellars built in cement date from 1800 and the tanks are treated with a special paint to protect the wine from temperature fluctuations. The house is built in an old colonial style, with traditional corridors and courtyards around which the rooms are distributed. Visiting this vineyard is like entering the real Chilean countryside, where traditions are preserved and *huasos* (Chilean cowboys) can be still seen riding their horses.

W : J.Bouchon Mingre, blend of Cabernet Sauvignon, Malbec, Carmenère, Syrah and Merlot. Intense red colour with aromas of ripe fruits of the forest and notes of vanilla, tobacco and chocolate.

TS : Possibility to stay in the estate house. Previous booking required.
Tel. (56-2) 246 97 78

Maule Valley
(www.valledelmaule.cl)

BOTALCURA

WWW.BOTALCURA.CL

H : Combining Chilean and European expertise, the Botalcura vineyard was founded in 2000 by Juan Fernando Waidele and Philippe Debrus, French œnologists. It derives its name from the little village where it is located, meaning "great stone" in the Mapuche language.

S : This vineyard is committed to the route of sustainable development. It has obtained for the village of Botalcura and its inhabitants a new economic development (advent of electricity, the internet, school computers) and a fair return, while putting in place a series of ecological measures (optimising water usage, use of recycled materials, etc.).

W : Cayao Icon, blend of 45% Cabernet-Sauvignon, 39% Carménère, 12% Malbec and 4% Syrah. Ruby in colour, with aromas of plum, cherry, blackberry, mint, cardamom and black pepper.

TS : Tours by appointment.
Tel. (56 2) 370 13 00

Maule Valley
(www.valledelmaule.cl)

GILLMORE WWW.GILLMORE.CL

H : Family vineyard acquired in 1990, led by Francisco Gillmore, his daughter and son-in-law.

S : A warm and welcoming family with a passion for wine and tourism. They have developed an integrated tourism project: they have a traditional mud-brick cellar approximately 200 years old, a guest house in the shape of butterflies, a biotherapy Spa where all the virtues of wine are used as a medicinal agent, a museum of wine-related items, and a small park with native animals such as rheas, alpacas, pudús (Chilean dwarf deer) and pumas.

W : Cobre, in its Cabernet Sauvignon, Cabernet Franc, Merlot and Carignan varieties. Aroma of tobacco, cassis and elegant fruit.

TS : Tour through the vineyards with native animals and a tasting. Approx. value per person: €7 (USD$10). Duration: 1 hour. Possesses a guest house with guest rooms. Offers its guests a Spa with services such as massages and special red wine baths. Average price per double room €150 (USD$212).
Tel. (56-73) 197 55 39

APPRECIATIONS

I want to especially thank my father
with whom I shared, page after page,
the inspiring adventures of this book.

A warm thank you to Marta Rebolledo Espina
for the hours she spent in the library of Santiago,
and to Vania Berrios for his text on Valparaíso
which reflects so well the spirit and charm of this magical city.

The owners of the wine producers are also thanked
for their warm hospitality during my travels.

Thank you to the Versant Sud staff
for the enthusiasm throughout this project.

And, finally, special thanks to Luc, my husband,
for his encouragement, his steady presence and his patience…